Hot Text
Web Writing That Works

Jonathan Price and Lisa Price

The Communication Circle
Albuquerque, New Mexico

D1296525

Advance Quotes about *Hot Text—Web Writing That Works!*

"This is the best web writing book around, with excellent coverage of history, theory, and application. Outstanding material on object-oriented writing and audience analysis!"

—**Muriel Zimmerman, Coordinator, Programs in Technical Communication, University of California, Santa Barbara**

*"Inspiring, authoritative, fun, and personal—*Hot Text *is an instant classic."*

—**Rich Coulombre, Principal, The Support Group, Needham, Massachusetts**

"Why is online writing so bad? Probably because books like this haven't been available until now. Buy it. Read it. Try something new—it's got to be better than what we're used to!"

—**Seth Godin, Author of *Survival is Not Enough*, *Permission Marketing*, and *Unleashing the Idea Virus***

*"Fresh, honest and inspiring—*Hot Text *practices what it preaches, from mindset to mechanics."*

—**Yvette Nielsen, new media journalist, consultant and trainer at www.brizcomm.com.au**

"The Internet offers far more challenges to writers than any other media—hard-to-read text, short attention spans, customization options, and an 'audience of one.' This powerful book provides real-world examples, case studies and compelling 'object-oriented' solutions for mastering this potential minefield. It's a unique and much-needed resource that should be in every writer's toolkit."

—**Bob Saldeen, Creative Director, Rivenet.com, Chicago, Illinois**

"Lisa Price is unparalleled in the writing field and the 'genuinely good people' field. Her proven experience will help professional writers boost their income, her accessibility and thoroughness will help new writers break into the online marketplace, and her personality will make you just plain happy."

—**Anthony Tedesco, coauthor of *Online Markets for Writers: How to Make Money by Selling Your Writing on the Internet* and publisher of the free Web resource for writers, www.MarketsForWriters.com**

"Warm, informative, conversational, inspiring, and honest, this book gave me great ideas and models without feeling like a lecture."

—**Colombe Leland, Web writer, newspaper editor, Albuquerque, New Mexico**

"Although we've known for years that writing for the Web follows different rules of grammar and style, until now, no one has tackled this issue. From the broad to the specific, the Prices guide you through the art of composing text for the Web that readers will really read."

—**Saul Carliner, Professor, Information Design, Bentley College**

*"*Hot Text *is a superbly written guide with dozens of humorously presented tips and real world examples for all of us who must deal with the limitations of the computer screen as a medium. I have already found myself sharing many of these suggestions for brevity and clarity with my 'client writers.' What good is a beautiful Web site unless you get your message across? I only wish I had had this book two dozen Web sites ago. Don't wait—add this book to your resource library today."*

—**Chere Hartman, Red Desert Designs, www.reddesertdesigns.com**

*"*Hot Text *is really a master-class-in-a-box. Both practicing and wannabe Web writers will want to read it and join the online discussion group. Teachers and trainers will find everything they need for courses on writing for the Web: sensible, authoritative precepts; clear explanations; useful examples; discussion questions; research topics; extensive bibliography; and much more.*

"The Prices model their own advice about persona and genre. Knowing how "to write like human beings," they are witty and

genial guides through the thickets of XML, menu structure, and object-oriented writing. Hot Text is authoritative. It draws on its authors' considerable experience as Web writers, but its precepts are also supported by a lot of book-learning. The authors' copious research shows, but it does not distract the reader. The references are well-integrated with the text, and fuller documentation appears in unobtrusive end-notes. A big, thorough bibliography is a gift to other researchers."

—Dr. Helen Moody, Writing Coach and Trainer, ProTrainCo, www.protrainco.com

"Jonathan and Lisa Price have crafted a panacea of web writing—weaving threads of practicality with attitude, they put the reader on the right track. Not to mention the fact that they deem it acceptable to lob multiple compliments in my direction."

—Eric Norlin, CEO, Titanic Deck Chair Rearrangement Corporation, Renegade editor and troublemaker for hire

"Jonathan and Lisa Price have written a truly useful book—graceful, engaging, and compellingly intelligent. The Web has changed how communication occurs, and Jonathan and Lisa illuminate successful approaches to creating Web documents of all kinds, including customer assistance, FAQs, resumes, and XML documents. Hot Text treats the people who use the Web as real people, with actual brains and real selves. From such a point of departure, Jonathan and Lisa's idea of communication is deeply humane. This is a key book for anyone composing information for the Web."

—Mick Renner, PhD, MR Communications, Berkeley, CA

"The Prices know how to "sing the body [text] electric" in this new book for Web authors, in which their theoretically sound yet eminently practical advice will lead would-be and accomplished Web authors into and out of the skills they need to design and build audience-sensitive Web sites. Especially useful is the Web-based advice on audience, which takes the seemingly infinite range of web audiences and focuses instead on 'The Audience of One,' the single user who must navigate the electronic mosaic of text, frames, links, and whatnot that make up the modern-day Web site..

A must for serious Web authors and those who would teach others to be such."

—Scott Sanders, Chair, Department of English, University of New Mexico

"This is one exhaustive and erudite look at Web writing."

—Doug Lavender, e-Copy Specialist, http://douglavender.ca

"Don't just read this book. Follow its advice. With such a pleasant reading one easily forgets that this book intends you to act. This book will empower your clients and yourself."

—Hans van der Meij, Professor, University of Twente, The Netherlands

"Hot Text examines good writing practices and discusses their application to and implementation on the web. It's a great book. The tone of the book is easy going: it feels as if you're chatting with the author over a cup of coffee, except that you're constantly stopping to highlight the great ideas you want to apply to your own website. The content rules in this book, so much that it's easy to overlook the relevant quotes in the sidebar. Overall the book is a very useful tool for anyone writing for the Web."

— Dr. Jean A. Pratt, Business Information Systems, Utah State University

"The Prices' new book is HOT. These authors bring deep experience across many contexts of writing—they know what works and why it works. They show what happens when writing becomes part of a machine—how it must change shape, change its relation to audiences, and change its texture. Jonathan and Lisa Price take all the fine common sense they have gathered over the years and have always shown in their other work. Now they demonstrate concretely how to move writing from paper to the web. They do so with a deft touch—with style and verve."

—Stephen A. Bernhardt, Andrew B. Kirkpatrick Chair in Writing, University of Delaware Department of English

Hot Text
Web Writing That Works

Jonathan Price and Lisa Price

The Communication Circle
Albuquerque, New Mexico

New Riders 1249 Eighth Street, Berkeley, California 94710

Hot Text—Web Writing That Works

International Standard Book Number: 0-7357-1151-8

Library of Congress Catalog Card Number: 2001089176

Printed in the United States of America

First Printing: January 2002

7 6 5 4 3

Trademarks

Warning and Disclaimer

Publisher | David Dwyer

Associate Publisher | Stephanie Wall

Executive Editor | Steve Weiss

Book Packager | Justak Literary Services

Production Manager | Gina Kanouse

Managing Editor | Sarah Kearns

Acquisitions Editor | Karen Whitehouse

Product Marketing Manager | Kathy Malmloff

Publicity Manager | Susan Nixon

Manufacturing Coordinator | Jim Conway

Cover Designer | Allison Cecil

Interior Designer and Compositor | Allison Cecil

Proofreader | Lara SerVaas

Indexer | Sandi Shroeder

Contents

About the Authors

We are professional Web writers and editors. We regularly coach other writers, showing how to tailor their prose for e-mail, Web pages, and discussions. We focus on text, not design or tags. If you have to write text that will go up on the Web, we're talking to you. We have written for the Internet for the last seven years, so we talk from real experience—and affection. We love the spirit of the Net.

We come out of a background in journalism (writing for magazines such as *Esquire, Harper's, Reader's Digest,* and *TV Guide*), technical communication (writing and consulting with an A-to-Z of high tech firms), art (conceptual art in New York), TV and radio (dozens of interviews, and our own shows).

Along the way, we've written 24 books for major publishers and hundreds of articles for Web sites. Our consulting clients include such firms as America Online, Apple, Broderbund, Cadence, Canon, Cisco, Coupons.com, Disney's Family.com, Epson, eToys, FileMaker, Fujitsu, Hewlett-Packard and HP.com, Hitachi, IBM, KBKids.com, Ketchum, Kodak, Los Alamos National Labs, Lotus, Matsushita, Middleberg Euro, Mitsubishi, Nikon, Ogilvy, Oracle, PeopleSoft, Relational, Ricoh, Sprint, Sun, Symantec, Visa, Xerox, and Zycad.

Jonathan has taught writing at New Mexico Tech, New York University, Rutgers, University of New Mexico, and the Extension programs of the University of California, Berkeley, University of California, Santa Cruz, and Stanford.

Lisa was the Features Editor at KBKids.com from startup days to $80 million merger; she writes a weekly Internet column, ShopTalk, for Coupons.com. She frequently appears on TV and radio.

We live in an adobe house in the woods along the Rio Grande as it flows through New Mexico. Our sons, Ben and Noah, take the Web for granted, but prefer football.

Dedication
for Ben and Noah

Acknowledgments
Our thanks to Karen Whitehouse, who got this book rolling, and kept us focused, Marta Justak, who guided us through editing and production, Victoria Elzey, who saw the book into print, Allison Cecil, who came up with this wonderful book design, and Kathy Malmloff and Susan Nixon, who developed a great marketing campaign. Joyce Daza inspired us with her attitude, attention, and spirit, and passed along her expertise on citationology; we appreciate her help in so many ways! Our sons, Ben Price and Noah Price, have kept us from getting too serious, and they got us to laugh a lot as they took the photographs that show up at the beginning of each chapter. And thanks to all of the writers who have participated in our workshops, asking good questions, and helping us to think through our ideas from many perspectives. This book is a collaborative conversation, and we are pleased to hear all these voices throughout these pages.

To Teachers
If you're looking for supplementary materials, exercises, and Web explorations based on our book, please visit the Challenges section of the Web site, at http://www.WebWritingThatWorks.com. Your students will also find advice on citing information discovered on the Web.

If you would like to post a link to your course site, please e-mail us the course title and URL at theprices@theprices.com. We would be glad to put new students in touch with you. Have some questions or suggestions? Please e-mail us at theprices@theprices.com.

A Message from New Riders

As the reader of this book, you are our most important critic and commentator. We value your opinion and want to know what we're doing right, what we could do better, in what areas you'd like to see us publish, and any other words of wisdom you're willing to pass our way.

E-mail: errata@newriders.com

Visit Our Web Site: www.newriders.com

On our web site, you'll find information about our other books, the authors we partner with, book updates and file downloads, promotions, discussion boards for online interaction with other users and with technology experts, and a calendar of trade shows and other professional events with which we'll be involved. We hope to see you around.

E-mail Us from Our Web Site

Go to www.newriders.com and click on the Contact Us link if you

- Have comments or questions about this book.
- Want to report errors that you have found in this book.
- Have a book proposal or are interested in writing for New Riders.
- Would like us to send you one of our author kits.
- Are an expert in a computer topic or technology and are interested in being a reviewer or technical editor.
- Want to find a distributor for our titles in your area.
- Are an educator/instructor who wants to preview New Riders books for classroom use. In the body/comments area, include your name, school, department, address, phone number, office days/hours, text currently in use, and enrollment in your department, along with your request for either desk/examination copies or additional information.

Home Page

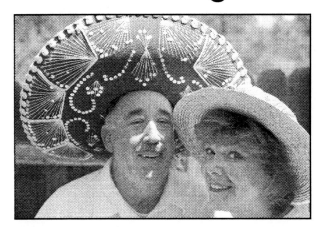

Writing for the Web transforms our old ideas of audience, structure, and style. When we immerse ourselves in the Internet, we see concepts that we have inherited from years of writing on paper begin to dissolve.

On the Web, for instance, the audience is no longer just a passive recipient of documents that we publish. Instead, in many cases, the audience starts the communication, asking pointed questions, lodging lengthy complaints, bugging us for a response. We can no longer think of ourselves as "authors." We are instead participants in a conversation, swapping ideas across the Net, exchanging e-mail, Web pages, discussion postings with these other folks, many of whom have better ideas, more experience, and deeper wisdom than we do. What a comedown! And how much more fun! Our relationship becomes more sociable.

In a blitz of flames, rants, and instant messages, this new, active audience suggests topics to discuss, problems to resolve, and entertainment they would like to experience. They are guiding the conversation. And, in response, we can no longer simply dish out entire documents, with the answers buried in there somewhere. Sometimes the answer to a particular question lies in one paragraph—and that is all the person wants to read.

So we are beginning to abandon whole documents, turning our attention to the components that make up those documents—the informative objects within. Responding to the demand for pinpoint information while producing content in an object-oriented environment, we must write carefully following a standard organization, so that the software can skim right to the relevant objects, displaying them and manipulating them at the command of the user. We are learning to think structurally as we write.

And the way that our text appears on the computer screen constrains the way people perceive, use, interpret, understand, and recall whatever we write. Because the screen resolution is so much worse than that of a printed page, our Web text is harder to read, more difficult to grasp as a whole, and more blurry in memory. Visitors to our sites resist reading to the last moment, using text to navigate, postponing actual reading as long as possible; and when they do settle down to read, they often ask for short chunks of prose—abrupt talk. To move our ideas through this medium, adapting to the situation in which our text will appear, we adopt a tighter, tougher, and smarter tone. Web style grows naturally out of the electronic medium we use for this extended conversation.

Our aim is to help you write Web text that works for your guests. We want a visitor to your site to send you e-mail describing your text in terms like these:

"Hot"
- "So interesting that I chatted your site up on my favorite listserv."
- "I recommended this to my friends."
- "Your text is warm to the touch—human. Perhaps even passionate."

"Attention-grabbing"
- "Your ideas really caught my eye."
- "Right off, you persuaded me to focus on what you say."

"Interactive"
- "You encouraged me to move around the site and explore."
- "You made me want to click those links."
- "With your encouragement, I didn't mind filling out those forms."
- "After reading what you said, I just had to buy."

"Relevant"
- "Your text was especially meaningful to me."
- "You seem to be able to relate to my situation."
- "You understand my dreams."
- "You helped me solve my problem. Thanks."

"Sticky"
- "This was so great that I couldn't bring myself to click away."

"Persuasive"
- "You've convinced me."
- "You get me stirred up, all right."

- "You made me get out of my chair and act."

"Informative"
- "You gave me tons of great ideas."
- "This was the news I needed."
- "Heck, your text was an education in itself."

"Conversational"
- "I felt like you were talking directly to me."
- "I felt like we were sharing ideas. You weren't just lecturing me."
- "I felt like you really listened to me."

"Open-handed"
- "You provided far more information than you had to. Thanks."
- "I appreciate your letting us see your company—warts and all."
- "You went way beyond the minimum, to make sure you are really helping a visitor like me."

People come to your sites for lots of reasons. Some of their motives are downright crazy. Some dreams are impossible for you to fulfill. But when you care about your guests, you want to help them accomplish their own goals. You know you are succeeding when you get e-mails like these.

In this book, then, we give you our personal take on what works best when writing on the Web. We draw on the advice of other writers and editors, research from reading experts, recommendations from usability gurus, and even theories from literary scholars. But the book expresses our own point of view.

And we hope you'll let us know where you see things differently, where you think we've gone wrong, and where you see changes taking place. We see what we have written as a part of an extended discussion. We invite you to send us your comments, by posting to the Hot Text list and joining the Web conversation. Like this:

POST |

Express your own idea on:
HotText@yahoogroups.com

My Idea:

Post to HotText@yahoogroups.com

Visit:
http://www.WebWritingThatWorks.com

part 1

Catch the Net Spirit

chapter 1

Who Am I Writing for, and Incidentally, Who Am I?

Get to Know the Audience of One

The very concept of an audience is stained with the word's original meaning—a large group of people *listening* to a speaker. The traditional audience was a mass. Before the Web, we tended to think of our audience as a rather vaguely defined crowd or, perhaps, as a collection of several groups, each of which had a different interest in our subject matter. A single speech, book, or document would address all these groups, we hoped.

On the Web, though, the mass audience is crumbling. In its place, small groups are emerging, forming around common interests, aims, jobs, politics, hobbies, or obsessions. And within these groups, we see individuals arising, demanding that we deliver information specifically tailored to their personal taste. We are moving from a writing situation in which one author addressed a single vast audience to a process in which many individuals exchange information with each other, aided by some people who do more writing than others.

The mass audience was always just a convenient fantasy, allowing us to ignore the complexity of groups with competing aims, and within those groups, individuals, each with a unique perspective. We had no way of knowing each person we were writing to back then, and we had little useful information about the groups they might be segmented into by marketers intent on persuading them to buy. We were forced to guess what people needed, and we often imagined that the audience was a lot like us and our teammates. As a result, we often failed to connect with people in a meaningful way.

You can't hold a conversation with a faceless cloud of people, a generalized audience such as "beginners" or "experts." You won't get your point across. You will lose them one by one.

Your audience is one single reader. I have found that sometimes it helps to pick out one person—a real person you know, or an imagined person—and write to that one.

—John Steinbeck

The more you know about your visitors, the better you can write for them

When you actually know a lot about the people you are writing for, you can tailor your site to their needs. For example, you can:

- Come up with more of the topics they want.
- Organize those topics the way these people think.
- Use words that they use.
- Adopt a tone they find congenial.
- Tailor your words to the relationship you have developed with them.

In these ways, you allow your visitors to influence the way you write. In a real conversation, you are always aware of the way the other person is reacting—where they nod, when they lunge forward hoping to interrupt, and so on. You adapt your words and tone to indicate how you regard the other person, what you want, where you are going. But when you do not have the full bandwidth of direct human contact, you have to guess what the other people think of you, how you are going to relate to them, what they want to hear, and what you want to say to them.

The more sensitive you are to online conversation and its nuances, the more you can eliminate the odd quirks, biases, and focal points in your prose, so it begins to seem transparent to the readers, that is, you do not rub them the wrong way with your own personal agenda. In part, you are erasing your own originality, but you're doing this for a reason: to make contact, to make sense, to convince, to reach out to this other person. How sociable!

Do you really know your audience? We write for ourselves, for our boss, for our team. Oh, and incidentally, we may draw on the little we know about our audience, too, but that doesn't take us very far. So we soon forget it.

In hundreds of meetings, we have heard clients, bosses, and peers announce that the target audience is, well, beginners, oh, and some experts, too. Enough said. On to the next agenda item.

In situations like that, writers tend to write for each other or the team, rather than the actual consumers of the information. Result: consumers find the prose impenetrable, and gripe about the frightening amount of jargon, the unfriendly tone, and the confusing

I know I am solid and sound,
To me the converging objects of the
universe perpetually flow,
All are written to me, and I must
get what the writing means.

—Walt Whitman, *Leaves of Grass*

way the material is organized.

Info consumers are not you. To psyche out what topics really matter to your many different audiences and to develop a tone that works for individual members of that crowd, you need to learn more about them as members of particular niche groups, and, more important, as unique individuals.

Information consumers are pushy

On the Web, most consumers of information demand content fast. They may be surfing to amuse themselves, to learn something, to buy, or to participate in some community; but no matter what their aim, they have seen that some sites care who they are, allowing them access to all the information the organization has, while also personalizing the topics, tone, format, and transactions. These uppity consumers are impatient, self-absorbed, and a bit confused, but if you give them the content and service they want, they will return over and over, becoming loyal fans and customers. Here are a few of the things these consumers demand of your text:

"Don't waste my time."

No more lengthy explanations. Clear away those introductions, transitions, summaries. Get to the point.

"Remember me."

Like Hamlet's father, I want to be remembered when I arrive at your site. But recognition goes beyond greeting me by name. I want to see topics I care about, like on my personal version of the *Wall Street Journal, Interactive Edition.* I want to have my pages look and sound like the design I chose for My Page. I want your text to sound as if you share my concerns, goals, and obsessions.

"Let me answer my own question."

Embed answers right in the forms I have to fill out. If I have to go to the Help or FAQ, organize it the way I think. Provide all the answers, not just the part that marketing folks feel comfortable with. Give me a way to run a diagnostic on my own problem, so I can troubleshoot it myself. Admit all problems, and send me to a discussion board where other consumers have come up with solutions.

Armed with information, access, and power, today's customers can dictate new practices and policies faster than your firm is likely to be able to implement them.

—Patricia Seybold, Ronni Marshak, and Jeffrey Lewis, *The Customer Revolution*

"Exceed my expectations."

The road to delight leads past satisfactory performance. When you give me more than I expect, I'm pleased. If you go beyond the standard a few more times, I am yours.

"Talk to me in real time."

If I've just put a product in the shopping cart, don't act like you don't know. Drop the pitch for that product. Add stuff about add-ons. Just as I expect used links to change color, I expect your system to know where I have been and what pages I have looked at, adjusting the text to reflect that.

"Let me customize the content."

I like some content, and I want to see that first. Let me choose what shows up at the top of my own page. Let me opt in for e-mail about topics, products, services, and controversies I am interested in right now, and when I change my mind, let me unsubscribe from e-mail hell.

"I want to feel special."

I've been to your site so often I feel like I know you. I've read much of your material and I have debated with you, either in my head, or in e-mail. I expect you to recognize that I am a repeat reader.

A good designer and a good writer have to share certain characteristics, among the most important being empathy.

—Donald Norman, *Turn Signals are the Facial Expressions of Automobiles*

Purpose seizes us, binds us rather than being deliberately crafted by us.

—Robert Weber, *The Created Self*

With all these impulses, each consumer envisions a different text. At the least, each small group of consumers demands that you pay attention to them, reflecting their interests in your organization, attitude, and style.

Figure out who you are really talking to

When you ask your boss or client who actually consumes your text, you often get a lot of waving of hands without much detail. Maybe you hear a few numbers that research developed six months ago, some shorthand guidelines issued by a committee reviewing the latest design, and some slogans from the latest marketing campaign. But you rarely hear much about individuals, and because your job is to develop and carry on a conversation with these people, your prose can easily take on the all-purpose smarmy charm of an airline clerk announcing another delay. The more you know individuals in your audience, the better you can write for them.

To find out about real individuals, you may be able to examine a consumer's profile, which may be a dossier that the site should build as the consumer navigates, ponders, buys, sends e-mail, phones in, faxes a question, visits a kiosk, clicks in from a handheld. Ideally, your organization should have a single collection point for all information about each consumer.

Develop a deep understanding of how your customers do their jobs.
—Patricia Seybold and Ronni Marshak, *Customer.com*

Unfortunately, many organizations have no idea who consumes their text. Manufacturers of packaged goods, for instance, haven't a clue who most of their customers are because they tend to act as if the big buyers at the department stores and grocery chains are their "real customers." The only real consumers they are aware of are the ones who complained or sued. Companies that sell big-ticket items gather a lot of financial information about each customer, but sometimes that gets spread across several departments, so there is no one file you can open, to review the facts about a particular individual.

If your site has any profiles for consumers, absorb them. But if those profiles are skimpy, or so mired in transactional information that you cannot envision the person behind the sales, you may need to do your own research to find out who is really consuming your text.

First, volunteer:

- Answer the phone in technical and customer support.
- Respond to e-mails sent to technical and customer support.
- Schmooze with consumers at trade shows, conventions, user group meetings.

Then watch:

- Watch through the one-way mirror as the facilitators lead demographically representative consumers through questions created by the marketing group. (See if you can add a few questions of your own).
- Hover around the usability lab. Watch how people get in trouble using your site. (Caution: this experience can be embarrassing if your text happens to be on-screen).

Next, read:

- Competitive analysis to see what the competition is creating for whom, and why.
- Marketing and sales numbers to see what the trends are.
- Marketing materials and plans to see how the organization is positioning itself, and for whom.
- Product documentation to see what tasks the writers imagine people are doing, what concepts need explaining, and what context people are assumed to be using the product in.
- Annual reports—the biggest marketing documents of all—to see how upper management is trying to position the company in front of shareholders and analysts.
- Every news story about your organization to figure out who the reporter thinks your audience is.

Then schmooze: Talk with anyone who has met, corresponded with, sold to, mollified, or hung up on a consumer, including:

- Sales reps and sales engineers
- Marketing people
- Researchers
- Trainers
- Technical writers
- Phone support and field-support personnel
- Consultants
- People in your partner organizations
- Anyone who hires or manages the actual consumers

Finally, when you have a good mental picture of whoever is visiting the site, go out and meet the consumers to see what they are really like. Pick a dozen consumers who matter—ones whose good

In between setting out and coming back, they continually shifted their goals, their preferences, and even their rules without hesitation. Shopping was in many ways a process of discovering or creating underlying preferences rather than acting in accordance with them.

—John Seely Brown and Paul Duguid, *The Social Life of Information*

will and loyalty guarantee the site's survival. Not partners. Not influential stakeholders, like investors, ad guys, designers, engineers. Real consumers of your text. Try to get to talk to them at length, in person, so you can watch their reactions. But as Hackos and Redish (1998) suggest, you must ask a lot of questions.

Ask about work:

- What's your official job title?
- What kind of content do you really use on the job?
- What tasks do you have to accomplish using that content?
- Where did you learn to do your job? (School, training, on the job training, stand-up classes, Web courses, gossip, whatever).
- Where does work come from, when it arrives on your desk, and where does it go after you get through with it? (Workflow)
- What is an average day like? A crunch day?
- How much leeway do you have to decide what you do when?
- Where do you turn for general news relating to your work, organization, or industry?
- What kind of Internet connection do you have at work?

Probe motivation and free will:

- What are your main goals at work? How do particular tasks relate to those goals?
- Is it your idea to come to our site, or are you required to do so?
- Do you feel you have the power to affect the culture of your workplace?
- Are you regularly involved in decisions that revolve around our kind of content?
- What do you most like to do when exploring our site?
- Do you feel eager to learn new information that relates to your tasks, your job, your organization, or your industry?
- What are the consequences if you do not find the information you need on our site?

Focus on tasks at work:

- What are the main tasks you do on the job?
- What are the little tasks within the big ones? (Hierarchy.)

- In what sequence do you usually do all these tasks?
- Which ones do you do by yourself? With other people?
- How long have you done each of these tasks?
- How did you learn to do each task?
- How have the tasks changed over the years?
- Which tasks currently involve using our site?
- What tools do you use to perform those tasks?
- How comfortable are you with those tools?
- Which of your tools do you like most, dislike, and why?
- What problems come up when you are working on a task?
- How do you generally solve the problems?
- How do you describe the process of analyzing and solving one of these problems?
- How well does our content match what you need to complete the task?
- What is missing?
- What other sites do you use in performing your tasks?

Is there agreement throughout the organization about who your end customers are and what matters to them?

— **Patricia Seybold, Ronni Marshak, and Jeffrey Lewis,** *The Customer Revolution*

Ask about home, if appropriate:

- What are your aims in life?
- What do you do for fun?
- How much time do you spend on the Internet at home? TV? Radio?
- What kind of hobbies do you have?
- What kind of neighborhood do you live in?
- What kind of Internet connection do you have at home?
- How close are you with your family? Friends?
- What languages do you speak at home? Read? How familiar are you with languages other than the one you consider your primary language?
- What is your highest level of education, and how do you think that affects what you do now?

Ask about mental models:

- How would you describe the content we provide?
- How should it be organized?
- What terms do you use for the key concepts?
- Which pieces of content are the most important for you?
- What other content do you need, for your job?

- Is that something we can help you with?
- What topics are associated with other topics?
- Do you learn better from a diagram or from text?
- If you want to learn, do you turn to another person, TV, radio, newspapers, magazines, or books?

Explore personal differences:

- How do you prefer to learn new material? (For instance, trial and error, asking others, formal training, reading ahead of time, self-paced interactive training, online courses).
- What special needs do you have?
- Are you color blind?
- Do you have difficulty reading small type, or making small movements with your hands?
- How do you feel when you have to change the way you do your job?
- When do you prefer working together with a team, or by yourself?
- How do you describe your gender? Your age?

Explore group identities and affiliations:

- How would you describe your organization's culture to an outsider?
- What are the aspects you like most or least?
- What groups do you belong to, formally or informally?
- What volunteer organizations do you occasionally work for?
- What ethnic and racial cultures do you identify with, and how do you describe those? How would you describe my own ethnic and racial background?
- Do you have a preference for a certain way of organizing information, or carrying out tasks, based on the way you were raised in another country?
- How would you describe your socio-economic status? Mine?
- Do you belong to any trade association, professional group, or union?

Obviously, you can't impose on someone for a whole day asking a thousand questions like these. But some responses are more important for you than others. Concentrate on those issues.

Pay people for their time; give them cups, t-shirts, products,

Segments are the passive targets of marketing initiatives. They don't try things out, ask questions, negotiate price and terms, make adjustments, substitute spending for one item by sacrificing another, or complain and seek refunds.

—Don Peppers and Martha Rogers,
Enterprise One to One

attention, and, yes, money. For you, their answers are gold.

Online, people resent having to fill out a lengthy registration form just to visit a site or look at a particular page. If you are going to invite people to give you information to create an electronic profile, add to it incrementally.

1. At first ask only for the bare minimum needed for a transaction. Make sure that the visitor can see a single substantial benefit from giving the information and then make sure that you deliver. They are investing their time. You must give them an immediate return on that investment. Feedback delayed fails to ingrain any habit.

2. **Log each visit** by IP address, browser, date, and time, in the profile.

3. Record any **downloads** along with the e-mail address needed for that.

4. Keep asking for **feedback**, and each time they offer some, ask a few more questions.

Do you have a customer-focused culture?

— Patricia Seybold, Ronni Marshak, and Jeffrey Lewis, *The Customer Revolution*

Encourage people to look at their profiles on your site. Let them see their entire transaction history, and all the information they have provided you over all their visits. Let them modify their profiles. You'll be surprised how many more fields they fill in once they get started. As soon as a consumer enters updates, display those right away—not the next day. Convince your consumers you are listening:

- Never ask for the information the consumer has already given you.
- Supply names, addresses, preferences, without being asked.

You can see that you need a lot of time to explore all these questions with an individual. But once you have met with a dozen consumers, and read a hundred profiles, you'll begin to have a very deep sense of the different kinds of people you may be writing for. How do you articulate this "sense" in practical terms?

See: Beyer and Holtzblatt (1997), Hackos (1995), Hackos and Redish (1998), Jonassen and Hagen (1999), Peppers and Rogers (1993, 1997), Price and Korman (1993), Schriver (1997), Seybold and Marshak (1998), Seybold, Marshak, and Lewis (2001).

Make Sense Out of What You Learn about Your Audiences

Psychology at your service: How many ways can you slice a personality?

You'd think that by now humans could have come up with a single theory of personality. But no. Just in the realm of therapy there are dozens of theories taking off from Freud and Jung, and spreading like jungle grass. If one of these therapeutic approaches makes sense to you, go ahead and use it to interpret the information you have just gleaned from the actual consumer.

Ditto for religion. If a particular religion gives the world meaning for you, then by all means use its theory of personality to interpret the consumer and your relationship to that person. If you follow a spiritual practice, observing the movement of your inner life, use your guru's ideas to understand yourself in relation to the other. If you're a novelist, write a narrative. Stories are an excellent way to envision a character in action, or create a drama, a video, or a song.

Whatever profession you come from or live among, it probably offers you its own dominant psychology, its own way of interpreting human behavior, refined and disputed by various splinter groups, crusading sects, and reformers. For instance, economists, who for years believed that all economic behavior was reasonable, are now beginning to recognize a new type of person: the irrational consumer. Similarly, cognitive science which has focused for years on thought problems that can be simulated on the computer, has edged into fuzzy logic and a deeper sense of human unpredictability.

Even the discipline that fostered writing, rhetoric, has its war of psychologies between the post modernists, the traditional Aristotelians, the Sophists, the discourse community folks, and worse.

O I say these are not the parts and poems of the body only, but of the soul,

O I say now these are the soul!
—Walt Whitman, *Leaves of Grass*

Bottom line: There are hundreds of psychologies out there, and you should adopt whichever one you feel familiar with, because the point is for you to make sense out of your users and readers internally. If a particular approach seems cold, unfeeling, or unfamiliar, skip it, because it will not help you to conceive of your audience in realistic human terms.

But adopt some method. You need a theoretical framework in which to organize and preserve what you have observed. If no psychology appeals to you, consider task analysis, use cases, or niche analysis—a set of interlocking tools that come from usability study, object-oriented programming, and, yes, marketing.

Analyzing the tasks

Somehow, through direct interviews, studying the research, or asking questions on your site, you have gathered a lot of information about exactly what your consumers do and why. If you want to produce text that helps people achieve their goals, try thinking through the tasks each consumer performs over and over.

A task is an action someone performs to reach a goal. The name of the task is whatever the consumer says it is—not what your team likes to call it.

Each person starts with a goal, such as finishing the budget, getting a raise, learning a new skill, getting in touch with other people, or just being amused. Sometimes this goal aligns with what the boss wants, but usually the organization's goals, such as increasing profit margins, reducing time to market, or cutting five people from the support team, just make the person's life difficult. Pretending to do what the boss wants, while getting some personal amusement, can be a challenge.

As a writer you must care more about your consumers than about their corporations, universities, agencies, labs, or non-governmental bodies. Corporations don't read. Try to identify the goals in the way your consumers really talk about them because the terms they use to describe their goals reflect their values, passions, and life experience.

Goals are as multifarious as people. For instance, here are some of the different goals people may come to your site with:

- To have fun—to be entertained, pulled out of one's self, aroused, fulfilled, stirred up and satisfied, to participate in a game, to play.
- To learn—to pick up facts, to see patterns, to recognize sequences, groups, hierarchies, and themes, to learn to solve problems, to talk in a new language.
- To act—to make a purchase, to register, to acquire, download, send or receive information, software, music, videos, or whatever.
- To be aware—to sense what is going on internally and in others, to grow, to become, or just to be.
- To get close to people—to share, to show off, to feel intimate with total strangers through virtual conversations, postings, flames, posturing and revealing.

Generally, people formulate a goal rather vaguely and then form a specific intention, which demands a certain course of action. When they carry out that activity, they pause and look around them, to see what has changed. They interpret the state of the world, to evaluate the outcome. Carrying out a task involves the entire cycle, starting with the aim and moving through the activity to a decision about whether or not the actions have led to success.

You may want to analyze important tasks by walking the person through this cycle. Or you might settle just for noting the concrete actions taken to achieve the goal. (These actions may end up as individual steps in your instructions, if you need to tell people how to do the task.)

Start by listing all the tasks that flow from a particular goal in no particular order. Then organize them into chronological order as best you can. (Some tasks always happen at the start, others at the end, and the rest could happen, well, at any time). For the tasks that could happen anytime, try to discern a reasonable grouping by action or object worked on. You want to make some kind of meaningful order out of the collection of tasks because this inventory may form the basis for a menu system and an organization of your instructions, procedures, or FAQs.

You may find that some tasks are very large scale, such as shopping or getting a raise. Other tasks are intermediate in scale, such

There are many selves in a character, and their relation to each other is the matter that is often most obscure. What complicates the search, then, is not the simple fact that identity inheres in action and must be sought there, but rather than the action is not single in its purpose. Once again we are looking for a cast, for a script, and for an explication du texte.

—Jerome Bruner, "Identity and the Modern Novel," in *On Knowing*

as finding the section of the site that describes printers or completing the new proposal for the boss. And lots of tasks are small scale, like spell checking the proposal to make sure the company name is spelled right. Beneath the level of a task are individual steps.

Turn your inventory into a task hierarchy, a multilevel taxonomy of all the tasks that your individual consumer performs in pursuit of a particular goal, from large to small. At some point you may want to build a task hierarchy for each goal pursued by each of your consumers and then merge them, to see which tasks are vital to everyone, and which aren't, or where the variations occur. In this way you are creating a menu system for a set of procedures, or FAQs, showing people how the large-scale tasks relate to the others, as they drill down to the specific task they want help on. And you are beginning to see where you may need to offer separate menus for people who have different goals.

Because work often moves from one person to another, you may need to diagram the workflow to show how the same document or transaction moves from desk to desk. In this way you can create accurate scenarios for different consumers, looking at things from one person's desk and then another's.

Insert the problems along the way. You'll probably want to write a way around these or offer a solution.

Extract a vocabulary—the terms that these different consumers use for the goals, the tasks, the objects they operate on, and the outcomes. For definitions, quote your consumers, if you can, rather than acting like Noah Webster.

Tie consumer profiles to business rules, events, and objects

If you work in an object-oriented environment, you may want to adopt a similar approach as a way to make sense out of the raw impressions you have collected from actual interviews. If your organization already has developed electronic profiles of each visitor, you can work with the team to use the profiles to recognize individuals or groups who trigger these events. These events, to which the system reacts by following certain business rules, can invoke particular objects—some of which may include your text.

For example:

- **User profile:** The profile shows this person is a network engineer, who has a dozen of your high-end routers installed, visits the site every few days, joins the trouble-shooting discussion list, and is interested in beta-testing new products.
- **Business rule:** If the company has more than $500,000 worth of our products installed, and if the person is an engineer, and if the person has volunteered to do beta-testing, then we should alert this person by e-mail and in a special notice on his personal Router Page.
- **Event:** The person arrives, and the system checks the profile, then checks whether there are any beta-testing products available for this type of customer, decides there is one, and calls for the content management software to display an object called Notice on this person's personal Router Page.
- **Object:** Along with the other objects that go to make up the personal Router Page, the software displays the Notice object that shows a photo of the new box, and invites the visitor to ask for beta testing, using the dropdown form.

The informative objects that you care about are extremely simple from a programmer's point of view. They are chunks of text, with associated art, sound, video—a single unit of meaning with all the necessary components. Unlike a programming object, an informative object has a limited function that responds to a question or need of a consumer by providing some kind of information (no calculating the interest on a bank loan, or figuring out the extended price). The main activity your informative objects perform is to display themselves when instructed.

To figure out when and where to display an informative object (and for whom), you develop little scenarios called *use cases*. You sketch out little scenes in which one or more actors get involved in tasks, leading up to an event that is handled by one or more objects. For programmers, these tasks, events, and objects can be quite complex. For writers, the picture is crude. Someone comes to the site with a goal in mind, starts acting to attain that goal, and sets off various alarms, signals, and activity in the software, which

is comparing the person's profile with the relevant business rules, and wondering if any of these actions merits calling a new object. You probably don't care about the subtleties of event handling, triggers, or object methods. You just want to know who comes to the site and does something that deserves special content wrapped up in an informative object.

After you have developed a few dozen use cases, you can start shuffling them:

- Which ones are the most important to the consumers?
- Which ones really involve offering substantially different content?
- Which ones cause the most problems, raise the most questions, and require the most support?

For instance, you might find that most shopping carts are abandoned at the page when consumers discover the true shipping costs. One solution might be simply to move shipping costs to the product pages so that people can make an accurate estimate of the complete cost of the item before wading into the purchase process. This approach might seem a little up front, even daring, but by telling people this information ahead of time, you avoid the moment of disappointment when they discover the real costs after laboriously typing in their name and address, credit card number, expiration date, and so on. In effect having looked at the use case that had dramatic problems, you would move that informative object—the shipping options and their costs—to a more relevant page.

A use case offers the following information:

- **A story** with screenshots and imagined conversation, and internal dialog.
- **A description** of a complete and meaningful experience from the consumer's point of view.
- **A focus** on the goals of the user, rather than the mechanics of the software.
- **A way of figuring out** how to improve your site, not just record the current process.

Use cases live comfortably in an environment of content management software built on top of a database full of objects that get assembled on a moment's notice to form pages for a particular

visitor. Unfortunately, unimaginative use cases often end up describing current practice, suggesting no need for new content. And even when the team focuses on problem areas, the theme is usability, with the subtext of action and transaction, but that often makes the team think about what is doable rather than what consumers really want. In the world of objects, people can easily become stick figures.

Lumping people together into small groups

Niches are a compromise. Identifying a particular segment of the audience can help you figure out particular topics that will interest that group, develop a tone that establishes your attitude toward them, and signal the relationship that you hope to have with those people. But grouping people into a niche like this may overlook the unique character of individuals, the very specific facts you learn when you talk to people directly.

Traditionally, when creating a large document like a manual, book, or CD, we throw together topics that appeal to many different subgroups in the audience. We may create certain sections for absolute novices, offer troubleshooting for the competent performers, provide information on what's new in this edition for the old-timers, and show specs and behind-the-scenes data for the truly expert. All of that goes into a single document on the theory that different groups can find what they want in different places. But on the Web, we have the opportunity to create separate paths for each group we write for, displaying only the content appropriate for that group so the beginners don't bump into the 20 levels of hardware specs by accident, and the experts are never insulted with a home page featuring a marketing overview. (Each group can find the other material; but if we customize content by niche, first show each group what interests them most).

Based on your research and talks with actual consumers, you can probably figure out a half dozen niche audiences. For instance, when researchers tried clustering regular Web users, they found:

- Upscale, sophisticated, urban-fringe or ex-urban families use the Web to gather news and information, make travel reservations, buy stuff, and handle finances and stocks. For them, the Internet is a convenience.

Who am I? In part a persona supplied by culture and in part one crafted by myself. My persona is the image I have of myself and what I want to project to others, how I connect to others, a set of self-concepts.

—Robert Weber, *The Created Self*

- Small-town, middle-class families and working-class farm families prefer entertainment and sweepstakes sites, viewing the Internet as a replacement for TV.
- Men spend more time than women buying stocks, comparing and buying products, bidding at auctions, and going to government Web sites, whereas women prefer e-mail, games, coupons, and info on health, jobs, and religion. (Michael Weiss, 2001)

Niches form around income, age, gender, geographic location, occupation, and outlook, as advertising researchers have demonstrated over the last 30 years. Generally, people behave on the Web as they do in the rest of their life, favoring certain brands, attitudes, ideas, and activities. So demographic information developed over the years may help you flesh out what a particular niche wants from your text. On the other hand, the Web also allows upper-income folks to visit stores they wouldn't go into at the mall, and the Web shifts shopping times into the evening, and dampens seasonal variations in purchasing, so you need to define your own niches, based on your own research, supplementing it with the generic stuff. Nowadays, the customer relationship management folks think this way, developing clusters of people around their shopping habits, interests, and industries. But so far most of this data is being used to determine which ads to display to which visitors. Today, only the most advanced sites customize content for more than three or four niche audiences.

The smaller the niche you define, the better, because the focus helps you figure out exactly what topics they care about, what moves them, what examples might make sense to them, what ideas they resonate with. Imagine writing in five different voices for five distinct groups. As you become more attuned to the little groups within your audience, you become a ventriloquist or a character actor playing a series of roles.

This chameleon-like ability to take on the tone and attitude of a niche audience is not as insincere as it sounds. People do this all the time, to earn their way into a particular community, adopting that group's way of talking. More subtly, you can prove that you

should be considered a **member** of the community. Here's how:

- Show you recognize the divisions within the community.
- Indicate that you agree on the boundaries of the community (who is in, who is not).
- Accept the latest definition of what is hip and not hip.
- Stress the values and attitudes that are widely and deeply shared by the community.
- Follow the general agreement on what topics are important today.
- Take sides in the arguments that go on continuously within the community.
- Contribute new ideas, comments, and support to the ongoing conversation (taking part, caring enough to hold up your end of the conversation).
- Position yourself in relation to the rest of the community (as a leader, follower, troublemaker, what not).
- Use key slogans, totem ideas, and jargon in the right way (not like a school principal trying to talk to kids in their own slang).
- Refer regularly to activities that people in this community take for granted and do not mention activities they disdain, can't afford, or never heard of.

In a way, you are like a method actor pulling out personal memories to build a new character. To help clarify what you need to do to appeal to the niche audience, you'll probably want to draw up some guidelines—lists of likely topics, positions, and arguments. But like an actor, you may also want to think of personal experiences that resemble the activities, evoke the values, and support the ideas of the group.

To succeed in writing for a niche, you must really join the niche, wading right into the conversation. For writers a community has more to do with their discourse than their purchasing habits. Despite working for a particular site and taking its direction, you are adopting the group's style, adding to its stock of ideas, and becoming a member.

Create personas to represent the people you are writing to

When you write as if you were someone else, fitting into his or her skin, you are adopting a persona. But Alan Cooper, inventor of Visual Basic, suggests creating a persona for each important segment of your audience to give a personal face to the group's prominent characteristics, and to get past the blandness of demographic generalizations. In his book, *The Inmates are Running the Asylum*, Cooper advocates using personas during the design of software. As you try to make sense out of what you have learned about the people who consume your text, you may find his approach helpful in planning your writing, particularly if you already have a taste for fiction.

A persona is a made-up person you will write to. A real person may have several different goals in mind, but a persona is built around a single goal or one main objective. Every time you spot a different goal, you create a new persona.

Remember that a goal is the persona's purpose, not a set of tasks. Too often we focus on the tasks the "average" user might want to accomplish, particularly if that sucker does what our management wants and buys, buys, buys. Task thinking quickly leads to decorating the site's functions with labels and help, assuming, for instance, that everyone has the same reason for using the shopping cart, and therefore offering the same boring FAQ text to everyone. (What if some people are just using the shopping cart to hold products they might buy, but fear they will never find again, in your confusing morass of a site?) Emphasizing one goal per persona helps you get your mind out of the gearbox.

Once you have a persona's goal clearly defined, dress the character up. Assign a name, an age, an employer, a daily routine, and a car, but not just any car—a particular car with a dent on the front right bumper. The specificity is important because it helps you believe in your own creation. For instance, starting from the fact that many consumers come to your site with the goal of deciding which kind of software to buy, you might create a persona named Emma Aragon.

Is this then a touch? Quivering me to a new identity.

—Walt Whitman, *Leaves of Grass*

Emma is a 35-year-old mother of Adrian (12), Lucero (10), and Jose (6). Her husband Herb is the head of the morning shift down at the Sears Auto Parts shop at the Coronado Mall. She works as an architect of one-family homes in a three-architect firm, Aragon, Carter and Rodriguez, in downtown. She's responsible for meeting potential clients, interviewing them, preparing preliminary estimates, sketching out floor plans, refining the design, working with the engineering team on air, electrical, and plumbing plans, preparing budgets, supervising contractors during construction, meeting with the partners to plan expanding their practice into office buildings and manufacturing plants. She has a Masters in Architecture from the University of New Mexico, and is working on a Masters in Business Administration through the Anderson School of Management at UNM (only two more years of night and weekend courses). She drives a six-year-old white Ford pickup with a dream-catcher hanging from the mirror. Her concerns include daycare for her youngest child and healthcare for her grandmother Elisa Baca, who lives in the house next door. She is also concerned about the poor quality of her neighborhood elementary school, Los Gallegos, which regularly ranks in the bottom third of all schools in the state. For blueprints, she uses AutoCad but hates its interface, and for presentations to clients, she uses consumer programs such as 3D Architect, because the results look more attractive and help clients imagine what the house will look like. Her main objective is to create such imaginative designs that when her clients move into their new homes, they are delighted. She expects her drafting software to offer technical precision as a minimum, but as an experienced designer, what she really seeks is flexibility.

You want to create a character you can believe. Borrow facts from the people you have actually met, but do not just copy wholesale from a real person. Build in the details that will influence what you write. If you succeed at developing a believable character,

We must produce more selves for newer situations because, in William James's sense, the number of social selves is growing rapidly.

—Robert Weber, *The Created Self*

Serious creations of the self, like the inventions of technology, have the capacity of transfiguring life and society.

—Robert Weber, *The Created Self*

you will stop letting yourself assume that if a sentence makes sense to you, it will do. Now you have to make sense to Emma.

You escape the conventional idea of skills, too. You begin to see that individuals have expert skills in some areas, but novice abilities in other areas. No one person is a complete idiot. By focusing on goals, you can get away from the easy but simplistic distinction between power users and beginners, a distinction that was probably first created to excuse failures in interface design and programming ("Well, any power user could manage this feature," or "Well, we know beginners can't figure this out, so we provide a wizard for those dummies.")

A persona helps you focus on the main activities this kind of person wants to carry out, pursuing her goal, encountering your text as part of the interface, and then as meaningful content. A persona embodies a niche audience in action, following an intention through your prose. Now you are in a virtual conversation with an individual, and your prose takes on a warmer tone.

Develop a cast of personas and then winnow the list down. You might create a few dozen, then recognize similarities, toss out redundancies, and end up with six or seven. Give top priority to any persona who must be satisfied with your text, and who cannot be satisfied with text intended for someone else. In this way you end up with a set of "real" people you are writing to, like familiar e-mail correspondents, and you can create targeted text for each.

You're going to create content for each persona. You're not going to make one persona read something that's really intended for another, the way a magazine site often does. "The broader a target you aim for, the more certainty you have of missing the bull's eye," says Cooper.

And, because you come to envision each persona as if he or she were a living person, you develop a unique relationship with the persona, and your tone reflects that, making your style more, well, personal.

Personalize, Honestly

Fitting into the "ize"

People want to be recognized, catered to, and served personally. You can't keep feeding them generic content, when they are able to customize their own content on places like Yahoo.com, Lycos.com, and the *Wall Street Journal Interactive Edition*. And you can't win repeat visitors if you post a bunch of generic, all-purpose pages on your site, when consumers are seeing how delightful real personalization can be, when they visit pioneering sites like Amazon.com, Lands' End, and Reflect.com.

The content you do create must live within this increasingly personalized environment, being dished up in different ways to different people.

- Greeting guests by name, because the site has recognized them on arrival. Most people find this recognition reassuring, even though it is a cheap trick.
- Displaying the content they asked for, arranged in their own personal order and format. Picking out the news feeds that interest them and prioritizing them, gives people a feeling of control over the subject matter.
- Offering products that are similar to ones a visitor has just bought, or bought on earlier visits. Far from offending, these relevant offers smooth a visitor's path, inform each one of news in areas they care about, and, generally, lead to sales.
- Wish lists. These help friends and family figure out what to buy—encouraging them to visit the site.
- Custom pricing. Rarely done, but clearly this can make a site very attractive to repeat customers.
- Express transactions, like Amazon's patented, copyrighted, trademarked, and locked-up, 1-Click® shopping, which makes all sales after the first one so simple that visitors can hardly resist.

The impersonal computer screen seems to invite a no-holds-barred communication that is, paradoxically, more personal.

—**Constance Hale,** *Wired Style*

The more differences that exist among customers in what they need from the enterprise, and the more difficult or complicated it is for a customer to specify those needs, the more benefit can be gained by customizing.

—**Don Peppers and Martha Rogers,**
Enterprise One to One

- Access to the guest's own account and profile information. Turns out people like to see everything they've bought from the site, going back to the first dinosaur saddle. Using the account, they can check on orders, see when things will be sent, change their address, and add express credit card info. Being allowed to modify their account directly lets them see what the site sees, and reassures them that it is accurate, and on the level. Also, because people see all the preferences they checked, they can make changes, to bring it up-to-date—if they believe that the site is really acting on their preferences.
- Tailored e-mail alerts. If the consumers have to opt in twice, they are much more likely to welcome tailored e-mail marketing, particularly if it really does tell recipients about subjects they care about. What stinks is e-mail that obviously has no relevance to the topics they ticked on the form.

If your text is going to stay afloat in this sea of information about products, prices, positions, and transactions, you need to remember personalization's larger purposes:

- **Making the site easier to use.** If the site guesses right about what people are interested in, they do not have to search, or stumble around the menu system. Personalization saves time.
- **Increasing sales.** People are not averse to buying. In fact, they enjoy it. Making product pitches relevant helps them get to the fun part faster.
- **Increasing loyalty.** Once a guest has filled out some registration info, and seen that the site really responds, he or she might as well come back, to avoid taking the time to fill out the same info at some other site. Plus, there's a certain satisfaction to being recognized, catered to, cajoled personally.
- **Giving the consumer control.** When guests feel as if they can manipulate the content on a site, the site itself becomes a little like their own personal application, a tool they can use.

If you're making personalized offers to customers based on what you know about their interests, at what point does that practice become invasive?

—Patricia Seybold and Ronni Marshak, *Customer.com*

27

Of course, a lot of sites pretend to personalize their content, but have no idea what content to deliver to which visitors. If the site doesn't collect much information in the user profile, then the software will make stupid decisions about what to offer a particular visitor, providing trivial, generic, or off-the-wall content. Some sites ask a lot of questions, developing quite a detailed profile of each visitor, then fail to act on that information, leaving the consumer feeling cheated, or disappointed. The best sites develop a very rich profile, and act quickly, and very visibly, to show the user the payoff with intelligent suggestions, relevant content, and smart services. Paul Hagen, of Forrester Research, defines the best personalization this way:

> Content and services actively tailored to individuals based on rich knowledge about their preferences and behavior. (Hagen, 1999)

Customizing and personalizing content

Customizing content means addressing a niche group. Personalizing allows an individual to get exactly what he or she wants, whether or not that matches the content delivered to his or her group. Customizing goes a long way toward satisfying most people, but personalizing makes people consider the site their own.

To write customized content that can then be personalized, you have to look behind the curtain to find out what information the profile contains, what business rules or inferences the software is going to use, and what categories of information the site already uses. For each piece of information in the profile—each nugget of personality—you need to figure out how you could create new material or adapt existing material, to show that you have "heard" the group, or the person.

An enterprise gets smarter and smarter with every individual interaction, defining in ever more detail the customer's own individual needs and tastes.

—Don Peppers and Martha Rogers,
Enterprise One to One

Much of this thinking ends up dividing the audience into very small groups, micromarkets, or niches. For instance, if you recognize that your most valuable visitors fall into five different niches, then you should create specific content for each one. Perhaps one group wants to see specs right away, while another group prefers broader strokes with large benefits and graphs. For each group,

put the information they want first, and move the other material to a See Also, or linklist in the sidebar.

Customizing content means writing text for a small group, organizing the content in the order they want to see it, and demoting or hiding content they do not care about. In some circumstances, you may also prevent one group from seeing what another reads, such as confidential pricing terms, development reports, or in-progress manuals.

But you have to keep coming up with new stuff for each niche. For instance, take customer support people to lunch and find out what the latest problems are, by audience group. Help solve these problems within a day or so by posting new content, addressed directly at those groups—for instance, revising labels in the forms they use, adding a new topic to their own list of Frequently Asked Questions, or rewriting a key paragraph at the top of their personal pages.

In this environment, you are often creating new objects, not whole documents. In fact, you are probably going to be using an elaborate tagging system, with XML, to indicate which niches (identified by their personas, perhaps) each chunk is suitable for. You might have an attribute such as Audience, and an agreed-upon list of audiences, so when you create a new text chunk, you say, "Well, this is for the suburban mom, only." (Or Rebecca).

The more you can tailor your text to a particular group, the more the members feel your content is relevant. You can then offer personalization, allowing individuals to pick and choose the content they like best, offering personal tips directly to them based on their recent clicks, and setting up a one-to-one chat or e-mail conversation with individual visitors. In fact, the best way to talk personally to one individual is by chat and e-mail. Your Web content may be niche-y, but your chat and e-mail must show you have really read the person's last message, and are responding to that particular person's unique (they think) situation. From customization to personalization, the path leads through you, personally.

Consider your aims, honestly

By its nature, mass marketing aims to sell. But to win the loyalty of consumers, to get them to come back, you must give some real value

Customers don't relate to anonymity on your part or theirs. If you want to differentiate yourself based on personalized service, you need to be prepare to interact with customers—even millions of them—as individuals.

—Patricia Seybold and Ronni Marshak, *Customer.com*

when you customize and personalize your content, or they will rebel, clicking away from the page, or deleting your e-mail in disgust. The values you can communicate through personalization include openness (showing all you know about them), privacy (allaying their legitimate fear of cross-selling, junk mail, and credit card fraud), and reliability (showing an order confirmation page, e-mailing a confirmation of the order, e-mailing when you ship, e-mailing after arrival, including a return address label in the box, not arguing about returns). But honesty works best. If you don't know the answer, say so, and promise to get an answer soon—then amaze them by actually following up.

> Honesty is the beginning of open communication.
> Communication is the beginning of interaction.
> Interaction is the beginning of personalization.
> (Eric Norlin, *Personalization Newsletter,* 2001)

Develop an Attitude

Cut through the anonymity

On paper, corporations, universities, and governments have always favored an impersonal style, talking in a consensus-seeking committee speak, avoiding taking any stand that might offend anyone anywhere, squeezing out resolutely anonymous prose. In the rush to fill up Web sites, a lot of this faceless prose got posted. So now some sites are like Wall Street at midnight in winter—cold as granite under ice.

It's the voice of quirky, individualist writers that best captures the quirky, individualist spirit of the Net.

—Constance Hale, *Wired Style*

Your style reflects your attitude toward your readers, implying a relationship. The old approach was authoritative: "We know what we are doing, and you are lucky to be listening to us."

But the Internet works best as a series of two-way conversations. Interact with your visitors. Ask their opinion. Start a conversation. If you intend to provoke a conversation, reveal yourself. At the least, tell your readers as much about your own life as they reveal in registering, answering your questions, or stating their preferences. Instead of being all-knowing, admit when you feel confused. Include a byline. Hell, put your picture at the top of your articles.

When people sense that you are a real person, they respond. And if you take a definite position, clearly distinguishing your ideas from the herd, refusing to take a corporate snoot at them, people get the sense that you might listen to their opinions. The more you express your own individuality, the more you cut through the plastic, silicon, wire, and glass of the computer and the Internet.

Customers expect to receive a consistent branded experience no matter which touchpoint or channel they use.

—Patricia Seybold, Ronni Marshak, and Jeffrey Lewis, *The Customer Revolution*

Tone shows how you react to your readers. Contemplate the relationship with Emma, if you have developed a persona to represent an important niche audience.

Figure out what your stance is. What are you doing in this conversation? What is your aim, in this relationship?

- **If you want to amuse people**, as on a site like a webzine, be outrageous. Go beyond the norms. Get into the intimate details of your emotional *sturm und drang*, your paranoid fantasies, if you think they will be entertaining on a particular site. Recognize what people normally think, and come up with something different. Your job at a webzine is to provoke discussion, and the hotter your prose, the more they talk.

- **If you want to teach**, then be considerate. Be willing to start with the familiar and move step-by-step into the unfamiliar. Teaching requires enormous sympathy, an intuitive awareness of each moment when the student may be puzzled, upset, or drawn off course. The more you pay attention to the student's internal experience, the more you can articulate your subject matter for them. (Too many academics write Web pages to impress their colleagues, leaving students far behind).

- **If you want to help people become more aware**, then open yourself up to sense their inner life each moment. Tune in to their fears, desires, dreams, and as you write, imagine how the readers react. Shifting your attention from your made-up self to your listeners lets the meaning flow through. Your text loses some of its personal flavor, but takes on a deeper significance. Oddly, at that moment, some people will start to praise you for your "original style."

- **If you just want to be helpful**—a good scout—then be plain. Give up all those tricks you learned in school, when you were struggling to be persuasive, attractive, plausible, and convincing. When you are mentally trying to demonstrate how unusual, special, fascinating, mysterious, or complicated you are, your writing draws attention to itself, away from the subject— it's okay if you are deliberately showing off, but not particularly helpful.

Let's talk persona to persona

So you have to invent some kind of persona on your own side, to figure out how to talk to the individuals in your audience, whom

you may have caricatured in a set of fictional personas. Generally, we consider creating a writing persona as a little dishonest, almost like putting on a mask. True, when the intent is to deceive, over-awe, or attack. But you can create a perfectly reasonable persona, one that has some of your own background, concerns, and pet ideas without being dishonest.

You are about to engage in a virtual conversation, after all, where you don't know a lot about the person you are talking to. Sure, you've read the profile, plowed through the e-mail, checked the transaction history. But you are still guessing. And so you really don't start out with a human relationship.

But if you build your own persona sincerely, out of your own real experience, you will develop a definite connection with the person you are writing for. If you reveal a few facts about yourself, watch the response. People realize, gosh, there is a person there. Suddenly, they want to know about your town, your hobbies, and your kids.

To guard your own privacy, and to keep your own boundaries secure, you need a carefully developed persona—a public personality. In fact, you may need to develop a different writing persona for each major group you talk to, so you can morph into their team, looking at things from their point of view as much as possible, using their language, dealing with their concerns.

The process resembles writing a script, where you switch from one character to another, speaking as intensely as you can in that voice, then switching character, and responding. Sound crazy? Well, sure. Nutcases carry on imaginary conversations and get locked up. The challenge for you is to stay sympathetic enough with each group and each person so that you don't feel strained adopting the appropriate stance for your relationship.

We celebrate subjectivity.
—Constance Hale, *Wired Style*

So you are acting in a role, as one persona, and when you address a niche audience, you are talking to a character you have invented, a persona who stands in for the real people who are members of that group. That's talking persona to persona.

And when you answer e-mail, or type responses in a chat session, or post replies on a discussion board, you are, in a way, writing person to person. But even here you are acting in a role,

adopting a persona, and the other person is too. So the conversation has an artificial flavor.

Your job is to break through the artificiality of the experience, the distance imposed by the medium, and the constraints of your own context. You have to work hard to become a human being on the Web.

Imagine the way you would like the virtual conversation to go—what you will say, and what she will say, and how the exchange will progress. Envision a satisfactory outcome. What exactly do you want to happen, as a result of the texts you send and the responses you get back? Where is this relationship headed? As Ann Landers asks, what will make you both happy?

Stretch the canvas and sketch in the basic outlines of the goal. But leave the picture unfinished.

Let the unknown enter—the unpredictable other, the amazing quirks, the surprising feelings, the odd twists of the other person's thoughts—and your own. Because people turn out to be full of surprises, if you listen with an open heart, build your persona loosely enough to make room for their side of the conversation.

You ask. I answer. You ask. I answer. You're not supposed to watch the sun set, listen to the surf pound the sun-bleached sand, and sip San Miguel beer as Paco dives for abalone while you craft your e-mail.

—Guy Kawasaki, *The Guy Kawasaki Computer Curmudgeon*

See: Bruffee (1986), Clark (1990), Cooper (1999), Dumas and Redish (1993), Fish (1980), Freed and Broadhead (1987), Hagen (1999), Jonassen, Hannum, and Tessmer (1989), Norlin (2001), Norman (1980), Ong (1975), Porter (1992), Redish (1993), Rubin (1994), Seybold and Marshak (1998), Seybold, Marshak, and Lewis (2001), Shneiderman (1998), Stevens and Gentner (1983), Weiss (2001), Wood (1996).

POST

My Idea:

Post to HotText@yahoogroups.com

Express your own idea on:
HotText@yahoogroups.com

Subscribe:
HotText-subscribe@yahoogroups.com

Unsubscribe:
HotText-unsubscribe@yahoogroups.com

Visit:
http://www.WebWritingThatWorks.com

chapter 2 |

What Kind of Thing Am I Creating?

Goodbye Documents, Hello Objects **38**

Building Informative Objects **51**

Goodbye Documents, Hello Objects

Every time we don't post product information on our web site, our customers give us grief. They want to know everything we know about our products.

—Phil Gibson, National Semiconductor, quoted in Seybold and Marshak, *Customer.com*

All the information about your company, your products, and your services will need to be XML tagged and encoded with searchable attributes so that people and software programs can selectively retrieve only the most relevant and useful information and products for their purpose.

—Patricia Seybold, Ronni Marshak, and Jeffrey Lewis, *The Customer Revolution*

Shifting from paper to the Web makes you think more seriously about the structure of what you write. You ask yourself more consciously, "What is the form I am going to fill?"

Traditionally, we wrote whole documents following loosely defined but fairly conventional structures. Different sections may have addressed different groups and served different purposes, but all those sections were bound together to form a single unit—a book, a manual, a data sheet.

But when we post hundreds or thousands of these documents on a Web site, our software often has trouble locating the particular passage a person wants to read. To help software locate specific chunks within these documents, so people do not have to read through a lot of irrelevant pages, we now identify each part of the document as a distinct object, tagging each element we write, labeling this one "a procedure," and that one "a product description."

But in a giant pile of information, tags are not enough. We must also organize each document, and each component object, according to a clearly defined structural model, so that the software can anticipate exactly where each element will appear and skip all the intervening material.

Gradually, our idea of the document is being decomposed into its constituent objects, and the document itself comes to be regarded as just another object, containing other objects nested within, like painted wooden dolls within dolls, endlessly.

As we write in this environment, our method of discovering and arranging material becomes more routinized, more conventional, and less improvisational. The group we work with sets up a model structure for each type of informative object, defining which pieces are required or optional, in what order, and we have to write the objects that will fit, like blocks, into that architecture.

But each class of object has a purpose—to answer a particular

type of question, deal with a common request, or satisfy a fairly widespread need, wish, or whim. The abstract structure reflects the team's best idea of a satisfactory response. And each new object we create following this model is designed to serve as a virtual reply to our visitors in this odd conversation that takes place over the Net and through the screen.

Arising, then, as a way of coping with the huge amount of information accumulating on the Web, this new way to come up with ideas, explore topics, and organize our writing necessarily focuses our attention on the individual building blocks that software assembles into Web pages, customizing them for niche audiences, or personalizing them for individual visitors. Subtly nudged by XML and an object orientation, by customization and personalization, and by the sheer volume of content, we are being led to worship at the altar of structure.

The problems of content

As Web sites expand in size and more people in every organization pour content onto the sites, new problems emerge:

- **Inconsistent structure and format.** A series of documents, posted as individual pages, turn out to be organized differently (because they were written by different people at different times for different purposes, but now appear together on the site). Visitors who get used to product descriptions that start with a *challenge*, and go to a *solution*, followed by a section of *features* and *benefits* may be a bit puzzled to find another product description that only offers a list of *features*. From department to department, the structure of similar pages, the layout, and the interface all subtly change, challenging and sometimes completely frustrating visitors.

- **Manual processes.** The old system of hand coding HTML tags—dropping in the standard elements of an interface and publishing one page at a time—just won't work any more when a company publishes thousands or hundreds of thousands of pages a month. The process has to be automated.

The World Wide Web is a medium that gained acceptance where earlier attempts had failed by providing the right combination of simplicity and fault tolerance. Now it faces the job of reinventing itself as a scalable, industrial-strength infrastructure strong enough to carry both human communication and electronic commerce into the new century. The story of XML and its companion standards is the story of that reinvention.

—Jon Bosak, XML Architect, quoted by Charles Goldfarb and Paul Prescod, *The XML Handbook*

- **Gigantic chunks of information, instead of pinpointed answers.** When visitors search for a specific fact, they often receive a 20-page report or a 300-page manual, and the site says, in effect, "It's in here somewhere. Good luck." That approach was bad enough when users got actual books, but on the Web, it's crazy. People need fast access to a particular fact, and just that fact, even if it appears in a tiny paragraph, sentence, or phrase. You must be able to serve up the smallest chunks of information someone might want to look at.

- **Lack of customization.** When everything appears inside large documents, it's difficult to create different content for different visitors. You need to offer parts of these documents in a new order, adding a few elements tailored just for that niche audience. But taking apart an existing whole and rebuilding it can be tedious if you work in word-processing software. On the other hand, if you can treat the pieces as objects in a database, then you can issue a wide variety of reports by picking and choosing different components.

- **The audience of "IT."** Humans are reading your stuff, but software must read it, too, manipulating the content, transforming the structure, and adjusting the format to deliver a customized version to a particular user. You may want to be able to send down a Java applet, for instance, that offers to re-order the list of book titles by date, by author, by price, or whatever—on the client's machine, without having to go back to the server and ask the original database to perform this chore. To aid the software, your text must contain tags indicating what each component is, preferably in eXtensible Markup Language (XML) with a Document Type Definition or schema to tell the software how each element fits into the overall structure. That way, the software can quickly tell which paragraph contains a date, which contains an author's name, and then—if the user asks for a list sorted chronologically, or by author—reorder the paragraphs. You are now writing for two audiences, one made of code, and the other of flesh—software and wetware.

HTML—the HyperText Markup Language—made the Web the world's library. Now its sibling, XML—the extensible Markup Language—is making the Web the world's commercial and financial hub.

—Charles Goldfarb and Paul Prescod, *The XML Handbook*

These large problems are forcing content creators to take apart entire documents, breaking them down into their components, and building new assemblages out of those chunks on the fly, to offer personalized, updated, consistently organized content through software rather than human control. To identify the chunks, we are being forced to expand the tags with which we mark up our text.

Mark up that text!

Markup is not scary. Markup is at least two millennia old. Text itself started out as a set of marks on a surface, so as the surfaces and tools changed, people naturally added extra marks that told the reader something useful about the text. This meta-information, at first, was fairly crude. For instance, in Roman days, most scrolling text was an unending stream of characters, like this:

armavirumquecanotroiaequiprimusaboris
Isingofarmsandthemanwhofirstfromtheshoresoftroy

Then someone invented white space, marking the division between words with an empty slot.

I sing of arms and the man who first from the shores
of Troy

Someone else thought of marking the beginning and end of sentences. Soon capital letters and periods set off sentences.

Easy is the path leading down to hell, but long and
hard the climb out.

Then came a triumph of markup—paragraphing.

Easy is the path leading down to hell, but long and
hard the climb out.

The ghost led me down past the caves and the smoke,
to the river Styx. Charon, the boatman of the dead,
poled out of the mist.

Headings, too, came along as another way of adding information about a chunk of text, saying, "Hey, this is what this section is about."

The Song of Solomon

Book One

In fact, many of the formats we take for granted were invented to give information about the passage. For instance, bulleted lists could be considered a kind of markup, indicating that the items all belong together.

The commons belong to the people.
- They may run their cattle on the green.
- They may use the green for their dances.
- No man may fence in the commons.
- All souls tend the green equally.

When printing became established, we could plan changes in emphasis, weight, width, size, slant. To signal these to the printer, someone had to mark up the text, indicating what formats to use where, using editorial markup symbols and abbreviations.

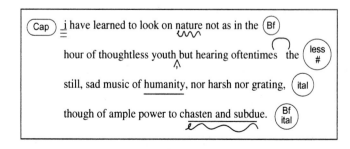

> I have learned to look on **nature** not as in the
> hour of thoughtless youth, but hearing oftentimes the
> still, sad music of *humanity*, nor harsh nor grating,
> though of ample power to ***chasten and subdue***.

When 19th century printers came up with typesetting machines that poured lead into molds, generating hot chunks of metal that could be dropped into a tray to print with, the operators used levers to shift from boldface to plain text and back, following the editor's markup. In the late 1960s and early 1970s, when programmers were inventing word processing, they looked at those levers and decided to insert corresponding tags into the stream of characters. Each tag corresponded to a lever that the operators had pulled, when they were generating hot lead. Of course, the result was now cold type.

> I have learned to look on <bf>nature</bf> not as in the
> hour of thoughtless youth, but hearing oftentimes the
> still, sad music of <i>humanity</i>, nor harsh nor
> grating, though of ample power to <bf><i>chasten and
> subdue </bf></i>.

Each word processing machine and each program had its own proprietary set of tags with different tags for each element of markup. Boldface might be indicated by [b] on a document coming from one vendor, {bold} in a document from another vendor, and #—emph—# in a third. But organizations such as airplane and tank manufacturers that had to bring together hundreds or thousands of documents from different word processors ran into a problem. They had to pay to have some programmer convert all the different tags into a single tag system, or vocabulary, so that a single printer could run the job. Eventually, the Pentagon and its suppliers asked computer vendors, publishers, and librarians to come up with a solution.

Working at IBM, a team came up with a new approach. They saw that book designers typically analyzed a manuscript looking for the major components and diagnosing the structural relationships between them (this is a major heading; that is a minor heading, and

If a tag identifies data, that data becomes available for other tasks. A software program can be designed to extract just the information that it needs, perhaps join it with data from another source, and finally output the resulting combination in another form for another purpose.

—Elizabeth Castro,
XML for the World Wide Web

this is just running text). Assuming that most documents had some kind of hierarchical structure, the team decided to use tags to indicate the structural role of each component (H1, H2, P).

To record the abstract structure, the team invented another document, the *Document Type Definition*, which described all the content tags and showed how those elements related to each other in the larger structure.

Then, in a stroke of genius, the team suggested separating format from content. In a classic mainframe approach, they moved all formatting rules into their own file. So now the team had three different documents:

- The original document, with tags indicating the role of each item in the larger structure (*this is a major heading, this is a caption*).
- A file full of formats, arranged in a series of equations. *If the tag indicates this text is a major heading, then format it in 24 points blue.*
- A file describing the abstract structure that all documents of this type must follow, laying out all the official tags in a kind of vocabulary.

IBM's General Markup Language of 1969 grew into the Standard General Markup Language (SGML) of 1974 and became an international standard in 1986. It is called a language, but really it is a machine for producing vocabularies—sets of standard tags that define the structure and content of a particular type of document. SGML had a lot of pluses:

- It aided large-scale publishing (in areas such as aircraft manufacturing and maintenance, nuclear power, telecommunications, space) because it let corporations, industries, and governmental agencies create a standard set of tags that could be inserted into ASCII documents instead of proprietary formatting codes, enabling a printer to accept thousands of documents from hundreds of different subcontractors, to blend together into a single document set, without paying for extensive translation of different formatting tags.

Using XML to mark up data will add to its size, sometimes enormously, but small file sizes aren't one of the primary goals of XML: it's only about making it easier to write software that accesses the information, by giving structure to data.

—David Hunter, *Beginning XML*

- It worked fine with long-lasting documents, particularly those requiring many revisions, updates, and cross references, because the structural model remained the same despite all the tinkering.
- It ensured consistency across many pages and across many books.
- It gave you a single source of raw text that could be traded back and forth among many vendors, because it was just ASCII text.

But yielding to the influence of its requesters, SGML soon acquired so many options, exceptions, and tangled syntaxes that it became too complicated for most mortals to use. Corporations had to have specialists work on a project for a few years to get the right set of tags, and then they had to convert all the old documents at great expense. Plus, the language was aimed at publishing a lot of paper. No one had heard of the Web back then. Because the SGML software ran on large computers, the code sprawled and grew heavy—not an easy applet to download over the Internet.

In the 1980s, people began to see that you could not only create text electronically, but you could deliver it that way—in e-mail, help files, and CD-ROMs. The invention of hypertext gave users a way to move around in that electronic text. Click here and go there. Taking off from these ideas, Tim Berners-Lee used SGML to come up with a Document Type Definition—a specific set of tags—for hypertext. With the Hypertext Markup Language (HTML), the Web was made possible.

HTML is just a bunch of tags. H1 means Level One Heading, and P stands for paragraph. Despite the term "language," HTML is really a vocabulary list—it is not a factory for creating new tags, like its generator, SGML.

New software, called a *browser*, downloaded the HTML page, read the tags, and, by using the Document Type Definition that Berners-Lee had created, applied its own format to each element and then displayed the result on-screen.

HTML encouraged the explosion of Web pages because its tags were:

While XML demands a bit more attention at the start, it returns a much larger dividend in the end. In short, HTML lets everyone do some things but XML lets some people do practically anything.

—Elizabeth Castro,
XML for the World Wide Web

- Flexible enough to allow you to format the text in a lot of different ways.
- Easy to write in a text editor or word processor, and (relatively) easy for human beings to read.
- Just part of regular text files (rather than proprietary binary code), making for faster transmission, low overhead, and portability from one application to another.

But when the Web took off, and individual sites grew to millions of pages, HTML revealed some limitations, such as:

- Its tags do not identify meaningful content. Yes, it is a heading, but what is it about?
- The tags can appear in almost any order because the Document Type Definition is purposely loose about structure (to encourage almost anyone to put almost anything up on the Web). But that lack of definition means that software has only a crude model of the structure of a document, and so, instead of zipping right to a structural element such as price or author, it must read every character, hoping for a clue to indicate which is which. Searching and manipulation of the contents were therefore tedious and unreliable.
- E-commerce demanded database exchanges and HTML took a lot of massaging just to get its content in and out of databases.

All that HTML tells the software is general information such as:

- This is the header part of the document.
- This is the body part of the document.
- This is a heading.
- This is a paragraph.
- This is a table.
- This is the anchor for a link; if someone clicks it, the browser should follow the path to this other page.

HTML does not tell the software that this element is a *book title*, and this one over here is an *author name*, and that both live within an element called *Book Description*. In HTML all of those elements might be tagged as paragraphs. In those circumstances, it is hard to tell software how to look within a Book Description to find the

particular paragraph that has a book title, as opposed to an author name. For ordinary consumers this failing seems trivial. But if a company wants to be able to order products and sell them over the Web, tags distinguishing one type of content from another become critical.

Also, over the years customers drove the vendors to expand the tag set to include more tags that could help format the page more attractively. But because users were so sloppy, the browser makers had to write a lot of code handling exceptions, mistakes, and problems, so the code became bloated and slow.

To resolve these problems, the eXtensible Markup Language (XML) was created in 1996, becoming a standard in 1998. XML is really just SGML lite. Like SGML, XML lets you create your own vocabularies of tags for different purposes. Because it is a subset of SGML, any old SGML processor can read XML. As it is still fairly new, only the latest Web browsers can handle XML in its pure form, so servers have to transform the XML document into an HTML one. But XML is well on its way to outshining SGML as an all-purpose markup machine, a way of generating your own tags for your own purposes.

XML tags identify the content, not the format. XML says things like:

- This document is a catalog.
- This is a book description.
- This is the book's title.
- This is the book's subtitle, if any.
- This is the book's page count.
- This is the book's price, in U.S. dollars.
- This is the book's ISBN.

Here's an example of the XML markup of the body of a marketing article. This genre is called featuresandbenefits, and it consists of a challenge followed by a solution. Over and out.

```
<featuresandbenefits>
<challenge> Today, even a small business needs a Web
site. To make it easy for customers to find out about your
products, see testimonials from other satisfied customers,
get a map to your store, you need a Web site.</challenge>
<solution>The PR Express offers a fast and easy way to
build a Web site that expresses your business
case.</solution>
</featuresandbenefits>
```

The tags are defined in a document called the Document Type Definition, which declares each element, shows what components should appear inside it, in what order, and how often. For instance, to define the tags used in the marketing article, the team declares an element called featuresandbenefits, which contains a challenge, and a solution. Then the DTD declares the challenge consists of ordinary text (grandly known as data made up of characters that will be checked by software called a parser, i.e., parsed character data). Ditto for the solution. That's it.

```
<!ELEMENT featuresandbenefits (challenge, solution)>
<!ELEMENT challenge (#PCDATA)>
<!ELEMENT solution (#PCDATA)>
```

Content tags resemble the names of records and fields, or rows and columns, in a relational database. Looked at another way, the tagged elements resemble objects in an object-oriented database. Either way, using XML tags, you have created what programmers call "structured" information (as opposed to the sloppy irregularly organized and unpredictable documents you usually produce), so a programmer can easily grab your content and send it to a database, or pull facts out of the database and plug them into your document without inadvertently putting the address where the phone number belongs. In effect, your document becomes a little database capable of talking to other databases.

In this way, XML makes it easy to write programs that manipulate the content of XML documents. Because it enforces a strict model of the content and insists that writers observe a rigorous discipline on

tagging (no exceptions, no mistakes, no craziness), XML limits the number of possible tags and organizational models so processing software like parsers and browsers can be lightweight. Any vocabulary generated in XML is methodical and precise, and therefore unambiguous (at least from the point of view of software). But, amazingly, with a little training, anyone—even you—can read an XML document. If the original tags are written well, even a newcomer can figure out what each element is, and where it belongs.

And XML files are text files using standard codes for every character, such as the American Standard Code for Information Interchange (ASCII), or Unicode. Therefore, almost any software in the world can read these documents. Plus, the markup adds metadata, making the file "self describing" and much easier for software to digest. Total strangers, with software you never heard of, can pick up your XML document, read it, copy from it, insert data into it, and generally manhandle it. Where HTML focuses on formatting content in a browser, XML enables that, but offers software a chance to perform further processing of the contents, such as searching, sorting, reorganizing, inserting, and deleting at the behest of the user, and your own little applet downloaded along with the file.

XML is democratic, too. Anyone can create a vocabulary of tags, using XML, defining what the content elements will be, and how they will be organized, in a Document Type Definition (DTD) or schema. Once displayed on the Web in an XML document with its accompanying DTD, those tags and structures are open to anyone else to read and manipulate. They are not proprietary or hidden, so other people can disassemble the document, reuse parts of it, and translate the tags into their own vocabulary. Industries can adopt standard vocabularies. Businesses can have their own variations and easily translate content back and forth.

Fundamentally, XML separates the structural model, the actual content, and the rules for formatting the content.

- The Document Type Definition defines the abstract structure for this type of document, creating a vocabulary and organization of tags.
- The document itself uses those tags to label the actual content.

This is where the extensible in Extensible Markup Language comes from: anyone is free to mark up data in any way using the language, even if others are doing it in completely different ways.

—David Hunter, *Beginning XML*

- One or more stylesheets tell the browser what format to apply to the content, using those tags, in different circumstances (old browser, new browser, handheld device).

That division of labor often means that you don't get to see exactly what your text will look like—a step back to the awful days of UNIX editors like vi, or worse. But you can have your software display the text in a way that imitates one or another of the stylesheets, while an inset window displays the standard structure, and the software beeps at you if you get out of line and try to insert the wrong element next, or delete a required element. You are still writing, but at your elbow is a structure monitor. You have lost the independence of word processing, where you can organize and format any way you like. But your text is becoming a lot more useful for your users.

You are leaving the free-wheeling world of documents and entering the world of carefully defined, standardized objects—steps, captions, definitions, introductions, whatnot. Each element that has been identified with an XML tag now acts as a discrete object. Often, it is stored as an object in an object-oriented database, but most writers do not care how the software stores the element. What does matter is that now, instead of creating whole documents and formatting them, you have to craft a set of distinct objects without always knowing in advance all the structures into which they may be fitted together and formatted.

See: Coombs, Renear, and DeRose (1987), Goldfarb (1990), Goldfarb and Prescod (2000), Hunter et al (2000) , Kay (2000), McGrath (1998), Megginson (1998), Musciano and Kennedy (1997), Travis and Waldt (1995), Turner, Douglas and Turner (1996), Young (2000), Yourdon (1994).

Building Informative Objects

Think of an object as a little creature that has only one purpose in life: to apply certain methods to a specified collection of data.

—James Martin

The biggest change for writers moving into the world of XML is that now you must think more rigorously about structure, creating little Lego bricks of content, destined to be assembled and reassembled in ways you cannot always anticipate. You are no longer making a single document; you are preparing objects that can be put together in many different structures, formats, and media. But what is an object?

Programmers have their own ideas of objects, described in pattern languages and documentation. But as a writer you want to create chunks of text to communicate: you are making informative objects.

From a writer's point of view, objects have seven characteristics that make them informative. We'll cover those here. If you are familiar with object-oriented programming, you'll recognize the analogies here. But even if you don't live in an object-oriented environment, you'll begin to see some of the benefits—and the challenge—of organizing your content in objects.

1. Each object starts life as a category of conten

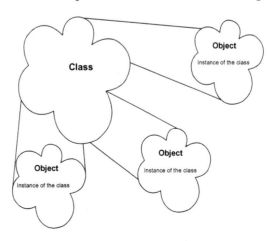

Each object is defined abstractly as a class, such as a Procedure. The abstract object is an ideal notion, like a Platonic form—a category of information. As soon as you write something, you are creating an instance of that class—a unique example of the class, a particular real object.

2. The class has a standard structure.

The class defines its components in a certain sequence within a single hierarchy. The standard tells us how many components are allowed or required, in what order, and which ones are just optional. The relationships between objects are defined in a content model, known in XML as a Document Type Definition, or schema.

Every instance of that object must follow the same internal pattern.

3. Each type of object has a job to do.

Class:
The Step

Object:
Step 2, in the procedure called "Establishing the Pin Connection"

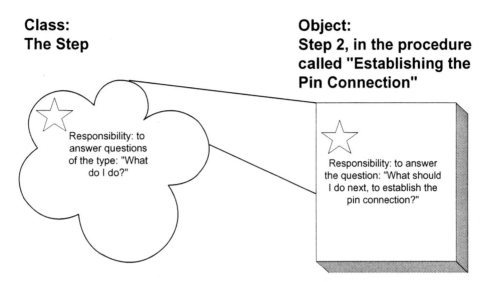

The responsibility or function of each informative object is, in its simplest form, to respond to a particular type of question, such as, "What are the results I can expect if I do this step?" (Answer: an object called an Explanation.)

Over the centuries, writers in any genre have invented common elements to answer the kind of questions that keep coming up. For instance, in creating procedures, writers came up with a standard element to answer the question, "What do I do next?" That element, the step, shows up in so many manuals that we can now say it is conventional. Turning a routine element like that into an object is easy. We recognize the element from our reading, and we are simply blessing it with a new description and a new role. Informative objects are often familiar elements doing a traditional job in new clothes.

An individual object does not make a system. A system is made up of a number of objects. A model of a commercial organization usually consists of many objects that are related in some way.

—Ivar Jacobson, Maria Ericsson,
and Agneta Jacobson,
The Object Advantage

4. Objects talk to each other.

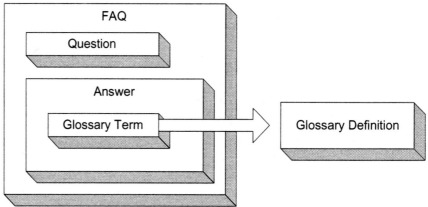

Being electronic, and living within a world of software, each object can exchange messages with other objects. Yes, these objects can link up. Basically, one informative object sends a message to another saying, "Will you display yourself?" If the linkage works, the other object shows up on-screen. Unlike the complexity of messaging between heavy-duty programming objects, this little exchange is essential to our job as creators of interactive text.

5. The same object can be reused in many different locations and media.

Each object can be used as a component in other objects, placed in a different position in a sequence of objects, or used without some of its optional components.

Re-use goes more easily with objects because:

- We can use exactly the same object in many locations without rewriting it. (This kind of reuse can save hours of our time, and thousands of dollars in the budget.)
- We can select certain objects to be sent to a handheld device, others to go to a Web page, and still others to be printed out on paper simply by picking a different Document Type Definition or stylesheet without any rewriting.
- When updating material, we can search for a set of objects by class name. (Give me all the steps in this long procedure.)

Nothing can have value without being an object of utility. It it be useless, the labor contained in it is useless, cannot be reckoned as labor, and cannot therefore create value.

—Karl Marx, *Capital*

That way we can make a change in the steps without having to paw through the intervening explanations.

- We can take apart an existing object and use selected components, but not others, in a new object.

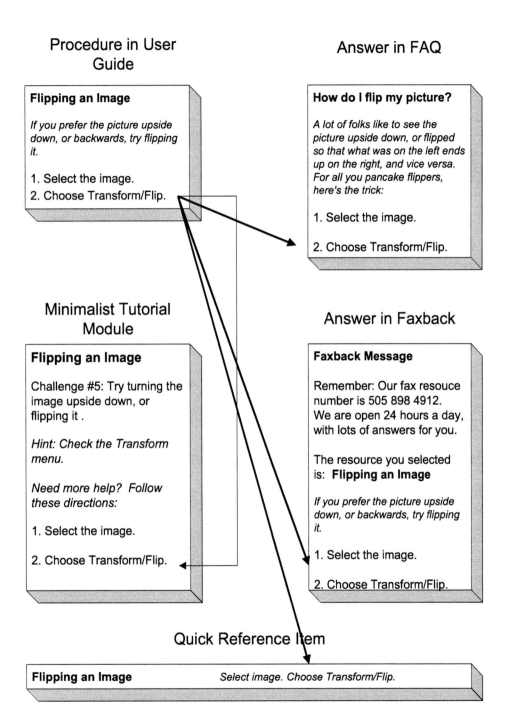

Procedure in User Guide

Flipping an Image

If you prefer the picture upside down, or backwards, try flipping it.

1. Select the image.
2. Choose Transform/Flip.

Answer in FAQ

How do I flip my picture?

A lot of folks like to see the picture upside down, or flipped so that what was on the left ends up on the right, and vice versa. For all you pancake flippers, here's the trick:

1. Select the image.

2. Choose Transform/Flip.

Minimalist Tutorial Module

Flipping an Image

Challenge #5: Try turning the image upside down, or flipping it .

Hint: Check the Transform menu.

Need more help? Follow these directions:

1. Select the image.

2. Choose Transform/Flip.

Answer in Faxback

Faxback Message

Remember: Our fax resouce number is 505 898 4912.
We are open 24 hours a day, with lots of answers for you.

The resource you selected is: **Flipping an Image**

If you prefer the picture upside down, or backwards, try flipping it.

1. Select the image.

2. Choose Transform/Flip.

Quick Reference Item

Flipping an Image *Select image. Choose Transform/Flip.*

6. Searches can turn up individual objects, thanks to attributes.

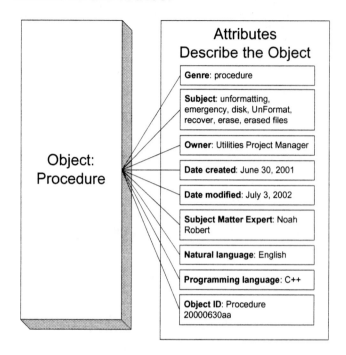

Attributes describe the object. For instance, the Procedure object has attributes such as subject and owner; when you create a new procedure, you fill in the blanks with the new subject and the person who "owns" that particular object.

Each class of objects has a set of attributes, like fields on a record in a database, and each instance of that class has its own values in those attributes. The point is to allow users (and writers) to search on values in a variety of attribute fields, such as:

- Genre
- Subject
- Owner of the information
- Date created or modified
- Subject Matter Experts or Authors
- Products named
- Product ID
- Natural language used in the writing
- Operating systems this product runs on

7. Objects can be assembled quickly, creating personalized content.

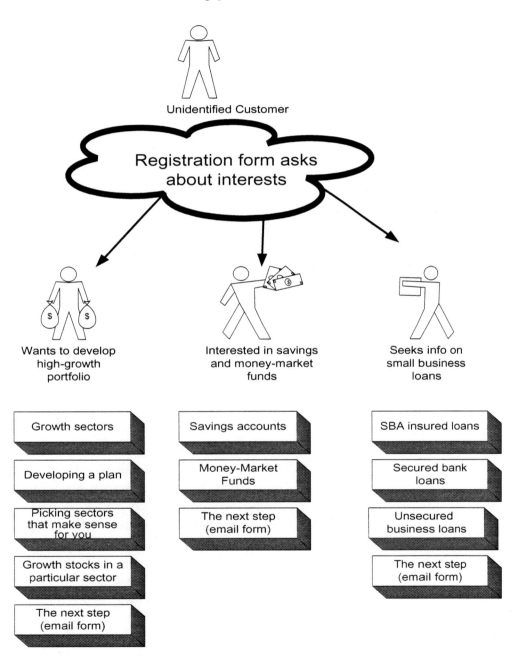

Unidentified Customer

Registration form asks about interests

Wants to develop high-growth portfolio

Interested in savings and money-market funds

Seeks info on small business loans

Growth sectors

Developing a plan

Picking sectors that make sense for you

Growth stocks in a particular sector

The next step (email form)

Savings accounts

Money-Market Funds

The next step (email form)

SBA insured loans

Secured bank loans

Unsecured business loans

The next step (email form)

Personalization demands that you break up your content into small chunks so you can deliver just the pieces one person wants without the annoying extra details they would like to avoid. Customer relationship management, Web application server, customization and personalization programs can track individual visitors by their cookies and offer personal welcome pages with customized content, including topics the person has indicated interest in—but only if you have carved your material up into a lot of bite-sized chunks.

A use case is a sequence of transactions in a system, initiated by a user of the system. A use case has a complete flow of events, that is, it has a well-defined beginning and an equally well-defined termination.

—Ivar Jacobson, Maria Ericsson, and Agneta Jacobson, *The Object Advantage*

Taking an object-oriented approach to structure cuts through the noise

Looking at the elements in current documents as informative objects can help you improve the effectiveness of your writing. Having an object model to work with (taken from the DTD), you can do a number of things that tend to make your writing more alert. You can, for instance:

- Define the purpose of each object you use so you can include only what is relevant, and leave out the interesting but extraneous details that confuse people.
- Follow the standard pattern for these objects so readers (and programs) know what to expect and do not get derailed by strange variations.
- Apply that pattern in editing old documents to spot places where the document is not working properly, correcting those passages without getting lost in stylistic revisions.
- Create team templates that restrict and direct new writing.
- Build in attributes that allow more pinpointed searching for particular small objects, such as a definition or a single procedure. You are making it possible for software to filter out thousands of near misses and duds, focusing on the particular type of object you or your users want.
- Make your conceptual model explicit and articulate. Exposing your structure generally makes for faster reading and better comprehension.
- Support the users as they grasp and use the structural model you present by being consistent in your own use of

it, avoiding internal inconsistencies that raise questions in people's minds.

- Offer multiple perspectives on the same information and various organizations on different media.
- Identify possible audiences for particular objects using an attribute such as Audience.

The Web drives your organization to take traditional types of documents, such as the data sheet or procedure, and standardize them, defining each one as a distinct genre with a clearly articulated purpose, audience, subject, and organization. At first, moving into this environment feels constricting, artificial, and a bit abstract. But after a while you'll probably find that your writing goes faster, gets cleaner, and does its job more efficiently because you know what the purpose of each object is, understand what kind of question it answers, and you do not get distracted, drawn off on a detour, or just plain confused about what goes where. You begin to think structurally, and, interestingly, that often leads to uncovering new facts, understanding your subject in more depth, and shaping your material for the benefit of your readers, not yourself, or your teammates. What you give up in originality you gain in impact.

Business rules go hand in hand with customer profiles. By combining the two, you can begin to target the right information, products, and offers to your customers.

—Patricia Seybold and Ronni Marshak, *Customer.com*

See: Ames (2000), Belew (2000), Bradley (2000), Coad and Yourdon (1991), Coombs, Renear, and DeRose (1987), Gamma, Helm, Johnson and Vlissides (1995), Goldberg and Rubin (1995), Goldfarb (1990), Goldfarb and Prescod (2000), Herwijnen (1990), Hunter et al (2000), Jacobson, Ericsson, and Jacobson (1994), Kay (2000), Khoshafian and Abnous (1995), Lee (1993), Lie and Bos (1999), McGrath (1998), Megginson (1998), Object Management Group (1997), Rumbaugh, Blaha, Premerlani, Eddy, and Lorensen (1991), Taylor (1992), Travis and Waldt (1995), Turner, Douglas and Turner (1996), Young (2000), Yourdon (1994).

POST

My Idea:

Post to HotText@yahoogroups.com

Express your own idea on:

HotText@yahoogroups.com

Subscribe:

HotText-subscribe@yahoogroups.com

Visit:

http://www.WebWritingThatWorks.com

chapter 3

What Will the Web Do to My Text?

Your Words Are Virtually There

They call TV a medium because it is so rarely well done.
—**Goodman Ace, TV writer**

When I ask for a kiss, I do not want a piece of paper with "A kiss" written on it.
—**Alan Watts,**
The Book: On the Taboo Against Knowing Who You Are

As a medium, the Web is a storm of electrons generating light and sound, moving through circuits, networks, and servers, guided by machine code, operating systems, and applications, and displaying our text along with images, animation, video, and audio on a brilliant screen. Electrons are mobile, uncertain, erratic, and fast— quite different from ink on paper. But many of our ideas of text still derive from our experience with paper documents. (In fact, our names for many documents assume that they will appear in that medium, i.e., term papers, newspapers, or corporate white papers.) And even though many of us grew up with all media blaring—the radio on, the TV going, the CD playing in our headset, and the video games live in the next room—many of our ideas of text come out of the older culture and the tradition of print.

Think of some of the assumptions our culture makes about text, even in the Internet Age:

- "I publish, you read. I am the authority; you are the note-taker." Only an authority can produce a book.
- "It must be true. It's right here in the paper." Text in print must be accurate.
- "It's as clear as black and white." Text is so crisp it is simple to read.
- "Text preserves information." Text stays put on the page, and the page lasts for hundreds of years in a library.
- "I have it in my hand." You can touch the thing that carries text, hold it, lift it up, close it, and move it around. Text is physical stuff.
- "I know how long the book is." On the page, text stretches from top to bottom in two dimensions—height and width. Considered as an object, a book also has a third dimension—depth. But all those dimensions are fixed. All pages are the same length, and once printed, no book gets any

Gentle reader: start anywhere. Linearity optional. Some repetition may occur.

—**Mick Doherty,** *"[@TITLE THIS_CHAPTER AS... [WAS: ON THE WEB, NOBODY KNOWS YOU'RE AN EDITOR]"*

longer than it is today. We know in advance how much information there is, and that volume never changes.

- "It's a text." Because text appears in a discrete object such as a book, we know where it ends. We conceive of text as having a beginning and an end, a front and a back, and a fixed amount of stuff in between. We think in terms of "a text."

Time to throw those assumptions away! For instance...

- Anyone can produce text on the Web, and most do. Individuals without corporate sponsorship often have more juju than the official spokesperson. Putting text up on the Web does not make you an authority—your work, honesty, attitude, and character do that.
- Text is not crisp on-screen; it is hard to read.
- Text is no longer stable. It comes and goes. You leave a page, and you may never see that text again.
- Text has no physicality. You can no longer touch it, hold it, or weigh it.
- As a result, when we enter a text area, we do not know how long it will be, how much information is buried there, or where it will stop.
- Text flows from here to there, on and on. Text no longer shows up in a neat package called a book or a report. It just goes on and on, from link to link.

The Web, as a medium, makes reading hard, limits context, challenges even the most eager skimmer, destabilizes the text we devote to content, stabilizes and solidifies the text that acts as part of the interface. Because navigation is so often confusing, visitors are forced to rely on these menus, buttons, and other fragments of text for clues about their location in the larger structure. Before you write, consider the situation.

Your words look fuzzy

Reading text on-screen is harder than reading print, in part because of the lack of resolution. Where a printout from a laser printer has 600 dots per inch, and a *National Geographic* page may have 2400 dots per inch, the screen has 72 or 96 dots per inch. Those are big fat dots, and they do not make individual letters very sharp.

Moving closer, which can clarify words on paper, only works up to a certain distance from the computer screen, after which we begin to be aware of pixels, not meaningful language.

Using software controls to zoom in can make the individual words easier to read—but then the proportions of the screen and the small size of the window interfere, limiting us to portions of paragraphs. We have to resort to kludges like resetting the margins, just to avoid horizontal scrolling.

Because the text is more difficult to read on-screen, people often read slower, comprehend less, recall less, and do less in response. Reasonably enough, whenever you ask people to read on-screen, they resist. In fact, they duck and weave and bob, just to avoid actual reading. They may use text artifacts such as headings to navigate, but only to make sure that they really, really have to start reading, a job they put off as long as they can.

Result: you have to work harder to shoot your ideas through the glass.

Also, due to the lousy resolution on-screen, skimming a page is harder. Looking at a screen, the eye has trouble picking up the particular word that our mind is looking for, whereas on paper, the word jumps off the page.

Context shrinks, too. We cannot see the facing page. We cannot see what lies above or below the passage we are reading. We are wearing blinders so we lack the sense of our surroundings, an awareness that—on paper—enables faster movement within the page, and from page to page. There's no such thing as riffling through the pages looking for a particular idea.

For all the miracles of hypertext, a book is still a faster interface for some lookups. The slowness of the Web, even on a fast connection, the likelihood of going to the wrong location, the excess of search results—all of these factors make the computer a clumsy research tool. As a result, people spend more time navigating and verifying their position online, to make sure they have gotten to the right information, because they are so often led to the wrong location, and they don't want to read anything that's not relevant.

Again, the emphasis has shifted, as we move from paper. In a book, we use headers, headings, captions, and boldface lead-ins to

orient us. But we quickly move from those to the running text, in order to "read." The amount of time we spend online reverses that ratio because we have to spend so much more time "using" text to find out where we are, compared to the time we actually spend "reading" when we arrive at the target.

Your words appear and disappear in a moment

The text's lack of stability (now it's here, now it's gone) means that users cannot easily revisit, re-examine, and compare what you said just a moment ago.

The fixed printed surface becomes volatile and interactive.

—Richard Lanham,
The Electronic Word

On the Web, words do not stay put, as they do on a paper page. As a visitor moves from one link to another, the pages disappear, and, even with a Back button, people find it difficult to flip back to one page, then forward to another to compare. The book page stays put, more accessible than the electronic page, and more open to study. Little wonder users print out important pages to read the old-fashioned way. As an electronic writer, you are entering a world of dissolving text. You are writing on clouds.

On-screen, the most stable words serve as labels, signs, buttons, and directives

Words dominate the controls people have to use to move through the electronic world:

- Words on menus
- Words in dialog boxes
- Words in warnings
- Words that appear when we hover over a tool.

For all the icons, the graphic user interface is still an extremely verbal medium; but people perceive this very reliance on words as annoying, restrictive, confusing, ambiguous, slow. Users constantly complain about running text on the screen, referring to the words there as "verbiage."

The blue underlined word became one of the Web's first contextual clues to functionality.

—Jeffrey Veen,
The Art and Science of Web Design

As elements of the interface, words become labels, more like street signs than an article. Even when you are communicating complex ideas, difficult operations, or interesting perspectives, and people are actually slowing down to read, they do so within an environment in which words are embedded in buttons.

Most of the time, using the computer, your audience is not made up of readers. They are users.

Words annotate what goes on the Web, and they influence our opinion of the images, links, and environment. But words are only part of the event, and for many people, they are the least attractive aspect of the experience.

Users who are impatient to "get through" the "verbiage" tend to regard an e-mail as a hint, rather than a thoughtful expression of ideas to be weighed seriously. Naturally, people miss subtleties, qualifications, extended riffs, and irony.

Our culture emphasizes speed, and many users just want to "get it" and "get out." Entering an environment in which words are for clicking, users expect even running text to act, to jump, and to communicate in one quick bite. No full course meals: people want a snack they can heat up by pressing buttons on the microwave.

People turn to your language for quick indications of structure

In a book, readers have many cues to their location within the overall structure—the front cover, the back cover, the headers and footers, the headings, the chapter openers, the chapter endings, even summaries. But on a Web site, users cannot tell how much info it contains, where it begins, or where it ends. To find out where they are in the hierarchy of a site, users need to look at words as button labels ("Products," "FAQ," "About Us"), and words as menu items, because these words offer an idea of the structure of the site. Layout and graphics reinforce the words, but as with icons, a user must first figure out what the graphic representation means before being able to rely on it as an indication of the department, section, or topic.

Within a page, people rely very heavily on your title, headings, boldfacing for indications of your structure, and their location within it. Oddly, because they cannot flip through the pages quickly like a book reader, Web users are more dependent on verbal cues about their position in the hierarchy than book users are. Moral: you have to be more aware of structure when you write online than you were when you wrote for paper. The shape and

As far back as you look in the history of the Web, plain old text has been the lingua franca.

—Jeffrey Veen,
The Art and Science of Web Design

scope of your online writing is difficult for users to perceive. So you have to work harder to communicate your main point, your organizing patterns, and your starting and stopping points.

Web text is three-dimensional

I think Web writing needs to be conversational and direct.

—Marisa Bowe, producer of *Word*

Visitors to your site are following an erratic path that goes forward and back, up and down, in and out. Short-term memory is quickly exhausted trying to recall the trail, so the users must devote considerable energy to deciding where to go next and figuring out where they are now. They ask that question of your text long before they choose to "read" it for meaning. Like visitors to a new city, they are wondering:

- Have I come to the right place?
- Is this the topic I am interested in?
- Does this person have anything interesting to say?
- Are the paths through this material recognizable?
- Are its districts clearly defined?
- Are there landmarks I can use to navigate with?

On the Web, people use the text for movement up, down, and in—long before they actually read for ideas.

Caution: Date-stamp your idea of the medium

Media are of the moment. Our understanding of a medium reflects the culture of the hour, the technology, and the mental models of the day. Our idea of a medium like print grows, morphs, gets redefined, every ten years. A medium like the computer seems to grow so fast that established ideas about interface design change every few years. And the Internet draws in so many new people every day that our very idea of the medium (computer-like devices hooked to the network or networks) gets changed every few months.

See: Apple (1999), Black and Elder (1997), Bolter (1991), Bork (1983), Bricklin (1996, 1998), Broadbent (1978), Cooper (1995, 1999), Dillon (1994), Doherty (2001), Haas (1989a, 1996), Heim (1987), IBM (1997, 1999), Johnson-Eilola (1994), Keeker (1997), Keep (1999), Kilian (1999, 2001), Krug (2000), Lanham (1993), Levine (1997), Lynch and Horton (1999), McLuhan (1962, 1964a, 1964b), Microsoft (2000), Morkes and Nielsen (1998), NCSA (1996), Nielsen (1997b, 1997d, 1999f), Ong (1982), Price and Price (1997), Siegel (1996), Spool, et al (1997), Spyridakis (2000), Uncle Netword (1999c), Veen (2001).

Web Text = Content + Interface

On the Web, a chunk of text acts as both content and interface. A menu item, considered as content, tells a user what the page is about; the same menu item, considered as an interface element, is just a hot spot. Text can swing both ways:

- Content is what people are looking for—information, activity, perspective.
- Interface is what people use to find the content, move through it, act on it.

Text as content

As content, text responds to questions the users ask about topics they care about. A product description is content. An article is content. Even a phrase that sums up an idea elaborated in the article is content.

As content, text also encourages and guides activity. For instance, when people shop online and have to fill in their billing and shipping addresses, they are providing their own content within a form that contains a (somewhat) meaningful message. In this sense, the labels identifying the fields are content.

As content, text also communicates context. The company name, the mission statement, the text in the main menu all signal who owns the site, what it is about, and how the people there think about the site's value.

Text as interface element

The same chunk of text that acts as content may also act as an interface element.

A heading that tells the user something about the topic to be discussed in a particular section also appears as a menu item on another page. As a participant in the menu, that text acts as content in a new way, forming part of a group of related topics, indicating

Content is the information that resides in a computer or other information-processing device and that has meaning and utility for you.
—Jef Raskin,
The Humane Interface

how the writers think about the whole array of topics. But the heading is now hot, and acts as what user interface folks call an *affordance*—a way for the user to move to the section. The text has become an active part of the interface.

When the user clicks the menu item and goes to the page, the heading appears again at the head of the section. The format— 14-point, let's say, bright red Arial, centered, with plenty of space before and after—indicates to the user that this text is more important than the running text that follows. The graphic treatment acts as a passive, or inert, part of the interface because although the formatting does not offer any software action, it helps direct the eye, offering help to the mind looking for a particular piece of content. So, even though the heading is a significant part of the content, stating an idea briefly and advertising the content to come, it is also an element of the interface.

Working together

Content itself is reflected in the interface elements, including the graphic layout and the menu system, but considered as interface, these verbo-visual expressions are not content. They point to meaningful content, support it, and reflect it. But as buttons, formats, or links, they serve a different function, helping people use their eyes and fingers to navigate through the content pile to particular tidbits.

When the interface designer and graphic designer have worked well in collaboration with the content providers, the organization, purpose, and tone of the content shines through the form. The inventor of the IBM logo, Paul Rand, once said,

> Design is the fusion of form and content, the realization and unique expression of an idea.
> (*Design Form and Chaos* 1993)

Of course, Rand thought of design as a purely graphic effort, expressing relationships between the parts and the whole, through visual affordances such as contrast, balance, proportion, pattern, repetition, scale, and rhythm. But on the Web, many people are

If the computer behaves unexpectedly while you are using an interface, you become less likely to see hints, help messages, or other user aids as you become increasingly agitated about the problem.

—**Jef Raskin,**
The Humane Interface

builders of structures, organizing and manipulating content, giving it form through which the user will move. Today, we are all information architects.

Text is one of our most important building blocks. Almost anyone can make text. No one except a poet puts on a beret and announces, "I am extremely cool because I can create text." Only specialists create flashy animations, layout templates, and interface icons. But the rest of us create text. We have to be aware of the way each piece of text will cooperate in the construction. What we write must function as a unit, taking up its own space, and as a part of the whole, holding the arch together.

To be heard or read, text takes on a format, whether that is a font on-screen, or a voice-over. And to be used, the text also takes on affordances for action, such as link tags, scripts, or active fields. By its nature as a symbolic representation of ideas, text is content. Therefore, the general rule is:

Web Text = Content + Interface.

Whether your text is meaningful or confusing, helpful or annoying, depends on you. This book gives you a lot of advice on how to create text that guests will be able to understand, play with, act on, and enjoy. But you have to create the text itself, alert to its double life.

Affordances provide strong clues to the operations of things... Knobs are for turning.

—Donald Norman,
The Psychology of Everyday Things

See: Black and Elder (1997), Bolter (1991), Krug (2000), Morkes and Nielsen (1998), Nielsen (1997b, 1997d, 1999f), Siegel (1996), Spool et al (1997), Spyridakis (2000), Veen (2001).

Warm, Warmer, Hot!

Computers are cool, and the Internet is warming them up.

Despite the pronouncements of media guru Marshall McLuhan, TV is hot because it shows dramatic conflict, evokes strong emotions, and arouses intense fantasies.

Lacking all that visual drama, radio is not as hot, but because we can hear real people saying what they think and making music, both of which stir us, radio is at least warm.

Compared to TV and radio, computers are cold.

The chilling effect

Washington-Moscow Hot Line to Open in 60 Days.
—New York Times, June 21, 1963

When computers come into an office, schmoozing goes out. Instead of talking with our neighbors, we begin to carry on a dialog with the file system, trying to get along with the reasoning of geeks, struggling with the hostile interface of many programs, and watching not another person but the glass, silicon, metal, and plastic of the object itself.

And the annoying modes, the prissy error messages, the sheer stupidity of the computer make it more like a bossy intruder than a friend. Despite Microsoft's millions, it could not persuade people that the utility Bob was a friendly personal agent. By itself, the computer removes us from contact with other people, increases our workload, makes us look like fools, and forces us to turn out ever more text, more total output, and more crap.

Media Hot and Cold.
—Chapter Title, Marshall McLuhan,
Understanding Media

Enter the Internet

When you hook your computer up to the Internet, you get e-mail, and suddenly the computer can communicate with other people directly. You can see past the screen and make human contact.

If you have a fast connection to the Internet and indulge in video conferencing, you actually see and hear the other people. If you tap into Internet radio or use Internet phone connections, you actually

hear individuals talking to you or to each other. With the Internet, people are trying to heat up the computer, making it more sociable, more personal, more human.

Raising the temperature

The more we share ideas, opinions, outrage, and recipes with other people on the Internet, the warmer we feel toward the discussion list as a whole. Community binds us and makes us feel close, despite the keyboard, the screen, and the distances between the people chatting or posting. Wild personal rants on a webzine, flames on an e-mail list, pornographic prose—all these raise the temperature.

The electronic medium is cold, so if you want to break the ice between you and your guests, you have to be intensely human. Your prose should be warm to the touch.

Getting warmer

The warmth comes from your attitude toward your audiences, not tricks of style. Warmth comes from paying attention to every inch of your audience.

Consider what they might need that they haven't asked for. Chat with them. Answer their e-mails. Go to their meetings. Talk to them on the phone.

The more you establish direct personal relationships with individuals, the more your prose will sound like a human being wrote it to another human being. No more bloodless writing!

The electric light escapes attention as a communication medium just because it has no "content."
—Marshall McLuhan,
Understanding Media

Finally

To get hot, reveal yourself.

Not every site allows self-expression. But if your site gives you this kind of freedom, let go of your shame.

Admit your craziest impulses, silliest actions, utter confusion. Stop acting smart.

But keep your attention on the individual people and your relationships with them, which they see expressed in your tone. From your language, they can tell what you think of them. In a few sentences, they sense your affection or your contempt. Honest passion

sweeps them away. But fake feelings, sentimentality, preening, and posturing, simply repel most people.

If you don't feel up to writing with the blood from your opened veins, that's fine. Most sites just need a human touch.

See: McLuhan (1962, 1964a, 1964b), Ong (1982).

POST |

Express your own idea on:
HotText@yahoogroups.com

My Idea:

Post to HotText@yahoogroups.com

Subscribe:
HotText-subscribe@yahoogroups.com

Unsubscribe:
HotText-unsubscribe@yahoogroups.com

Visit:
http://www.WebWritingThatWorks.com

chapter 4 |

Attention!

The Point of Attention **78**

The Point of Attention

The scarcest resource for today's business leaders is no longer just land, capital, or human labor, and it certainly isn't information. Attention is what's in short supply.

—Thomas H. Davenport and John C. Beck,
Harvard Business Review

The faculty of voluntarily bringing back a wandering attention, over and over again, is the very root of judgement, character, and will.

—William James,
The Principles of Psychology

Attention is the coin of the Internet. In the economy of attention, value is measured by Time × Intensity. How long have you paid attention to me? And how intently have you stared at me? That is my net worth.

Of course, the Internet is built on the old economy of capital, labor, goods, services, and money. But parallel to the traditional market there has always been another exchange in which we trade attention with each other. And the Internet has dramatically increased the volume of trading on that floor.

Even though attention is not gold, it is valuable. When business people talk dreamily of eyeballs, click-through streams, stickiness, and ideas spreading virally, they are hoping, of course, that winning someone's attention may pay off in purchases, or at least goodwill. But millions of other people simply post because they want us to notice what they care about, to share their focus, or to get our attention. When a visitor writes to praise our text, we blossom; and when we respond thoughtfully to their e-mail or discussion post, their next message often shines with pleasure. We like the attention.

But what exactly is attention? It is an intangible energy, a subjective and intensely personal experience. You cannot put your thumb on it. Researchers can find no particular lobe of the brain in which attention resides. Scientists can track eye movements, and guess what you are attending to on a Web page, but they cannot share your experience of attention as it is pulled here, sidetracked, or diffused.

Attention acts as a scout. If we have a conscious purpose, we can direct our attention very efficiently. If we have a sharply defined goal on a visit to a Web site, we tend to represent the quest to ourselves in words, and as we scan, our attention seems to pick up any of those words in the text. Unfortunately, this kind of scanning is hard to do on-screen because of the fuzzy display of text. So we direct attention to certain areas (at the top of the page, for

instance), and we look for certain formats (such as headings, bold-face phrases, the first line of a paragraph) because we expect that if the words show up in those spots, the text will be relevant to our concern. Primed to catch certain words, attention seizes on them—if it can spot them. When pursuing a goal like this, human attention turns out to be an excellent hunter.

And when we actually pay attention to something, our mind ignores the other things in the neighborhood. If we try, we can attend to several different items at once, but we soon feel the strain. Essentially, our being is built to focus. Attention acts as a kind of filter.

In fact, research shows that we usually devote attention to only one thing at a time, even if we switch quickly from one to another. In most cases, what we think of as multitasking is actually just shifting our attention from one thing to another and back. At any moment, our attention is one-pointed, but the point shifts from moment to moment.

To sustain attention takes a steady, dynamic flow of impulses.

—James Austin, *Zen and the Brain*

When we do not have an intensely felt or fully articulated goal, attention seems to float over the page, watching for targets of opportunity, eventually swooping down and pouncing on a particular object. Why does undirected attention seem to be pulled to one object and not another?

First, it seems, a certain instinct for self-preservation directs attention. We seem to be genetically wired to notice sudden change because that could suggest danger. Anything that changes the scene dramatically, introduces something new, or transforms something that we were already familiar with, draws our attention instantly. We may be annoyed to find we are looking at a flashing text or inverted video advertising insurance, but our attention went to the motion automatically. Similarly, attention descends on any word or phrase that has a different format from the rest of the text—bold-face, say, or blue and underlined. We can see the physical difference long before we understand the difference in meaning, as we move from one word to another. Attention tends automatically to ignore the routine, and swoops down on the exception.

The hunter is the alert man.

—Ortega y Gasset, *Meditations on Hunting*

Next, passion draws attention—good old greed, lust, envy, curiosity, hero worship, ambition, rage, or vanity can arise in a

split second, triggered by a mere word, nudging attention toward the scene. Whatever we have a passionate interest in, our attention discovers, even in the most unlikely places.

And if a phrase evokes any strong feelings, our attention is quickly drawn to the emotion-laden text. Then, if we are what the psychologists consider normal, we can, if we want, withdraw our attention just as quickly without thinking too much about the subject. But if we are anxious, defensive, neurotic, or downright crazy, we will take more time to ponder, fondle, and digest the words. In either case, attention is riveted to the text's area and significance for as long as it takes to enjoy and then disengage.

People, too, attract our attention inadvertently. Think how quickly you size up a stranger. But if you see a friend, or someone you love, your attention settles on them. Just seeing the name of the object of your affection, attention circles the text. Love, and its companion, desire, guide attention.

So, to draw attention to your text:

- Make scanning easy by putting key terms where attention knows to look first—at the top of the page, in headings, and so on.
- Write about topics that people are looking for. When they spot one, they'll pay attention and praise your text as relevant.
- Respond to the purposes that bring visitors to your site. The more you use the terms they think of to explain their goals, the quicker their attention will pounce on your text.
- Avoid distracting visitors with a lot of off-topic text, links, and images. Keep the focus.
- Write something new, as the poet Ezra Pound suggested. Surprise, oddness, and unfamiliarity attract attention. Put key terms in a format that stands out.
- Let your own passion show through the prose. Mention feelings and interests. Yes, it's OK to get emotional; in the cold world of the computer, those strong feelings capture attention.

Each of us literally chooses, by his way of attending to things, what sort of a universe he shall appear to himself to inhabit.

—William James,
The Principles of Psychology

- Talk about people. We're always interested in people. If your audience has some heroes or heroines, indulge in a bit of biography.
- Reveal yourself. Hey, you're a person. Letting that secret out will automatically interest other people.

Simplicity saves attention

Attention turns out to be a limited resource. We only have so much to give.

Allowing targets of opportunity to swim into view takes only a little attention. Scanning for a particular topic takes more attention. The process of reading takes a lot. Having a particular term or topic in mind, anticipating where the target words may appear, we can scan fairly smoothly. When we spot a likely target, we shift gears and actually read the word, to confirm that it is related to the topic we are concerned with. We are, first, a user, and second a reader. More generally, we turn attention to an object first, and only then do we identify its meaning, a much more complicated task.

Reading demands a great deal more attention than scanning because we must pick up the general theme of a passage by skimming for thematic markers, spotting the key words, piecing together an interpretation back in our mind, and then returning to the text to test our evolving idea, refining it as we move forward. We only have a limited amount of attention to devote to this process. Interestingly, what can strain our capacity for attention is the very act of reading if the text grows more complex. The simpler the text, the less strain.

When we are reading on-screen, and the effort eats up a lot of our attention, we have little attention left over for navigation or other tasks. When the text itself grows tangled, our attention may blow a fuse. Messy text, combined with the poor legibility of characters on-screen, may require more attention than most of us have available. Result: we do not comprehend, think about, or act on the message.

Simplicity helps our readers preserve their fragile attention and ensures that they can focus on our meaning.

Because of information technology, the object of the person's attention is capable of both learning from the person's past behavior and expressed preferences, and then behaving differently toward that particular person, based on this learning.

—Don Peppers and Martha Rogers,
Enterprise One to One

Writing means paying attention

As you write for the Web, you have a lot of things to pay attention to—your evolving understanding of the subject, your sense of your guests, your progress in building the formal structure of your text, and your feel for the way your words will work on-screen. In wrestling with a paragraph, for instance, your attention may dwell on the event you are trying to describe, then turn to a particular group who cares about the subject, switching back and forth repeatedly as you work to express your idea in terms they will understand. In editing a passage, you may notice that your attention is following along very nicely until, all of a sudden, you are thrown out of the text as your attention goes into orbit, launched by some irrelevant but interesting analogy. You direct your attention as you dig into your notes, and you watch your attention as if it were a reader's, to see how your own text makes it jump or keeps it hanging in there, as you review your output.

As a craft, writing has always demanded concentration, which most people think of as walling out the rest of the world and putting a tight rein on attention. But writing for the Web demands that you pay more attention to small groups in your audience and even individuals, at times; that you change your habits of writing to make your text work in the Web environment; and that you keep consulting a standard structure to see how you are matching its model. This multiplicity of points of attention can make you dizzy if you try too hard to exert control. Better to relax and follow the conversation as best you can, recognizing that it's natural for attention to move.

People who read what you write are very aware of your attitude toward them and toward your topic. Between the lines of your text, they can sense when you have paid attention to them, when you have been sensitive to their concerns, and when you share their interests and their passions.

In this sense, attention is the soul's antenna—soft, sensitive, quick, alert. It picks up facts we cannot articulate. It senses moods, possibilities, points of view. It goes where imagining can only follow, inside our own body and across the Internet. As the eyes and ears of the spirit, attention is what we communicate. In our virtual conversations on the Internet, attention is the exclamation point.

When attention is fully deployed into behavior, it means, quite literally, that the person leans into just one activity at a time.

—James Austin, *Zen and the Brain*

When you are awake and conscious, your locus of attention is a feature or an object in the physical world or an idea about which you are intently and actively thinking.

—Jef Raskin,
The Humane Interface

See: Austin (1999), Broadbent (1957), Conner (2001), Dalgleish (1995), Davenport and Beck (2001), DeRuiter and Brosschot (1994), Green (1991), Goldhaber (1992, 1996, 1997a, 1997b, 1998), James (1890/1950, 1925), Lanham (1994), Palmer and Rock (1994), Pashler (1998), Thorngate (1988, 1990), Titchener (1908), Treisman (1982).

POST |

Express your own idea on:
HotText@yahoogroups.com

> My Idea:
>
>
>
>
>
> Post to HotText@yahoogroups.com

Subscribe:
HotText-subscribe@yahoogroups.com

Unsubscribe:
HotText-unsubscribe@yahoogroups.com

Visit:
http://www.WebWritingThatWorks.com

part 2

Write Like a Human Being

chapter 5 |

Idea #1: Shorten That Text

Cut Any Paper-Based Text by 50%

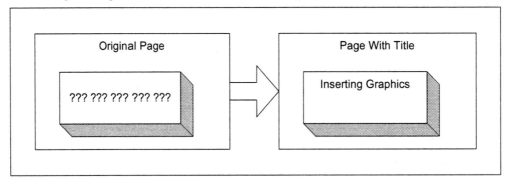

BACKGROUND

Don't make me read!

The computer builds each letter out of big fat dots on the screen, and these jagged-edged characters become so fuzzy that they challenge the eye, making the job of reading much harder than on paper. Jakob Nielsen's research, for instance, suggests that people read 25% slower from a computer screen than from paper.

Struggling to see the text on a blurry screen, people are also uncertain where they are within the site, doubtful whether your page really has the info they want, and distracted by ads. In such circumstances, people resent text. They resist reading in many clever ways. They cry out, "Don't make me read!" Nielsen's remedy: "Write 50% less text."

Cutting half the words in your text works. The point is not the number. Fewer words mean less reading. When you get close to half the words you would ordinarily use on paper, you're finally writing for people who see any extra words as "verbiage."

People use text, to put off reading

To figure out what topics to look at, people use the text that you create in menus, headings, and search results. To navigate through the site, people use the text in buttons and links. To decide whether or not to go ahead and read what you write on a particular

page, people use the text in the page title, headings, and introductory sentence. Using text is like using signs, not what we usually think of as reading. Only when a guest has successfully used your text to identify a topic as worthwhile will he or she actually slow down and read.

The way you write all the text that people must use just to find the right topic determines how much brainpower they have left to consider your actual ideas. Now they face the near illegibility of the actual characters, and the tempting art and ads around your article. And reading means they must also give attention to the many simultaneous tasks involved in figuring out and understanding the text. Reading is a tougher job than using text, and their attention is always being drawn away. If you want to be sure someone will read what you write on the web, write less.

Less text means less strain on a visitor's ability to concentrate, less material to juggle in short-term memory, and a faster rush to meaning.

Pithy sentences are like sharp nails driving truth into our memory.
—Diderot

Cut on-screen and off

When we cut text that we originally wrote for a paper magazine, we do it on-screen so we can see the characters blur just the way they will for our users. That near illegibility encourages trimming.

Sure, you can use a paper copy to slash away, but you may not go far enough. Paper pleads for more text. Coming from a background of books, magazines, and the Sunday New York *Times*, paper carries a tradition of long documents, thick paragraphs, and elaborate sentences. As experienced readers, we are used to lots of text—on paper.

If you insist on editing on paper, you'll know you have cut far enough when the printout begins to look quirky, abrupt, telegraphic. On-screen, that text will go down fast and smooth.

Take several whacks

It is my ambition to say in ten sentences what others say in a whole book.
—Nietzsche

We cut everything we can and then stop. When we look at the text again, we see it is too verbose.

We cut again and again and again. Sometimes, we have to make five passes to get rid of the last ounce of fat.

Don't expect to make all the cuts at once. Keep at it.

Save the meaning, cut away the rest

When looking for text to delete, cross out:

- Words that have been included just to emphasize your sincerity, like *really* and *truly*
- Words that don't add anything to what you have already said
- Unnecessary details
- Phrases that unnecessarily repeat words you have already used, when a pronoun would do
- Phrases that tell the readers something they already learned earlier
- Pompous b.s.
- Corporate speak (phrases only a committee could love)

Unfortunately, to edit in this way requires thought. You can't do it mechanically. In his admirable book of lessons on style, Joseph Williams points out that, "The only reliable way you can identify and remedy wordiness is to slog through every sentence, word by word. That's hard work."

The more you say,
the less people remember.

—**Fénelon**

EXAMPLES

Before

Using various technologies we intend to study, identify, or otherwise characterize changes in the physicochemical state of a myriad of plutonium compounds found in various residues, destined to be stored as interim waste over decades. Uncertainties about the practical effects of possible changes, such as gas generation and corrosion and other possibly deleterious transformations that might lead to unsafe storage conditions, adversely affecting the waste form, result from inadequate previous studies of these complicated residues, as opposed to the more straightforward metal and pure oxides, which we will not study. The chemical behavior of this material, especially the material intimately in contact with the plutonium,

After

The problem: The lab intends to store some waste materials containing plutonium compounds for decades, but we do not know how these plutonium-containing materials will behave, chemically, over this long a time. We fear they may rust or give off gases, damaging the waste, or its environment.

This project: Excluding metal and pure oxides, the residues will be studied to identify potentially dangerous changes in the local chemical environment of the plutonium metal center.

Next step: Countermeasures.
77 words

needs to be studied over time to identify any chemical changes due to aging, corrosion, or gas generation of the problem residues. Once we can identify these possible changes, we can proceed to the next phase of our project, which is to suggest countermeasures.

149 words

Before

How do I check out when I am all done with my shopping at the stores within the Jumbo portal?

Whether you are buying one item, a dozen, or maybe a hundred, you can just simply click on the Shopping Cart icon, which appears at the top of every JumboShop page. Once you are in the shopping cart, you can do several things, if you want. Optionally, you can confirm that everything you wanted to buy has shown up in the order, enter billing and shipping information, and then click the Check Me Out button, to move the order along. At the moment you click the Check Me Out button, we send your order to the individual store. At that point, the transaction is between you and the store, and if there are any problems, you need to talk to the store. If you call us, we will only be able to help you with our part of the transaction, that is, before we actually send the order to the store.

171 words

After

How do I check out?

1. Click the Shopping Cart, at the top of the page.
2. Look over your order. (You can delete items if you want).
3. Enter billing and shipping info.
4. Click Check Me Out.

At that time, we send your order to the individual stor

50 words

Before

I am a little uncomfortable with some of the things you have been saying in the last few messages on this discussion group, and I know you don't intend to make people upset, but I have to share with you that I am feeling a little hurt at what you said about me, if you know what I mean. I hope you take this the right way. I am trying to reach out and clarify our relationship.

77 words

After

I'm hurt and angry at what you've been saying about me.

11 words

AUDIENCE FIT

If visitors want this...	How well does this guideline apply?
TO HAVE FUN	Once people decide they want to be entertained, they may choose to read and read and read, online. High tech researchers evidently never met a girl who wanted to have fun, so their usability studies have focused on techies looking for techie info—not personal insight, rants, or rambles. If you're writing a column for a webzine, you can take a few breaths, and write, well, as long as 500 words at a shot.
TO LEARN	Definitely relevant. Spike the lectures.
TO ACT	Ditto. Tell me what to do, and let me do it!
TO BE AWARE	Lao Tse showed that you can say a lot in a little space. How about those short stories Jesus used to tell?
TO GET CLOSE TO PEOPLE	Rambling is usually bad form in a discussion group. In an e-mail, too much text drives me to the Delete button.

See: Baker & Goldstein (1966), Bork (1983), Glass (1989), Horton (1990), Krug (2000), Levine (1997), Morkes & Nielsen (1997, 1998), Nielsen (1997a, 1997b, 1999f), Spyridakis (2000), Sullivan (1998), Williams (1994).

Make Each Paragraph Short

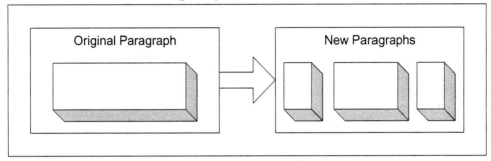

BACKGROUND

Let your guests skip and skim

Long paragraphs fill up the screen, demanding to be read or skipped. Like a barricade in the road, a thick paragraph slows you down. If you are really interested, you may condescend to read through one of these monsters. But if you are still trying to figure out whether or not to bother to read, this kind of text acts more like a roadblock, requiring that you stop to read, scroll past, or back out of there. However, if you scroll past one of these big blocks of text, you may not be able to pick up its point (or the point of the article) as you go on.

Dan Bricklin, who invented the first electronic spreadsheet and now sells a Web page editor, argues that short paragraphs help people dip and dive, taking a quick look, and, if that does not arouse their interest, skipping forward to the next paragraph. He says, "Short paragraphs help skimming."

There is no artifice as good and desirable as simplicity.

—**St. Francis de Sales**

The ideal: 2 or 3 lines

How long should a paragraph be? Two or three lines—that's the best. Sure, you're going to need to write longer paragraphs once you get rolling. But keep in mind that on the Web one sentence is a great paragraph.

Figure you have short line lengths like a newspaper. In that situation, half a dozen lines begin to seem long; nine or more lines

go over the top. Crawford Kilian argues that if you have more than six or eight lines, you should break the paragraph up "into two shorter paragraphs."

I'll take the shortcut

If you give users a choice, they pick the shorter paragraph. In its Web guidelines, Apple admits that reading on-screen text is "more difficult and time-consuming" than reading hard copy, so people are "even less likely to thoroughly read long sections of text on a computer." When Jonathan worked at Apple, he tested text taken directly from books, and bored the hell out of Help users, so he threw out introductions and reduced the hand-holding explanations to a sentence or two. Users started giving the online text thumbs up.

America Online, the most popular portal to the Internet, urges its content providers to make every paragraph short. "Users are not inclined to read long paragraphs." These folks ought to know.

Use short words we all know

People understand some words faster and more accurately than others. Interestingly, if you pick short words that refer to concrete, physical objects, words most people can easily pronounce, and words that are used a lot, people will understand you. The fewer syllables, the higher the impact.

Choosing words like these turns out to be easier than it sounds because, in English, "these word features often correlate," says Jan Spyridakis. A word like *vehicle* sounds elegant, but *car* means more to more people. Replacing *hiatus* with the simpler *gap* makes sense.

Making these edits makes your text more comprehensible. But you get another benefit. Your paragraphs end up shorter and easier to understand as units of content, and easier to skip.

Whenever you feel an impulse to perpetrate a piece of exceptionally fine writing, obey it—wholeheartedly—and delete it before sending your manuscript to press. Murder your darlings.

—Arthur Quiller-Couch

Everything that is needless gives Offense.

—Benjamin Franklin

EXAMPLES

Before
Under what circumstances will you charge me sales tax?

Generally, such taxes must be levied with respect to the ship-to address, rather than the bill-to address, on the assumption that the ship-to address is receiving the substantial benefit of the purchase. The tax is triggered if we have a physical store in the ship-to state. Currently, those states for which we must charge sales tax (when we ship to addresses in these states) are Connecticut, Maine, Massachusetts, New Hampshire, Rhode Island, and Vermont. We regret any inconvenience.
87 words

After
When do you charge sales tax?

We have to charge sales tax on any orders we ship to states where we have physical stores—Connecticut, Maine, Massachusetts, New Hampshire, Rhode Island, and Vermont. Sorry about that.
36 words

Before
Practice moving your awareness up each leg, starting with your toes, then going on to extend your consciousness to the entire foot, gradually moving up to the ankle, and, over time, up the leg. Concentrate for a moment on the knee, and then go up the rest of the leg, being aware of your entire thigh.
56 words

After
Sense your toes, feet, ankles, calves, knees, and thighs.
9 words

Before
Bitmaps go back to the earliest days of computer graphics. Until bitmaps, people thought making a Christmas tree out of x's and v's was pretty artistic. But with the innovations of machines like Apple's Macintosh and the Xerox Star, the engineers conceived of the screen image not as a bunch of characters, but as a set of dots, in a grid. At the time, each dot, or picture element could either be on

After
Originally, a bitmap image stored your picture by making a map, or grid. Each square of the grid represented a tiny portion of your screen—the amount displayed by one pixel, or picture element.

In those days, a pixel could either be on or off, that is, black or white—so it only took one bit of information to record its state. Hence, the file

(black) or off (white). So by recording the exact coordinates of every pixel, and its state (on or off), engineers could capture your picture. Thus, a bitmap image stored your picture by making a map or grid and populating it with bits. Each square of the grid represented a tiny portion of your screen—the amount displayed by one pixel or picture element. And each pixel was represented, electronically, by a single bit. That's how the file came to be known as a bitmap.

But then along came grayscale—mixtures of black and white, from 0%, or white, to 100%, or black. That meant that each pixel had, somehow, to record more information than before (not just on or off, but a percentage of gray), and that took up more bits. Then came colors. When you just had 256 colors, you didn't have to use a lot of bits to record the number of the color of a particular pixel. But then we began to see millions of colors. Just to record, say, "Color Number One Million Two Hundred Thousand One Hundred and Fifty Two" took up even more bits. That's why you hear people talking about "8-bit color," "16-bit color," and so on. Each pixel in the map required a lot of bits.
287 words

became known as a bitmap.

Now, of course, each pixel can record many levels of gray or one of millions of colors, so we have to use more bits per pixel to record all that information — hence, terms such as "8-bit color," or "16-bit color."
110 words

Before

I found out how to sort my messages, something you were wondering about last week, and I thought you might like to know. I noticed that at the top of the message list there are words like New, and From, and Date, and Subject, and so on, and if I click one of those, the whole list gets reorganized that way. You know what I mean?
66 words

After

To reorganize the message list, click a column title such as New, From, Date, Subject,or Size.

Presto! The list is sorted that way.
24 words

AUDIENCE FIT

If visitors want this...	How well does this guideline apply?
TO HAVE FUN	Amusing, intriguing, erudite or aberrant prose can go on forever, like a Faulkner paragraph, and we don't object. In fact, we jump in. So if you're planning to entertain your readers, you might start with a short paragraph, and throw a few more in, but you can certainly take a long breath and expound, too.
TO LEARN	Definitely relevant. What looked fine in the lab handout looks intimidating online. Keep every fact, save every idea, but put them into distinct paragraphs.
TO ACT	To guide action, keep your paragraphs as short as you can, without making them cryptic.
TO BE AWARE	Compress the overtones by choosing words that resonate, rather than rambling on.
TO GET CLOSE TO PEOPLE	Long paragraphs make me scroll forward, whether I am reading e-mail, a discussion, or a Web site.

See: Abeleto (1999), America Online (2001), Apple (1997), Bricklin (1998), Gee et al (1999), Henderson & Bradford (1984), Holcomb et al (1999), Horton (1990), Hudson & Berman (1985), Kaiser (2000), Kilian (1999), Lynch (1997), Marschark & Paivio (1977), NCSA (1996), Spyridakis (2000), Sullivan (1998), Williams (1994), Zipf (1949).

Delete Marketing Fluff

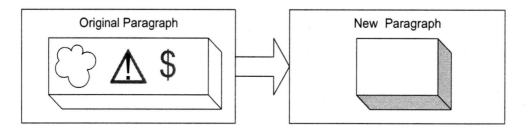

BACKGROUND

If you're out to describe the truth, leave elegance to the tailor.

—Albert Einstein

Most writers regard truth as their most valuable possession, and therefore are most economical in its use.

—Mark Twain

Filter out the hyperbole

Exaggeration makes your text less useful than objective prose. In one study by Nielsen (1997b), the objective language was 27% more usable than the promotional language because people understood the plain language faster, made fewer errors, and remembered the ideas longer. Nielsen hypothesized that people have to spend extra energy "filtering out the hyperbole to get at the facts."

If you routinely describe your company with adjectives such as *premier, top-rated,* and *world-class,* you need to calm down. Let the facts speak for you. You don't need to give up your enthusiasm, just your adjectives and adverbs.

Be direct

Users mistrust anything that looks like an ad, so they tend to ignore logos, mission statements, and slogans.

If you want to earn your users' trust, turn down the hype. As Bricklin says, "Simple, direct language works better on-screen than flowery or 'marketing-oriented' prose."

You can still do plenty of marketing on the Web. You just have to make your case with nouns and verbs, rather than adjectives and adverbs, particularly the ones that suggest you are being swept away by emotion or your own hype.

Features and benefits, yes. Hand-waving, no

If you are marketing a service or product, you have to point out your unique selling proposition, and you must stress the features and benefits. But keep the explanations simple and cut back on the exclamation points.

If you absolutely positively must have an adverb or two, or an adjective, well OK. Just make sure they don't look, well, silly.

EXAMPLES

Before

As the world's premier provider of e-mail services to the beauty industry, we are extremely proud to offer you the most imaginative creation and fastest delivery of highly targeted e-mail messages aimed at consumers, spa owners, and staff in beauty boutiques.

After

If you want to send e-mail marketing beauty products to consumers, spa owners, or staff at beauty boutiques, let us help you create and deliver targeted messages.

Before

Welcome to the incredibly useful FormFiller, with the revolutionary algorithm for filling in forms for you. No more remembering user names and passwords. No more typing the same address over and over. FormFiller is just so easy. You click once, and the form is filled in with your information. Our world-class recognition software reads the form and figures out what information should go where, enters that, and presses Enter, so the login form just whisks away. And it's super safe, because your personal information lives on your own computer, encrypted so no one else can read it.

After

The FormFiller bar saves you time by filling in forms for you.

It's easy. You don't have to type the same information over and over.

It's fast. You enter the information once, and FormFiller does it for you from then on. One click, and the form is filled.

It's safe. Your personal information is secure on your own computer, encrypted so no one else can read it.

AUDIENCE FIT

If visitors want this...	How well does this guideline apply?
TO HAVE FUN	Only a marketing manager thinks that raving about your product will actually amuse people.
TO LEARN	Any fluff interferes with learning. Cut it out. If you must save the promotional lingo, move it to a different location.
TO ACT	Marketing themes distract from instructions.
TO BE AWARE	If you can't tell the truth about your topic, you're not making anyone more aware. You may fool some folks, or annoy them, but most people will react with anger when they encounter a pitch along the path to enlightenment.
TO GET CLOSE TO PEOPLE	Acceptable. You can be carried away with enthusiasm for your product or service. But if we suspect that you are insincere, or just voicing the party line, we delete your message.

See: Bricklin (1998), Morkes & Nielsen (1997), Nielsen (1997b, 1999f, 2000a, 2000b), Spyridakis (2000).

Move Vital but Tangential or Supplemental Materia

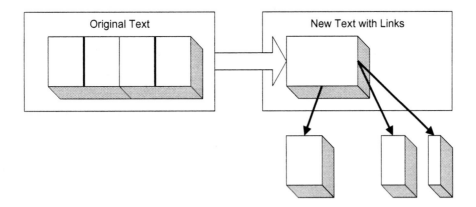

BACKGROUND |

If most people know it, move it

To let your readers know that you, too, belong to their community, mention ideas they are familiar with. But even more convincing proof that you are a member of the community is what you leave out. You understand what can be taken for granted as part of the shared knowledge of the community, so you omit it.

Unfortunately, on the Web, you cannot always tell how knowledgeable a visitor may be. So you take your best guess at the audience, and, instead of omitting the basics, or the extras, you put them elsewhere on the site and link to them. That way, a beginner can find out more, an eager learner can explore at will, but the impatient or experienced visitors do not have to stumble over the material.

> If your product is complex enough that you cannot provide all the information someone needs in one presentation (and most of ours are that complex), make it easy for them to get more information.
> (Rick Levine, *Sun Guide to Web Style*)

Move the baby talk, and the esoterica

When looking for passages to pull out of your page and move to secondary pages, grab:

- Basic background
- Laborious history
- Abstract theoretical discussions
- Information of interest only to a small fraction of the audience
- Advanced arguments for the benefit of the cognoscenti
- Important topics that do not belong here

But don't just carve up a single long article into a bunch of short takes, just because you can. Downloading a bunch of little segments slows up the process of reading, and makes printing a headache.

Let's go to the sidebar

In the O.J. Simpson trial, we learned that when the prosecutor and defense lawyers huddled with the judge, they were "having a sidebar."

Magazines run extra information in boxes next to the main article, and those boxes are also called *sidebars*.

Web designers have adopted the sidebar as the place for a quick digest of a long story and links to supplementary information. Usually, the Web page sidebar shows up on the far right, near the top of the story, just below some annoying ad.

Both the summary and the links let users know what the whole story centers on, so they help people decide whether or not to bother reading on. In some cases, people like the links more than the story, and jump right to the secondary pages.

One who uses many periods is a philosopher; many interrogations, a student; many exclamations, a fanatic.

—**J. L. Basford**

Remove the irrelevant

If users bump into irrelevant info, it blinds them to the info they want. Unnecessary info actually keeps them from finding what they are looking for.

Of course, you have to be psychic to know what information your visitors will consider most relevant. But if you can figure that out and move the rest elsewhere, visitors will voluntarily sharpen

their focus on your ideas, understand them better, and remember more. When readers find content to be relevant, they give it more attention. So figure out what most visitors will find intriguing and relevant to their own interests, and then put any other info into a sidebar or links.

EXAMPLES

Before

Another benefit of TAPI is that it accommodates multiple applications on a single phone line. (The Telephone Application Programming Interface, or TAPI, is the standard proposed by Microsoft for making the computer work as a telephone.) TAPI lets several applications use the same phone line, so one can be waiting to receive a call while another places one. So you can leave a fax program running, waiting for a fax you know is coming, while using dial-up networking to pick up your e-mail. In the past you had to cancel the first program, to free up the modem, before you could launch a second program using the modem. With TAPI, the fax program simply recedes into the background, like background printing.

After

Another benefit of <u>TAPI</u> is that it accommodates <u>multiple applications</u> on a single phone line.

Pop-up text:
The Telephone Application Programming Interface (TAPI) is the standard proposed by Microsoft for making the computer work as a telephone.

Moved to another window:
TAPI lets several applications use the same phone line, so one can be waiting to receive a call while placing another call. So you can leave a fax program running, waiting for a fax you know is coming, while using dial-up networking to pick up your e-mail. In the past you had to cancel the first program, to free up the modem, before you could launch a second program using the modem. With TAPI, the fax program simply recedes into the background, like background printing.

Before

Following Montaigne, Emerson studies his own mind at work. He describes composing a speech by assembling a series of sentiments, facts, and illustrations that work together to fire the audience. "Every link in this living chain he found separate; one, ten years ago; one, last week; some of them he found in his father's house or at school when a boy; some of them by his losses; some of them by his sickness; some by his sins."

Montaigne's essays strengthened Emerson's conviction that he would be his own best subject, and when he reflected on the way a writer goes about creating, he recognized "a multitude of trials and a thousand rejections, and the using and perusing of what was already written." In this interest in the internal give and take, the subjective piling up of associations, he imitates Montaigne, "the grand old sloven."

After

Emerson studies his own mind at work following Montaigne. Emerson describes composing a speech as assembling a series of sentiments, facts, and illustrations drawn from different eras in his life. He calls these links a living chain.

Separate window on Montaigne's influence on Emerson:

Montaigne's essays strengthened Emerson's conviction that he would be his own best subject. When Emerson reflected on the way a writer goes about creating, he recognized "a multitude of trials and a thousand rejections, and the using and perusing of what was already written." With this interest in the internal give and take, the subjective piling up of associations, he imitates Montaigne, "the grand old sloven."

Pop-up quote:

"Every link in this living chain he found separate; one, ten years ago; one, last week; some of them he found in his father's house or at school when a boy; some of them by his losses; some of them by his sickness; some by his sins."

AUDIENCE FIT

If visitors want this...	How well does this guideline apply?
TO HAVE FUN	Jumping around can be a game in itself. But people want time to immerse themselves in your personal point of view, so give them an uncensored rant before linking out to supporting evidence, background, or additional opinions.
TO LEARN	Good teachers work hard at figuring out what ideas they must present first, second, and third—postponing the advanced ideas for later. Learning is a gradual climb up the mountain, so separate each stage of the journey, so that students can absorb it fully before moving on.
TO ACT	Pull together only what people need to carry out the immediate action. Move anything else.
TO BE AWARE	One idea at a time, even though each one connects with all the others.
TO GET CLOSE TO PEOPLE	Think of this guideline as advocating patience. Take it easy. Slow down the pace of new ideas, unless you just want to give the effect of a total brain dump.

See: Asher (1980), Baldwin, Peleg-Bruckner and McClintock (1985), Bricklin (1998), Celsi and Olson (1989), Horton (1990), Levine (1997), Morkes & Nielsen (1997b), Rajani & Rosenberg (1999), Slatin (1988), Spyridakis (2000), Stevens (1980).

Move Repeating Categories of Information into Tables, Charts, or Graphs

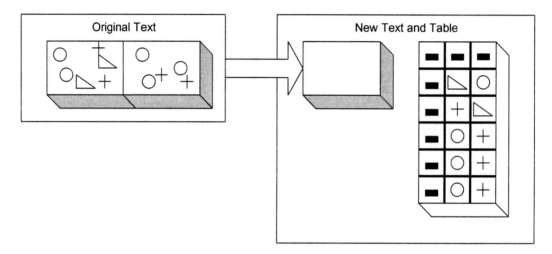

If you want people to compare the data, move it out of the text

The great data visualizer, Edward Tufte remarks, "The conventional sentence is a poor way to show more than two numbers because it prevents comparisons within the data."

By removing the numbers you want people to compare, you simplify your text. But where do you put the numbers?

Help people visualize the data

You make the numbers easier to compare by yanking them out of the running text and lining them up in rows and columns.

If you want to stress a progression, use a chart or graph to make the overall trends easier to spot.

If you have a small data set, or need to offer a lot of particular comparisons, use a brief table.

EXAMPLES

Before

Steel shipments rose dramatically during the first five years of this decade, then declined over the last three years, as estimated by the American Steel Institute. Steel used for automobiles rose from 14,610,000 short tons, in 1990, to 20,123,000 in 1995, and if trends continue, will dip to 14,475,000 for 1998, putting us behind the high point of 1990. Similarly, steel for construction rose from 9,664,000 tons in 1990 to 11,836,000 tons in 1995, then sank below 1990 levels, in estimates for 1998. Other market sectors showed 1998 slightly ahead of 1990, but still substantially behind 1995. For instance, rail manufacturers of freight cars and passenger cars bought 2,525,000 short tons of steel in 1990, then bought 3,805,000 short tons in 1995, and only 3,098,000 in 1998. The only sector showing an advance over 1995 levels are the growing number of steel distributors, who bought 11,125,000 short tons in 1990, then moved up to 14,813,000 short tons in 1995, and soared to 16,025,000 short tons in 1998.

167 words.

After

Steel shipments rose dramatically from 1990 to 1995, then fell in most market categories to levels below 1990 (in autos, and construction), or at least below the swollen figures of 1995 (railroad cars). The only group that continued to increase shipments beyond the highs of 1995: steel distributors. (See table).

50 words

Steel Shipments Comparison Table

Steel Products	Net Shipments by Market Classes, in thousands of short tons		
Market Class	1990	1995	1998
Steel for converting and processing	2,928	3,932	3,443
Independent forgers	841	1,250	1,048
Steel distributors	11,125	14,813	16,025
Construction	9,664	11,836	8,913
Automotive	14,610	20,123	14,475
Rail	2,525	3,805	3,098

AUDIENCE FIT

If visitors want this...	How well does this guideline apply?
TO HAVE FUN	Yes, get those serious numbers out of the text. I may not look at the table, but I will eventually look at a chart, after reading the caption (Nielsen 2000b).
TO LEARN	Very helpful. Tables isolate the data and make it easier to study. Ditto charts and diagrams.
TO ACT	Much faster if I have to pick one item, or compare two or three.
TO BE AWARE	Relevant data backs up your argument best if you separate the numbers out in their own world.
TO GET CLOSE TO PEOPLE	Unless you are trying to relate to a scientist or an engineer, numbers are not going to build intimacy. If you must provide them, move them out of the text, as a courtesy.

See: Brusaw, Alred, & Oliu (1997), Horton (1990), Nielsen (2000b), Tufte (1983).

Beware of Cutting So Far That You Make the Text Ambiguous

BACKGROUND |

Preserve *that* and *which*

If you cut out connective tissue such as *that* and *which*—particularly in a long sentence—you may make it hard for people to understand the connection between the parts of your sentence. For instance, you may make readers think a sentence is headed in one direction, only to startle them later with a reversal or change of meaning at the end. In these circumstances, people wonder: what is the main subject? Is this the verb that goes with that subject? But what is this other verb over here?

Their mind reconsiders the sentence, taking it one way and then the other. Judith Ramey calls this confusion an Escher effect, after the artist whose birds turn out to be holes in a pattern, as our eye flips them from foreground to background. "Escher effects force users to consider the context in which information appears, rather than simply taking in the information offered. They force users to analyze particular phrases and sentences." This dissonance slows the readers down, reducing their confidence in you.

So cut everything else, but leave *that* and *which*.

Also, leave those little articles, *a* and *the*, that sometimes indicate whether you are talking about the same thing as before, or a generic object of that type.

Leave the guts

When cutting your text, preserve the meaning. If you drop a key fact or a supporting idea, you have gone too far. Being concise does not mean saying less—just using fewer words.

Punctuation that won't be missed

At first you might think the way to condense your text would be to replace a verb phrase with a colon, to shorten a phrase like "of New Mexico" into "New Mexico's" or to glue two sentences together with a semicolon. No. Those changes rely too heavily on little punctuation marks the reader can miss.

Because the text is so hard to read on-screen, you cannot count on people spotting those little dots that make up a colon, semicolon, or apostrophe.

- Missing a colon, people barrel into a list or definition without realizing they have shifted from the first part of the sentence to the second.
- Missing a semicolon, people continue the meaning of one sentence right on into the subject and verb of the next sentence—the one that began after the semicolon.
- Missing the apostrophe, people turn a possessive into a plural, and then get confused.

Result: your users get puzzled, and, if they care, they must re-read to straighten out the difference between the two possible interpretations. Oh, so this is one sentence, and that is another!

Attention has shifted from your point to the challenge of parsing your syntax. And for many people, that loss of attention tells them it's time to click on—away from your annoying prose.

To keep people focused on your meaning:

- Instead of the strange condensed abbreviation, spell the term out.
- Instead of "it's" write "it is."

When Calvin Coolidge, asked by his wife what the preacher had preached on, replied "Sin," and, asked what the preacher had said, replied, "He was against it," he was brief enough. But one hardly envies Mrs. Coolidge.

—F. L. Lucas

- Instead of a colon introducing a list or a definition, use a dash (—) or ellipsis (...). We can see that.
- And get rid of a semicolon connecting two main clauses. Create two distinct sentences.

EXAMPLES

Before

The pyrochemical team expected a surge in gaseous emissions, and their associated environmental impacts, when released, would not occur.

After

The pyrochemical team did not expect a surge in gaseous emissions and their associated environmental impacts.

Before

As entered, the program reformats data.

After

The program reformats the data as you enter it.

Before

As core technology activities mature, they will be terminated, as one might expect, following carefully designed implementation schedules, by transfer to the applied projects areas: the radiation area, the pulsar area, or the quantum information area.

After

As core technology activities mature, they will be transferred to the applied projects areas. Each transfer follows a carefully designed implementation schedule. The applied projects areas focus on radiation, pulsars, or quantum information.

Before

No reformat now; reformat when in report.

After

I'm sorry, but you cannot reformat now. To reformat, you must enter report mode.

AUDIENCE FIT

If visitors want this...	How well does this guideline apply?
TO HAVE FUN	Even the fun-lovers hate to be confused. You can entertain without a lot of apostrophes, colons, and semicolons. Of course, you can't give up the exclamation point!
TO LEARN	Simplifying does not ruin your dignity.
TO ACT	Avoiding these ambiguities makes your instructions easier to follow.
TO BE AWARE	Why not? If you cut too far, you just shift attention away from your deeper meaning, turning the reader's mind to grammatical exegesis.
TO GET CLOSE TO PEOPLE	In the heat of a rant, any punctuation goes, because people type so badly when responding to a discussion or e-mail. But don't tighten up too far. Let yourself ramble, and you'll avoid the worst problems we describe here.

See: Bricklin (1998), Galitz (1985), Horton (1990), Ramey (1989), Waite (1982).

POST |

Express your own idea on:
HotText@yahoogroups.com

My Idea:

Post to HotText@yahoogroups.com

Subscribe:
HotText-subscribe@yahoogroups.com

Unsubscribe:
HotText-unsubscribe@yahoogroups.com

Visit:
http://www.WebWritingThatWorks.com

chapter 6 |

Idea #2: Make Text Scannable!

Create a Meaningful Title

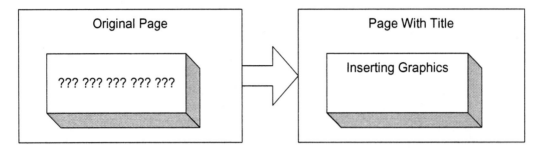

Make a title that can survive out of context

The first time most people see your title, they may be looking at a menu elsewhere on your site, or they may be zipping through a list of search results. Your title has to make sense outside of its own page, jostling with similar titles grouped together on a menu or a random assortment of titles on the hit page.

Ironically, that means you may need to include more text, not less. Your title must include enough words to stand on its own, making sense within its menu or search list

Start with the words that show why this particular page is unique. Don't start every title with the same word (such as your company name) because then every item in the search list will look almost the same, particularly if the user's screen cuts off the titles' tail ends, where the differences show up. (If you must include your organization's name, move it toward the middle or end of the title).

Compare your title with the other items on whatever menus it appears in. Make sure yours stands out, asserting its difference at the same time that its text hints at its solidarity with the other items in that menu. Guests should be able to tell why it belongs in that menu, and how it differs from the other items.

Test the first few words as a rollover

Here's another weird context where the title may appear. If the user minimizes the page and hovers over its tile in the Windows task bar, only a few words will appear in the rollover text. Make those first words key.

> Simple page titles that start with a salient keyword help users pick out pages from the minimized tiles.
> (Nielsen, 2000b)

Use the same title everywhere

When guests click the title in a menu or search list, they expect to see that very same title appear at the top of the page. Don't get creative. Writing different versions of the title confuses people and makes them reach for the Back button, thinking they made a mistake and came to the wrong page.

If possible, use the title verbatim in every location, so guests know what to expect when they click it.

Make a title that gives advance notice of the contents of the page

Web visitors are suspicious of your text. In fact, they aren't sure whether to read your page or not. Before they decide to settle down to read, they want to know whether they have come to the right page. To check, they scan the title, any headings at the top of the page, and the introductory sentences. Only when all those confirm the "rightness" of the page do they begin to read. So create a title that accurately describes the content. Nothing sly. No jokes. No puns.

> The title is crucial because the page title is often the first thing visible to users using slow Internet connections, and because the title becomes the text for any bookmarks the reader makes to your pages.
> (Lynch and Horton, 1997)

Mr. Swinburne is famed or infamed for having used a great many words which express nothing but "color" or "splendor." It has been said that he used the same adjectives to describe a woman and a sunset.

—Ezra Pound

Make the title echo what users already know, with a twist

The more your visitors know in advance about the topic you are discussing, the more successful they will be in understanding what you say. Seems simple. But your title ought to remind them of that prior knowledge, because any familiarity improves comprehension. In fact, if your title tickles the user's long-term memory, echoing some mental framework they have built earlier, that intellectual schema will help them read more successfully.

> Web pages should contain some explicit content that can help readers to orient themselves; access relevant prior knowledge; access relevant content and structural schemata in Long Term Memory, or construct new schemata; and identify content relationships within and across pages. (Spyridakis, 2000)

Just do all that in 64 characters (to make sure people can see your title at the top of an average window), and, hey, for an additional challenge, try to show how your approach gives a new spin to the old ideas.

Recheck your title in its context

After you've written the whole page, make sure that the title still describes the content accurately. You may not know exactly what your point is going to be when you start, so if you wrote the title first, it may be out-of-date, inaccurate, or misleading.

EXAMPLES

Before

Introduction

After

LugeNet—A Technical Overview

Before

Your Geophys Web Site: Tutorial: Learning to Calibrate a GPS

After

Calibrating a GPS—a Tutorial on Your Geophys Web Site

Before

Los Alamos National Laboratory: Division of Nuclear Stewardship: Remarks on Measuring and Understanding the Science of Diffusion of Plutonium into Materials such as Stainless Steel at Room Temperature over Long Time Periods

Los Alamos National Laboratory: Division of Nuclear Stewardship: A Study of the Rate and Intensity of Radiation Spreading from Uranium 235 under Standard Conditions

After

Plutonium Diffusion—Measurement and Science (Los Alamos, Nuclear Stewardship Division)

Uranium Radiation—Rate and Intensity (Los Alamos, Nuclear Stewardship Division)

AUDIENCE FIT

If visitors want this...	How well does this guideline apply?
TO HAVE FUN	Not so relevant. Visitors to webzines and game sites tolerate inconsistency and unpredictability, even look for it. They welcome a title that doesn't make sense until they read the article.
TO LEARN	Very relevant. Predictability and accuracy help reinforce the structure you are building in the user's mind.
TO ACT	Critical. Without a revealing title, users may conclude they have clicked the wrong link, and back out, never to return.
TO BE AWARE	Writing a meaningful title is like doing kitchen yoga. Not very glamorous, but a real challenge for your unruly mind.
TO GET CLOSE TO PEOPLE	What this guideline urges is simple courtesy.

See: Ameritech (1997), Ausubel (1986), Berners-Lee (1995), Bricklin (1998), Dumas (1988), Frisse (1987), Lawless and Kulikowich (1996), Levine (1997), Lynch & Horton (1997), Meyer (1984), Nielsen (1996, 1999f, 2000b), Rosenfeld & Morville (1998), Uncle Netword (1999b), Spyridakis (2000), Voss and others (1986), Waite (1982), Wallace (1985), T. Williams, (1994).

Insert Meaningful Headlines and Subheads

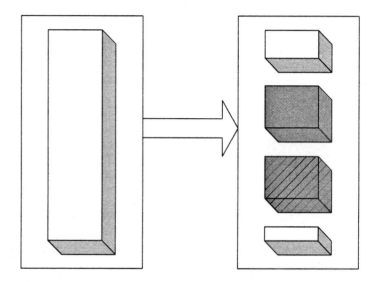

BACKGROUND | **Headings should blaze the trail**

In the snowy woods, making a trail that skiers could follow, we cut chunks out of big trees on either side of the route. Looking back, we could see the bright exposed wood in half a dozen trees. Those signs led the cross-country competitors through a dense forest where snow covered up the narrow trails made by animals heading down to the swamp for a drink and the wider paths tromped by humans during dry weather. Only the blazes on the trees showed where to go. Your headings and subheads should act like blazes.

> As readers scroll, they become lost, and headings help mark the way. (Spyridakis, 2000)

A good heading predicts what content will follow, letting visitors decide whether or not to read the content in that section. Headings and subheads act as visual dividers, marking the chunks along the

way and helping people skim to the next point, like skiers zipping cross country.

Use two or three levels of headings

Break your articles up into two or three levels of headings—a general page heading, plus some subheads, and, occasionally, some sub-subheads. This approach helps people skim for your main ideas, and structure.

In general, insert more headings than you feel comfortable with on paper.

> A single chunk of 100 words can still benefit from two or three subheads. (Kilian, 1999)

Plus, if a blind person is using a screen reader, nested headings make access easier, allowing the software to jump to the next heading, rather than narrating the entire text, one word at a time.

Headings reveal relationships

Write a series of headings and subheads so their text articulates the way their text chunks relate to each other. Guests skim your headings to get a sense of the way you have organized your page, mentally comparing one heading with another, building up a conceptual model of the structure. If you put extra thought into the relationship between the headings, you help people grok the structure without too much thinking.

That must be wonderful! I have no idea what it means.

—Molière

Critical review: Look at your headings and subheads as a group, distinct from the text, to make sure that a casual user can see why you have arranged them in this order, and why you have grouped some and not others.

Announce a new topic

Reread the paragraph you wrote just before the heading. Can you see how the heading announces a related but **new** topic? If not, rewrite.

Reading comprehension studies indicate that you should "Use anything you can to signal the transition from one topic to the

next." (Van Dijk and Kintsch, 1983). Headings and subheads bring that news.

Not too cute

When Jonathan was learning the "user-friendly" style at Apple, he once got his first draft back from an engineer with only two words scrawled across it: "Too cute!"

On the Web, cute headlines don't reveal the content of their chunk, and don't show the chunk's relationship with others on the page.

Watch out for analogies and metaphors, too. Users often misinterpret the comparison, take it literally, or start wondering what the heck you meant, getting distracted in their own imaginings. Also, headings based on a comparison demand that people read the rest of the text to figure out what the heading meant, a chore most folks are unwilling to undertake.

> 79 percent of our test users always scanned any new page they came across; only 16 percent read word by word. (Nielsen and Morkes, 1997)

Therefore, write headings that mean a lot, rather than showing off your cleverness.

EXAMPLES

Before

MRP can handle two kinds of manufacturing—discrete and repetitive. They differ in regularity and costing. When you need to make products in groups or batches, you use discrete manufacturing. You give each batch a job number, a manufactured part number, a quantity (for that particular job), a start date and end date. Because you have a discrete job, you can charge all production costs to that job. With job costing, you can open a job, collect the charges for a job, close out a job, analyze and report costs and variances by job. On the other

After

We Can Handle Two Kinds of Manufacturing

MRP can handle two kinds of manufacturing—discrete and repetitive. They differ in regularity and costing.

Discrete Manufacturing Works in Batches

When you need to make products in groups or batches, you use discrete manufacturing. You give each batch a job number, a manufactured part

hand, you may have to manufacture some products continuously. Instead of discrete groups, you have a nonstop flow of products through the line. You define your schedule by the daily rate of production, and you charge the cost of production to the product, on a lump or unit basis. You never close out a schedule; you just vary the rate of production. So you analyze costs by period; when the period closes, you total all charges, and divide that number by the number of products, to get a unit cost, and usage variances, during that period. You choose one method or another for a product when you set it up in the inventory. From that point on, MRP will plan production based on the method you have chosen—discrete or repetitive.

number, a quantity (for that particular job), a start date and end date.

Costing: Because you have a discrete job, you can charge all production costs to that job. With job costing, you can open a job, collect the charges for a job, close out a job, analyze and report costs and variances by job.

Repetitive Manufacturing Just Goes On and On

You may have to manufacture some products continuously. Instead of discrete groups, you have a nonstop flow of products through the line. You define your schedule by the daily rate of production, and you charge the cost of production to the product, on a lump or unit basis. You never close out a schedule; you just vary the rate of production.

Costing: You analyze costs by period; when the period closes, you total all charges, and divide that number by the number of products, to get a unit cost, and usage variances, during that period.

You Decide

You choose one method or another for a product when you set it up in the inventory. From that point on, MRP will plan production based on the method you have chosen—discrete or repetitive.

AUDIENCE FIT

If visitors want this...	How well does this guideline apply?
TO HAVE FUN	More headlines, more fun, if your users want to jump around. But if you are offering a chance to settle into your world, absorbing your point of view, then long passages without headings work just fine.
TO LEARN	Headings help users search, understand, and recall.
TO ACT	Headings guide the user visually and intellectually to the point of action.
TO BE AWARE	Making your work more skimmable can't hurt. But face it, to put in more headings, you have to get organized... and you may not like thinking structurally.
TO GET CLOSE TO PEOPLE	Helpful and courteous, even in e-mail.

See: Ameritech (1997), Bricklin (1998), Hartley and Trueman (1983), IBM Ease of Use (1999), Kaiser (2000), Lorch & Lorch (1985, 1995), Lynch (2000), Lynch & Horton (1997), Kilian (1999), Mayer, Dyck & Cook (1984), Morkes & Nielsen (1997), Nielsen (1997a, 1997b, 1998b, 1999d, 1999f, 2000b), Spyridakis (2000), Sun (2000), Van Dijk & Kintsch (1983), Williams (2000).

Highlight Key Words, Phrases, and Links

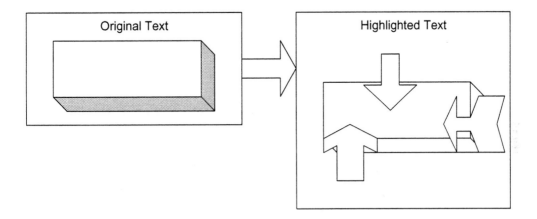

Boldface what is important

Boldfacing a word or phrase makes it **leap ou**t, so someone skimming sees it, but not the rest of the text, which is a gray blur. Just what skimmers want! They can catch the key point—if you have emphasized it—without doing any of that annoying activity called reading.

Emphasize small, **important** words. (Horton, 1990)

On-screen, *italics* get shaky, and <u>underlining</u> destroys the descenders (the parts of letters like g and q hanging down below the line). On paper or on-screen, ALL CAPITAL LETTERS are difficult to read. (Perhaps lawyers put software licenses in all caps on purpose, so nobody will read them). Net: use **boldfacing** as your main way to emphasize.

If you want to use color for emphasis, use only one color, because people will probably not understand your personal method of color coding, and a page with text in three or four colors looks very exciting, but unreadable.

Make links emphatic

In English sentences, we tend to put important new information at the end. So if you care enough to include a link in a sentence, put it at the very end.

> Because the link text is colored and underlined, it stands out from the rest of the paragraph, and attracts the eye. (America Online, 2001)

When you place the link at the end of the sentence—where we normally expect a big bang—the link also acts as a point of emphasis. In this way, you make important words catch the user's attention.

Don't overdo the emphasis

Don't overdo bold words.
— Dan Bricklin, 1998

Too much bolding in a paragraph creates a push-me-pull-you effect, because the eye sees the bold text jumping out, making the rest of the text mere background; but then the eye takes the white space in, and tries to bring the regular text to the front—and on and on. Like a camera that struggles to set automatic focus on a cloud, grinding in and out, uncertain because it cannot spot a straight line or sharp edge to focus on, the human eye remains in doubt when your highlighting risks overwhelming its surrounding text.

One or two phrases per paragraph—that's enough to emphasize by bolding or turning them into links. If you find you are highlighting half a dozen items, reconsider. Perhaps these could be turned into a bulleted list.

EXAMPLES

Before

What is a cookie?

A tiny text file holding information about you, such as your address and preferences. We send it along

After

What is a cookie?

A tiny text file holding information about you, such as your address and preferences. We send it along

with our Web pages, to live on your hard disk, along with the Web pages themselves (click here for more information about storage on your hard disk). When you sign in, we ask your browser to send us your cookie, so we know who you are. That way, we can recognize you, fill out forms for you, and make the site look the way you like. No other site can read your cookie, so your information stays private, if that is a concern.

with our Web pages to live on your hard disk. When you sign in we ask your browser to send us your cookie. That way, we can recognize you, fill out forms for you, and make the site look the way you like. No other site can read your **cookie** so your information stays private.

Before

Databases spawn Web pages in three ways. The old-fashioned way is that the database spits out a report in ASCII, and the user reformats that report in HTML and posts it on the site.

More recently, databases have begun to be able to turn out reports in HTML itself. But the information in such a page is only as good as your last report. It is static.

Better are pages built on the fly. In this third scenario, the Web page sends a request to the database, and the database pours the latest data into the correct template, then the browser displays that brand-new page. In this scenario, you do less work, once you get the delicate communication set up between your Web pages and the database. That's where our new database comes in handy.

Before
Why do I have to fill in a profile?

We are able to provide free e-mail because we are supported by advertisers. (Click here if you would like to see a list of advertisers).
They want to put their ads on e-mail you send—but

After

Databases spawn Web pages in three ways. **The old-fashioned way** is that the database spits out a report in ASCII, and the user reformats that report in HTML, and posts it on the site.

More recently, databases have begun to be able to turn out reports in HTML. But the information in such a page is only as good as your last report. It is static.

Better are pages **built on the fly**. In this third scenario, the Web page sends a request to the database, and the database pours the latest data into the correct template; then the browser displays that brand-new page. In this scenario, you do less work, once you get the delicate communication set up between your Web pages and the database. That's where you'll find a use for our new database.

After
Why do I have to fill in a profile?

We are able to provide free **e-mail** because we are supported by advertisers.
They want to put their ads on e-mail you send—but only if you fit their profile of a potential **customer**.

only if you fit their profile of a potential customer. To know which ads to drop into your e-mail, we need to know more about who you are. That's why we need you to fill in the profile. Please click <u>here</u> to return to the profile, to get started on your free e-mail.

To know which ads to drop into your e-mail, we need to know more about who you are. That's why we urge you to fill in the <u>profile</u>.

AUDIENCE FIT

If visitors want this...	How well does this guideline apply?
TO HAVE FUN	Bold is beautiful, loud, exciting, as long as you don't litter the page with highlights.
TO LEARN	Look at a textbook. Key terms are bolded, so clever students know they will be on the exam. (Dull students skip all the other cues, too).
TO ACT	A link is a dramatic cue to act. Make sure the reader can see it, putting it at the end of the sentence or paragraph.
TO BE AWARE	Signaling the mind what you consider important helps get your point across, even before someone reads. Using these tools means you are sensitive to the user's state.
TO GET CLOSE TO PEOPLE	Yes, like emoticons, boldfacing and links raise your voice and give a little bounce to your prose.

See: America Online (2001), Horton (1990), Lynch (2001), Morkes & Nielsen (1997, 1998), Nielsen (1997a, 1997b), Williams (1990).

Turn Any Series into a Bulleted or Numbered List

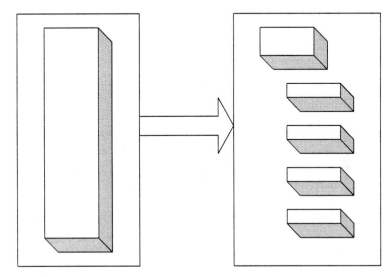

BACKGROUND

Let people skim

Breaking out a list allows people to skim through it quickly, skipping past the items they aren't interested in and spotting the one item worth reading.

By setting off these items in their own short paragraphs, preceded by some kind of dingbat (arrows, checkmarks, circles, pointing hands, or numbers), you show the user that:

- These items are all similar in some way.
- Each item is distinct.

The visual layout lets people "get" what the items have in common and skim for a specific item without having to read the irrelevant ones. That's true, to a degree, on paper. But when you move material onto the screen, you should turn any series into a bulleted or numbered list, to save users' time.

Boldface the lead-ins or headings in the list

If you have a sentence or two about every product in a series, make the list out of the product names in bold and then insert the descriptions in regular text, indented, so they are clearly subordinate (and can be skipped past).

> One format that works well on-screen is lists of **short, bold headings**, a few words long, followed by a sentence or two of summary in a lighter, perhaps smaller, font. (Bricklin, 1998)

The bolded items can be on their own lines, as individual paragraphs or as boldface text leading into the rest of the explanations.

Good fit: a list of shortcuts to popular areas on your site, best-selling items, or important links.

If you have a long list...

To help people scan quickly past large chunks they don't care about, turn a long list into several groups, each with its own subhead.

How many items are too many? No one knows. But, depending on your situation, you might set a limit of nine items per group, in no more than two levels—primary and secondary (Sun, 2000). That way, people can usually see most of the group within one screen, and can compare all the items without having to scroll around.

Usually, you are creating a list because you want to allow people to compare the items in some way. So make sure that people can see at least three or four items at the same time.

> Strike a balance between the number of items users can view simultaneously and the amount of information you provide for each item. (IBM, 1999)

No need to be absolute about these numbers, though; for example, if guests know in advance they are going to get a list of a hundred items in alphabetical order, they can handle the volume, because they understand the organizing principle.

Put the longest item last

If you can, put the longest item at the end of the list, so it does not interfere with reading the others.

EXAMPLES

Before

A bridge connects two local area networks (LANs). The bridge physically joins separate LAN segments, such as two Ethernet cables. We offer four main types of bridges: transparent, encapsulating, translating, and source routing.

After

A bridge connects two local area networks (LANs). The bridge physically joins separate LAN segments, such as two Ethernet cables. We offer four main types of bridges:

- Transparent
- Encapsulating
- Translating
- Source routing

Before

New in this release are additional items of information about each song, such as encoding options, handheld devices that play these formats, genre, total length of the track, name of the original album the track belonged to, and a summary of any preferences you set in your download profile.

After

New in this release are additional items of information about each song:

- Encoding options
- Handheld devices that play these formats
- Genre
- Total length of the track
- Name of the original album the track belonged to
- A summary of any preferences you set in your download profile

AUDIENCE FIT

If visitors want this...	How well does this guideline apply?
TO HAVE FUN	Lists work well for choices, but if someone just wants to roll through your torrential prose, soaking it up all in one breath, forget the bullets.
TO LEARN	Very helpful as an organizing device, showing that the items all belong together, as a sequence or collection.
TO ACT	Numbered steps increase the effectiveness of any instructions. (Only use bullets for actions that are optional.)
TO BE AWARE	Rarely used in this field, so some users may find lists uncongenial, with overtones of business and technical writing. But, hey, they can get over it.
TO GET CLOSE TO PEOPLE	Probably a bit too formal for messages on your discussion list, but very helpful in e-mails, because the lists overcome the lack of visual structure afforded by ASCII text.

See: Bricklin (1998), Brusaw, et al (1997), Bush and Campbell (1995), Hackos & Stevens (1996), IBM (1999), Kaiser (2000), Kilian (1999), Lohse & Spiller (1998), Morkes & Nielsen (1997, 1998), Nielsen (1997a, 1997b, 1999d), Price & Korman (1993), Sun (2000), Tarutz (1992).

POST

Express your own idea on:

HotText@yahoogroups.com

Subscribe:

HotText-subscribe@yahoogroups.com

Unsubscribe:

HotText-unsubscribe@yahoogroups.com

Visit:

http://www.WebWritingThatWorks.com

My Idea:

Post to HotText@yahoogroups.com

chapter 7

Idea #3: Cook Up Hot Links

Make Clear What the User Will Get from a Link

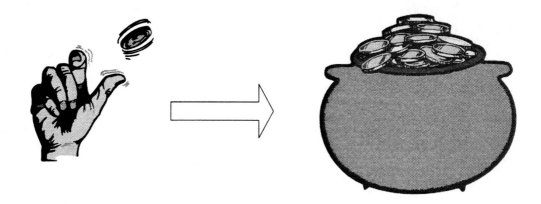

BACKGROUND

Give me enough information so I can skip the link

The ideal link is one that users can get **real information** from—enough so that some folks realize they don't need any more.

> Write links that don't have to be followed.
> (Bricklin, 1998)

Even the inventor of the Web, Tim Berners-Lee, urges charitably informative links. "When you make a reference, qualify it with a clue to allow some people to skip it."

Pop up a description

Javascript rollovers let you save space by popping up a sentence describing the target of the link. Users are less likely to waste their time going down a false trail, and someone following a good link can more easily understand the point of the destination page upon arrival.

Of course, the user has to guess that the description exists, and move the mouse over the link to get this extra info.

Descriptiveness aids prediction.
Differentness aids navigation.
—Jared Spool, 1997

Short link, big explanation

Instead of making a whole long phrase into a link, write a brief link and supplement it with an explanation. Put the explanation in its own paragraph or column in a table, so guests can skip it easily. (This approach works well in lists).

> This strategy often allows for more attractive visual design than is possible with lengthy links. Furthermore, it gives users the option of skipping the supplementary text if the link gives them enough information about the destination. (Farkas and Farkas, 2000)

Match the target

To avoid confusing the user, make the link text match the title of the target page. It's not always possible to do this exactly, but you can write link text that uses keywords from the title or similar concepts.

> Avoiding the problems associated with inconsistencies between link labels and where they lead is difficult. (Rosenfeld and Morville, 1998)

Difficult, yes, but worth trying

The ideal is, of course, that the very same title object appears as the link, so that if you change the title, the link changes too. But this utopia makes for ungainly link text, unless you craft your titles for both locations.

Include a relevance rating

As in the best search results, give users some idea how relevant the target pages may be, so users can decide how much they really want to download a page that may be off topic. Examples:

***** How to Choose the Right Paper
** Photographic Papers: Glossy vs Matte
** Notecard Papers
** Large size Papers
** Tyvek and Cloth for Printing
* Inks Available by Printer

EXAMPLES

Before

Aussie Birds and Ixnest may offer other information.

After

If you are planning a visit to bird sanctuaries in Australia, you may want to learn to recognize typical species through photographs of the birds in flight and at rest, as shown in Aussie Birds. The ornithologists at Ixnest also offer nesting information on all the birds of Australia.

Before

Click here for results.

After

62% of users found the new interface "an improvement," but significantly, 20% found it "confusing to learn," according to our Beta KM Product Usability Test Results.

Before

Non-imaging detectors have also been developed.

After

To prevent proliferation of **nuclear weapons**, we need to use detectors that do not rely on imagery. We track the movement of clandestine nuclear weapons by identifying the weapon's signal in the middle of a noisy background. These non-imaging detectors depend on sophisticated tracking algorithms.

Before

DeMaupassant's writing reflected many of Monet's experiences.

After

DeMaupassant published *Bel Ami* in 1885, the same year that he visited with Monet near Etretat. At the time, Monet was painting the tall, jagged rocks of that coastline facing the Bay of Biscay, in the Manneporte series. DeMaupassant's novel describes a journalist on the make in Paris, clambering out of the poverty that Monet had known so well for years. In fact, Monet's experiences during the previous 25 years were reflected, obliquely, in several of DeMaupassant's scenes.

Before

Next

Previous

Up

See Also

After

Next: The Unfolding of XML

Previous: How HTML grew out of SGML

Up: Why We Use Tags

See Also:

How Hot Lead Turned into Cold Type

The First Typesetting Tags

Before

Next

Previous

Up

See Also

After

Next: The Role of Gamma-Ray Detectors in Counter-Proliferation and Treaty Verification

Previous: How Gamma Ray Detectors Grew Out of Astrophysics

Up: Research into Gamma Ray Detectors

See Also:

Counting Warheads Remotely with Gamma-Ray Imaging Spectrometer (GRIS)

Seeing Behind Shielding with GRIS

AUDIENCE FIT

If visitors want this...	How well does this guideline apply?
TO HAVE FUN	The more text, the merrier. Long explanations of links form part of the entertainment on this page, and let users choose whether or not to go on.
TO LEARN	You can make clear what the relationship is between the target page and the one I am reading now. Educational.
TO ACT	Very helpful to let me know ahead of time where I am going and why. For instance, if you want me to buy something, alert me that I am about to go to your super secure server.
TO BE AWARE	Sensitive Web writers let users know where they are going—ahead of time.
TO GET CLOSE TO PEOPLE	Yes, in your enthusiasm for a particular link, take the time to describe it before just dropping it in.

See: America Online (2001), Apple (1997), Berners-Lee (1998), Bieber et al (1997), Borges et al (1998), Bricklin (1998), Farkas and Farkas (2000), IBM (1999), Levine (1997), Microsoft (2000), Nielsen (1995, 1998, 1999e, 1999f), Nielsen & Morkes (1997), Rosenfeld & Morville (1998), Spool (1997), Spyridakis (2000), Sun (1998), Tchong (1998b), W3C (1999).

Within a Sentence,
Make the Link the Emphatic Element

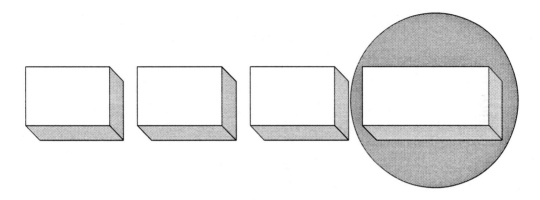

BACKGROUND |

Put the most important item last

If you are embedding links within your text, rather than gathering them into lists or menus, then you face the challenge of writing the actual sentences that contain the links. In an English sentence, we habitually stress the last phrase. So put your link last where it plays a double role as a link and a clincher.

There are three ways to revise a first draft to make the key idea end the sentence:

- Trim the end, getting rid of unnecessary rambling.
- Move less important information to the left.
- Move the important stuff to the right.

Of course, on the Web, the important information is the link.

The hyperlinks stand out by virtue of being colored, so they should be written to do double duty as highlighted keywords. Highlight only key information-carrying words. (Sun, 2000)

Don't disrupt your sentence

Because any link draws attention to itself, a link placed in the middle of the sentence tends to take over, rendering the continuation of the sentence ineffectual.

Putting important words in positions in a sentence that normally get relatively heavy stress can help provide emphasis; so sometimes can repetition and redundancy.

> If authors want to place links inside sentences, they should place them at the end of the sentence where they will least disrupt the syntax of the sentence. Notice how the embedded link...immediately grabs the reader's attention. (Spyridakis, 2000)

—Kenneth Wilson, *The Columbia Guide to Standard American English*

Move links to the beginning or end of the paragraph

"Too many links within a block of text can disrupt continuity and understanding," notes IBM in its Web guidelines. Solution: move links to the beginning or end of the paragraph.

If you put the link at the start of the paragraph, consider the rest of the paragraph a gloss on the target, explaining what it offers. Otherwise, put the sentence with the link at the tail end of the paragraph and make the link its last phrase.

EXAMPLES

Before

As a member of this discussion list, you have legal rights, and so do other members, so you may not defame, abuse, harass, stalk, threaten, or otherwise violate their rights.

After

As a member of this discussion list, you may not defame, abuse, harass, stalk, threaten or otherwise violate another person's legal rights.

Before

You can personalize your welcome page by clicking the Personalize button at the top right, and then entering your ZIP code and favorite stocks, to get headlines for your area, and the latest prices. This personalized information appears in the center of the page.

After

You can personalize the center of your welcome page by adding headlines for your area and the latest prices on your stocks. You just need to tell us your ZIP code and favorite stocks. Ready to personalize?

Before

The Knowledge Schema is a list of particular topics relating to the effort to re-engineer our business processes. The <u>schema</u>, then, is a set of categories of information—broad <u>topics</u> of interest to change managers. For instance, the topics of benchmarking, change management, leadership, and teamwork appear within the Knowledge Schema as individual categories in the List of Topics.

After

When you want to look up information about a particular topic relating to the effort to re-engineer our business processes, you should turn to our <u>Knowledge Schema</u>. The schema is a set of categories of information—broad topics of interest to change managers. For instance, the topics of benchmarking, change management, leadership, and teamwork appear within the Knowledge Schema as individual categories in the <u>List of Topics</u>.

AUDIENCE FIT

If visitors want this...	How well does this guideline apply?
TO HAVE FUN	Hey, breaking up a sentence with a link might be a kick. Then again, why throw people out of your sentence before you're through?
TO LEARN	Good practice, just because this way your links are less distracting. Also, students don't leave the room until they know what the link will contain.
TO ACT	Users have itchy click fingers. Make sure they know what the link will do before you give them something to click.
TO BE AWARE	This approach is calmer than throwing links into the middle of the sentence, so take a deep breath and rewrite.
TO GET CLOSE TO PEOPLE	This way of handling links seems natural, so in an e-mail or discussion message you might just end your sentence, press Return, and put the link in its own line. Then it's easier to copy and paste into the address line of the browser or to click as a separate hot spot.

See: Bricklin (1998), IBM (1999), Levine (1997), Nielsen (1997b), Spyridakis (2000), Sun (2000), Williams (1990).

Shift Focus from the Links or the Linked-to Documents to the Subject

BACKGROUND

Electronic text is the first text in which the elements of meaning, of structure, and of visual display are fundamentally unstable.

—Jay David Bolter, *Writing Space*

Don't point out your links

Sure, when you first create a link, you want to tell everyone, "Hey, this is a link." But now that you have created hundreds or thousands of links, you don't have to keep reminding the user that you have, in fact, provided links. Assume the links. Shift your attention to the subject and let the links grow out of your meaning.

The frustrated creator of the Web, Tim Berners-Lee, says, "Use links, don't talk about them."

He particularly hates expressions like "Click here."

He pleads with Web writers, "Let me urge you, when you construct your HTML page, to make sure that the-thing-you-click is actually some kind of title."

Ignore the apparatus

You don't have to tell people to "surf on over," or "point your browser." You don't have to emphasize that you are offering a link.

In fact, you don't have to alert visitors that a link will take them to another page or site. They get it.

Forget all the hard work you put in creating the link or the list of links. Concentrate instead on saying something meaningful about the subject, and you'll soon see which word or phrase to make hot. Just let links appear.

> Write about your subject as if there were no links in the text. (Levine, 1997)

EXAMPLES

Before

Click <u>here</u> to go to the Ecommerce Statistics Page, a listing of the most recent survey information in that area.

After

George Kennedy collects the most recent survey information in the field and publishes that on the <u>Ecommerce Statistics Page</u>.

Before

Click <u>here</u> for the tutorial.

After

Step-by-step instructions for using the Parameter Hunter appear in the <u>tutorial</u> (which takes half an hour) and the <u>online manual</u>.

Before

We have some wonderful <u>links</u> we have discovered for national parks.

After

The National Park Service describes every park in its system, giving information on campsites, utilities, stores, trails, and weather in its enormous <u>Park List</u>.

Before

After a lot of surfing, I have made up a list of <u>cool Web sites</u> dealing with the founders of pattern research.

After

The founders of the pattern movement were tentative, open, and quite flexible in their thinking when creating their original articles and books:

- <u>Design Patterns</u>

- <u>Thinking in Patterns</u>

- <u>Patterns as Breakthrough</u>

- "A Joint Report on Patterns"

Before

One site offers a lot
of information on
nonproliferation research.

After

To verify arms control treaties and help detect the
clandestine production of weapons of mass
destruction such as nuclear, chemical, or biologi-
cal weapons, we must turn to
laboratory research.

AUDIENCE FIT

If visitors want this...	How well does this guideline apply?
TO HAVE FUN	Unless you are indulging in self-referential post-modern whining (always amusing), follow this guideline and let the links take care of themselves.
TO LEARN	Students understand how links work. No need to distract them from your ideas by waving your hands around, pointing out the mechanism behind the screen.
TO ACT	Keep your focus on the action the user wants to perform. Make the whole mess of Internet protocols invisible.
TO BE AWARE	Unless you are dealing with absolute newbies, who find the Internet and computer an exciting new world, follow the guideline.
TO GET CLOSE TO PEOPLE	It's acceptable to boast about discovering a site you want your community to check out, and you may even admire your own links, without upsetting other people too badly. On the other hand, you could be polite and say something intelligent about the topic.

See: Arthur (2000), Berners-Lee (1995, 1998), Levine (1997), Nielsen (1997b).

Provide Depth and Breadth through Plentiful Links to Related Information within Your Site

BACKGROUND

In everything, no matter what it may be, uniformity is undesirable. Leaving something incomplete makes it interesting, and gives one the feeling that there is room for growth.

—Yoshida Kenko

Be generous—offer more information

Gather the key ideas on the first page about a topic. Then, to satisfy a range of audience needs, provide links to background, context, and amplification. Take visitors to other pages with information such as:

- **Examples** that tell a story, showing what someone wanted, what they did, and what the results were.
- **Scenarios** in which users can imagine applying your ideas, products, or services to their own situation.
- **Tutorials** in which the user does some simple work you provide, just to learn the concepts or procedures.
- **Case studies** showing how your product or service worked for a particular customer.

- **White papers** summarizing an industry with examples and research.
- **Full reports** on the ideas you have just summarized (complete proposal, full manual, developer notes).
- **Background information** (history, archives, specs, company personnel).
- **Low-decibel information** "of interest to a minority of readers (that) can be made available through a link without penalizing those readers who don't want it." (Nielsen, 1999f)
- **See-also information** (lists of related topics) because "Users rarely land directly at the desired page, especially when using a search engine." (Nielsen, 2000a)
- **Shortcuts** "to important nodes located deeper in the hierarchy." (Farkas and Farkas, 2000)
- **Spur-of-the-moment**, one-of-a-kind links to related topics.

All but the last item should be used systematically, that is, over and over, on every similar topic.

Essentially, you summarize your conclusions on your first page and then use links to take people to the details. In some ways writing like this is easier because you don't have to wonder how much to cover, worrying that you may be cheating the reader with too little information or overwhelming the unwilling reader with too much.

> The combination of **concise summaries** and **great detail** is one of the ways that a Web document can be much better than a paper document. (Bricklin, 1998)

Plan, don't improvise

Whatever links you create to supplement a particular type of information, offer those links on every page of that type.

Once people have used that set of links to details about one product, they expect to find the same kind of links on every product page. If you play this hit or miss, you disappoint users. Planning ahead lets you be consistent: Think, "every time I write this kind of article, I plan to include this set of links."

Be wide and shallow

Reporting on many years of research, user interface guru Ben Shneiderman says, "The evidence is strong that breadth should be preferred over depth" (1998).

Does your site have enough information for each **niche audience?**

> Your site should have enough breadth to be relevant to more than a niche audience. (Microsoft, 2000)

Add plenty of major topics at the top levels, so people can make more accurate choices right away, rather than going down a series of stairs, only to discover that the target is not what they sought.

Then offer extra details if users want them. Your page ought to offer plenty of information, and if that's enough, fine. But if users want more info, the links give that to them.

Most people have difficulty recalling more than three or four levels when they drill down, down, down. Result: they may feel lost if you take them down ten or twelve levels.

If you are going to offer half a dozen links from each major topic, display all those links at once, rather than forcing people to go down a level to another page to see one other link, following that down to see another link, and so on. That's building unnecessary basements.

Don't break up a coherent story

When Apple was first creating hypertext, using the earliest versions of HyperCard and Guide, Jonathan went overboard on chopping manuals into tiny pieces. His model was the index card that Bill Atkinson was using as the metaphor for HyperCard, a hypertext program that was still being developed back then. Plus, Jonathan hated scrolling, so he wanted a bunch of very short segments. He figured all these different pages would live on a hard disk, so download times would not be a problem.

Now that we are serving up pages on the Web, where some people face very slow download times, we've learned to live with scrolling pages that contain a lot of text—five, ten, twenty index cards worth.

Electronic links connect lexias "external" to a work—say, commentary on it by another author or parallel or contrast texts—as well as within it and thereby create text that is experienced as nonlinear, or, more properly, as multilinear or multisequential.

—George P. Landow,
Hypertext, The Convergence
of Contemporary Critical
Theory and Technology

Don't break up a coherent page just because you think you ought to have more links. Having to jump from page to page just to read another paragraph gets tedious pretty fast.

> Hypertext should not be used to segment a long linear story into multiple pages. (Nielsen, 1999f)

Remember: you're creating links to additional material, not carving up a single article just to have a bunch of links.

Be cautious with links within a page

Many users think that every link takes them to another page. When they click a link that takes them down the same page, as in a FAQ, they report being puzzled, because when they scroll up or down, they encounter text they already read "on that other page."

If you have a sophisticated audience, internal links won't be a problem. But if you have relative newbies, you can be sure they will be confused by links down to anchors within the page, even if you include all the usual apparatus, such as arrows pointing up, and buttons marked **Go to Top**. "Top of what?" they ask.

EXAMPLES

Before
How to use our electronic library

We have organized our electronic library catalog around authors, titles, and subjects—just like the card catalogs of old. To find one or more books, here's what you do. You choose a category, such as author, words in a title, exact title, or subject, by clicking one of the items offered in the Category List. In a moment you see a new screen, asking for a little additional detail about the kind of books you are after.

After
How to use our electronic library

We have organized our electronic library catalog around authors, titles, and subjects—just like the card catalogs of old. To find one or more books, here's what you do.

1. You choose a category, such as author, words in a title, exact title, or subject, by clicking one of the items offered in the Category List.

In a moment you see a new screen, asking

In the Detail screen, you type in the text that you hope will lead you to the books you are after.

You click the giant red Search button. If you are lucky, you get a list of authors, titles, or subjects that might be relevant like that in our Sample Results. If you aren't so lucky, you're told that the catalog doesn't have anything with that text as part of an author's name, title, or subject. So you have to try again.

for a little additional detail about the kind of books you are after.

2. In the Detail screen, you type in the text that you hope will lead you to the books you are after.

3. You click the giant red Search button.

If you are lucky, you get a list of authors, titles, or subjects that might be relevant like that in our Sample Results.

If you aren't so lucky, you're told that the catalog doesn't have anything with that text as part of an author's name, title, or subject. So you have to try again.

Before

Here are some examples of the way you might use our genealogy information.

If you are interested in locating people who have been researching your family, or some branch of your family, you can find e-mail addresses and Web sites in our database of surnames.

Just want to check up on a specific ancestor or line, when you know where they lived? You can use our services to check out Church and Parish Records, Town and City Records, County Records, State and Province Records.

For dates, addresses, and incomes, we have a full set of the Census Archives.

After

Wondering where to start?

Here are some examples of the way you might use our genealogy information.

If you are interested in locating **people who have been researching your family**, or some branch of your family, you can find e-mail addresses and Web sites in our database of Surnames.

Just want to check up on a **specific ancestor or line**, when you know where they lived? Check out Church and Parish Records, Town and City Records, County Records, State and Province Records.

To get dates, addresses, and incomes, visit the Census Archives.

Before
Case Study: Using our Photo Exchange

Geraldine took some wonderful pictures on her vacation, and brought them to her local photo shop for development. They told her that if she wanted, she could have her pictures posted on the World Wide Web in her own Photo Exchange page, and have prints made on paper.

- That way, she could send the images to her relatives along with her e-mail.
- Plus she could just tell people her personal address for a Web site within the Photo Exchange, and they could go there to view the entire set of pictures.
- And she could describe the pictures for visitors by adding captions.
- If she only wanted certain people to visit, she could also protect her site by creating a password.

Geraldine agreed. In one week, she had her prints in hand, and the pictures were up on the Web. She e-mailed everyone with one picture, and the address of her site on Photo Exchange. Her family got to see the whole tour, including tourist sites, their car, and their motels.

Her Mom said it was like a slide show at her own pace.

After
Case Study: Using our Photo Exchange

Geraldine took some wonderful pictures on her vacation, and brought them to her local photo shop for development. They told her that if she wanted, she could have her pictures posted on the World Wide Web in her own Photo Exchange page, and have prints made on paper.

- That way she could send the images to her relatives along with her e-mail.
- Plus she could just tell people her personal address for a Web site within the Photo Exchange; they could go there to view the entire set of pictures.
- And she could describe the pictures for visitors by adding captions.
- If she only wanted certain people to visit, she could also protect her site by creating a password.

Geraldine agreed. In one week, she had her prints in hand, and the pictures were up on the Web. She e-mailed everyone with one picture, and the address of her site on Photo Exchange. Her family got to see the whole tour, including tourist sites, their car, and their motels.

Her Mom said it was like a slide show at her own pace.

AUDIENCE FIT

If visitors want this...	How well does this guideline apply?
TO HAVE FUN	Links to discussions, controversy, pro and con, all add value to your opinion piece. Add audio, animation, and video clips, too.
TO LEARN	Keep your hierarchy clear, letting students focus on your main message before offering them the supplementary materials. In general, move your links to the end of sections, so people get the full details before leaving.
TO ACT	Embedding links allows people to backtrack, jump ahead, and carry out the task they just couldn't figure out before.
TO BE AWARE	You want people to immerse themselves in your ideas, no? But unfold gradually, with secondary links.
TO GET CLOSE TO PEOPLE	Politeness suggests that you allow people to decide whether or not to look at the secondary information. Don't pour it on them all at once.

See: Ameritech (1997), Apple (1997), Berners-Lee (1998), Bricklin (1998), Farkas and Farkas (2000), Gagne & Briggs (1979), Horton (1990), Levine (1997), Microsoft (2000), Nielsen & Morkes (1997), Nielsen (1999f, 2000a), Reigeluth et al (1980), Robinson & Knirk (1984), Sheetz et al (1988), Shneiderman (1998), Sun (2000).

Establish Credibility by Offering Outbound Links

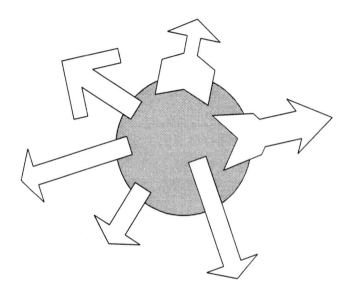

BACKGROUND

People may be suspicious of you

Many visitors do not know you, your organization, or your qualifications. They wonder if you are hiding something from them, if you are reliable, or if you are part of a larger community they trust. Oddly, you can increase your credibility by linking to other sites on the Web.

"Not being afraid to link to other sites is a sign of confidence," Nielsen says (1999a), because the other sites are seen as giving you credibility. Plus, as one test subject told Nielsen and Morkes, "Links are good information. They help you judge whether what the author is saying is true."

Presenting different points of view through links shows that you are not afraid to be compared with the other sites, and that you believe they will back you up. Refusing to link out of your own site makes you look selfish, withdrawn, and a bit paranoid.

Hyperlinks subvert hierarchy.
—Rick Levine, Christopher Locke,
Doc Searles, and
David Weinberger,
The Cluetrain Manifesto

We are concerned with whether people can author and construct text that allows rich multiple paths that are sufficiently well ordered and comprehensible. We are concerned about whether the protocol of reading from a text that tempts users to go off in many diverse directions at multiple points will be a well functioning cognitive tool.

—Thomas Landauer, Dennis Egan, Joel Remde, Michael Lesk, Carol Lochbaum, and Daniel Ketchum, Enhancing the Usability of Text Through Computer Delivery and Formative Evaluation: the SuperBook Project, in McKnight, Dillon and Richardson (editors), *Hypertext: A Psychological Perspective*

The Web spirit is **openness**. By linking to the rest of the Web, you show that you have some trust in those other sites, and suggest that your own site is trustworthy.

Link to reviews

Don't retype someone's review of your product and post it on your own site. Link to the actual review. That way users know that you haven't doctored the text like a movie ad.

> A few hyperlinks to other sites with supporting information increase the credibility of your pages. If at all possible, link quotes from magazine reviews and other articles to the source. (Sun, 2000)

Just as footnotes allow a scholar to make sure you aren't distorting the original author's meaning or research, these outbound links show your confidence that the target pages will make you look good.

Outbound links add value

Links are information. Sometimes all a user wants is a list of links. When you provide real links to substantial information, you are being generous, and people appreciate that.

Of course, the more links, the more maintenance you face. Link rot can set in, and you may begin to get e-mail from frustrated users. So run a link checker regularly.

EXAMPLES

Before

Our JuicyJuicer has won critical acclaim around the world. One article comparing juicers awarded us the palm for "the simplest setup by far." Another called the JuicyJuicer "the fastest and most powerful" juicer around.

After

Critics love the JuicyJuicer:

- "The simplest setup by far"
 —<u>Consumer Reports</u>
- "The fastest, and most powerful"
 —<u>Veggie Times</u>

Before

For many of us, the current rapid-application tools automate the creation of the user interface, plus some code connecting that to an underlying relational database through SQL operations. But as soon as we want to conduct business, not just access data, we run into a problem. How do we create the business logic and rules that determine exactly how we process the data, and handle transactions? Yes, upper-CASE tools help us create exact requirements, define entities and relationships, and even figure out the business rules. But then what? None of these tools, until recently, have been able to turn those rules into code.

What we need is an environment in which we can build a business model in the abstract, and have it turned into business rules that then control the actual definition of objects and their methods. A number of vendors of object-oriented development tools now claim to offer this capability. In this white paper, we will analyze three leaders in the field— Ellipse, from Price Information Systems, Force from Force Software, and Toby Vision from Toby. In our appendix we describe all the other competitors in this emerging market.

Summary of Before's outbound links:

- Price Information Systems home page
- Force Software home page
- Toby home page
- List of competitors, with links to home pages

After

For many of us, the current rapid-application tools automate the creation of the user interface, plus some code connecting that to an underlying relational database through SQL operations. But as soon as we want to conduct business, not just access data, we run into a problem. How do we create the business logic and rules that determine exactly how we process the data, and handle transactions? Recent articles in Datamation, Re-engineering, and DBMS all point to the difficulties that programmers experience when they face this question.

Yes, upper-CASE tools help us create exact requirements, define entities and relationships, and even figure out the business rules. But then what? As pointed out in reviews in KM, DBMS, and Re-Engineering, none of these tools, until recently, have been able to turn those rules into code.

What we need is an environment in which we can build a business model in the abstract, and have it turned into business rules that then control the actual definition of objects and their methods. A number of vendors of object-oriented development tools now claim to offer this capability. In this white paper, we will analyze three leaders in the field— Ellipse, from Price Information Systems, Force from Force Software, and Toby Vision from Toby. In an appendix we describe all the other competitors in this emerging market.

Summary of After's outbound links:

- List of all current rapid-application tools. Each tool is linked to its vendor's home page (In appendix).

- *Datamation* article by David Baum
- *Re-Engineering* article by George Popadopolos
- *DBMS* article by Rich Coulombre
- Review in *KM*
- Survey review in *DBMS*
- Omnibus review in *Re-Engineering*
- List of all current upper-CASE tools linked to vendors' home page
- Price Information Systems home page
- Force Software home page
- Toby home page

AUDIENCE FIT

If visitors want this...	How well does this guideline apply?
TO HAVE FUN	If you can stand letting go of your visitors, you'll earn a return visit. Outbound links amuse the game players, tease the serious, and build your street credibility.
TO LEARN	If the other sites have significant information, go for it.
TO ACT	Not always relevant, in a call to action, or a FAQ about your own site. But if you need some credibility, include links to places that vouch for your privacy policy, honesty, or customer ratings.
TO BE AWARE	Yes, be an honest broker, and link to related sites even if you don't agree with everything they say.
TO GET CLOSE TO PEOPLE	Part of sharing is posting links. Just make sure that you copy the URL completely, so it works.

See: America Online (2001), Berners-Lee (1995), Levine et al (1999), Lynch (2000), NCSA (1996), Nielsen (1999a), Nielsen & Morkes (1997), Spyridakis (2000), Sun (2000).

Show Where We Are

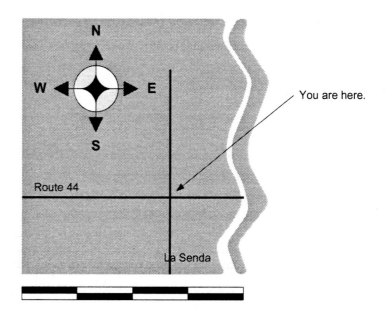

You are here.

BACKGROUND

A hypertextual essay in the computer is always a dialogue between the writer and his or her readers, and the reader has to share the responsibility for the outcome.

—**Jay David Bolter,** *Writing Space*

You are here

When people land on your page, they may be arriving after navigating a series of menus, leaping from a list of search results, or simply jumping helter-skelter from some other location on the site. They do not know where they are in your structure, and, generally, they do not make any conscious effort to figure that out. So you have to work hard to give them context.

If your interface allows, signal the location in the main menu.

> Show the users where they are. One way to do this is to highlight the current location in a table of contents that shows the main levels of your site. (Apple, 1997)

> Or display breadcrumbs—a list of the pages the users would see

if they actually came down from the home page all the way to this one, using menus.

Of course, that may not be the exact path a user took coming here, but the breadcrumbs show the location of the page within the site's hierarchy. Showing how the page is nested within the site helps users interpret the page better. "You don't just know that you are looking at product 354, you also know that it belongs to the widget product family." (Nielsen, 2000a)

Plus, each item in the trail is hot, so a user can zip back up the structure using these links.

No Up buttons

Every time we have tested an Up button, taking people up one level, the users cry out in agony. They become surly and suspicious. Only programmers get the idea.

Ordinary people, having never seen the next level up, wonder why this strange Up arrow takes them there. Many users develop a superstitious dread of the Up button, and refuse to go near it.

Branding gives context

Identify your site on **every page**—that's a minimum.

Make sure that visitors can see, from a quick glance, that they are still on the same site.

Lost in hyperspace

Knowing where I am within the overall structure of a site, or part of a site, helps me understand what I am looking at. I don't feel so lost, and I can build a conceptual model of your site.

But most sites prevent users from understanding their location within the structure because:

- The site has been **poorly organized**, growing like tumble-weeds over time.
- The **page design hides** any evidence of the larger structure, and the position of this page within that structure.
- The **browser** doesn't have any mechanism for displaying structure.
- Users get so **frustrated** that they refuse to take the time to study the site's structure.

There are three rules for writing the novel. Unfortunately, no one knows what they are.

—W. Somerset Maugham

Consider a clickable map

Consider having a picture, to supplement the text version of your site map. Make a diagram showing how you have organized your site. Just don't make this too complicated. When artists get carried away trying to represent every department as a different building in a perspective drawing of a town, many users find the drawing hard to interpret because they wonder how much meaning to read into the color of the walls or the arrangement along the streets (is this a sequence I have to follow?). Go for simple blocks arranged in a single hierarchy.

Image maps with organizing layouts can help the reader understand and use the document's structure. (Bricklin, 1998)

> *...we must abandon conceptual systems founded upon ideas of center, margin, hierarchy, and linearity, and replace them with ones of multilinearity, nodes, links, and networks.*
>
> **—George P. Landow, Hypertext,**
> **The Convergence of Contemporary**
> **Critical Theory and Technology**

EXAMPLES

Before

About our Interface

Our interface is not an afterthought. We work just as hard developing an interface as we do developing the combinatorial math that underlies the feature set. We see the interface as a kind of artistic environment. The user is visiting us for the first time, and we want to show that we encourage exploration. Everything is one click away. Click and go. For us, if you can't play when you're making art, you should go into accounting.

After

| HOME | SITEMAP | BUY | INDEX | SEARCH |

| GRAPHIC APPS | CLIPART | GAMES | EDUTAINMENT |

GRAPHIC APPS
Schmoozer
Whingding
Fabulossy
Sprinkles
Sand Storm
Overview
Interface
Screenshots
Specs

Sand Storm: Interface

Our interface is not an afterthought. We work just as hard developing an interface as we do developing the combinatorial math that underlies the feature set. We see the interface as a kind of artistic environment. The user is visiting us for the first time, and we want to show that we encourage exploration. Everything is one click away. Click and go. For us, if you can't play when you're making art, you should go into accounting.

Before

Original menu

Overview

Background

Problem Analysis

Requirements

Proposed Solution

 Design Phase

 Design Phase Deliverables

 Design Phase Schedule

 Implementation Phase

 Implementation Phase Deliverables

 Implementation Phase Schedule

 Maintenance Phase

 Maintenance Phase Deliverables

 Maintenance Phase Schedule

Conclusion

Specifications

After
(Revised menu as clickable image map)

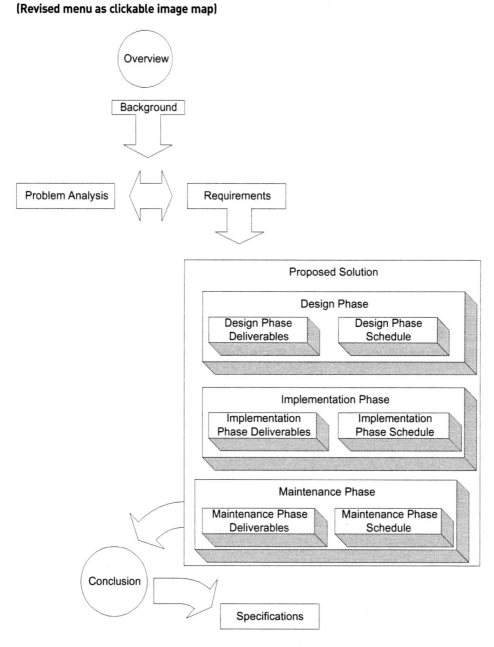

AUDIENCE FIT

If visitors want this...	How well does this guideline apply?
TO HAVE FUN	Game players like the challenge of a confusing interface and deceptive organization. All others like to navigate with confidence—tell 'em where they are.
TO LEARN	The more clearly you outline your structure and the place each page occupies in that structure, the more quickly and solidly students will learn your model.
TO ACT	Very helpful. Think how many people get lost with their shopping carts, because they do not understand why they are moving from one page to another.
TO BE AWARE	Sure, even someone who is grounded likes to know where the feet are placed.
TO GET CLOSE TO PEOPLE	Yes, telling people where they stand inspires confidence.

See: Apple (1997), Bricklin (1998), Conklin (1987), Nielsen (1995, 1996, 1997b, 1997d, 2000a), Utting & Yankelovich (1989), Zimmerman (1997).

Make Meta Information Public

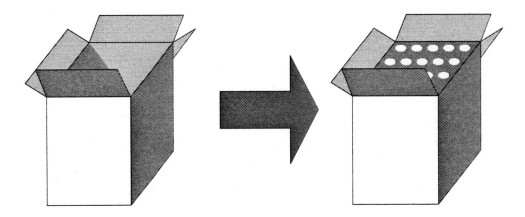

BACKGROUND |

Show what's inside the box

The worst online stores refuse to give out a **phone number**. Customers can't reach them. Even the e-mail address is general; visitors know the webmaster isn't going to be very interested in their little problems.

So open up. On every page tell guests who made the page, when, and how to reach you. At a minimum, put your **name** and **logo** on every page.

Other **meta information** (info about the info) helps visitors put your page in a larger context, too—gauging its timeliness, its source, and its level of openness.

Bring 'em back alive

Some folks print out your page and then want to return, but their system does not include the URL on the printout. These people may never find the page again.

So include the URL at the bottom of every page. If your site is so scripted that you can't legitimately include the URL for this page because it will not be valid tomorrow, then put the URL for the home page.

State the status

Tim Berners-Lee, reflecting his background in the scientific community, urges that you "declare the status of the information: i.e., draft, final, in progress, for comment" (1995).

If your material ages like this, definitely alert the user to the current status.

Date your pages, too. Telling people how current the information is lets them evaluate its relevance. (You should, of course, set up some system for deleting old material gracefully).

Admit who you are

Put your name on the page and give your real e-mail address. Act as if a human being wrote the page.

> Provide an e-mail address and telephone number, or a conspicuous Contact link to this information, on every page of the site. The contact opportunities you provide customers reflect the value you place on customer service. (IBM, 1999)

EXAMPLES

Before
Original page ending:

And so, in conclusion, the committee has voted to prepare the standard for publication, with a target date of January, 1999.

After
Revised page ending:

And so, in conclusion, the committee has voted to prepare the standard for publication, with a target date of January, 1999.

Overview / Rationale / Recommendations / Conclusion

Copyright 1998 W8Org
Free to copy with credit
Contact: Jonathan Price

This page:
http://www.w8.org/reports/schema98

Posted July 1999
**Formal Report (Archive version; will not
be updated)**

AUDIENCE FIT

If visitors want this...	How well does this guideline apply?
TO HAVE FUN	Sure, why not?
TO LEARN	Helpful for those who get lost, wonder how current your material is, or need to get in touch with you.
TO ACT	Critical.
TO BE AWARE	Think of this as an exercise in honesty.
TO GET CLOSE TO PEOPLE	Following the guideline may seem tedious, but you open yourself up to your visitors.

See: Apple (1997), Berners-Lee (1995), Cook (1997), IBM (1999), Levine (1997), Lohse & Spiller (1998), Lynch & Horton (1997), Nielsen (1999d), Spyridakis (2000), W3C (1999).

Write URLs That Humans Can Read

Detached from the materiality of the codex book, the text escapes to the other side of the computer screen.

—Christopher J. Keep, "The Disturbing Liveliness of Machines"
in Cyberspace Textuality

Keep it short and predictable

Wondering where a link will take them, users count on interpreting the address of the target page. If you throw up the confetti of a URL made up on the fly by your content management software or database, or if you just allow totally cryptic addresses, you frustrate some users.

> Because we know that users try to understand URLs, we have an obligation to make them understandable. (Nielsen, 1999f)

So keep the URL short enough to read. Make it **predictable**, too. If your company is called IBM, people expect your site to be found at www.ibm.com. Getting an expected domain name is worth millions of bucks.

In general, don't make up a name with half a dozen words and underscores just because you won't buy the rights to a reasonable name. If you must put words together, don't use hyphens, underscores, or a bunch of dots because users don't try those at first.

Avoid special characters. And remember, zero is a weird character because people just type a capital O and don't find

you, if your name starts with a zero. (Of course, your URL will show up at the top of most search lists if you start with a real zero).

Don't shuffle your pages

Leave those addresses alone. If you switch pages around, every customer who bookmarked the old pages will get an annoying message saying the page is unavailable. That doesn't look good. If you redesign your site, set up redirects on your server so people who click old links out there on the Web can get to the new pages.

> *As readers move through a web or network of texts, they continually shift the center—and hence the focus or organizing principle—of their investigation and experience.*
>
> **—George P. Landow, *Hypertext, The Convergence of Contemporary Critical Theory and Technology***

EXAMPLES

Before:

http://ad.doublesnit.net
/jump/clubelectric.newsletter
/news.iss34.???=mar10-4;sz=120x90

After:

http://www.clubelectric/newsletter/Issue34

Before:

http://ad.doublesnit.net
/clk;2572368;5624853;r?http:
//www.buyandsellit.com/Buy32?
request=rr.refBy&ref=
CLUBidiotW12"

After:

http://www.buyandsellit.
com/offer32

AUDIENCE FIT

If visitors want this...	How well does this guideline apply?
TO HAVE FUN	Why confuse them?
TO LEARN	May not matter. Depends on how suspicious your users are.
TO ACT	Keep it simple, if you really want people to go where you point them and do what you suggest.
TO BE AWARE	Why not?
TO GET CLOSE TO PEOPLE	Make it look as if your site was created by a human being.

See: IBM (1999), Nielsen (1999f).

Make Links Accessible

BACKGROUND | ## For people with special needs, label the media contents

For users who are visually handicapped, hearing impaired, or disabled, provide text equivalents for any sounds, animations, image maps, and images.

In general, avoid using images as bullets, spacers, and decoration. If you do put them in, take the time to add alternate text versions, to explain what they are doing.

Separate content from format by creating a stylesheet, so that the disabled can have their browsers display the page appropriately. Use conventional H1, H2, and H3 tags so blind users can have the top level headings read aloud, allowing them to skim through long pages.

> Making the Web more accessible for users with various disabilities is to a great extent a simple matter of using HTML the way it was intended: to encode meaning rather than appearance. (Nielsen, 1999f)

Move to the eXtended Markup Language (XML) as fast as you can, because its tags indicate content and structure, and let you move formatting rules into a stylesheet, separate from the main document. Use the mathematical markup language, MathML, not graphics, to display equations for the visually impaired.

Make links in text

Don't rely on an image or button as a link. Add alternate text explaining what the link is, including the actual URL, so a person who cannot see the image can still hear what it would do, and take action.

Use relative, not absolute font sizes, so a browser can enlarge the text for people who are visually impaired.

Give the full term, not an abbreviation or acronym, as the text in the link, because the shorter version may get misinterpreted by software as a real word, or mispronounced by the machine.

AUDIENCE FIT

If visitors want this...	How well does this guideline apply?
TO HAVE FUN	Barriers to access are no fun.
TO LEARN	Confusing people doesn't help them learn anything.
TO ACT	Clarifying what you're offering helps people with special needs follow your links, vote, and buy.
TO BE AWARE	Accessibility shows your own consideration, and lets visitors avoid becoming angry.
TO GET CLOSE TO PEOPLE	Making these adjustments to your site shows you want to invite everyone in.

See: Nielsen (1999f), W3C (1999).

Tell People about a Media Object Before They Download It

BIG DOWNLOAD
(8 MINUTES)

BACKGROUND

Let the user decide whether to wait for the download or pass

You've probably had it happen. You click a link, and suddenly you enter download hell. A dialog box shows you that you have 10 minutes to wait, no, 13 minutes, no 45, and so on. Slow downloads make people feel trapped.

So let them decide ahead of time whether to turn their computer over to your download. To make that decision, they must ponder their expectations about the value of the content, its relevance to their needs, and the possible complexity of the process of downloading, uncompressing, launching, and eventually reading or printing. Be straight with users, letting them know what they are about to get into.

Include the file size, the media type, and a description of the subject matter. (IBM, 1999)

Good manners are made up of petty sacrifices.

—Ralph Waldo Emerson,
Letters and Social Aims

Warn people before—and during—downloads

Attention may wander during delays as brief as one second. Delays of more than 10 seconds will almost certainly lead to attention loss. (Microsoft, 2000)

If you can get a programmer to help you, provide a status indicator showing how much longer the download will take.

EXAMPLES

Before

Find out more about our <u>business process</u>.

After

<u>Business Process White Paper</u>. (2.5 MB PDF file, 38 minutes at 56K, requires Acrobat Reader 4.0 or later)

Before

Plutonium <u>recovery</u>.

After:

<u>Diagram of the hydride/dehydride process for plutonium recycling</u>. (8 MB PhotoShop image in BMP format, takes 2 hours to download at 56K, requires paint program to display).

AUDIENCE FIT

If visitors want this...	How well does this guideline apply?
TO HAVE FUN	Nothing ruins the fun like an eternal download.
TO LEARN	Interrupting a lesson for a half-hour download is a sure way to lose your students.
TO ACT	Unless your only goal is to get people to download your white paper, warn people up front; then they can download later, if necessary, rather than starting the download and then canceling it altogether.
TO BE AWARE	Show you're aware of their feelings and schedule.
TO GET CLOSE TO PEOPLE	Giving this kind of information is a simple courtesy.

See: IBM (1999), Microsoft (2000), Nielsen (1999f), W3C (1999).

Announce the New with Special Links

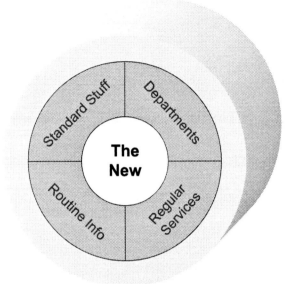

BACKGROUND | ## You want repeat visitors, don't you?

If someone comes to your site and thinks you haven't posted anything new, they may leave and never come back. On the Web, nothing looks as bad as cobwebs.

Nothing is news until it has appeared in The Times.
—Ralph Deakin, Foreign News Editor, The London *Times*

Statistics, numbers and examples all need to be recent or credibility suffers. (Sun, 2000)

So, on pages that don't change much over time, indicate new items with a little "new" glyph.

And **stress** dates. You can get across the message that you are always up-to-date by date-stamping every page and highlighting upcoming events with the dates.

Advertise content changes

You've put in all that work to create new content. Do a little marketing then.

> Boldly promote your most exciting content with size, color, animation, and/or screen position. Minimize less important content. (Microsoft, 2000)

AUDIENCE FIT

If visitors want this...	How well does this guideline apply?
TO HAVE FUN	On the Web, the new is synonymous with fun.
TO LEARN	Learners may not care what's new, unless it's a new course.
TO ACT	Newness impels clicking.
TO BE AWARE	The "new" labels just help folks understand what has changed on the site, which is convenient for people who are already paying more attention to their internal state than the site itself.
TO GET CLOSE TO PEOPLE	If what's new is relevant, you appeal to them; if not, you may not make them feel any tighter with you than before.

See: IBM (1999), Nielsen (1999d), Microsoft (2000), Sun (2000).

Write So Your Pages Will Be Found

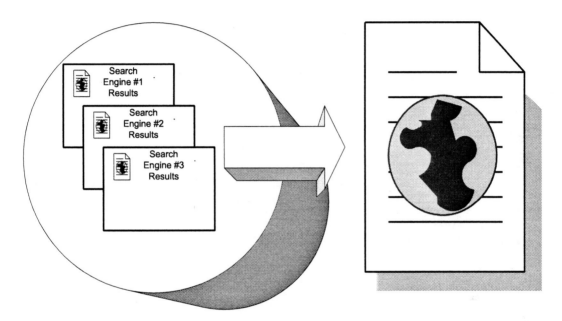

BACKGROUND

Do you want to be linked to?

If you manage to get a spot in the top 10 or 20 results on a search engine, people will follow the link and discover your site for the first time. If you place lower than 30, you might as well not appear. To rank high, you have to respect the way the search spiders work, the way the companies filter out spam, and the way the algorithms look for relevance.

Spiders are trained to follow links and look for keywords and phrases—text chunks that stress your unique content, service, or point of view. The spiders look for these keywords in critical locations on each page, particularly your home page. Oddly, given the robotic nature of these little critters, their most important focus is on the content on the page—title, headings, running text, and link

text. You have to write this material so it appeals to the spiders—and, oh yes, the humans. Managing that double perspective takes finesse and planning.

Before writing anything on the page, come up with one or two key phrases for each page—mantras and slogans that persuasively answer questions that users might ask about the page or the site, such as:

- What info, service, or product do you offer?
- What's the benefit of using your information, service, or product?
- What's the unique subject of this page?
- How do you distinguish yourself from your competitors?
- What is the main reason I should buy, subscribe, register, explore your site?
- Who are you aiming at? (Am I in that niche?)

Developing phrases that respond to these questions involves a lot of discussion with your team, and arguments that go on for days, but don't forget to ask your customers.

> Ask users what methods they would use to find a site such as yours. (IBM, 1999)

Most people use only one or two words in a query. You can use a service like WordTracker to see which of your new phrases are most commonly searched for, and you can sneak a look at the keywords used by your competitors (particularly if they already rank high on the search engines). But you should do some market research among your most valuable customers to see what they would enter to find a particular page (more revealing than asking them what keywords they would use for the site as a whole). Don't go vague, either, reaching for words so general that they would apply to General Mills, General Motors, and General Incompetence. Come up with your own focused and very precise keywords.

> Keywords become our characterization of what each document is **about**. (Richard Belew, 2000)

Having keyphrase-rich home page copy that converts traffic is incredibly important. However, ...if you rely on your home page to be the be all, end all for ALL your keyphrases, you're hobbling your Search Engine Optimization success and probably making your copy impossible to read.

—Jill Whalen and Heather Lloyd-Martin, *Rank Write Roundtable*

Having defined the messages you want to communicate to the people who come to your pages, repeat yourself enough to appeal to the spiders, but not so much that you make them suspect you are trying to bamboozle them.

Make those keywords visible in ordinary text

The spiders check your visible content to make sure it matches the words in your Title, Description, and Keyword tags. If not, suspicion sets in. If you use a bunch of words in the same color as the background (so the text is invisible to humans, but readable by software), the spiders suspect that you are trying to fool them, and they react by banning your site for life. Rule of thumb: write content so that it can be read by both humans and spiders.

Your headings should be text, not graphics, identified with conventional H1, H2, H3 tags. Each heading should pick up a keyword or phrase. After all, search engines figure that any text you put in a heading must be important on your site, indicating what topics are really relevant.

Running text, particularly on the home page, must weave together your keywords in a way that sounds convincing to a human. It's OK to repeat the phrases, but don't just say the same phrase over and over in a row, because humans hate it and spiders sense you are trying to con them. You want a dense thicket of keywords, but not such a jumble that a human reacts by puking on the screen. You don't have to jam all your keywords into the first paragraph; spiders read the whole page, and humans get indigestion if you try to force-feed them all those nuggets of compressed significance.

Don't put key text into graphics (which spiders can't read), animation (ditto), or intricately nested tables (which confuse the eight-legged ones).

Focus your title

Your title is all people see in the results on some search engines, so make it sell. As you write the content for the Title tag, double-check to make sure you are picking up a key phrase or two out of your visible copy. Bump the company name out of the title altogether or shove it to the very end where nobody will notice it, and concentrate

The search engines are changing their rules constantly, and if you're relatively new to e-business it can be really CONFUSING. Heck! I find it confusing sometimes...

—Corey Rudl,
Marketing Tips Newsletter

on one or two key benefits of using your services, products, or spirit. Remember that the search engines compare the title to the page content to determine whether or not you are really sincere—not just stacking the deck with a bunch of interesting keywords.

Add a description

Include an **abstract** in the meta-tag for the description in the page header. Like this:

```
<META NAME="description" CONTENT="Taken from the
journals of Delacroix, these words of advice still inspire
and guide artists today.">
```

Make sure the first sentences describe the page in 150 words or so, because that's the maximum that most search engines will display. Your abstract can go twice that long, though, because the spiders sent out by the search engines rely heavily on the description for information about the page, and read all of the description, robotically. Move your key phrases to the beginning. Spiders who read Meta descriptions give them a lot of weight—more than the Meta keywords.

Use the Meta keyword tag

Just don't count on this. People have abused this tag, cramming all kinds of irrelevant words in here, like adding *sex, free, new,* and *xxx* to a site devoted to pump engines just to catch a few suckers. So put all your key phrases here, but don't make this your main effort at appealing to the search engines. Do not repeat the same word over and over (spread out similar phrases so the spiders do not feel you are faking the density). Within your list of key phrases, resist using the same word more than half a dozen times, including all variations, to avoid irritating the spiders. And remember: If a phrase is not relevant to the rest of your content, drop it.

As far as the search engines are concerned, content IS king.

—Heather Lloyd-Martin,
Rank Write Roundtable

Got images? Write alternate text

Spiders can read, but they can't see, so any text you place into graphics passes right over their heads. Solution: Add alternate text to the tag because the spiders can read that. Great place to use keywords!

Make link text key

Spiders consider links a critical way of figuring out whether your site really deals with the subjects you announce in your Description and Keywords tags. Look at the actual text of your links. Could you possibly squeeze another keyword in?

> The search engines figure that hyperlinked keyphrases are important, and they'll give that phrase more weight. In fact, now that I'm on my soapbox, I think that every hyperlink on your home page should include a keyphrase. (Heather Lloyd-Martin, 2001)

Get out the thesaurus

Along with the keywords you actually use in the text, put **synonyms** in the Meta tags. Don't repeat the same word over and over in a row because the spiders consider that spamming and may ban your site. Don't try tricks like putting the same word a hundred times in white text on the page because the spiders recognize the trick and blackball your site forever.

Include generic terms used by customers or competing companies to describe the contents of the page. And remember that people can't spell very well so include typos for your keywords, too.

Don't stray too far from the topic

If you invent a set of keywords for your whole site and drop them onto every page, the spiders coming from the search engines may get suspicious, seeing that the keywords don't show up in the text on some pages. You may get downgraded or dropped as a cheater, when you were really just lazy.

Make the keywords **match the text on their pages**. Whenever you shift topics, you ought to edit your keywords.

If your target audience can't find you in the search engines...how will they know you exist? You may want to create a certain image for your site, but if your site is a beautiful billboard on a deserted highway, what good will it do for you?

—Jill Whalen,
Rank Write Roundtable

Invite the spiders to come back

Make yourself easy to tour. Add meta tags addressed directly to the robot, saying that all your content is available for scanning. Invite the little critter to revisit the site in a few weeks, too.
(See examples).

EXAMPLES

Before

```
<html>

<head>

<title>Department of Earth Sciences: Geology
101: Volcanoes</title>

</head>
```

After

```
<html>

<head>

<meta name="keywords" content="Haleakala,
Halemaumau, Vesuvius, Aetna, volcano, volcanoes,
lava, aa, crater">
<meta name="description" content="Free infor-
mation about volcanoes, for students and teachers.
Tour key volcanoes of Hawaii and Italy, with close-
up images of lava flows, before and after shots, and
timelines.">
<meta name="robot" content="all">
<meta name="revisit" content="15 days">
<title>Volcanoes: Geology 101: Department of
Earth Sciences </title>
</head>
```

See: Belew (2000), IBM (1999), Kilian (1999), Lloyd-Martin and Whalen (2001), Nielsen (1999f), Sun (2000).

POST

My Idea:

Post to HotText@yahoogroups.com

Express your own idea on:

HotText@yahoogroups.com

Subscribe:

HotText-subscribe@yahoogroups.com

Unsubscribe:

HotText-unsubscribe@yahoogroups.com

Visit:

http://www.WebWritingThatWorks.com

chapter 8

Idea #4:
Build Chunky Paragraphs!

Design Each Paragraph Around One Main Idea

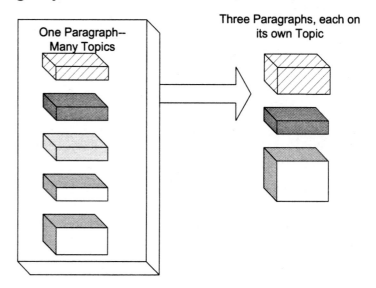

One Paragraph--
Many Topics

Three Paragraphs, each on
its own Topic

BACKGROUND ## Make each paragraph distinct

Paragraphs set off chunks of prose visually. Since each paragraph looks like a different object, write it that way.

On the Web, people see much less text than a book page can show, so each paragraph seems more prominent. Also, on the Web, users are looking harder for clues about the content of each object before deciding to read, so they tend to expect that each new paragraph will offer a different point.

Do what your guests expect. Organize each paragraph around a different purpose.

Answer a particular question

Each paragraph (or series of short paragraphs) should answer a different question from the user, providing one main type of information. Think catalog. The user asks a series of questions and the site responds with a series of paragraphs.

What's the name of this product?	Product name
What good is it?	Feature
	(and related benefit)
What gear does it work with?	Compatible hardware
Is it available?	Availability flag
How much does it cost?	Pricing

If you devote each paragraph to a particular purpose, you fit into an object-oriented world, where the tags indicate the purpose of the content and its place within the larger structure. Think of something you've just written and ask yourself what kind of tags might delimit the paragraphs, answering user questions such as:

One point per paragraph.
—Bricklin, 1998

What does this mean?	Tag: Definition
What is your unique proposition?	Tag: Pitch
Can you prove that?	Tag: Evidence
Can you give me some numbers?	Tag: Statistics table
What's the general rule?	Tag: Guideline
What do I do next?	Tag: Procedure step

Create one sentence that sums up the paragraph's point

For most readers, a paragraph seems to hang together as a unit if it includes a sentence that states the gist of the paragraph—the core point.

> Readers will expect to find in each paragraph... a sentence that will be the logical, argumentative, expository center, a sentence that you could send as the telegram capturing your central idea. (Williams, 1990)

Make all the sentences coherent

To reinforce the main point of a paragraph, sprinkle other sentences with terms that a reader would normally associate with your main idea. Then organize those themes into one or more sequences, building toward the end of the paragraph.

Readers expect a paragraph to contain at least one set of words

A paragraph is in fact a whole composition in miniature.

—J. G. R. McElroy, quoted in
Young, Becker, and Pike,
Rhetoric: Discovery and Change

that are conceptually related to your main idea. For instance, if your main point is that recording the exact location of fossils helps archeologists determine the chronological history of a dig, then readers expect to see words such as *bones, shovels, levels,* and *time periods.* Because these subordinate topics are associated with the main idea, readers see the paragraph as holding together.

But don't multiply synonyms for the same subject. If you really mean *bones,* use *bones* over and over. Repetition signals that you are still discussing the same subject, which may seem boring to you, but eliminates confusion. Too many thesaurus terms make the reader wonder whether you are talking about subtly different subjects, making the paragraph explode.

Proceed from familiar to unfamiliar topics

As one sentence moves toward the next, put familiar information into the first part of the sentence, and launch into the new idea, the unexpected twist, the interesting turn—at the end. Then start the next sentence with that new idea. By creating a chain of familiar ideas leading up to new ones, you propel the reader forward from the known to the unknown.

> A reader normally expects coherence and takes it for granted that there is a connection between sentences that occur sequentially in a speech or in writing. (Quirk, 1972)

Look at your paragraph as a structure

Every idea is an incitement. It offers itself for belief, and if believed, it is acted on unless some other belief outweighs it or some failure of energy stifles the movement at its birth.

—Oliver Wendell Holmes,
Gitlow vs N.Y., 1925

As you write, sense the way your paragraph is shaping up. Let your attention move from the individual word to the whole sentence, from the currently unfolding sentence to the purpose of the paragraph—so you work from the bottom up—and from the top down. The more you're aware of the structure of the paragraph and its goal, the more your language will reveal that overarching shape.

After you've written a draft of a paragraph or two, take another look and edit to surface the patterns of thought that tie one sentence to the next. Perhaps you have been moving from the old to the new, from the problem to the solution, from the most common

to the least. Any organization will do, as long as you insert words that signal that structure, such as *first*, *next*, and *finally*. You're increasing the drama by polishing the story.

> Paragraphs have plots, patterns that organize sentences into a whole unit. (Young, Becker, and Pike, 1970)

Simplify by throwing out other ideas

If you really want to get two points across, put them in separate paragraphs. In the blurry, hectic experience of skimming through your text, people guess what your paragraph is about, based on the opening, and if that topic does not interest them, they move on. Even if they do decide to read, they may miss the second point because they are focusing on the original idea and overlooking anything else.

> Each paragraph should contain one main idea. Use a second paragraph for a second idea, since users tend to skip any second point as they scan over the paragraph. (Sun, 2000)

> Press Enter to start a new paragraph. Use lots of short paragraphs, each dealing with a distinct topic—that is best for e-mail, Web pages, or discussions.

Ideas are, in truth, forces. Infinite, too, is the power of personality. A union of the two always makes history.
> —Henry James,
> on Charles W. Eliot

Ideas won't keep. Something must be done about them.
> —Alfred North Whitehead,
> *Dialogues*

EXAMPLES

Before

We balance out the acidity, thickness, and taste, when we put together a coffee blend for a mild, bold, rich, or casual impression. We bring together beans from different countries, each with its own flavor. Of course, sometimes we serve coffees that are "single-origin" because all the beans come from one country, in one season. We think these beans are tangy enough to stand on their own. So you can see that we brew both single-origin and

After

We serve both **single-origin** and **blended** coffees. How come? Like grapes, coffee beans change their aroma, acidity, body, and flavor from year to year, and from one climate to another.

We brew some coffees that are "single-origin" because all the beans come from **one country** in one season. We think these beans are tangy enough to stand on their own.

blended coffees. Why do we do that? Like grapes, coffee beans change their aroma, acidity, body, and flavor from year to year, and from one climate to another.

And we serve blends of coffees bringing together beans from **different countries**, each with its own flavor. In this way, we balance out the acidity, thickness, and taste, for a mild, bold, rich, or casual impression.

Before

Recovering from wounds in World War I, Moholy-Nagy asked himself whether he had the privilege of becoming a typographer, sculptor, or other kind of creative person just for himself, when everyone's skills were needed to solve the problems of simple survival. No more subjective painting, he decided. In 1919 he said, "The personal indulgence of creating art has contributed nothing to the happiness of the masses." Moholy-Nagy came to believe in design for social change.

After

Moholy-Nagy came to believe in design for **social change**. Recovering from wounds in World War I, he asked himself whether he had the privilege of becoming an artist for himself, when everyone's skills were needed to solve the problems of simple survival. No more subjective art, he decided. In 1919 he said, "The personal indulgence of creating art has contributed nothing to the happiness of the masses."

Before

Please use the original box if you still have it, when sending us back a product. For a refund, you must return the product in good condition, including any accompanying disks, books, and batteries. As stated earlier, we offer a money-back guarantee for 30 days from the time you receive the product. To return a product, please use the Return Address Sticker that came with the original package, so we can credit your account, or call us to get the correct address and code. (505 555-1212).

After

We offer a money-back guarantee for 30 days from the time you receive the product. For a refund, you must:

1) Return the product in good condition, including any accompanying disks, books, and batteries. (Please use the original box, if you still have it.)

2) Use the Return Address Sticker that came with the original package, so we can credit your account. Or call us to get the correct address and code so you get credit. (505 555-1212).

AUDIENCE FIT

If visitors want this...	How well does this guideline apply?
TO HAVE FUN	People out for entertainment sometimes like long tangled paragraphs, enjoying the rich prose, without restlessly asking, "What's the point?"
TO LEARN	Critical. One idea at a time helps the mind absorb the argument.
TO ACT	Critical. Each instruction deserves its own paragraph, and explanations belong in their own paragraphs, quite separate.
TO BE AWARE	If simplicity is a virtue for you, follow the guideline.
TO GET CLOSE TO PEOPLE	In e-mail and discussion groups, focusing each paragraph on a single idea helps people see what you mean. Nonstop rants, without paragraphing, are just self-indulgent.

See: Bricklin (1998), Bush and Campbell (1995), Dragga and Gong (1989), Morkes & Nielsen (1997), Nielsen (1997a, 1997b), Quirk (1972), Sammons (1999), Sun (2000), Weiss (1991), Williams (1990), Young, Becker, and Pike (1970).

Put the Idea of the Paragraph First

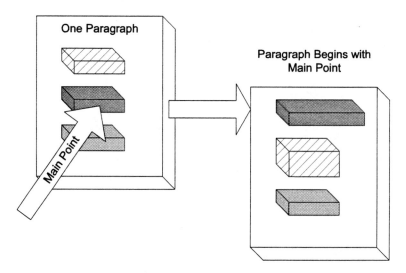

One Paragraph

Main Point

Paragraph Begins with Main Point

BACKGROUND

"It got my attention right away. This is a good site. Boom. It gets to the point."

—Test subject, in Morkes and Nielsen, 1997

Make the point faster than on paper

On paper, readers usually expect to find the point at the end of the introduction to the paragraph or at the end of the paragraph. Of course, in high school, our English teachers yammered on about putting a "topic sentence" first, but that seemed too hard to do, so we often just mentioned the topic in the first line and postponed saying anything about the topic for quite a while. We did not lead off with an idea—just a subject.

Slow intros work OK on paper because readers can hold their breath for a few sentences as the writer leads up to the main point of the paragraph. In fact, traditional writers often take more than one sentence to introduce the topic of a paragraph, and readers have come to expect that the key idea will appear at the end of that introduction.

But on the Web, users have less patience. They want the point right away—not just the topic of the paragraph, but the real, substantive idea. Not a noun—a sentence.

A writer has to make her message clear at the beginning of each paragraph, and not try to keep the reader in suspense. (Abeleto, 1999)

Even if you state your point at the end of the paragraph, you have to tip your hand at the start, to orient the impatient Web user and to establish the coherent theme for that individual paragraph.

Several participants, while scanning text, would read only the first sentence of the paragraph. (Morkes and Nielsen, 1997)

The topic sentence is a more or less fictitious entity.
—Harold Martin,
The Logic and Rhetoric of Exposition

Picking up the point from the first sentence lets a guest decide to skip the whole paragraph—always a mercy. And if the guest chooses to read on, knowing the main point makes the rest of the paragraph clear.

If someone actually reads the paragraph...

Research on reading printed text shows that people generally understand and remember paragraphs best when the paragraphs start off with a main point.

In fact, if users start off with your main idea and choose to read your whole paragraph, they will probably understand what you are saying better than they would if you had just thrown the main idea in somewhere in the middle.

When presented at the beginning, the main point offers a hook on which readers can hang all the other details, in a mental hierarchy (main idea at the top, others hanging off of it).

Using that framework as they work their way through the paragraph, readers can verify how each new topic fits into that structure. Result: they remember what you say longer.

In the matter of ideas, the public prefer the cheap and nasty.
—Charles S. Peirce,
in Popular Science Monthly, 1878

They want to see the POINT up front. (Williams, 1990)

And this demand to know the main point right away grows more intense on the Web.

Revise—be bold

Back when you were writing the first draft, you may not have found out what you really thought until you got to the second or third sentence, or even later. Just revise to move that idea forward.

Politeness may restrain you. Get over it. Even though you may feel you are being abrupt, even rude, putting the main point first is a kindness.

EXAMPLES

Before

You may be surprised to learn that there are many different kinds of shampoos made up especially for your dog. Yes, you can make your pet's coat shinier with one shampoo, get rid of fleas and ticks with another, moisturize with another. But all of these shampoos have one thing in common. They aren't as strong as human shampoos. How come? Dogs' skins have a different amount of pH than human skin, so they need less acid in their shampoos, to cut through the oils that build up on the surface of the skin. Human shampoos irritate dogs' skin and make their coat dull and stiff.

After

Dogs need their own shampoo—not yours. Your shampoo could irritate your dog's skin and make the coat dull and stiff. Why? Dogs need **less acidic shampoo** than humans use to cut through the oils building up on the skin surface.

Dog shampoos address **different problems.**

- Want to make your pet's coat shinier? Use a whitener shampoo.
- Want your pet to smell good? Use an aromatic shampoo.
- Want to get rid of fleas and ticks? Try our anti-pest shampoo.

Before

Sometimes, we go through a lengthy period of preparation, during which we gather information, think about the problem, and, perhaps, try out some preliminary solutions. You have probably observed yourself doing this on various projects. Much early work on the way we think was similarly based on **self-observation**. In 1926, for example, Wallas published his classic, *The Art of Thought*, in which he summarized his reflections on the way he himself thought that he thought—and backed up those introspective analyses with autobiographical narratives by other people. He saw four major phases to thinking. You might be interested to

After

Much early work on the way we think was based on **self-observation**. In 1926, for example, Wallas published his classic *The Art of Thought*, in which he summarized his reflections on the way he himself thought that he thought—and backed up those introspective analyses with autobiographical narratives by other people. He saw four major phases to thinking:

1) **Preparation** during which you gather information and make some preliminary attempts to solve the problem.
2) **Incubation** during which you put aside the

know that after the **preparation** phase came:

1) **Incubation**, during which you put aside the problem to work on other things, or sleep

2) **Illumination**, when the solution appears in a flash.

3) **Verification**, during which you check the solution carefully to make sure it works.

problem to work on other things, or sleep.

3) **Illumination** when the solution appears in a flash.

4) **Verification**, during which you check the solution carefully to make sure it works.

AUDIENCE FIT

If visitors want this...	How well does this guideline apply?
TO HAVE FUN	You can let the point slide a bit when writing to amuse. People still expect to see some sign of an idea at the end of the introduction to an article, but that could take two or three sentences before they demand a main point.
TO LEARN	Definitely put the idea up front. Alerting the students to your idea in advance means that they understand and remember it better.
TO ACT	The instruction is your main idea. Put it first, and cut away everything else.
TO BE AWARE	A bit of rambling may be forgiven, but make sure that your main idea really does appear toward the beginning of the paragraph.
TO GET CLOSE TO PEOPLE	If you want to be understood quickly, follow the guideline, even if it means rewriting before you post.

See: Abeleto (1999), Barstow & Jaynes (1986), Bricklin (1998), Brusaw et al (1997), Dee-Lucas and Larkin (1990), Frisse (1987), Horton (1990), Kieras (1978, 1980), Lorch and Lorch (1985), Mayer (1992), McKoon (1977), Morkes & Nielsen (1997), Nielsen (1997b), Spyridakis (2000), Van Dijk and Kintsch (1983), Williams (1990).

If You Must Include the Context, Put That First

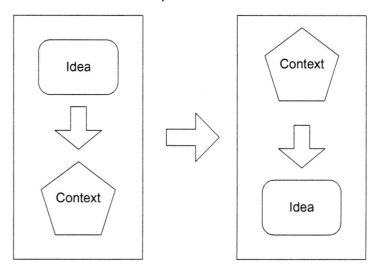

BACKGROUND

Connect the dots

As you write, proceeding from one sentence to another within a paragraph, or from one paragraph to another, you may need to signal the way you are organizing the sequence—how one idea follows from another. If so, slip the logical connection in quickly, starting the sentence (or paragraph) with words like:

- *Also*
- *Therefore*
- *Next*
- *For example*
- *As a result*
- *In conclusion*

Words like these will answer the question, "What's the connection between what I just read, and this new information?"

You are stressing the way you are organizing the sequence of ideas by:

- Adding one to another (*plus, in addition, moreover*)

- Moving forward in time (*then, last*)
- Enumerating a sequence (*first, second, third*)
- Comparing or contrasting (*similarly, by contrast*)
- Tracing causes (*thus, as a result*)
- Explaining (*in other words*)
- Summarizing (*in short*)

Quick phrases like these clarify the relationship between one sentence and the next, between one paragraph and the next.

Point back to earlier ideas

Even though you are eager to get to your next idea, you may need to start off by reminding your readers of an idea you mentioned earlier, just to set the context.

Be not the first by whom the new are tried,

Nor yet the last to lay the old aside.
—Alexander Pope,
An Essay on Criticism

> Give your readers a familiar context to help them move from the more familiar to the less familiar, from the known to the unknown. (Williams, 1990).

If you fear your users may not grasp how one sentence flows out of the previous one, or how one paragraph follows another, begin with a reminder of old or familiar information, echoing words you used in the previous sentence or paragraph.

If you follow this given-new order, research shows that your users will:

- Process the new sentences more quickly than sentences that do not hark back to ideas mentioned earlier. (Albrecht and O'Brien, 1993; Suh and Trabasso, 1993)
- Remember the ideas more often. (Trabasso and van den Broek, 1985)
- Retain the new information longer. (Clark and Haviland, 1977; Just and Carpenter, 1980)
- View the sequence as relatively coherent. (Spyridakis, 2000)

Drop transitions that refer to missing text

Because you cannot tell where people come from, avoid starting a page with generalizations such as, "As we have seen," or,

"Following up on that thought... ."

Your context is only as large as your current page. If you fear some people will not understand the topic or may not share your assumptions, create another page of background and link to it early in the paragraph, so people who want the context can go find it, while others, who could care less, can skip past the link.

EXAMPLES

Before

As we have just seen in our page about problem hair, long tresses can pull thin or fine hair down, revealing almost-bare patches. Get a short haircut, if your hair is just naturally fine, or you will have areas where your hair is thinning out. Add **volume** to each shaft of hair, too.

Before

Meet smooth, **progressive resistance**, as you go "uphill," or increase the difficulty level.

We use a special **hydraulic turbine**, which has none of the noise of a fan trainer. TV or music will get through now. Our very large flywheel makes your cadence **even and fluid**, too. To make indoor training fun, drop your bike onto our solid steel frame, and pedal away.

Order our Indoor Trainer. It makes your workout way cool.

After

If your hair is just naturally fine, or you have areas where your hair is thinning out, get a **short haircut**. Long tresses can pull the hair down, revealing the almost-bare patches. Next, add **volume** to each shaft of hair so each hair looks thicker and stays in place all day.

After

To make indoor training fun, drop your bike onto our solid steel frame and pedal away. Your bike's wheels meet smooth, **progressive resistance**, as you go "uphill," or increase the difficulty level.

The resistance comes from our special **hydraulic turbine**, which has none of the noise of a fan trainer. Our **silent** trainer always lets you hear the TV or music as you work out.

As you pedal, your cadence will be **even and fluid**, too, because we use a very large flywheel, so you don't feel any hurried shifts or jerks. Our Indoor Trainer makes your work out way cool.

Order our Indoor Trainer.

Before

Earthquake supplies

Get a space heater or wood-burning stove, and plenty of fuel, plus fire starters such as matches. Store blankets and sleeping bags, and many layers of warm clothing, in case the power and gas lines are out. If the earthquake destroys your house, you'll need shelter, so get a tent rated for the worst weather in your area (winter storms, summer heat), large enough for your whole family.

After

Be prepared for an earthquake.

If the earthquake **destroys your house**, you'll need shelter, so get a tent large enough for your whole family.

- The tent should be rated for the worst weather in your area (winter storms, summer heat).

- To heat your tent, get a space heater or wood-burning stove, and plenty of fuel, plus fire starters such as matches.

If your **house is OK**, but the power and gas lines are out, you need a way to keep warm.

- For comfortable warmth while sleeping, store blankets and sleeping bags.

- To stay comfortable during the day, prepare many layers of warm clothing, including thermal underwear.

AUDIENCE FIT

If visitors want this...	How well does this guideline apply?
TO HAVE FUN	People want lush context, not less. They enjoy spotting several themes operating within a paragraph or article. Just make sure you highlight your idea within the forest.
TO LEARN	People learn better when the teacher starts with the familiar, and moves to the unfamiliar. Same here.
TO ACT	In instructions, assume people have done the previous step. That's the main context. At the start of a step, limit yourself to saying where to operate, or why—briefly.
TO BE AWARE	All is context, no?
TO GET CLOSE TO PEOPLE	Keep the context-setting to a minimum. Like a person who takes forever to set up a joke, you may bore people if you lose yourself in setting the scene or laying out your rationale before you ever get to the point.

See: Albrecht and O'Brien (1993), Clark and Haviland (1977), Just and Carpenter (1980), Spyridakis (2000), Suh and Trabasso (1993), Trabasso and van den Broek (1985), Walker (1987), Williams (1990).

Put Your Conclusion or News Lead
in the First Paragraph of the Article

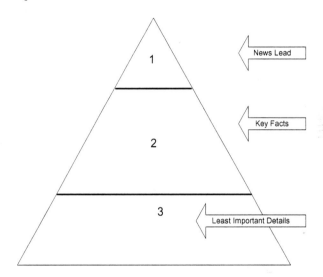

BACKGROUND

Start with the summary or conclusion

When you think, the conclusion comes last. But when you write for the Web, you need to move that conclusion—or summary of the news—up to the front of the article.

Guests wonder whether your article is worth reading.

> You have to let readers know right away what's in it for them. (Amy Gahran, in Silva, 1998)

By putting your main idea into the first line of the first paragraph, you let people figure out whether the rest of the article is relevant to them and whether the topic is what they were after.

Begin each product description with information that

Anticipate your conclusion.
—Abeleto, 1999

distinguishes that product from others and enables customers to recognize quickly which products do and don't meet their needs. (IBM, 1999)

Like the lead sentence in a news story, the short conclusion gives users the gist of the page. That will be enough for most guests.

It was more than three times as common for users to limit their reading to a brief, as opposed to reading a full article. (Nielsen, 2000b)

Putting your main point first lets people skip the evidence that led you to that conclusion, if they aren't interested. But if they care, they can stick around.

A Web site has only two to three seconds in which to grab and retain the user's attention. Therefore, the first page—and the first items that appear on that page—must make a positive first impression. (America Online, 2001)

Write the first sentence last

You may be used to building up to a conclusion through careful argument, so stating the idea right away seems bald. Here's the trick:

Write the beginning last. (Bricklin, 1998)

Just write your draft the usual way, and when you finally figure out what you are saying, grab that paragraph or sentence and move it forward.

Life is very nice, but it lacks form. The aim of art is to give life some shape.

—Jean Anouilh

Form is not something added to substance as a mere protuberant adornment. The two are fused into a unity. ... They are the tokens of the thing's identity. They make it what it is.

—Benjamin Cardozo

Before

In a recent study, we challenged our participants to set up a candle so it would light up the whole desk area, a task that demanded people find a way of attaching a candle to a screen behind the desk. We gave 15 participants some candles, tacks, matches, and boxes, without anything inside; we gave another 15 participants the same materials, but put the candles in one box, the tacks in another, and the matches in another. The first group, having never seen anything inside the boxes, felt free to put a candle inside a box, attaching the box to the screen by hot wax. The group who saw the boxes as containers for the supplies never realized they could use a box as a platform. They were stuck with the limiting idea that the boxes could act only as containers.

Thus, a person may get fixated, adopting the point of view so vividly presented by a demonstration or display, and never letting go. Our study proves that although a diagram, display, or demonstration may help someone understand a solution or function, that very success can limit the person's imagination when dealing with another problem.
195 words.

After

A diagram or demonstration may help someone understand a solution or function, but limits the person's imagination when dealing with another problem. The person may get fixated, adopting the point of view so vividly presented, never letting go.

In our study, we challenged our participants to set up a candle so it would light up the whole desk area, a task that demanded that people find a way of attaching a candle to a screen behind the desk.

> 1) We gave 15 participants some candles, tacks, matches, and boxes, without anything inside.
>
> 2) We gave another 15 participants the same materials, but put the candles in one box, the tacks in another, and the matches in another.

The first group, having never seen anything inside the boxes, felt free to put a candle inside a box, attaching the box to the screen by hot wax.

But the group who saw the boxes as containers for the supplies never realized they could use a box as a platform. They were stuck with the limiting idea that the boxes could act only as containers.
186 words.

AUDIENCE FIT

If visitors want this...	How well does this guideline apply?
TO HAVE FUN	Not necessary, but acceptable. Making your point right away ensures that your guests will be able to follow your article. But when entertaining, you're entitled to draw out the introduction quite a while. Put the news at the end of your intro.
TO LEARN	General ideas need a brief intro, but not a lot. Highlight them right away, and then expand on them.
TO ACT	Say what the goal or purpose is, right off, in the title and any introduction.
TO BE AWARE	Not so easy, and not so necessary. You can build up to your point if people have a general idea where you are going. Just don't take more than a paragraph or so to get there.
TO GET CLOSE TO PEOPLE	Always best, if you want to be understood. On the other hand, if you prefer to start off by venting, go ahead and make your point by repeating yourself a dozen times. (No one will be listening).

See: Abeleto (1999), America Online (2001), Bricklin (1998), Deese and Kaufman (1957), Frase (1969), Freebody and Anderson (1986), IBM (1999), Isakson and Spyridakis (1999), Levine (1997), Morkes & Nielsen (1997), Nielsen (1997b, 1999f, 2000b), Silvia (1998), Spyridakis (2000).

POST

My Idea:

Post to HotText@yahoogroups.com

Express your own idea on:
HotText@yahoogroups.com

Subscribe:
HotText-subscribe@yahoogroups.com

Unsubscribe:
HotText-unsubscribe@yahoogroups.com

Visit:
http://www.WebWritingThatWorks.com

chapter 9 |

Idea #5:
Reduce Cognitive Burdens

Reduce the Number of Clauses Per Sentence

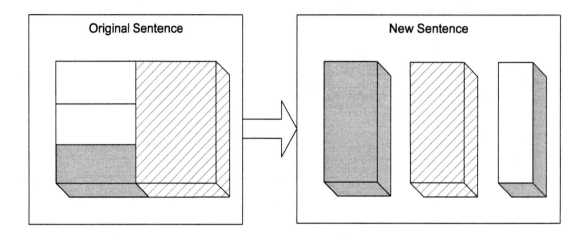

BACKGROUND

A clause is a miniature sentence, because it contains a subject and a verb.

—Robert Osgood

Move or remove *that, who,* and *which* clauses

Using a *that, who,* or *which* clause lets you embed one idea inside another—and that's excellent. Embedding a small sentence inside a larger one lets you show what is important and what is not, emphasizing one thing, demoting another, while extending the reach of your accumulating sentence so that it expresses a complex thought. But when you go too far, you have to learn to disembed sentences.

Don't let minisentences crop up right in the middle of your main sentence. When readers are moving along nicely in a sentence, but encounter a clause starting with *that, who,* or *which* right in the middle, gosh, they space out, make mistakes in understanding, and fail to recall the information inside those relative clauses.

> Complex syntax distracts the user from the task and taxes his or her memory. (Horton, 1990)

Readers seem to be built to understand one idea at a time. They get confused when they think they have grasped the general subject of a sentence, but then hear something different. Now they must hold the original thought in reserve, while contemplating a new, smaller idea, after which they must remember the original subject and apply that to the verb that emerges, just to understand who does what. So don't let the relative clauses get between the real subject and the real verb.

Strategies to handle a clause standing between a subject and a verb are:

- **Remove** the clause altogether and turn it into a separate sentence. The risk: sounding a little dumb.
- **Transform** the clause into an introductory *if* or *when* clause.
- **Move** the clause to the end of the sentence, where people can digest it because better it no longer distracts from the flow of the main sentence.

Remember that the matter of wordiness is entirely secondary to the matter of how your sentence sounds. When longer phrases suit the rhythm of a sentence better than short ones, the longer ones are a better choice.

—Webster's Dictionary of English Usage

EXAMPLES

Before

Some customers, who have already been identified by our system as repeat customers, may want to see their wish list on the first page. The preferences that they chose earlier must be recognized, too, and acted on, by the content management system.

After

Our system identifies repeat customers. They may want to see their wish list on the first page. Also, our content management system ought to act on the preferences that these customers set earlier.

Before

Now you can shop for the same items that you always liked in our paper catalog, on the Web, using our online shopping service.

After

Now you can shop online for the same items that you always liked in our paper catalog.

Before

Of all the areas of uncertainty that an asthma sufferer encounters in the research literature that has developed over the years, as pharmaceutical companies and the National Science Foundation (NSF)

After

Does the flu vaccine cause asthma attacks? We don't know, despite extensive research by pharmaceutical companies and the National Science Foundation (NSF).

invest in clinical studies as to the effect of influenza vaccinations on asthma, no question that scientists address seems as difficult to resolve as the concern that the vaccine may actually cause asthma attacks.

AUDIENCE FIT

If visitors want this...	How well does this guideline apply?
TO HAVE FUN	Keeping it simple, stupid, or KISS, was developed as a guideline for business correspondence, not entertaining prose. You can play around with this rule, if you know you're amusing.
TO LEARN	One idea at a time works best. Disembed, move, or remove.
TO ACT	One meaningful action per instruction. No more. No extra explanations, either. Just the action.
TO BE AWARE	If you have something profound to say, it will come out simply. On the other hand, if you are selling a cult, use more clauses, because they act like incense smoke, to blind and ensnare.
TO GET CLOSE TO PEOPLE	Would you use complicated syntax when talking to a friend? Probably not, unless you were pontificating—or lying.

See: Bush and Campbell (1995), Creaghead and Donnelly (1982), Galitz (1985), Heckel (1984), Horton (1990), Isakson and Spyridakis (1999), Kilian (1999), Larkin and Burns (1977), Lynch and Horton (1997), Rayner, Carlson, and Frazier (1983), Roemer and Champanis (1982), Spyridakis (2000).

Blow Up Nominalizations and Noun Trains

True ease in writing comes from art, not chance,

As those move easiest who have learned to dance.

—Alexander Pope,
An Essay on Criticism

Rescue the verb

On the Web, people feel impatient with any text that seems ambiguous or hard to understand. Turning verbs like *suggest* and *define* into nouns like *suggestion* and *definition* may seem innocuous, but if you keep transforming actions into things, your prose gets clotted. Readers struggle to figure out who does what, because the prose seems full of objects with only a few fuzzy actions. Compare:

> Our general suggestion is that your definition of the goal should probably have greater precision.

> We suggest that you define the goal more precisely.

Which sentence can you understand more quickly? The second one, probably. It tells you who is talking and makes clear what they want you to do. It's more precise.

When you turn a verb into a noun, you are nominalizing—a horrible thing to do. An obvious indication that you have just

nominalized a verb is that the word gets longer, often by adding a Latinate suffix like *tion, ization,* or worse. But nominalizations occur whenever you make a verb do a noun's work—even when it's the same word. Compare:

> Upon the receipt of our product, please conduct a review of the contents of the box.

> When you receive our product, please review the contents of the box.

Don't abuse a verb by making it act like a noun.
- When the nominalization trails after a nondescript verb, as in "may register improvement," get rid of the verb and turn the nominalization into the main verb ("may improve").
- When the nominalization follows a phrase such as "There is..." lop off that phrase, change the nominalization into a verb, and discover a new subject. For instance, "There is a development from our European office" might be changed into "Our European office has developed...."

Untie the noun knot

To compress a bunch of concepts into a single phrase, professionals often chain together a series of nouns, such as *office design management worksheet user manual.* Unfortunately, ordinary folks have trouble teasing apart the sequence, figuring out which noun goes with which other one, and what the whole shebang means.

> They're often another form of jargon, a shorthanding of longer concepts. But clarity demands that the editor unpack the noun string. (Bush and Campbell, 1995)

Noun strings are often ambiguous because people can consider several nouns as a unit, modifying something else, but then reconsider and see several other nouns as a complete descriptive phrase, getting an entirely different viewpoint. For instance, a reader might consider these interpretations:

- The manual for people who use the worksheet that lets them manage the design of their office.
- The office copy of the manual explaining how to design the management of worksheet users.
- The manual for worksheet users who focus on design management in offices.

Of course, without knowing more, the reader could only guess which meaning was intended. This kind of push-me-pull-you process drives people right off your site.

EXAMPLES

Before

We're sorry, but the product specification of the selected hardcopy output device lacks the requested status indicator liquid crystal displays, as well as the supply feed extension mechanism.

After

We're sorry, but the selected printer lacks two things you asked for: the LCD display and an extra-large paper tray.

Before

There is a need for annual testing of both untreated water and treated water for a determination of contaminant levels.

After

Every year we should test both treated and untreated water to determine the level of contaminants.

Before

The system model security software made an investigation into the clock set violation breach.

After

The security software investigated the attempt to reset the system clock.

Before

The intention of the site development project team is to meet the beta deadline, even if that means the excision of some features.

After

Our project team intends to meet the beta deadline, even if we have to drop some features.

Before

Then there was a review of the file format conversion module.

After

We then reviewed the module that converts our files to other formats.

AUDIENCE FIT

If visitors want this...	How well does this guideline apply?
TO HAVE FUN	Noun strings are no fun. Neither are those other thingamajigs.
TO LEARN	Obscure and ambiguous. Definitely a no-no.
TO ACT	Follow the guideline to make sure people know what to do.
TO BE AWARE	Self-defeating to use.
TO GET CLOSE TO PEOPLE	Use nominalizations to be one-up on the poor bastards. Noun trains just baffle anyone who doesn't already understand you completely.

See: Bush & Campbell (1995), Horton (1990), Price & Korman (1993), Tarutz (1992), Waite (1982), Williams (1990).

Watch Out for Ambiguous Phrases a Reader Must Puzzle Over

 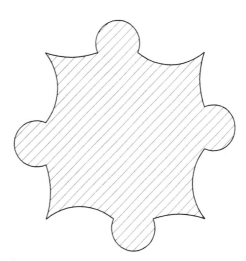

Time flies like an arrow.
Fruit flies like a banana.

—**Groucho Marx**

BACKGROUND |

When a word can be taken two ways...

Sometimes, we let a word fall between two phrases—it could refer to either topic, and the reader has to puzzle out which way we meant. Figuring out an ambiguity is always a nuisance, but online, where people have less patience than they exhibit reading a newspaper, such uncertainties make people mad. Anything that drives your readers to debate about what you might have intended, distracts them from your point, and risks heading them in the wrong direction—like off your site.

The amount of thinking that the user has to put in, just to move around the Web site, already burdens the mind. Add to that the barely recalled sequence of pages coming here, and now you are waving puzzle pieces in the readers' faces saying, "Which one did I really mean?"

To reduce what Morkes and Nielsen call "cognitive load," be concise, scannable, and unambiguous.

Beware modifiers that point forward and backward

Consider this sentence:

> Overdoing your fitness routine seriously results in aches and pains.

That *seriously* raises a little uncertainty. Does this sentence mean that seriously overextending yourself can result in aches and pains? Or does the author mean that overexertion must always lead to serious aches and pains?

To avoid unintended double entendres, try these strategies:

- Watch out for adverbs and adjectives that might be taken to modify two different phrases—one before, and one after.
- Place an adverb near its verb.
- Place an adjective before its noun, not after.

It's not a sandwich, except in San Francisco

In the Bay Area, the *It's It* is a patty made out of chocolate wafers with ice cream sandwiched in between. Delicious. But online, where no one knows what it is, beware of pronouns. People have to think a bit to see what the pronoun refers back to. If you give them two or three possible referents, the mind gets dizzy, and the finger clicks away.

So be attentive whenever you realize you have just perpetrated a long sentence or paragraph carrying a lot of nouns and different pronouns, such as:

> Marketing mavens addressing their prime customers are vitally concerned about their goals, and they are equally concerned with understanding how features relate to benefits and their own objectives.

Who's *they?*

Sorting out your own pronouns is a service to your readers. Strategies:

- Repeat the darn noun. At first the repeated noun sounds clunky, even boring. But as Gerry McGovern says, "Boring is beautiful on the Internet, because the Internet is a very functional place."
- Move the pronoun so it is close to the noun referred to.

One keeps saying the same thing, but the fact that one has to say it is eery.

—**Elias Canetti,**
The Human Province

- Use the pronoun only one way in the sentence. If you find three uses of *it*, make sure *it* always refers to the same noun.
- Make the noun explicit. Don't imply a general topic and then refer broadly to "it." You're making readers guess what you mean, and they may guess wrong.

Don't point offstage

On the Web, you can't assume you know where guests have come from, so suggesting they go back to a page they have never seen may seem odd, or raise unpleasant thoughts, even anxiety in some guests. Watch out for relative directions, particularly when borrowing material that was originally written for paper, where *forward*, *above*, *below*, and *back* all have real meaning.

> Describe the subject of the page, or use absolute directions. (Jutta Degener, quoted by Levine, 1997)

Ixnay on the creative variations

In a poem designed to be read on paper, we may struggle to find new words to describe the same object, giving the reader new perspectives, new slants, and new overtones. In literature, consistency stinks. Oscar Wilde called it "the last refuge of the unimaginative." Aldous Huxley said, "The only completely consistent people are dead." So go ahead, be inconsistent in life—and poetry.

But when you write practical Web prose, adopt Gertrude Stein's maxim, "A rose is a rose is a rose."

Changing the word you use to describe the rose could make people wonder whether you have begun talking about some new flower altogether.

> How can users follow a procedure if the terminology changes, if you call something a *screen* one time and a *window* the next? It's not the user's job to figure out what you mean. It's your job to make it obvious. (Henning, 2001d)

If you call a gizmo a *stylus* here, don't start referring to the same thing as a *pen*.

If you use the word *user* to refer to a consumer in one paragraph, don't switch in the next paragraph, and write *user* when you really mean developer.

Adopt a controlled vocabulary—a list of terms your team agrees to use, consistently, throughout the site.

> By predetermining the terms that make up a controlled vocabulary, and using those terms to describe your site's content, you can minimize the negative effects that variants, synonyms, and various other annoyances can have on your site and its users. (Rosenfeld, 1999)

EXAMPLES

Before

You'll find that information <u>at the top</u>.

...as shown in the table below.

If you go <u>forward</u>, you'll ...

On the <u>next level up</u>, look for ...

<u>Below</u> this section....

<u>Next</u>

<u>Previous</u>

We put 12 rosebuds coated with chocolate entirely on your monthly subscription.

After

You'll find that information on our <u>home page</u>.

... as shown in <u>the table</u>.

In the <u>System White Paper</u>, you'll

In the <u>Security Overview</u>, look for

In the subsection on <u>The Protocol Recommendations</u>

Next: Our extension of this study, <u>Further Thoughts</u>

Previous: The authors' <u>initial report</u>

Once a month, we send you 12 rosebuds entirely coated with chocolate, throughout your subscription.

The families in our cooperative make 100% Scottish cashmere apparel. It creates kilts, capes, scarves, sweaters, pullovers, blankets, and throws. These items are available direct from them, through our secure ordering pages. Click to see <u>them</u>.

The new window may have appeared right on top of the original page, so that you can no longer see that frame.

The families in our cooperative make 100% Scottish cashmere apparel. We create kilts, capes, scarves, sweaters, pullovers, blankets, and throws. You can buy these items direct from individual families, through our cooperative's secure <u>ordering pages</u>.

The new page may have appeared right on top of the original page, obscuring it.

AUDIENCE FIT

If visitors want this...	How well does this guideline apply?
TO HAVE FUN	Ambiguity may be part of the game. Just make sure you signal your guests that you are being deliberately provocative, not just lazy.
TO LEARN	Half your effort is simply avoiding ambiguity.
TO ACT	Don't make someone pause in mid air, wondering whether you mean A or B.
TO BE AWARE	Poetry and parables work on several levels, referring to different planes of experience. But on each plane, the best lines are unambiguously powerful.
TO GET CLOSE TO PEOPLE	In a direct exchange, people overlook accidental ambiguities, if they think they know what you mean. Strangers, though, may choose the worst possible interpretation and send you flames.

See: Fowler, Aaron and Limburg (1992), Henning, (2001d), Horton (1990), Kilian (1999), Levine (1997), McGovern (2001), Morkes and Nielsen (1998), Price and Korman (1993), Rosenfeld (1999), Tarutz (1992), Williams (1994).

Surface the Agent and Action, so Users Don't Have to Guess Who Does What

 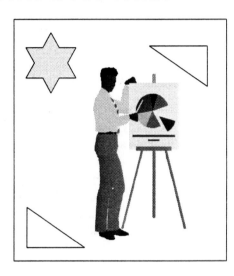

BACKGROUND |

Write actively, to speed people's understanding

People habitually think in terms of characters carrying out actions that affect objects or other people. So readers expect this pattern in sentences:

Character or actor = Subject

Action = Verb

Object = Direct object

Williams says readers think prose is clear when:

(1) The subjects of the sentences name the cast of characters.

(2) The verbs that go with those subjects name the crucial actions those characters are part of.

(Williams, 1990)

The interest to myself would seem to have been, as I recover the sense of the time, that of all the impossibilities of action, my proceeding to Cambridge on the very vaguest grounds that probably ever determined a residence there might pass for the least flagrant; as I breathe over again at any rate the comparative confidence in which I so moved I feel it as a confidence in the positive saving virtue of vagueness. Could I but work that force as an ideal I felt it must see me through, for the beauty of it in that form was that it should absolutely superabound. I wouldn't have allowed, either, that it was vaguer to do nothing; for in the first place, just staying at home when everyone was on the move couldn't in any degree show the right mark; to be properly and perfectly vague one had to be vague about something; mere inaction quite lacked the note—it was nothing but definite and dull.

—Henry James,
Notes of a Son and Brother

But writing in the passive voice turns that pattern on its head. A passive sentence turns the object into a subject, and deletes the true actor, or pushes that person off into a prepositional phrase toward the end of the sentence.

Active: The batter hit the ball.

Passive: The ball was hit by the batter.

Some readers may actually encode the passive text in active voice, to understand it. Reading a passive sentence like "The chocolate sauce was poured over the raspberry by the chef," the mind evidently pauses to translate that into "The chef poured chocolate sauce over the raspberry."

Now the main actor has become the true subject of the sentence, matching the mind's expectations, and the object of her pouring has ended up where it belongs—as the object of the verb. And the active verb shows us what the lead actor does. The chocolate sauce is no longer acting as if it were the person in charge.

This process of translation adds 25% to the time required to understand the sentence.

> Not only do readers move more quickly through active-voice text, but they prefer it and feel more familiar with it. (Spyridakis, 2000)

Of course, some minds just enjoy thinking about chocolate, so those folks may not object to the split seconds devoted to reinterpreting the sentence. And in science, engineering, bureaucracies, and academia, the passive voice sounds sober and professional in research papers. But online, that paper mentality takes too many words, and eats up too much thinking time.

If your users are just going to download and print a document, you don't need to change the passive voice. But if your audience will try to read the material online, you should transform all those weak-kneed passives into healthy, active sentences.

1. Make the actor the subject (the batter).
2. Change the verb to active voice (from "is hit by" to "hits")
3. Move the object (the ball) after the verb.

Is *is* OK?

Occasionally, you have to define a term, or create an equation.

> Literature is news that stays news.
> (Ezra Pound, *ABC of Reading*, 1934)

> Mediocrity is a handrail.
> (Montesquieu, *Mes pensées*, 1755)

The verb *is* acts as the equal sign. That's OK. The verb *to be* is not, in itself, passive. The passive crops up when you turn the subject into a victim, being operated on by the verb.

EXAMPLES

Before

If disks are swapped with others, or picked up at flea markets, it must be noted that viruses could be a problem on the disks; the same is true if disks are received from people whose game software has been downloaded from the Internet, or if software gets loaded on the disk after being downloaded from unknown sites.

After

A virus could infect your disk if:

- You swap disks with friends.
- You pick up disks at flea markets.
- You receive disks from people who download games from the Internet.
- You download software from people you don't know.

AUDIENCE FIT

If visitors want this...	How well does this guideline apply?
TO HAVE FUN	An occasional passive voice does no one any harm. But get in the habit, and you put your readers to sleep.
TO LEARN	Passives are OK when there is no true subject. Avoid them when you want to help students understand concepts, processes, or ruling principles.
TO ACT	Follow the guideline to be clear. Better yet, write in the imperative. Tell people what to do. Give orders!
TO BE AWARE	Some passives reflect reality. The person does nothing, but is transformed. Still, keep the passives to a minimum.
TO GET CLOSE TO PEOPLE	Somehow, folks know you are covering up, exaggerating, or lying when you overuse the passive—they'll say you sound just like a bureaucrat.

See: Broadbent (1978), Flower, Hayes, and Swarts (1983), Henning (2001c), Herriot (1970), Horton (1990), Kilian (1999), Kintsch (1993), Miller (1962), Spyridakis (2000), Tarutz (1992), Williams (1990).

Make a Positive Statement, so People Understand Right Away—without Having to Unpack a Nest of Negatives

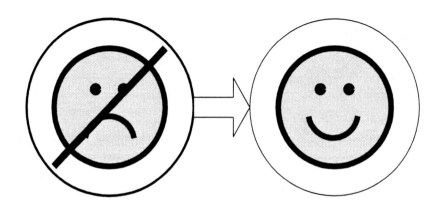

BACKGROUND

Negatives slow people down

Faced with a negative, readers must often translate it into a positive statement to figure out what it means.

Comprehension suffers when the reader must make a logical reversal, such as when translating the statement "The switch is not off" to get the meaning "The switch is on." (Simpson and Casey, 1988)

Negative words, especially two in a row, require more effort from the reader to understand, causing information overload. (Sammons, 1999)

The world's as ugly, ay, as sin
And almost as delightful.
—Frederick Locker-Lampson,
The Jester's Plea

Do the translation for your guests.

- not many \rightarrow few
- not the same \rightarrow different
- not strong enough \rightarrow too weak
- did not remember \rightarrow forgot

One negative is bad, but two or three will confuse anyone

Avoid combining *no, not,* or *never* with verbs that give off negative vibes, like *avoid, deny, doubt, exclude, fail, lack, prevent,* or *prohibit.* First, the reader has to figure out what positive action may have been attempted or asserted. Then the reader has to understand how the action got stopped. And finally, the *not* appears, turning the stop-action back on itself. Beware, too, words that are implicitly negative, such as *unless, however, without, against, lacking.*

- The cancellation form was not accepted by the server. Please do not retry at this time unless the text in fields marked with red arrows has been erased.
- The filtering criteria you submitted have not been rejected, but failed to exclude any known sites.

To completely confuse your readers, combine negatives with passive verbs and our dreaded nominalizations.

- Returns must not be sent unless a cancellation process has been refused.
- We're sorry but privacy concerns cannot be addressed individually, except in non-secure e-mail transmissions.

If you must say NO, say why

Sometimes, you just have to say "No!" If you have to contradict an idiot, deny a statement, or fight against a misunderstanding, go ahead. But rush in afterward with a positive statement.

- We're not geeks. We're just ordinary consumers, like you.
- No surrender! We're going to go on fighting for the environment.

Take a positive stance

Making a positive statement takes more imagination. Instead of telling people, "Don't operate in an unsafe manner," you have to think what safe operation consists of. That takes more effort than merely waving your hand and saying, "Don't get in trouble." But if you can come up with concrete actions that users can take, you increase the likelihood that they will follow your advice. Which sentences would you find easier to act on?

Negative

Don't put tools on the floor.

Don't overload the power supply with nonstandard voltages.

Overboiling could have a negative impact on taste and texture.

Positive

Put tools on the table.

Use only 220 volt power.

Boil for 7 minutes, then drain, for best taste and tex-

EXAMPLES

Before

Caution: do not reject this offer to cancel unless you have already discounted the many benefits of membership.

After

Please reconsider your resignation. We want you as a member, and hope you value the many benefits of membership. To stay a member, click <u>Stay</u>.

Before

Except when verification of income cannot be made because of lack of documentation, applications will not be denied.

After

To make sure your application is approved, please send us documentation so we can verify your income.

Before

ture.

We cannot agree with those negative people who unaccountably deny the reality of freedom of speech.

After

We cannot agree. We believe in freedom of speech.

Before

However often the secure server has identified a break-in, it would not be advisable to prohibit administrative access.

After

The administrator must always have access to the secure server—even if a hacker has broken in.

AUDIENCE FIT

If visitors want this...	How well does this guideline apply?
TO HAVE FUN	Taking a negative position intrigues your readers. But attack with gusto and not too many negatives.
TO LEARN	Negatives rarely work. Teach pluses, not minuses.
TO ACT	People need to know what to do. Telling them what not to do risks confusion, or worse, people doing just what you told them not to do.
TO BE AWARE	Try not thinking of fudge. Negatives have their place when you must disabuse people of established notions. But move quickly to what is true.
TO GET CLOSE TO PEOPLE	A few negatives get a good argument going. Too many, and people tune out.

See: Boomer (1975), Chase & Clark (1972), Clark & Chase (1972), Dewer (1976), Hackos & Stephens (1996), Herriot (1970), Horton (1990), Sammons (1999), Simpson & Casey (1988), Whitaker & Stacey (1981), Wickens (1984), Williams (1990, 1994).

Reduce Scrolling

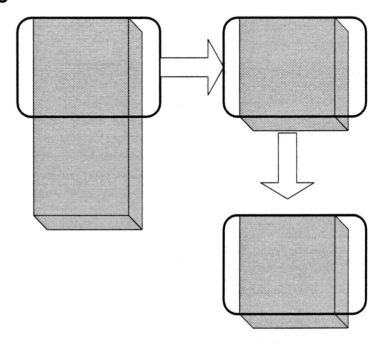

Scrolling disorients some people

You've had the experience. You scroll down, down, down—and discover you've gone past the topic you were looking for. So you scroll up, up, up—and go past it again.

Plus, once you've located and read the topic, you may not be sure where you are on the full page.

> Excessive scrolling can disorient computer users.
> Information that has scrolled off the screen is invisible,
> and therefore harder to remember. (Lynch, 2000)

Readers tend to remember where topics occur within the layout of a printed page. That memory is reinforced by the fact that an item stays put as the person reads through the page. But on the

Web, scrolling moves the item, pushing it out of sight, leaving users uncertain how long the page may be, and where the item may fall within its layout. Users can only see how the item relates to its nearest neighbors. With a fuzzier image of the item's place in the overall structure of the page, people have more trouble remembering the point.

> Very long Web pages tend to be disorienting, because they require the user to scroll long distances, and to remember the organization of things that have scrolled off-screen. (Lynch and Horton, 1997)

Some people don't scroll at all

When Jakob Nielsen first studied users, back in the early days of the Web, he found that only 10% of them would scroll "beyond the information that is visible on the screen when a page comes up" (1996). Year by year, more users are willing to scroll, at times. But many don't bother to scroll below the top of the page.

> Many participants want a Web page to fit on one screen. (Morkes and Nielsen, 1997)

Pack the top

The most important part of your site is the top of the page. That's the only area you can be sure your users will see. So show it off.

> Avoid requiring users to scroll in order to determine page contents. Users should be able to recognize immediately whether the subject of any given page interests them. (IBM, 1999)

Move up any information that you absolutely want to get across.

> For presentations that must grab people's attention to be successful, don't make the page longer than the window. (Levine, 1997)

For most people interviewed, paths were the predominant city elements, although their importance varied according to the degree of familiarity with the city. People with least knowledge of Boston tended to think of the city in terms of topography, large regions, generalized characteristics, and broad directional relationships.

—Kevin Lynch,
The Image of the City

| 227

No scrolling menus, please

The point of a menu is to let people choose between various options. When some of the options disappear, or never appear, the users have to guess, remember what they scrolled by, and they may make the wrong choice, and end up on irrelevant or dud pages.

> Most navigation pages should not scroll.
> (Microsoft, 2000)

But if you have a long list of links that form a single conceptual unit, such as a list of football teams or cities, you can allow scrolling because once people figure out the organizational scheme, they know how to troll for the link they want.

When scrolling is OK

Destination pages can go long. When users find the first screen interesting, they will deign to scroll through a few more screens of text. But not many.

> Users will almost never scroll through very long pages.
> (Nielsen, 1999f)

Try rewriting to make the whole page shorter. Consider breaking the piece up into a series of shorter chunks, linked together. If you decide that the piece really hangs together as a single unit, show the whole article on one page. Users may dislike scrolling, but they hate waiting for another download.

> Content pages should contain one conceptual unit of content. In general, people prefer to scroll to continue a single unit of content like an article, skit, or short story, rather than click from page to page of an article.
> (Microsoft, 2000)

If you have a page that people will want to read at length, a scrolling page is tolerable. But you might provide a printer-friendly version, as we suggest in the next guideline.

Before

```
┌──────────────────────────────────────────────┐
│  ┌──────────────────────────────────────┐      │
│  │//////////Navigation Bar//////////////│      │
│  └──────────────────────────────────────┘      │
│  ┌──────────┬───────────────────────────┐      │
│  │Topic Menu│  About our Interface       │      │
│  │          │                            │ Screen│
│  │          │  ...                       │ Limit │
│  └──────────┴───────────────────────────┘      │
└──────────────────────────────────────────────┘
```

About our Interface

A lot of people see interfaces as just cosmetic, you know, coming afterward, putting a pretty face on the whole product, but not ours. Our interface is not an afterthought. A lot of engineers talk about interface design as if it is all decided in Redmond; whatever Microsoft says, we do that, and, voila, we have an interface. But that is not true. You don't have to do what Bill says. We are more like Mac designers. We see interface as a major part of the product. We work just as hard-early-developing an interface that will be fun as we do developing the combinatorial math that underlies the feature set. We see the interface as a kind of artistic environment. The user is visiting us for the first time, maybe, and we want to show that we encourage exploration, play. That is why everything is one click away. Click and go. Also, everything is reversible. No matter what you do, you can undo. Now some of the pros scoff at our interface, because it makes the process, well, too easy. Tough. For us, if you can't play when you're making art, you should go into accounting.

Screen Limit

After

About our Interface

Our interface is not an afterthought. We work just as hard developing an interface as we do developing the combinatorial math that underlies the feature set. We see the interface as a kind of artistic environment. The user is visiting us for the first time, and we want to show that we encourage exploration. Everything is one click away. Click and go. For us, if you can't play when you're making art, you should go into accounting.

AUDIENCE FIT

If visitors want this...	How well does this guideline apply?
TO HAVE FUN	People who really, really like to read are willing to immerse themselves in very long pages, and prefer reading those to hopping about among arbitrarily short chunks. On the other hand, many people enjoy the breather they get when downloading the next short passage. Play scrolling any way you like.
TO LEARN	If you want someone to learn online, the short chunks work best. If you expect students to print and read off paper, who cares how long the page is?
TO ACT	Out of sight, out of action. Instructions that scroll always lose people. Try to get all the key steps in view at the same time. If not, work within two or three screens.
TO BE AWARE	Scrolling is a religious issue. Practice not getting self-righteous pro or con.
TO GET CLOSE TO PEOPLE	Whatever you write in the first screen determines whether I am willing to go on. In most cases, you should be able to say what you have to without going on and on and on.

See: Black & Elder (1997), Dillon (1994), IBM (1999), Farkas and Farkas (2000), Levine (1997), Lovelace and Southall (1983), Lynch (2000), Lynch and Horton (1997), Microsoft (2000), Morkes and Nielsen (1997), Nielsen (1997, 1999f), Rothkopf (1971).

Let Users Print or Save the Entire Document at Once, to Avoid Reading Any More On-screen

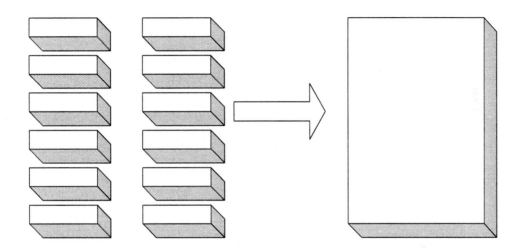

BACKGROUND

Our host has filled many note-books with the sayings of our fathers as they came down to us. This is the way of his people; they put great store upon writing; always there is a paper.

—**Four Guns**

Archive the printer-friendly version

If you have a lot of little chunks making up a long document, offer people a separate page containing the whole document, formatted just for printing. That way, users can save and print without having to jump through dozens of links to see individual portions of the document.

> Most users will save long documents to disk or print them rather than read extensive material online. (Lynch and Horton, 1997)

If the document is long, and built as a linear sequence, its natural medium is paper. You are just delivering that document to the user's printer.

Long, linear-text documents really belong back on paper. Your web site is just an archive for them. (Kilian, 1999)

See: IBM (1999), Kilian (1999), Levine (1997), Lynch & Horton (1997).

POST |

Express your own idea on:
HotText@yahoogroups.com

Subscribe:
HotText-subscribe@yahoogroups.com

Unsubscribe:
HotText-unsubscribe@yahoogroups.com

Visit:
http://www.WebWritingThatWorks.com

My Idea:

Post to HotText@yahoogroups.com

chapter 10 |

Idea #6: Write Menus That Mean Something!

Write a Heading as an Object You Will Reuse Many Times

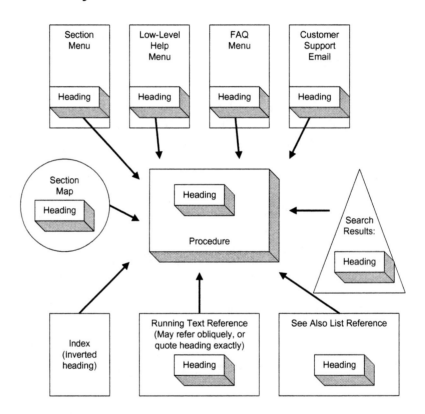

BACKGROUND

A heading must be reusable

A heading does more than describe the content right below it. The heading may appear in many other locations—in a menu at the start of a section, in a FAQ menu, inside running text as a link, in search results, and in other menu-like objects. If the heading is also the title of a page, it appears at the top of the window as well.

Plan to use the same heading over and over—as a single object without modification—in almost every location.

> It is reassuring to users to see an item such as
> Business and Financial Services and, after it has been
> selected, a screen that is titled Business and Financial
> Services. (Shneiderman, 1992)

Avoid making people wonder: "Did I land at the page I wanted, or did I make a mistake? Is this the same section I visited before, or is it subtly different?"

> Headline text has to stand on its own and make
> sense when the rest of the content is unavailable.
> (Nielsen, 1999f)

One exception occurs when you are embedding the heading inside running text, where you lead up to its link, giving some of the context. The full text of your heading may look pretty awkward in this situation. So trim from the end, if you must adjust it. (People expect the beginning text to be the same in both locations).

Generally, though, write so the heading does double duty, acting as the beginning of the article, and—without change—as an isolated advertisement for the contents of that article (as in a menu or search list).

In every circumstance, the heading answers the question: what is this article about?

Write longer headings

Brevity is not a virtue in headings. The purpose of a menu is to reveal all the choices open to a user, but extremely terse headings may be impenetrable, or so general as to be ambiguous. If your team has spent three weeks trying to come up with one-word names for departments, and you keep forgetting the distinction, well, what will your guests think?

> Our menus have to explain what a given function does,
> not just where to invoke it. Because of this, it behooves
> us to be more verbose in our menu-item text.
> (Cooper, 1995)

Make the heading fully expressive of the content, so users can distinguish this section from others like it in a menu or a search list. And if you have a department that posts new articles every week, go beyond the department title to describe this week's column in some detail.

> Promote topics, articles, guests, or features specifically and dynamically (for example, "This week, Jon Stamos on Freudianism in TVTalk") as opposed to generically promoting a section of content (for example "See stars in TVTalk"). (Keeker, 1997)

The menu item (a.k.a. the heading) should be distinctive, specific, and long enough to be clear, but not any longer.

Explain what the article is about using terms that a guest might use. No puns, insider jokes, or metaphors—just the gist of the content. Teasing headlines may get people to click and go, only to find the page is nothing like what they expected. As a result, people grow leery of any heading that might mean several different things, or may glance at its subject sideways.

If possible start off with a keyword, so someone skimming through a search list can spot your article under that topic. Of course, struggling to express the content of the article fully, while distinguishing one heading from another, may make it difficult to put an important, information-carrying word first. No one said writing headings would be easy. But the hard work is worth it because guests rely so heavily on the headings when trying to understand your overall structure, predict content, and make efficient choices.

Make the heading complete on its own, too. Do not depend on some higher-level heading as if it were the beginning of a sentence, completed by this heading. Guests may never have seen that higher-level heading.

Compare your heading with others in its menu

Because people may encounter your heading in a menu before they read the page, edit the heading in the context of the other items on that menu.

Precise knowledge is the only true knowledge, and he who does not teach exactly, does not teach at all.
—Henry Ward Beecher

Thought is subversive and revolutionary, destructive and terrible; thought is merciless to privilege, established institutions, and comfortable habit.
—Bertrand Russell

Group together items that refer to the same thing, and then write each heading so a user can tell the difference between each item in the set. In this way, you help users compare, contrast, and choose.

Ensure that items are distinct from one another. (Shneiderman, 1992)

To show that several headings refer to the same kind of topic (a procedure, say, or a product description), write all these headings in the same grammatical form. Consistency makes people more successful in spotting what the items have in common, and then making a choice.

EXAMPLES

Before	**After**
Introduction	Introducing the Unified Process
Boolean Conditionals	Writing IF, THEN, and ELSE Statements
Organizing	Organizing Your Time in a Plan
Ordering	Putting Sections of a Document in Order
Outlining	Creating an Outline for your Document
Structuring	What Goes on When You Structure a Document
Estimation Fundamentals	1. Starting your Estimate
Pre-submission Circulation	2. Getting In-House Feedback on your Estimate
Follow-ups on Comments	3. Revising the Estimate
Submission Process	4. Submitting Your Estimate to he Client

AUDIENCE FIT

If visitors want this...	How well does this guideline apply?
TO HAVE FUN	When people want to be entertained with double meanings, "punny" headings may amuse. But remember that many guests use search engines to discover your page, and a terse, joking, or abstract heading may repel.
TO LEARN	No jokes, please. We're in school. Flat-footed titles and headings work best.
TO ACT	Make the heading indicate that you are going to tell people how to do something. Use an infinitive, or gerund—*To do*, or *Doing*.
TO BE AWARE	You can't avoid multiple overtones, and deliberate ambiguity, so ignore the guideline.
TO GET CLOSE TO PEOPLE	Straightforward, consistent headings and titles reassure your readers.

See: Conklin (1987), Cooper (1995), Farkas and Farkas (2000), Keeker (1997), Mandel (1997), Nielsen (1999f), Raskin (2000), Shneiderman (1992), Shneiderman and Kearsley (1989).

Write Each Menu So It Offers a Meaningful Structure

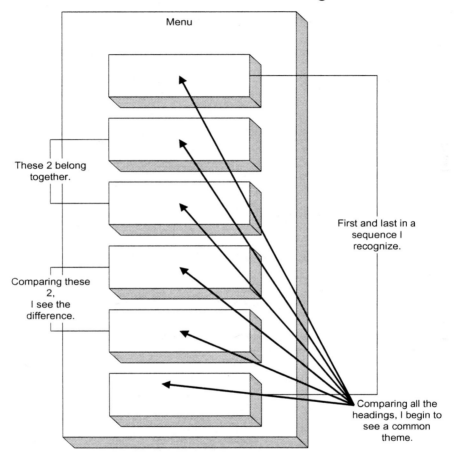

These 2 belong together.

Comparing these 2, I see the difference.

First and last in a sequence I recognize.

Comparing all the headings, I begin to see a common theme.

BACKGROUND | **People learn by discovering structure**

Guests rarely try consciously to figure out the way you have organized your site. But as they look through a menu, trying to understand just enough of the structure to be able to carry out their tasks, people do ask some questions, implicitly, under their breath:

- Why are all of these topics put together in a single menu?
- What do these topics have in common?

It must be possible somehow to read the structure to find good paths.

—Furnas,

Effective View Navigation

- Would the topic I am looking for belong in this menu?
- What information lies behind this item, or that one?
- How are these two topics different?
- Why are these topics grouped together?
- Why do the topics appear in this particular sequence?
- Does this menu really contain everything about the topic I think it describes?
- Which item might contain the information I am after?

As your menu items respond to these questions, in unspoken dialogue, guests begin to form a fuzzy mental model of the menu's structure.

And, visiting several menus, guests begin to sense the structure of the site as a whole. Learning is, in part, a process of uncovering patterns in the material. Menus make those patterns visible—if you write the items well.

> Humans are driven to seek out structure and pattern. By implication, readers will learn the "flow" of your site—but only if you let them. (Sullivan, 1998)

You will understand your material better if you try out various methods of organizing the items on a menu, to uncover new and deeper meanings. Consider several alternate structures before freezing your structure, using some or all of these tactics:

- **Move** topics around considering whether the new structure reveals more about the individual objects and their relationship. (Maybe these items should appear down here.)
- **Eliminate duplicate** or redundant topics. (Oh, this is the same as that!)
- **Annotate** topics, writing preliminary drafts and notes. (Oh, this is what lies behind this phrase. This is what the link leads to.)
- **Add** a topic that was missing or **delete** one that is unnecessary or irrelevant. (Oh, now I see that if we cover x, we must also cover y).

- **Replace** a topic with its components. (Now I see that that term really covered three different subjects, each of which belongs at this level).
- **Divide** a topic into components, putting them on a sub-menu. (Oh, so these are the pieces of that.)
- **Create** a new topic to serve as a menu item leading to a group of subtopics. (Yes, these all go together somehow, and I think this new menu item is the name of their group.)
- **Disassemble** a set of subtopics. (Now I see that these really are not related, and should be parceled out among other topics).
- **Promote** a subtopic or **demote** a topic. (Oh, this is less important than I thought, but this subtopic is actually just as important as other topics on the main menu, and ought to go there).
- **Group** related topics. (Now I see these do belong together).
- **Sequence** activities that take place one after the other. (Oh, these should be in order!)
- **Extend a range** to include items that don't have a natural sequence or grouping. (Oh, this is a lot more common than that, and both are more common than this other thing).
- **Rewrite** to emphasize similarity and difference. (Yes, these items all have to do with the same subject, so the language ought to indicate that.)
- **Verify** that similar topics have similar subtopics. (Well, if Topic A has three subtopics, shouldn't its mate, Topic B, too?)
- **Confirm completeness**. (I'm pretty sure now that I have not left anything out.)

Without knowing the force of words, it is impossible to know human beings.

—Confucius

Building a menu is a process of constant reorganizing. Of course, the effort is like making an outline, which most people fear and hate. But making an outline electronically, as a tool for others to use to understand and navigate your structure, makes sense. Remember, the guest chews your structure to taste your meaning, so you must chop, cook, and serve your material with full attention.

Help people find their way

"Wayfinding" involves picking up cues about your location, putting those together with information you already have, and building up a conceptual model of the structure you are moving through, so you can choose the right path to take next. Menus can either help or hinder this process.

> Situational awareness ...[is the] continuous extraction of environmental information, integration of this information with previous knowledge to form a coherent mental picture, and the use of that picture in directing further perception and anticipating future events. (Whitaker, 1998)

Moving through physical space, we take an egocentric point of view ("I am moving"), and take one step after another ("I go forward, then turn left"). As we go, we build an internal map, using our understanding of our current location, the distance we have traveled, the directions we have turned, the amount of time that has passed during our trip, the relationship between the places we see along the way, and a sense of the unrolling sequence of scenes—navigation takes quite a bit of thinking, all by itself. The clearer this evolving conceptual map becomes, the better it serves to orient and help us as we collect and organize information that we pick up along the way.

Like a physical map, a menu helps guide a guest through your site. The guest has a more-or-less conscious destination in mind, and uses one menu to select a path, then follows that path to another menu, and so on—through a structure that is hard to visualize, often inconsistent, fragmented, and unpredictable.

> Knowing an environment is a dynamic process in which the current state of information is constantly being updated, supplemented, and reassigned salience depending on the short- and long-run purposes that activate a person's thoughts and actions. (Golledge, 1999a)

In completing one discovery we never fail to get an imperfect knowledge of others of which we could have no idea before, so that we cannot solve one doubt without creating several new ones.

—Joseph Priestley,
Experiments and Observations
on Different Kinds of Air

In an unfamiliar territory like your site, a newly arrived guest will often take the first path that looks promising, following a zigzag route through your material without bothering to analyze the structure you have built.

When stumped or curious, the guest may ponder your menus a little more thoughtfully. The menus offer a bird's eye view of the content, somewhat like a physical map, but unfortunately Web menus are usually expressed in text, rather than a two-dimensional image with representations of landmarks, routes, neighborhoods, and boundaries.

Because users are in virtual space, aided only by verbal lists, finding their way around an unfamiliar Web site can be more challenging than exploring a strange city at night. If you want to help these visitors, you must think of each menu as a set of well-lit street signs. The challenge is to organize and write those signs so that visitors can find their way while moving at high speed.

Menus add value

Menus, like tables of contents, site maps, and even indexes, can provide a meaningful structure of objects—a value beyond the simple offer of choices. Write headings to reveal the meaning you see in that structure.

> Help viewers understand the nature of the relationships you use, e.g., use hierarchies or heterarchies of information that embody clear, logical structures. Because viewers become easily bored, disinterested, or irritated with lists of unordered items or links, and have difficulty finding specific information in random lists, create useful organizational structures to support scanning and locating information. (Ameritech, 1998)

Search results and see-also lists do not show any particular structure, because they are assembled "out of order." Your menu reveals more, because you have actually worked on the structure. Let each heading show some of your reasoning about its relationship to the

other items on the menu.

You have organized your menu items in an order that adds meaning and value to the individual sections whose headings appear at the same level in a menu. Write individual headings so that:

- One heading bounces off another, illuminating both.
- Users begin to perceive why certain headings are grouped together.
- Users sense a certain sequence, from the early headings to the last.
- Users begin to get a sense of what this whole section is about.
- Users get a hunch about where the information they want may lie.
- Users form a mental map of the order of topics, a map they will use when they begin navigating the material.

Group and sequence menu items

When experimenters show people a random assortment of objects on a tray and then hide the tray, most people have difficulty remembering more than nine objects. But when the experimenters put the objects into groups, people remember them much more accurately.

Grouping helps people spot the organization of your menu, find what they want, and recall the organization more accurately later.

If you throw a handful of marbles on the floor, you will find it difficult to view at once more than six, or seven at most, without confusion.

—Sir William Hamilton

> The screen layout and organization of menus allow users to assign meanings to the groupings and make both the menus and the individual choices more memorable. (Mandel, 1997)

Group sets of headings that serve the same purpose (five how-to's), describe the same kind of object (seven types of music) or answer the same kind of question (troubleshooting your printer). If the subject matter has common or standard categories, use those to group headings. Doing so reduces the amount of thinking people have to do as they use your menu, because they quickly grok the rationale behind each group, reducing even a long menu to a few groups.

Break up groups visually, too. Then the menu is easier to read.

> Don't let menus just run on with a dozen submenu
> items without offering the eye and the brain some
> grouping clues. (Minasi, 1994)

Then order items within each group and create a recognizable order out of the groups. One way to organize items or groups is to create a range from familiar to unfamiliar, from general to specific, from most commonly used to least, from first to last. Only use alphabetic or numeric order when you have a very long list of items that have no other obvious organizing feature. According to Don Norman's research (1991), these orderings are only slightly more helpful than purely random order. Of course, to hint at your order, you may need to tinker with some of the headings again— more rewriting.

Watch your hierarchy

Grouping headings into menus, submenus, and sub-submenus creates a hierarchy. In general a hierarchy helps people store incoming information and remember it, because people organize the information in their long-term memories (LTM) in hierarchies.

> Chunking or grouping information items facilitates the
> reader in building these LTM frameworks and decreases
> attentional demands because readers can perceive the
> text structure more easily. (Spyridakis, 2000)

So, when you group information items at various levels and provide cues in your writing as to why you organized the items in this way, people begin to understand the underlying information structure.

Experience is a good teacher, but she sends in terrific bills.

—Minna Antrim,
Naked Truth and Veiled

But remember, not too deep. In any area, two or three levels work best, with four to eight choices on each level. According to Don Norman's research, this menu structure results in faster, more accurate performance, compared with more levels containing fewer items at each level. Alan Cooper, who started life as a computer jock,

points out that computer geeks tend to find hierarchies logical and familiar, but most users do not. So, write each heading to indicate why you are putting it together with its neighbors.

Of course, the tradeoff between depth and breadth may be a distraction from the main challenge, which is revealing the menu organization to your users, while reducing the number of pages they have to go through and the number of choices they have to make.

Think of each menu as a jungle gym that users are climbing over. Build it, sand it, and open it up so they can climb quickly, and surely. If you get lazy, your guests will skin their knees.

EXAMPLES

Before
Setup Procedures

- Powering on the monitor
- Powering on the hard disk drive
- Powering on the computer
- Powering on the CD-ROM drive
- Making the connection with the local network
- Attaching cables to computer
- Locating the power cable
- Attaching the power cable
- Finding the right spot to place the computer
- Using an extension cord, power bar, and surge suppressor

After
Setup Procedures

Before you Start
> Finding the right spot to place the computer
> Using an extension cord, power bar, and surge suppressor

Hooking Things Up
> Attaching cables to computer
> Locating the power cable
> Attaching the power cable

Turning on the Power
1. Powering on the monitor
2. Powering on the hard disk drive
3. Powering on the CD-ROM drive
4. Powering on the computer

Getting on Your Network
> Making the connection with the local network

AUDIENCE FIT

If visitors want this...	How well does this guideline apply?
TO HAVE FUN	Only game players like confusing, long menus, because of the challenge.
TO LEARN	Hey, grouping and hierarchies foster long-term memory. Enough said.
TO ACT	Organizing menus in a meaningful way speeds people on their way.
TO BE AWARE	Why not be aware of your guests' needs?
TO GET CLOSE TO PEOPLE	The more time you spend sanding your menu items, the smoother the ride.

See: Abeleto (1999), Ameritech (1998), Apple (1987), Cooper (1995, 1999), Farkas and Farkas (2000), Golledge (1999a), Gregory (1987), Hix & Hartson (1993), Keeker (1997), Krug (2000), Larson & Czerwinski (1998), Lynch (1960), Lynch (2000), MacEachren (1992), Mandel (1994, 1997), McKoon (1977), Miller (1956), Minasi (1994), Norman (1991), Price (1999), Spyridakis (2000), Sullivan (1998), Thinus-Blanc and Gaunet (1999), Whitaker (1998).

Offer Multiple Routes to the Same Information

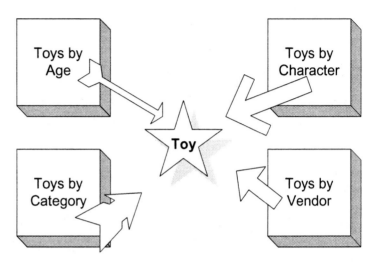

BACKGROUND

1, 2, 3, many menus

To encourage guests to follow their own trail of association, offer multiple menus leading down to the same low-level items. Reuse the same heading in each of these menus. In an online music site, for example, you might let guests browse menus showing different types of music, new items, imports, customer favorites, and highlighted specials. The same CD—a new rap album that is already popular with customers—might appear at the bottom of several different menu chains.

The more access mechanisms the better.

—Hoffman, *Enabling Extremely Rapid Navigation in Your Web or Document*

When people come to your site with different purposes, tasks, and mindsets, you can support them by putting the same heading in multiple menus. In a way, these menus offer different perspectives on your content. Following separate branches of your hierarchy, users converge on a single node, so write the heading and text so they appear to belong to each branch.

> Write nodes in converging branches in a modular style so that they fit the context of both branches. (Farkas and Farkas, 2000)

See Also

Some users come to your page out of desperation, because the heading seemed close to the right topic, even though not exactly right. These guests hope you will point to the right info. For these people for whom your page is close-but-no-cigar, make up shortcut lists and suggestions of See Also links.

> Shortcuts minimize the time and effort users spend navigating, allowing users to bypass the site's hierarchy. (IBM, 1999)

Multiple menus, multiple perspectives

Offering several different menus gives people a chance to follow the paths that make sense to them.

> Provide different site paths to facilitate different shopping strategies. (IBM, 1999)

In this way, you are also offering people different representations of the information and different ways to think about it, so they can follow the model that comes closest to their current concern.

The more you personalize information, the more menus get made up on the fly, to match a guest's profile.

> You need to stop thinking of your Web pages as static files on a server and more like a collection of scripts and intelligent content that can figure out how to display itself correctly. (Veen, 2001)

EXAMPLES

Before	After
Binary Stars	Stars
Black Holes	Binary Stars
Clusters of Galaxies	Black Holes
Colliding Galaxies	Individual Stars
Dark Nebulae	Neutron Stars
Elliptical Galaxies	Nurseries
Emission Nebulae	Open Clusters
Galaxies	Sun
Individual Stars	White Dwarfs
Milky Way	Galaxies
Nebulae	Colliding Galaxies
Neutron Stars	Elliptical Galaxies
Nurseries	Galaxy Clusters
Open Clusters	Milky Way
Planetary Nebulae	Spiral Galaxies
Reflection Nebulae	Nebulae
Spiral Galaxies	Dark Nebulae
Stars	Emission Nebulae
Sun	Planetary Nebulae
Supernova Remnants	Reflection Nebulae
White Dwarfs	

Before

Two ways to find a music CD:

Browse by genre

Search

After

10 Ways to find a music CD:

Top 50

New Releases

Advance Orders

Genres

Artists and Groups

Composers

Labels

Gift Ideas

Seasonal Sounds

Search

AUDIENCE FIT

If visitors want this...	How well does this guideline apply?
TO HAVE FUN	Multiple menus offer even more fun.
TO LEARN	Yes, you can tailor menus to different learning styles, backgrounds, and interests.
TO ACT	Good, because not everyone conceives of the task in the same way.
TO BE AWARE	Everyone is on an individual path, no?
TO GET CLOSE TO PEOPLE	Offering multiple menus is like lending your ear. You're listening to your guests.

See: Bushell (1995), Farkas and Farkas (2000), IBM (1999), NCSA (1996), Veen (2001).

Write and Display Several Levels at Once

Impressions--the Graphic Solution			Search	Order

Corporate Mission	Bacon Look	Brushwork	Artist's Floating Studio
Our Organization	Bonnard Look	Buildup	Boulevard des Capucines
Graphic Tools	Cezanne Look	**Composition**	Breakup of the Ice Floes
Graphic Hardware	Degas Look	Subject Matter	Bridge at Bougival
Imaging Software	Delacroix Look		Camille on Deathbed
Imaging Hardware	Goya Look		Cap d'Antibes
OCR Solutions	Hals Look		Catheral de Rouen 1-6
White Papers	Manet Look		Charing Cross Bridge
Press Releases	**Monet Look**		Green Reflections
Recent Awards	Picasso Blue Look		Thames:Parliament
Wall Street News	Picasso Late Look		Torrent, Creuse
Partners	Pissarro Look		Sunset Seine, Winter
Standards Groups	Rembrandt Look		Water Lilies (1908)
	Renoir Look		Water Lilies at Twilight
			Water Lilies Series
			Waterloo Bridge
			Women in the Garden
			Yacht Races

BACKGROUND |

Organize your guest's impressions

In the Impressions home page, the user clicked Graphic Tools, and the second level menu appeared. On that, the user clicked the Monet look, and the third level appeared. When the user chose Composition, the fourth column appeared with some of Monet's most famous paintings. Simply by clicking around, a user can unveil the entire contents of the site, gradually unfolding columns to find out what lies beneath what. Without going anywhere the guest can explore the complete structure.

Using every spatial and visual hint at our disposal, we should arrange the menus from left to right in some meaningful order. (Cooper, 1995)

Don't hide top-level menus

In the bad old days, every time a user chose an item on one menu, the menu disappeared. The user went to another menu. Then, when the user chose something on that menu, it too disappeared.

In the early days of online help, we regularly confused our users by snatching one menu away to display another. After puzzling people for six months, our team stumbled on the idea of displaying submenus on the same page as the main menu. What a concept!

Immediately the people we were testing sighed with relief. They no longer had to try to remember where they had been. If they happened to guess wrong about a particular top-level item, they could just back up and try another one. The penalty for guessing went way down.

> To help users' short-term memory, menus should not require users to remember information from a previous menu or screen in order to make a selection on the current menu. If that information is needed, the system should present the information wherever it is needed, not just on the original screen. (Mandel, 1997)

We've come to accept the convention that a main menu will remain visible at the top of every page, so people can navigate quickly (and soak up the basic structure of the site). By extending the menu system in columns from one side to the other, in sequence, you can help people remember where they have come from, which also helps them figure out where they are going.

Don't try cascading more than one level where people have to slither over from one column to the next, without slipping off. Most people fail to navigate more than one level of these slippery submenus.

There is no expedient to which a man will not go to avoid the real labor of thinking.

—Thomas Alva Edison,
Placard in his factories

Thinking is the hardest work there is, which is the probable reason why so few engage in it.

—Henry Ford

The recognition of structure gives the mind its ability to find meaning.

—Suzanne Langer

A work has form in so far as one part of it leads a reader to antici-pate another part, to be gratified by the sequence.

—Kenneth Burke

Let users perceive stability

Bruce Tognazzini, former user interface czar at Apple and Sun, liked to say that people hated go-to's. Whenever the background of a page dramatically changes, people register that as going to a new location. Once they perceive more than the magic number of seven (plus or minus two) locations, their short-term memory bursts, and they no longer feel confident that, if asked, they could recite the exact sequence they have traversed.

They begin to feel lost in hyperspace. For example, once, when Jonathan was testing an early version of a help system, a woman ran from the room retching. She threw up some more, and then came back and told him that she felt so disoriented by his hyper-text that she had begun to feel woozy, as if she were sitting in a rowboat in a heavy swell. She had lost her bearings.

When the background stays put, people feel that they have not gone anywhere. Remember those cartoons where Roadrunner zips across the desert in front of mountains? If you look carefully at the individual frames of animation, the mountains stay put, but Roadrunner moves an eighth of an inch from cel to cel. So we feel like we are standing still watching, without changing our position, as Roadrunner goes by.

Similarly, if you keep the main menu steady on the left, and simply expand to the right, most people perceive the scene as sta-ble. They do not feel they have gone anywhere. Result: their inner ear stays calm. That's what Tog calls "perceived stability."

EXAMPLES

Before

The original site showed only one menu at a time—tedious.

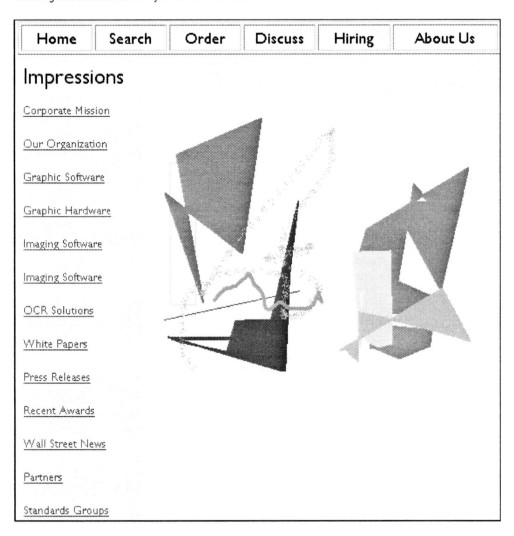

After

The site puts the first level menu on the left side, and when the users choose a topic, opens that topic's second level menu on the right, and so on. Because the background does not change from click to click, the user receives the illusion of staying put.

Home	Search	Order	Discuss	Hiring	About Us

Impressions

Corporate Mission

Our Organization

Graphic Software

Graphic Hardware

Imaging Software

Imaging Software

OCR Solutions

White Papers

Press Releases

Recent Awards

Wall Street News

Partners

Standards Groups

Bacon Look
Bonnard Look
Cezanne Look
Degas Look
Delacroix Look
Goya Look
Hals Look
Manet Look
Monet Look
Picasso Blue Look
Picasso Late Look
Pissarro Look
Rembandt Look
Renoir Look

Brushwork
Buildup
Composition
Subject Matter

Artist's Floating Studio
Boulevard des Capucines
Breakup of the Ice Floes
Bridge at Bougival
Camille on Deathbed
Cap d'Antibes
Cathedral de Rouen 1-6
Charing Cross Bridge
Green Reflections
Thames: Parliament
Torrent, Creuse
Sunset Seine, Winter
Water Lilies (1908)
Water Lilies at Twilight
Water Lilies Series
Waterloo Bridge
Women in the Garden
Yacht Races

AUDIENCE FIT

If visitors want this...	How well does this guideline apply?
TO HAVE FUN	If your guests like guesswork, hide the menus and make them figure out the path. Otherwise, keep the main menu steady and reveal the others gradually.
TO LEARN	Best to show the whole structure, or as much of it as you can, to organize understanding in advance, and build long-term memories.
TO ACT	This method assures faster and more accurate navigation.
TO BE AWARE	The mind likes structure. Even if you are trying to still the mind, revealing your structure gives it less to chatter about.
TO GET CLOSE TO PEOPLE	The less you confuse them, the more they can listen to you, and swap opinions.

See: Cooper (1995), Mandel (1997), Norman (1991), Tognazzini (1992).

When Users Arrive at the Target, Make Success Obvious

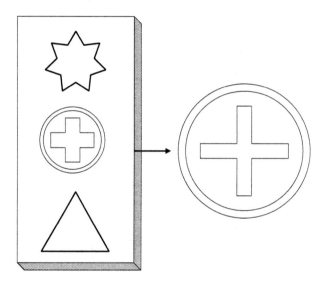

BACKGROUND

Confirm that the link worked

How often have you clicked a link, gone to a page, and wondered, "Did I click the wrong thing? This doesn't look like what I clicked."

Bait-and-switch links tempt you to click, but dump you onto a page where the title has nothing to do with the linktext.

To defend themselves against this common practice, users scope out the target page before settling in for a good read. They look at:

- The **title** ("Is it the same text as the linktext?")
- Any **headings** at the top of the page ("Same topic?")
- Any **introductory text** ("Is this about what I am after?")
- The **caption** under any prominent picture ("Forget the image. Does the text match my expectation?")

Only after some or all of these confirm that the page is on topic, relevant, and interesting, will the user bother to read any more

The greatest torture in the world for most people is to think.

—Luther Burbank

text—or look at those gorgeous images.

To reassure users and confirm they reached the target page they were after:

- Make the title text match the original link—exactly.
- Make the title as descriptive as possible, moving keywords to the front, and assuming users will not see more than 65 characters.
- Make any headings near the top of the page echo the same theme as the title. Ditto for headers (the text that appears at the top of each page in a section).
- Write introductions to sum up the page accurately, to warn people off if the title itself confused them.
- Consider captions as major content and write for the arriving visitor (who may not have looked at the image), rather than an intrigued fan who has just spent thirty seconds looking at the image.

EXAMPLES

Before

Linktext: <u>Help</u>
Title: Frequently Asked Questions

Linktext: <u>Home Office Supplies</u>
Title: So You Need a Stapler?

Linktext: <u>Gardening Tips</u>
Title: Can You Dig This?

Heading: Shoveling and Hoeing
Caption on nearby image: Sun brings out the robins.

After

Linktext: <u>Help</u>
Title: Help

Linktext: <u>Home Office Supplies</u>
Title: Home Office Supplies

Linktext: <u>Getting a New Garden Shovel</u>
Title: Getting a New Garden Shovel

Heading: Choosing the Best Shovel for Your Soils and Seasons
Caption on nearby image: Sharp-edged and shiny, a new shovel signals the start of a new year of gardening.

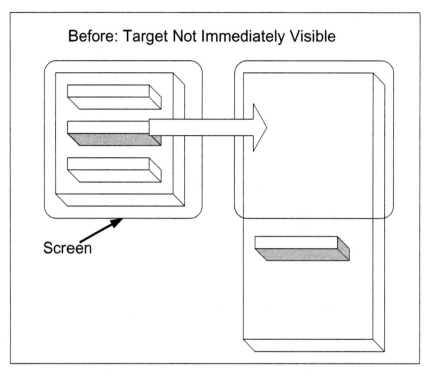

Before: Target Not Immediately Visible

Screen

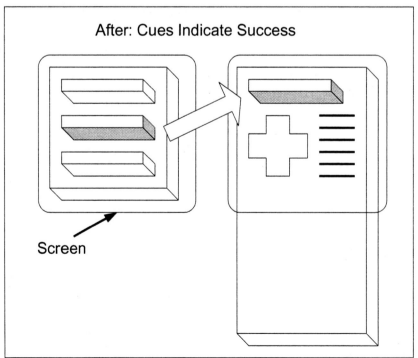

After: Cues Indicate Success

Screen

AUDIENCE FIT

If visitors want this...	How well does this guideline apply?
TO HAVE FUN	The misleading link, the confusing title, the heading that's not apropos, a skewed intro, and off-topic captions can be seen as intriguing, if your audience likes solving puzzles. If they just want to have fun, maybe not.
TO LEARN	Confirm arrival, to avoid distracting the learner.
TO ACT	Not following the guideline simply makes the user think and do more than expected, just to find out how to carry out the original task. Not cool.
TO BE AWARE	Be gentle, even if your prose seems plain. Confirm that your guest has arrived. Pour some tea.
TO GET CLOSE TO PEOPLE	Don't get them angry at you with loused-up links and misleading pages.

See: Apple (1999), Berners-Lee (1995), Krug (2000), Lynch and Horton (1999), Microsoft (2000), Nielsen (2000b), Shneiderman (1992).

Confirm the Location by Showing the Position of This Informative Object in the Hierarchy

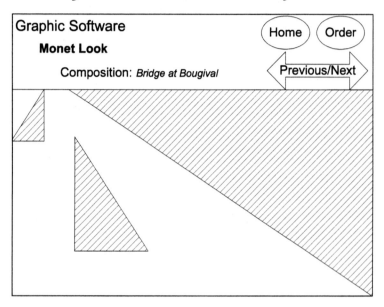

BACKGROUND

You are here

What's the most smudged, worn, stared-at part of the maps displayed in museums, subways, or parks? Right—You are here!

Reading anything goes better when you know where you are in the larger framework—deep in the book, say, or just starting the introduction, or glancing at an appendix way at the back. From that context, you know how to interpret the material. You can fit it into your mental model of the document.

Online, of course, you see no front and back covers, and you do not know how far "in" you are. When most users dive into a site, they lose their bearings quickly, and even a carefully built hierarchy is, in their minds, a mess. Don't assume that users perceive the way a site is organized or the place a particular page has within that organization.

> Start your design with a good understanding of the structure of the information space and communicate this structure explicitly to the user. (Nielsen, 1996)

Tell people what branch of the hierarchy they have landed in. Yes, they may have navigated down the menu system to this page, in which case they really ought to know (but they don't). Or they jumped in from Mars, in which case they have no way to know what area this page lives in.

And within that branch, give people a clue how far down they have gone.

Another reason people want to know where they are is to return later. Without a fairly clear picture of the place this page occupies in the structure of the site, people fear they may never see it again. Yes, they can always bookmark the page, but, hey, that requires an effort on their part, and they may still not be sure the page is worth "bookmarking" when their attention is being drawn away to another page, and another.

Leave a trail of breadcrumbs

Show the path that leads from the home page down your primary menu system to this page. Show at least the first dozen characters of the title of each page beginning with Home, coming all the way down here. Each higher-level title should be hot, so a user can jump back.

- Home/Gourmet/Truffles/French Specialties
- Home/Beauty/Skincare/Moisturizers

The trail of breadcrumbs can help users understand where they are in the structure, if they care to figure it out. (Not everyone cares).

> A breadcrumb navigation list has the benefit of being extremely simple and taking up minimal space on the page, leaving most of the precious pixels for content. (Nielsen, 1999f)

When you show the choices made, from the top level to this level, users know at a glance how they got here—or how they

would have gotten here if they had walked down the staircases from the top level, rather than making a hyper-jump here. That list reinforces their sense of knowing where they are, of navigating through a stable structure.

Highlight the page within a table of contents

If your design always shows a table of contents at the top or side of the page, negotiate to have each page highlighted in the table of contents. Perhaps the table of contents expands a section containing the page and boldfaces the page title. Argue for any device that reveals the main levels of the site.

> Show users where they are. Provide users with a way to know where they are in the context of your site. (Apple, 1999)

Headers help

In a book, a header is the text that appears at the top of every page, indicating the chapter you are in. To programmers, a header is the information at the front of an electronic file, with information such as date, author, and file format; and to HTML jockeys, a header is the HEAD area containing information for programs such as the browser and search engines' spiders. To users of a Web site, though, a header is that thing that appears at the top of every page, along with the main menu and logo.

Headers tell users what the section is about. Appearing on several pages in the same section, they reinforce the title and the major headings, orienting users.

> Use highly visible page headers to provide location feedback. (Microsoft, 2000)

> Button bars can also display location information much the way running chapter headers do in printed books. (Lynch and Horton, 1997)

Remember that moving through hyperspace is like walking through a foreign town peeking through a bandanna over the eyes. Peripheral vision is limited, so users rely heavily on text in bread-crumbs, tables of contents, or headers for orientation.

Going down any path involves uncertainty. It's important to have road signs along the way to let people know when they're on the right track and when they need to change paths. (Keeker, 1997)

EXAMPLES

Before

HOME SEARCH BUY

Departments:

- New

 Breakout Product Wins Big

- Products

 Geneva
 Lucerne
 Zermatt
 Zurich

- Solutions

 Agriculture
 Air Freight
 Automobile
 Construction
 Electronics
 Financial Services
 Publishing
 Steel

- Alliances

 Open Docs
 XML Init

- Support & Services

 Standard
 Premiere
 Repair

- About Us

 Our People
 Our Press Releases

After

HOME MAP INDEX SEARCH BUY

WHAT'S NEW PRODUCTS **SOLUTIONS** ALLIANCES SUPPORT ABOUT US

SOLUTIONS
Agriculture...
Air Freight...
Automobile...
Construction...
Electronics...
Financial Services...
Publishing...
Steel...

AUDIENCE FIT

If visitors want this...	How well does this guideline apply?
TO HAVE FUN	Only the programmer and game player enjoy the complex challenge of getting lost.
TO LEARN	Knowing where you are in an intellectual structure helps you learn.
TO ACT	To move the world, we need a place to put our feet. In your writing, clear the ground and put up a signpost, welcoming visitors.
TO BE AWARE	The mind uses the experience of the body moving through space as a model for even the most intellectual activities. Forgive the senses and cater to them by telling people where they are.
TO GET CLOSE TO PEOPLE	If you forget to show people where they are in your structure, they consider you thoughtless or rude.

See: Apple (1999), Black & Elder (1997), Bransford and Johnson (1972), Farkas and Farkas (2000), Keeker (1997), Lynch and Horton (1997), Microsoft (2000), Nielsen (1996, 1999f), Omanson et al (1998), Siegel (1996).

POST |

Express your own idea on:
HotText@yahoogroups.com

My Idea:

Post to HotText@yahoogroups.com

Subscribe:
HotText-subscribe@yahoogroups.com

Unsubscribe:
HotText-unsubscribe@yahoogroups.com

Visit:
http://www.WebWritingThatWorks.com

part 3

Fine-tune Your Style for the Genres

chapter 11 |

Writing in a Genre

Why Genres Matter

Each separate utterance is individual, of course, but each sphere in which language is used develops its own relatively stable types of these utterances. These we may call speech genres.

—Mikhail Bakhtin,
Speech Genres and Other Essays

The larger your site grows, the more pressure you get from your software, your visitors, and yourself to write generically.

When thousands of pages are being posted every month, the content management software demands that each object of a certain type have the same internal structure, containing the same components in the same order. Why? Because that generic approach to organization will:

- Allow the software to assemble components on the fly, as needed
- Guarantee consistency since each object of a particular type has the same structure
- Speed up searches for content, as the software climbs down the predetermined hierarchy, ignoring branches that do not contain the target objects
- Allow the site team to offer customized content to niche audiences (a manager gets these three pieces, but a worker gets only one of them)
- Allow individuals to make personal selections of the content they really want

But to make all this assembling, searching, reusing, customizing, and personalizing go smoothly, you, as the writer, must work within the confines of a genre.

A genre is a familiar pattern, a way of organizing information that has become so common that readers will probably recognize each new instance as belonging to the genre, such as a catalog, a romance novel, or a FAQ.

In fact, visitors generally prefer that you write in recognizable forms, because as soon as they spot the genre, they can anticipate the information you'll be providing, the basic structure, and the point of view you will probably adopt. All that advance preparation helps them absorb your material, move around in it successfully,

and remember what they read because they can associate the new info with a pattern they already know. Think of how many people go to horror movies knowing what will happen when the innocent girl goes into the dark room. Audiences enjoy knowing roughly what they will get and getting it. Basically a genre makes a promise to the user, and as you write, you have to fulfill that contract.

Of course, writing in a genre seems constricting at first, because it imposes a set organization on your material. Once you internalize the model, though, you begin to work faster. For instance, when you uncover a new fact, you know right away where to put it. When you edit, you know the purpose of each component, and can quickly spot information that is off target, and shift it to the right spot. You become ruthlessly efficient as you tweak individual phrases, because you are clear, at the start, about your stance. Knowing what you are doing tends to make the writing flow.

If you are about to write in an established genre, ask yourself:

- What's the point? Each genre has a widely acknowledged purpose, addressing some particular need, question, or wish, in your target audiences.
- How's it organized? A genre tends to have a standard structure, with predefined components appearing in a certain order.
- What's the right style? With a few variations, a genre tends to dictate a style, by convention.
- Who am I in this context? A genre comes with an expected persona—that is, a character you are supposed to adopt as the writer, indicating your stance toward your readers.

To succeed in writing within a genre you have to recognize, follow, and test these conventions. The best way to grapple with the genre is to look back at why and how it was originally invented.

The conversational model points up the fact that writing occurs within the context of previous writing and advances the total sum of the discourse.

—Charles Bazerman,
Constructing Experience

A genre is born as a response to an audience's questions, needs, wishes, fantasies

Writers don't start genres, audiences do.

A niche audience starts the conversation by asking a certain kind of question over and over in the same general context. For instance, newspaper editors tend to ask, "What's the news item

here? When can I release this? Who can I call for more info?"In response, publicists came up with the generic press release, a fairly standard approach to answering those questions in a methodical way, with a heading, release date, and contact phone number. Through the ongoing virtual conversation between editors and flacks, a peculiar type of text developed—a genre.

A genre starts with thousands of texts created by individual writers in response to real or imagined requests from a group, attempting to resolve some of their anticipated problems, to address their needs, or to appeal to some of their passions. As more people write the same type of text, the audience and the writers begin to recognize a pattern emerging—a new genre.

A genre has a conventional structure

One way to understand the purpose of a genre is to figure out what type of question it answers. For instance, here are some questions that have provoked earlier generations of writers to develop certain genres:

- How do I do x? **Procedure**
- What does x mean? **Definition**
- How is the company doing? **Annual report**
- What is your original idea? **Academic essay**
- What can you do for my organization? **Resume**
- What's the real crime here, and how will it be solved? **Detective novel**

Once the audience has gotten your attention with a broad question, and persuaded you to write in a particular genre in response to that question, you discover that, buried inside that larger question the audience may have a whole set of follow-up questions, which come up in a certain order. In fact the follow-up questions often fall into a nested hierarchy. For instance, within the basic question, "How do I do this?"(which we reply to with a procedure) are smaller questions such as, "What tools do I need to get ready?"and "What should my work look like now?"

In response to questions like these, writers have come up with tool lists ("You need a Phillips head screwdriver") and illustrations inside the steps ("Insert Tab A into Slot B"). So the procedure, as a

genre, has a set of components that must be included and convention—the rough agreement of thousands of writers over many years—dictates a certain way of organizing those components.

For instance, to be a procedure, a text must include at least one instruction, which is a step the reader should take. That step answers the key question, "What do I do next?"

But a procedure may also contain other elements, each of which addresses a particular question the reader might ask in this context. Here are some of the follow-up questions that may lead to particular pieces of a procedure:

- What should I know before I start? **Introduction**
- What's the point? **Goal**
- When should I do this? **Context**
- What tools do I need? **Tool list**
- Is there anything I should do before I start? **Prerequisites**
- What's the basic idea here? **Conceptual overview**
- How does this task fit into the larger process I am working on? **Process diagram**
- What do I do next? **Step**
- What should I watch out for? **Warning**
- What did that term mean, in the step? **Definition**
- Can you give me a hint? **Tip**
- Now that I've done what you said to do, what's the result? **Result statement**
- Do my results match yours? **Illustration**
- What's that strange gizmo in the corner of the illustration? **Callout**
- What does this picture show? **Caption**
- Could you give me an example of the way this step is supposed to work? **Example**
- I did what you said, but it didn't work: now what? **Troubleshooting**

You can see that these questions—and the elements that carry your responses—follow a rough sequence. If you were creating a diagram of a generic procedure, you might draw a nested hierarchy, indicating which elements were optional, and which were required and in what order—a document type definition for the

genre. In fact genres are informal analogies of the content models you create for XML delivery.

A genre acts as a general model, an uncodified but widely acknowledged structure, with an implied style. Each writer, through pressure, inspiration, or laziness, will twist the model a little, to fit a particular context. But even with these variations, writers expect that visitors should recognize that the text is following an established convention with a familiar structure.

A genre has an agreed-upon tone

If you're writing a webzine opinion piece, you may feel obliged to include some embarrassingly intimate personal details, a strong emotional appeal, and a sprinkling of intriguingly irrational exclamations. You're adapting your tone to the genre. But if you're writing a procedure, you are probably going to write in a neutral, almost flat voice, ordering readers about with corporate authority. Each genre has its expected style.

You could write a procedure in prose that is emotionally lush, but you would be moving toward the boundary of the genre. When you write a FAQ, for instance, you know what tone is expected because you have read a bunch of them.

Sure, you can stretch the style, and you should. Adapt the tone for the particular audience, their tasks, goals, and dreams. Press to include your own observations, feelings, attitudes, because you are on the Web, and you are aspiring to actual one-on-one contact with another individual. But recognize that a genre's style has its own boundaries.

The formalist always insists that you should maintain the conventional tone in any genre. But really your job is just to figure out what that conventional tone is, then bend it, twist it, and expand it, taking it right up to the limit. The limit is that break point after which you are no longer writing within the genre—you have entered the realm of parody, pastiche, or joke. OK, but at that point you are probably no longer responding to the audience's original question.

To write a genuine, familiar, or truly English style is to write as anyone would speak in common conversation who had a thorough command or choice of words or who could discourse with ease, force and perspicuity setting aside all pedantic or oratorical flourishes.

—**William Hazlitt**

In matters of grave importance, style, not sincerity, is the vital thing.

—**Oscar Wilde**

A genre demands that you take on a conventional persona

Each genre comes with a few standard personas, a cast list of potential roles for you to play. For example, if you're writing a procedure, you can give friendly explanations, or you can act as an arrogant geek; you can be expansive or tight-lipped, generous or nasty. Often, your organization, and its relationship with your audience, dictate which of the cast of characters you are to play, because a persona implies a certain kind of relationship with your audience.

You may slip into the role without much effort, or you may find it ill-fitting, out of character, and hard to assume. Your personal struggle with the persona will probably show up in your prose style. If you are under immense pressure to act as if the product really works well, when it's a stinker, your prose may become a little defensive or deliberately ambiguous. Your mask may slip off occasionally, as you try to write around those embarrassing flaws in the product, covering up the lousy parts of the interface, overlooking the messy inconsistencies, and pretending that the product works just fine.

The more intensely you feel that the persona you have to adopt is fake, the less certain your prose will be. In that situation, redefine your relationship with your audience. Start writing like a human being talking to a real individual. Of course, you may get fired for your effort, but you'll leave behind some decent prose. But generally, you'll succeed in reaching your audience. Remember: there are several personas available within any genre, and if you don't like the persona that your organization has settled on, consider a change of costume.

Adapt the genre to the forum

The place where you carry on your conversations with your visitors—the Web site, or your particular area within the site—acts as a forum in which several communities come together. Each niche audience has its own vocabulary; its own ideas of what is fashionable, valuable, or innovative; its own arguments and controversies; its own fixed opinions. If you are trying to become a member of

The brain is the neurological repository of the human past, and personae are the hidden masks of our ancestors and heirs.

—Camille Paglia,
Sex, Art, and American Culture

"The writer" is a role, a subject position, constituted by community constraints.

—James Porter,
Audience and Rhetoric

one of these communities, your effort to fit in will affect the way you write, no matter what genre you are working in.

But the forum itself imposes its own rules, values, and style. The forum (including all the people who participate in the conversation there) defines whether a particular topic is required, acceptable, or never to be mentioned; whether one of the genre's component element is really important, optional, or definitely to be included; whether one of the genre's conventional styles really works; whether one persona pleases, amuses, reassures, or bores.

When you first enter a forum, you do not yet understand all the conventions and assumptions of the communities there. You may make mistakes and embarrass yourself. But gradually you become socialized. You learn how to write for these folks.

After a while you outgrow the conventions and start to challenge some of the constraints, dead ideas, and ossified beliefs. Only in this way can you remain in the community, while giving your own perspective on the issues it holds dear, carving out your own identity. You begin to transform the genre, taking it in a new direction, making it more your own.

But to use a genre freely and creatively is not the same as to create a genre from the beginning; genres must be fully mastered in order to be manipulated freely.

—Mikhail Bakhtin,
Speech Genres and Other Essays

Go gonzo once in a while

For your own sake and for your audience, once you have learned how to write within a particular genre, you must push it to the limit, changing it so that it does a better job accommodating your audience, your context, and your own experience. Generic writing may do an adequate job for the audience for a while, but if you do nothing but obey the conventions, you cannot write well, and eventually your audience wanders away.

Take Christopher Locke's project, Entropy Gradient Reversals, a webzine and e-mail list that asks, "Does intelligent life exist in online business?" Locke's alter ego, RageBoy, challenges most of the assumptions of mass marketing and mass media. "RageBoy is all my own worst qualities and character defects, somehow split out into a separate personality, that, allowed free range on the Web, has attained a disturbing measure of autonomy. He is my science-fiction monster run amok." Naturally, stretching the genre of marketing advice to the limit, Locke won thousands of subscribers, who

liked his heretical stance, and, ironically, big businesses paid him a lot of money to come in and do presentations to shock their marketing troops. As Locke says, you may want to go gonzo:

> Everyone needs an outlet for that part of themselves
> that usually isn't allowed to speak at all. Not always to
> be sure, but often, that part has something vital to say.
> It has a certain wisdom, but we repress it, thinking it's
> too weird, too untamed, too out of control.
> (Christopher Locke, *Gonzo Marketing*)

See: Bruffee (1986), Burke (1969), Fish (1980), Foucault (1972), Locke (2001), Park (1986), Phelps (1990), Porter (1992).

POST |

Express your own idea on:
HotText@yahoogroups.com

My Idea:

Post to HotText@yahoogroups.com

Subscribe:
HotText-subscribe@yahoogroups.com

Unsubscribe:
HotText-unsubscribe@yahoogroups.com

Visit:
http://www.WebWritingThatWorks.com

chapter 12 |

Creating Customer Assistance That Actually Helps

Where Can I Get the Answers to My Questions?

Visitors may come to your site with a definite purpose, but get distracted because they do not understand how to navigate through your menus or links, how to fill out your forms, how to place an order, or how to track down a human being in support. They wonder, they suffer doubts, they make strange hypotheses, and they become superstitious. And think about **where** this confusion attacks your visitors.

Often, the visitors get stuck at site-critical moments, such as when the visitors are:

- Filling out a registration form or customer profile
- Wondering whether to provide private information because it might be passed along to spammers and boiler-room phone operations
- Trying to grasp and use the organization of the site through the menu system
- Struggling to find a topic using the search mechanism
- Landing on a page that is close, but no cigar, with no suggestions for related topics
- Trying to get an answer to a question about a product, process, or service, and finding that the content ignores that question, or treats it with the back of the hand
- Wondering whether or not they can return a product easily
- Struggling to pick the right shipping options
- Trying to complete an order and make a purchase
- Looking for a way to get in touch with a human being in support

If visitors fail in these tasks, your site fails. The visitors don't see the information you've written, don't act in the ways your organization hoped for, and most folks leave, never to come back. Better customer assistance might make their visits successful, encouraging another visit. But, to overcome a mediocre interface

If you have an unhappy customer on the Internet, he doesn't tell his six friends, he tells his 6,000 friends.

—Jeff Bezos, Amazon.com

and confusing design, you have to write this material, organize it, and advertise it so it speaks to visitors in terms of their goals.

Assistance gets buried

Web sites often bury their customer assistance, providing almost no explanations on the spot and hiding the detailed information behind confusing or ambiguously named links. For instance, in a survey of the 100 most popular Web sites in mid-2000, we found sites using a confusing array of similar terms for different aspects of customer assistance or for the same content. 75% use the term *Help*, 35% use the term *Customer Service*, 30% use the term FAQ, 20% talk of *Customer Support*, and fully 25% use additional terms. (Yes, that adds up to more than 100% because one site may use multiple terms).

Guests see your site as part of the Web, so, following Web conventions, they tend to expect that a Help button will actually help, and a FAQ link will actually bring up answers. But the links to Customer Service or Customer Support may just bring up e-mail forms. Who knows?

Whatever the term, only 35% of the sites we surveyed put a helpful link at the top of every page, and most of those also put the same link at the bottom of every page. Another 30% of the sites included a link in their side menus. The other sites put links on only some pages, slipped links into running text, or added them mainly to interactive forms. The inconsistent, hit-or-miss approach indicates that almost half the sites regarded customer assistance as something people only need occasionally.

Chaos and indifference is what many consumers experience when using the average site's customer assistance. And many sites treat the writing of customer assistance materials as a kind of janitorial task, something best left to new hires, part-timers, and junior programmers. Little wonder the results drive users away.

The genres of customer assistance

Customer assistance generally takes several forms (shown here with the percentage of the top-100 sites that offer each type):

- Answers to frequently asked questions (FAQs) (90%)

- A bland privacy statement (90%)
- Responses to customer e-mail (80%)
- A separate section devoted to help, organized around tasks, concepts, or departments (65%)
- Phone numbers for customer support (45%)
- Labels embedded within the page on which the visitor is working (40%)
- Instructions during an activity (20%)
- Some kind of customer discussion board (20%)
- Chat with a live customer support person (10%)

Customer assistance shows up in many different forms and locations. Unlike a manual or a help system, Web customer assistance is decentralized, often diffuse, sometimes conflicting with itself or providing multiple overlapping chunks—more like gossip than a publication. This casual approach, in which assistance grows here and there, watered by various departments, means visitors see plenty of innovation, but little coherence.

And guess what? Almost all customer assistance is verbal. Fewer than a quarter of the sites we looked at use any diagrams, screenshots, or animations to show people what they need to know. Most sites seem to think that assistance must equal text. Crazy, but think of the responsibility that puts on the words you write.

See: Price (2000).

Embedded Assistance—Labels, Tips, and Clues

Design the interface as if the product will have no documentation.

—Andrea Ames,
Architecture and Design of Online
Information for Information-Rich
User Interfaces and User Assistance

If you're in the middle of ordering, and wonder how to fill out a slot in the form, or ask yourself what the choices mean, you may have to leave the order, go to the top of a FAQ menu, make a choice, read the material, realize it is not what you want, go back to the menu, choose another item, and, if it is relevant, memorize it, and then return, back, back, back to the form, to apply what you learned, if you can still remember it.

If you have a follow-up question, well, you just have to go through the same routine again.

In testing, we see people go through these loops two, three, four, even five times, just trying to understand one form. Little wonder that sites report half to three quarters of their shopping carts are abandoned before checkout is complete. GO TO is bad practice in programming, and GO TO is terrible for a visitor who just wants a simple answer to a question.

Put the assistance where people need it

Embedding assistance in the interface works best. Just as software should explain itself, your site's interface should offer advice, rather than requiring people to leave the page, go wandering around, find something relevant, and write it on a yellow sticky (or memorize it) and then return and try again. You may need to provide a big pile of information on other pages, in the form of FAQs and Help, but start out by giving people a word to the wise right when they need it.

When asked how useful they considered conventional help systems attached to software, almost three quarters of novice users call it "not helpful." (Two thirds of experts say the same thing). The whole idea of a separate help facility supporting users is antiquated, an echo of paper manuals. Yes, you may need to provide full documentation in a separate place, but you should let guests avoid that big pile, by offering them on-the-spot tips.

Make information part of the interface

Anywhere you want people to act, or where they might need to act, put advice, explanations, or instructions. Build assistance into the interface.

Your aim should be to help keep people on task, to make them successful, and to reduce the need to go elsewhere for information.

Of course, politically, this approach means you must join the design team, and make sure that the page layout has room for these little verbal flourishes. You are no longer creating a whole page about a subject, or even a few paragraphs. You are adding a phrase here, a sentence there, never more than a dozen words, total. You are not "writing about" the site—you are annotating the interface.

Label those fields

How should I enter the date, so your system accepts it? What do you mean, *province*? Do I have to fill in this second address line?

Silly questions. Stupid users, right?

No—stupid interface.

You can smarten up the interface by having it explain exactly how to enter the date. And I'm not thinking of the old-fashioned MM/DD/YYYY code from mainframe applications. You have room to say you want the month, day, and year, in that order, and you can give an example, so people don't accidentally confuse the software by entering March when the programmers expected "3" or, worse, "03."

Please enter month, day, year, like this: 3/25/2002

Notice that we are also trying to make the interface polite. As your mother told you, well-brought-up writers say "Please" and "Thank you," even in these labels.

If a field is required, say so. I know the marketing team worries that saying "Required" over and over again sounds authoritarian, and it is. But you need to make sure that users don't inadvertently miss a field and then press Submit, only to be bounced back to the form with an error message like "Illegal input. Retry." (And, in some cases, all the data has been wiped out of the form, so the user must type it all in again).

Explain why you want the information

If you suspect people will wonder why you are asking, give a paren-thetical explanation. If you are asking for a visitor's mother's maiden name, say why: "So we can make sure it's you calling, if you want to check your account or change your password over the phone."

Yes, a lot of words. But here more words equal more reassurance.

Generally, any request you have to explain belongs on a secure server, and you should be constantly—over and over—stressing that the information will be protected. Make a big deal of your secure server. At least once on every form page, down by the Submit button, state your privacy policy in a sentence, to allay fears and encourage that final click.

Put embarrassing information where they need it

Have you ever put a product in your shopping cart, then gone to check out, entered your credit card number, and gone to a confirmation page only to discover that the shipping charges are outrageous? That happens a lot, because sites feel guilty about the charges, and fear that if you know the shipping costs in advance, you will refuse to buy.

Best practice: put the shipping options—and their costs—on every product page. The costs vary by weight, delivery time, and delivery service. That's understandable. But part of the buying decision involves figuring out the total cost, so visitors need to see these options and the costs before they can confidently go ahead with the purchase.

Test: go to any e-commerce site and see how well they hide their policy on returning products. (Most sites seem to figure that they will avoid returns if they refuse to talk about them or limit their mention to a few cryptic sentences, implying that only Martians need to consider the issue).

Hiding key information is a form of lying. Don't do it. Remember: people have seen elsewhere on the Web, sites that expose all this information at first glance. People know you can do it. So redesign your pages to give people the facts that your team feels may be embarrassing.

Impatient people always arrive too late.

—**Jean Dutourd,**
Le fond et la forme

I think that in order to write really well and convincingly, one must be somewhat poisoned by emotion. Dislike, displeasure, resentment, fault-finding, imagination, pas-sionate remonstrance, a sense of injustice—they all make fine fuel.

—**Edna Ferber**

We're not just talking shipping rates here. Your team knows what facts are most embarrassing, because the reviewers have complained about those aspects of the product, customers keep calling in with questions about them, and your competitors take pleasure in pointing to those weaknesses. Expose yourself then. Overcome the shame and include those facts along with the more positive ones.

How come? On the Web people will find this stuff out anyway, sooner or later. If you tip your hand, right off, they feel they can trust you. If you hide the facts, or reveal them only when you have to (like at the last moment during the order process), you make people mad.

Give examples, even on search forms

If your advanced search offers Boolean choices, such as AND, OR, or NOT, make those into dropdown choices, so someone can build a query without guessing about the punctuation and sequence. But, in addition to the dropdown choices, give examples, right on the search page. Complex filters are great on large sites, but you need to tell people a little story with each choice.

Start by saying what someone wanted. "If you wanted to find a book by an author whose last name is Price, and you know you don't want books by Willard Price..." You are posing the scenario. When people know what the purpose is, they understand the next part of the example much better.

Show the actual syntax. Continue your story with Part Two: the actual action taken. "You would type Price NOT Willard."

Finally, Part Three of your example describes the results, so visitors can see what effect that action had. "You would get a list of all books by authors whose last name is Price other than Willard Price."

Three parts, then: 1) scenario 2) action 3) results.

This tiny narrative helps people see how their own purpose might gibe with the imaginary character, and, if it does, they then discover what action they should take, and, just in case they are still in doubt, they can confirm that the results are what they would expect.

Use examples wherever you know that customers find the

Apple Guide and similar applications permit users to perform actual tasks as they interact with the help system. The guide provides step-by-step procedures that the user can perform immediately, perform with assistance, or allow the system to perform.

—JoAnn Hackos and Dawn Stephens, "Instructional Information," *Standards for Online Communication*

process metaphysical—so abstract that only mathematicians and logicians think it makes sense. Times when you should consider adding examples, right on the page: when users are configuring a system, filling out a user profile, thinking about whether to subscribe, and choosing the most relevant marketing pitch.

See: Ames (2000), Boggan, Farkas and Welinske (1996), Duffy, Palmer, and Mehlenbacher (1992), Horton (1990), Price (2000), Price and Korman (1993).

Case Study: Embedded Assistance at Shop.Microsoft.com

Please indicate the intended use for your purchase (check all that apply).

We have other product and program offerings from shop.microsoft.com and non-Microsoft companies that enhance our customers' computing skills, knowledge, or product use.

Continue on to our secure server for credit card validation.

The Microsoft shopping site holds your hand pretty tightly, with clear labels for sections ("Billing Info," "Shipping Info"), clues about your progress ("Checkout (Step 1 of 2)"), and advice next to groups of fields, such as "Select a shipping option and enter a shipping address if different from your billing address."

You can see that the writers have chosen a pretty clipped style here, opting for the short form of information, ampersands instead of *ands*, and one sentence to explain as many as a dozen fields. The tone is impersonal, but efficient. No joking around, but no hectoring, either.

Unable to explain shipping options in a phrase, the writers offer a link into the middle of a list of Common Questions. Unfortunately, I was deposited at the wrong spot, a few questions below the target. When I scrolled up, I went past the right answer,

and then slowly inched down to the info I wanted. Once I got there, the text went beyond the usual, explaining that shipping times are from the moment the box leaves the warehouse, but it might take Microsoft a day or two to get the box ready. "Expected processing time is two business days." A lot of customers think that "2nd day" means that their package will arrive within two days of the order, and when nothing shows up, they start calling customer support in outrage. Here the writers—twice—emphasize that shipping times start after the package is ready to go. Good job! Of course, I'd like a personal and active style more like, "We usually get your order ready for shipping within two business days. (We don't work on weekends.)" Now that kind of confession would be good for business, I think.

When I clicked FINALIZE my Order, without having filled in my address, I caught hell. First a giant "Attention" came up in red with the self-pitying complaint from the verification routine: "The following errors were encountered." I had 16 errors, all in red, and all in the self-centered prose of system-centric messages, such as "Billing E-mail Address is a required field and was blank or only contained invalid characters." Bad user! Showing me a list like this makes me think I have to memorize each of my mistakes, go back to the earlier page, and atone, line by line. If I forget, I think I will get another lecture. Actually, when I scroll down to the last message, I discover the top of the form again, where, helpfully, the labels of all fields that need data showed up in red. I could have used a little labeling next to or within the list of errors, telling me to scroll down and try again. (But maybe the team never imagined anyone would be such an idiot as to make 16 mistakes on one form, driving the form out of sight).

The tone of these messages is a little like the barking of an accusatory grammar teacher telling me that I have made a series of "errors," I have not done something that was "required," and I may have used "invalid characters." The case against me is pretty damning.

So, despite working hard to offer assistance to customers, the site team sometimes focuses on its own concerns, its requirements—and my sins. They rarely tell me how to fix the problems.

Of 16 error messages, only one tells what to do to fix the mistake (the others tell me what they needed or expected and what data was missing, leaving it up to me to figure out the right way to behave). Net result: despite a good effort at assistance, the team has not completely overcome a tendency to be self-centered and arrogant.

Answers to Frequently Asked Questions (FAQs)

Every sentence I utter must be understood not as an affirmation, but as a question.

**—Niels Bohr,
New York *Times***

When guests get stuck they most often turn to the FAQ, because the style seems friendlier than the average help system, and the genre promises answers to real questions from users, rather than a stonewalling corporate pile of documentation.

Most FAQs adopt a fairly conversational style. That style probably reflects the List Serv heritage, where a list moderator who got tired of answering the same questions over and over would collect all the answers in one file for downloading. Originally, the relationship was personal, or at least one-to-one, as the moderator answered one e-mail after another, and then simply pulled together all the best answers in one place to make the FAQ. The moderator usually had a real interest in helping out, and knew the niche audience very well, being part of it, so the answers often sounded like insider talk.

The basic structure of a FAQ suggests a conversation, where the visitor asks a question and you respond. That give-and-take shows the genre is a pure Internet play.

But, perhaps because of this conversational setting, FAQ sentences tend to ramble. Worse, some writers add clause after clause, and insert subordinate clauses within relative clauses, tossing in some *whens* and *ifs*. A guest who wants to understand may have to pull these multiple clauses apart, parsing meaning out of each piece, and then putting the pieces together to make sense. Tip: Use only one subordinate clause per sentence—and put that clause at the beginning or end of the sentence, because readers find extra clauses easier to absorb in those slots.

Alas, the passive voice also attracts a lot of FAQ writers. Turning an active verb into the passive (transforming "We confirm your order" into "Your order is now confirmed") lets writers avoid saying who or what is doing the action, even though that kind of trick makes the sentence ambiguous, "Your entry is refused." By whom? By what? If no one is responsible, how can a visitor get mad? Easy.

Try 'fessing up by using the active voice. "If you get this message, that means that our database can't understand what you've typed. Please try again, using the tip next to the slot on the form."

Break your paragraphs up. Too many FAQs try to compress the entire answer into a single paragraph, as if that made it a unit. But you're on the Web. People come to the FAQ upset, anxious, angry, ashamed—not in a great mood for reading, and certainly not thoughtful enough to read 10 or 15 lines of prose extending from one side of the window to the other. Got a list? Reach for the bullets. Open that answer up even if you end up using half a dozen paragraphs.

Write the questions in the persona of the guest

Well-written questions—

- "How do I order?"
- "How do I find what I'm hoping to buy?"
- "How do I redeem a gift certificate?"

Notice the "I." The writers are standing in for the guests, speaking for them, phrasing the questions as if they were really coming from the guests. Sure, these questions have been sanded, planed, and simplified way beyond what the average guest might ask. But consider the position from which they are asked: they come from the guest, not the site. Right on!

Not so hot questions:

- "What is the order process?"
- "What is Findoramatic Search?"
- "Gift certificate policy"

These questions are self-centered. They reflect the site's concern with its own policies, concepts, and values. These questions do not sound like what a guest might ask. In fact, the last one is not even a question. Avoid "questions" that are really just labels for content: the point is to evoke a real conversation, even though it is virtual.

Should you start every question with the word *Question*? Sure, if you start every answer with *Answer*. But generally people understand the convention of Q&A, and grasp a boldfaced question without the label.

Students: *"Aren't these the same questions you asked on the exam last year?"*

Albert Einstein: *"Yes, but the answers are different this year."*

Key: Separate the answer from the question. Press Return after the question. Each paragraph has its own function, so it deserves its own location and format. The different look and place suggest taking turns in the conversation, with the users' questions bigger and bolder, as befits their importance, and your answers plainer, and perhaps even indented, to indicate your humble responses.

Create troubleshooting sections

Start with the symptom (not a question), as described by the user (not an engineer). "I downloaded the software, but it won't start." Not "Difficulty in launch."

Sum up the **problem** in terms that your guests would really use, so they can recognize their situation. When most people get in trouble, they describe their problem to themselves, and they use those words when they call or e-mail customer support. If you want people to recognize that you are offering a solution, use their words in the heading.

Then give your **diagnosis** of what may be going wrong, if you have any idea. Identify the diagnosis with a subhead, setting it off, so the anxious user can skip this section, and the curious can learn to perform this analysis.

Break out the **solution** with its own subhead. Usually, this section requires numbered steps if there is a concrete sequence of actions to perform. But sometimes you're offering a handful of options in a bulleted list. Only use numbers if the user must perform the steps in order.

If you face a really complicated problem, use a branching diagnostic. In response to the problem, ask a question and offer all possible answers as links. When the user clicks one, offer the next logical question, and the next, and so on, until you are pretty sure you know what the problem is. Then give the specific fix for that problem.

Branching diagnostics like this are wonderfully helpful. Look at the way Windows Help handles printing problems. The branching means the user is following his or her own path, unaware of all the other possibilities, able to maintain focus.

Worrying is the most natural and spontaneous of all human functions.

—Lewis Thomas,
The Medusa and the Snail

The task is to be aware and sensitive to your customers' expectations and level of upset.

—Ron Zemke and Tom Connella,
e-Service

Give steps

Breaking your instructions out into numbered steps makes them more effective. People understand the sequence better, skip fewer steps, and succeed more often with numbers.

One meaningful action per step, though. Don't try to cram two or three actions into a single instruction, because people do the first, then the third, or get confused. Piggybacking makes your procedure look simple, because there are fewer steps. But the individual steps, clotted with more actions than a user can absorb at once, end up failing.

To do all the talking, and not listen, is greedy.
—Democritus of Abdera

What's meaningful depends on the guest. For instance, beginners find command lines a tough way to interact with a program, and consider typing DIR a major action, and pressing Enter another big step. Of course, experienced DOS aficionados understand "Enter DIR" to mean, "Type these letters and hit the Enter key." Here's a case where personalization can help you differentiate your FAQs by skill level. The instructions for experts generally compress more actions into a single step, and skip most explanations.

Begin each instruction with a verb in the imperative, if possible. Don't say what the user can do, or may do, or might do. Tell them *what* to do. You may feel you are being rude, but bossing the user around is actually a courtesy because you save time, and make clear that the user really must do x, y, or z. No *maybes*, then.

What can you put before the verb? Motives and context. If you have to say why they should do the step, start with the purpose and then move to the action. "To confirm your changes, click Change." If you need to say exactly where to act, put that first. "At the bottom of the license click Submit." In this way, users know up front what the point is, and where to look. Knowing the goal and the locus of operations will help them grasp the instruction better. Also, this sequence follows psychology more closely: first, you have a goal, then you look around for an affordance to operate on, and then you act. (Evaluating whether you have succeeded comes later—in a following paragraph, if ever).

Don't pretend you are writing instructions and then decline into marketing talk. For instance, "3. Using Find Topics is a quick, easy, and powerful way to describe the particular product you may

be looking for." Oh gee, that's wonderful. But that text does not answer the basic question, "What do I do next?" Giving me an ad instead of a step just gets me mad.

Also, don't adopt the system perspective. You are not writing specs, describing how the system is supposed to work. You are giving a user instructions. So you are not responding to the user's needs if you write something like, "The system requires your billing and shipping information." Switch your perspective. "Please enter your billing and shipping information."

Separate the instructions from any explanatory material, putting the explanations in following paragraphs. Each step answers one question: "What should I do next?" The explanations tend to answer ancillary questions, such as, "What does that term mean? What's the result?" So the explanations are different elements, with different responsibilities, and they deserve their own separate identity.

Breaking explanations away from the steps means the impatient user can just read the steps and do those, and never read your explanations. Nervous folks want their sweaty palms held tightly, and seem grateful for the separation, which makes clear "You do this," and "Here's more information if you want it."

Gradually unfolding works better than jamming all the information into a single paragraph. Also, if you are working in an object-oriented environment, you want to identify and omit explanations when you send this stuff out to a mobile phone, or turn it into a quick reference.

Consider, too, the order of explanations, and try to follow the user's likely sequence of follow-up questions. For instance, people usually ask what a particular term means in the instruction, before carrying out the instruction; so a definition of a concept would come pretty close after the instruction before any description of the result of the action.

Whenever people recognize that they are reading a series of instructions, they expect the structure to be strictly chronological. They expect everything—steps, explanations, pictures—to show up in exactly the order they experience carrying out the instructions. This approach seems simple, but if you really try to apply it to your answers, you'll find that in many little ways you have jumped ahead

of yourself, or forgotten to mention some little action you take for granted, or you have actually scrambled the order of steps. Creating good instructions means beating on the sequence until you're certain that you have evoked the moment-to-moment experience.

Handle branching with bullets

The great end of life is not knowledge but action.

—**Thomas Huxley,**
Science and Culture

Occasionally, you reach a decision point. The guests should do X if they want to print, or Y if they want to save. OK: the step should read something like this: "Decide what you want to do now." Then drop in two bulleted items:

- If you want to print, do X.
- If you want to save the file, do Y.

In this way you bring the decision to the attention of the user, which is good, because many users don't realize they have to make a choice. A decision is a meaningful action; it deserves its own step.

The bullets separate out the options. Beginning each one with an *If* clause helps the user decide whether that particular option applies or not. If it doesn't, the user can skip to the next item. In this way, you avoid the peculiarly American problem, where people read an item such as "Do X if you want to print," and press X right away, even though they do not want to print, because they act before they read the whole line. Starting with the IF clause helps make sure they make the right choice.

Go ahead, repeat yourself

Few guests actually read through the whole FAQ. If you think the same caution applies in half a dozen answers, include it in each one. You won't bore anyone but yourself, because only you actually read all of those answers.

For instance, if you have ten answers describing various settings the user can change, but none of these changes takes effect until they complete the current login session, then you better warn them of that little constraint after each answer, so they realize that, even if they have made the change as you suggested, nothing will happen until they log out and log back in. Little stupidities like this often get described only once, somewhere in a note where nobody may stumble on the information.

Cautions should be repeated—wherever the user could get in trouble. By the way, don't call a cautionary passage a *note*, or a *tip*—people often skip sections with those names as unimportant extras. You don't have to put a skull and crossbones next to your cautions or warnings, but you should make clear what they are with labels and special formatting. And don't wait until the end of the answer to mention, "Oh, by the way, back in step 3, if you happened to type the wrong name, the software probably froze up." Better to put a caution in step 3, saying, "Please be careful to type your name right, so you don't confuse our rather simpleminded software." Obviously, your engineers ought to stop ambushing users like this, but until they do, your job is to alert people before they get in bad trouble. If a misstep could result in lost or garbled data, put your caution ahead of the step. If the problems are easier to fix, put the caution right after the step.

Can steps be links?

Yes. If each step is actually described in a separate answer, because it involves several actions, you can tell people, "Enter your credit card information," making that instruction a link to the full details on entering the credit card dope.

Show pictures

As our audiences grow to approximate the general population, people who have trouble reading join the ranks of people who just resent being forced to read on-screen. Even though your work revolves around text, think visually. If possible, make up a storyboard for each important answer showing the key concept or diagramming the process.

Where you have a series of forms you want people to fill out, put a series of numbered instructions at the top of each page with an illustration, and highlight the form the user is on. In that way, as the user moves forward through the sequence, the visuals show progress, while explaining each major step.

Bring that kind of thinking back to the FAQ. Look at the Macintosh manuals, where each step starts with an image on the left, shows a giant number in the middle, and, finally,

over on the right, explains the picture with text. Pictures first, text second—that ought to be your mantra in FAQs.

Show pictures of icons. Show tools. Show screenshots.

Develop diagrams of complex concepts, process flows, and relationships. When the text inside the diagram acts as notes, you are getting through. When the art is so expressive that you do not need to add any text you've achieved the high level of Lego manuals.

Find out if you've answered the question

This ploy takes a lot of guts. At the end of each answer, ask whether you have provided the information the visitor needed.

And what if you failed? Give them an e-mail form, addressed directly to you, personally. You need to find out if your answers are working. And you owe it to the visitor to clear up the confusion.

Only really bold sites do this. But think of the impression they make. A guest reads an answer, and it may make sense, but the guest sees the offer. Wow!

Of course, as the writer, you have to answer a lot of e-mail if your prose is murky.

Keep growing the FAQ

Every time a guest asks a question—by e-mail, phone, chat, discussion board, or mail—you should consider adding the answer to the FAQ. If you believe the answer is already up on the FAQ, ask yourself: How come this particular guest couldn't find that? Or, if they read it, how come they couldn't understand it?

More importantly, recognize that you may not really have answered the question. This morning we had a little battle with Amazon's customer support, because once we had started an order using their famous patented, copyrighted, and trademarked One Click™ process, the damn thing wouldn't let us change the shipping method, even though we changed the settings repeatedly. So we complained. Their first e-mail told us how to change the settings for the One Click process, which, of course, we had already done. Well, maybe the customer service person just hadn't read our e-mail carefully; maybe we didn't make it clear that we had already tried this. We wrote back, asking why we weren't able to

Every man becomes, to a certain degree, what the people he generally converses with are.

—Lord Chesterfield, *Letters*

300

change the shipping method during the One Click process. They responded—nice to get a response, of course—with a full boiler-plate FAQ about all the neat things you can change. Of course, the FAQ didn't recognize the problem we had encountered. Their writer, spotting a problem with changing the settings, just dumped those answers into the e-mail without really reading what we had written the second time. Net result: we were pissed.

Too often FAQ writers act as if the system is always working the way it is supposed to, or the way the engineers say it will. Try the task yourself and keep looking for areas where an ordinary person—like you—might get confused. Invent several scenarios and try each one out, using your instructions. You'll often find problems, variations, and unsuspected gotchas.

And when you feel your answers are really accurate, run a little usability test, the quick-and-dirty way, using half a dozen people to see if they can actually locate the answer and then succeed at acting on it. You don't need scientific proof or statistically meaningful measurements. You just need to watch people struggle with your prose. The experience of watching people not find your answer, not follow it, not understand it, and not succeed can be pretty sobering. Your fingers will begin to itch to rewrite.

See: Boggan, Farkas, and Welinske (1996), Duffy, Palmer, and Mehlenbacher (1992), Horton (1996), Price and Korman (1993), Price (2000), Weiss (1991), Zemke and Connellan (2001).

Case Study: FAQs at AltaVista

Home > Help > Search Help > **FAQ**

Frequent Questions from Searchers

To search for text on this page, press Control-F

 1. How can I improve my search results?

AltaVista, now billing itself as The Search Company, puts its marketing pitch inside the Help pages. For instance, in Help, when I choose the first topic, I am told that searching today is "far easier than ever before." How come? You "don't need to learn any commands." OK! I'm for that. "Just enter words related to what you want and chances are good that useful results will go to the top of the list of matches." I like the phrasing: the odds favor your getting decent hits.

The three-single-spaced-page topic contains thick paragraphs, wall to wall with 10-point Arial text—a daunting prospect, even on paper. The text is thoughtful, thorough, and unmarred with sub-heads, boldfacing, or tables (although these do show up on other Help pages). To escape, I go back to the Help menu and choose the Multimedia FAQ.

The questions are good. Most are simple, and some are even

phrased as if I were asking them: "How can I save an image?"

The answers appear in two to four short paragraphs. But even when the writers deal with a list of things, such as file formats, screen resolutions, or hardware requirements, the text remains resolutely running in paragraphs—almost no bulleted lists for options, no numbered steps for sequences of actions, no tables, just text.

Erudite, articulate text, making good points. Considerate text, recognizing my goals, and acknowledging problems I may face, even offering workarounds and remedies. But passive, *be*-all, *is-was* text, with almost no links to further resources.

I back out and choose Frequent Questions from Searchers. I guess I am a searcher. Here the writers believe in bulleted lists, and they boldface their sample search terms, so the page looks a lot brighter. "We" are talking to "You," which makes clear who does what. When telling me what to do, the instructions often start with verbs in the imperative, which I appreciate, but then some of the steps devolve into several different actions, so I have to reread the text several times just to sort out what I do first, second, and third. And as soon as the writers undertake to explain how the search mechanism works, they get choked up, and start writing ponderous stuff like this: "A search engine is comprised of software that automatically performs many complex tasks." Well, glory be, let me kneel down before the mainframe, and perform a salaam. In general, though, the writers keep their focus on the important players—we and you, our robots, and Webmasters. "Our robots will pick up these changes when they revisit a site or the Webmaster may resubmit the page." There's a little drama, and the writers describe the characters in action making the story pretty easy to follow.

And the writers also recognize that the FAQ may not be the final answer.

> Did This Help Page Answer Your Question?
> If not, try:
> Finding specific information
> Search FAQ from Webmasters
> FAQ for the AltaVista Network
> Or send us E-mail: search-support@altavista.com

When I go to the Frequently Asked Questions about the AltaVista Network I find a new style—numbered steps for actions and short single-paragraph answers for concepts. Crisp and clear, and easy to use.

So digging through the FAQs is like visiting an archeological site, where you can see different layers of ash and bones and pots left by the several generations of people camping there. The effect is not particularly confusing—in fact, I got the feeling that I was looking at ur-altavista material from its inception, tech comm stuff from its days as a Digital brand, and then shorter stuff from its newest incarnation, along with the marketing concepts in the surrounding Help. Various voices, then, are building up the site. But I think the results will vary, too. The most efficient answers—the ones I could put into action with the least thought—came in numbered steps. The least efficient answers were the all-text rambles about, of all things, multimedia (not a picture in sight). Perhaps the writers ought to get together at AltaVista, do some user testing, and agree on a common strategy, which I hope will focus on giving clear instructions.

Help

A Help system may be redundant if you have a FAQ. But once the FAQ grows beyond a few hundred questions, its structure may be hard to navigate. Even when you organize the answers into menu groups concentrating on particular tasks, the fact that every topic is described in the menu as a question may make it hard for users to find precisely the type of information they want, such as a definition or a procedure. Also, many answers combine different kinds of information in a single paragraph, demanding that guests read more than they may want.

Instead of presenting material as a series of questions and answers, Help is often organized around information types such as procedure, reference, concept, definition—and, more rarely, shortcut, troubleshooting, what's new. Looked at as a class of information object, each of these elements responds to a different type of question from the user. By breaking information up into these categories, and signaling exactly what type of information is to be found in each chunk, Help lets people locate the kind of information they want.

Coming from the tradition of documentation, with its dedication to completeness, Help is often more complete than a FAQ, which tends to focus only on the most frequently asked questions. Help quickly fractionates into hundreds or thousands of little pieces, where a FAQ tends to gather together the answers to half a dozen or a hundred questions all on one page.

The differences between Help and FAQs seem to grow out of the history of each genre. Help started as an online accompaniment to software, a hypertext system acting as a substitute or replacement for the manual. Delivered from the user's hard disk or the local server, each chunk appeared quickly, so Help writers could afford to post many small pages, each of which had to be accessed individually. Writers had thousands of tiny chunks they

could throw around. FAQs, on the other hand, started on early Internet list servers, where download speeds were slow. The only content possible was text, so list moderators tended to write omnium-gatherum answers, putting all the answers together in one gigantic ASCII file on the theory that everything was covered there if you would just download, print, and save.

Question: "How do I?"
Answer: Procedure

To understand is hard. Once one understands, action is easy.

—Sun Yat-sen

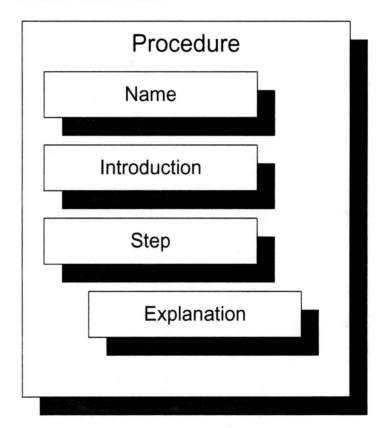

On a Web site, many of the most important questions begin, "How do I...?" We respond with the genre known as a procedure. These instructions are the most important part of Help, because each one promises to take the users one step closer to their goal. To support the individual steps, writers have, over time, come up

with many other components for a procedure, each of which answers a related or follow-up question. Looked at from a high level, the architecture of a generic procedure has four parts:

- What task does this procedure help me do? **Name**
- What should I know before I start? **Introduction**
- What do I do now? **Step**
- Can you explain that? **Explanations**

Naming the procedure. Because your guests will be trying to find this particular procedure among hundreds or thousands of other procedures, write the name to express the procedure's content in terms that the guests actually use (their terms, not yours). Because the name appears as part of a menu, your language should show why you put this procedure into that particular group, at this particular position in the sequence. You need to distinguish this procedure from others like it, while showing, through your choice of words, how they are related (why they belong together on a menu). Neat challenge. In this context, you are writing a single phrase that expresses the content accurately, and acts as a meaningful part of the menu. To add to these constraints, you should adopt a consistent grammatical form for the names of all procedures ("How to..." or "Doing...." or "To do this...."). The point is to telegraph to users that every item with that kind of phrase will be a set of step-by-step instructions. You are articulating the information type, so users can choose a procedure when that is what they want, or skip it when they want some other kind of information.

Introducing the procedure. Americans don't like introductions, but the French do, and many Japanese insist on them. Therefore, you may need to make any introduction into a distinct object, so it can be removed during customization or personalization. An introduction may be justified if you think the user may have questions about the subject of the procedure or the preparations needed. As you explore your audience's skills, knowledge, attitudes, expectations, problems, and goals, you may come to see that certain questions come up fairly often, as they get ready to perform an action. Those throat-clearing questions demand particular components in your introduction.

- What is the purpose of this procedure? **Goal statement**
- When would I do this, and why? **Context**
- What tools do I need? **Tool list**
- What do I have to do first? **Prerequisites**
- Is there some key idea I need to understand before I start? **Concept**

Knowledge is little; to know the right context is much, to know the right spot is everything.

—Hugo von Hoffmannstal,
The Book of Friends

You probably won't have to offer your guests every one of these components. The point is to think through what exactly an introduction can do for people, and decide which of these components, if any, are really needed.

Thinking about the function of each possible element lets you discard a lot of junk. For instance, many designs require an introduction just so the name doesn't butt into the first step, visually— and so writers come up with dud intros. For instance, if the procedure is "How to return a product," then a pointless intro would be, "This procedure shows you how to return a product." Don't commit this kind of nonsense.

Writing the steps. Each step gives an instruction, the raison d'être of the procedure. Here are some battle-tested strategies for writing steps that people can understand and act on:

- **Put one action per step**. Not two or three. (People expect one action per step, and get confused when you try to cram more in. In fact, users often miss the second or third, or do the third before the second, and wonder why the results are screwy).

- **Number the steps**. You increase their effectiveness with numbering. People make fewer mistakes, and keep going in order, when you add numbers. Don't use bullets, which suggest that every item is optional. Numbering may convince people to do steps in order.

- **Begin each step with an imperative**. Give direct orders that make clear what the user ought to do right now. OK, you can explain where to operate, when, or why, ahead of the verb, if you really must but keep that orientation short.

- **When describing the same action, use the same language**. You're not reaching for a cornucopia of phrases here. You just want to say what to do. And if the user ought to carry out exactly the same action, such as clicking, submitting, entering...make sure you describe it the same way each time. Otherwise, people begin to suspect a significant difference, where there is none.

- **Limit the number of steps**. If you get much above a dozen steps, you lose people. Perhaps they need fewer steps than fingers, to keep track of their progress, get a sense of the shape of the procedure, handle it all within a few minutes. We don't know why, but we do know that having more than half a dozen steps risks error, and more than a dozen, well, as the editors say, MEGO. (My eyes glaze over).

Explaining the steps. Make sure any explanations show up in separate paragraphs, because you may want to reuse the steps in many different locations without the relevant explanations. If you offer customization and personalization, people will probably want to be able to pick and choose which types of explanation they want to view or hide. Explanations tend to proliferate if you let them, so find out which questions your audiences ask most often. Then you can decide which elements your audiences want most, out of a list like this:

- What do you mean by that term you just used in the instruction? **Definition**
- What should I watch out for here? **Warning**
- How do I carry out the step? **Note** or **Elaboration**
- Could you give me a hint here? **Tip**
- What's the result? **Feedback** or **Result**
- Could you show me what my work ought to look like? **Illustration**
- What does that show? **Caption**
- But I didn't get that result. How can I recover? **Remediation**
- Could you give me an example showing how this is supposed to work? **Example**

The end of all knowledge is to understand what is fit to be done; for to know what has been, and what is, and what may be does but tend to that.

—Samuel Butler,
Prose Observations

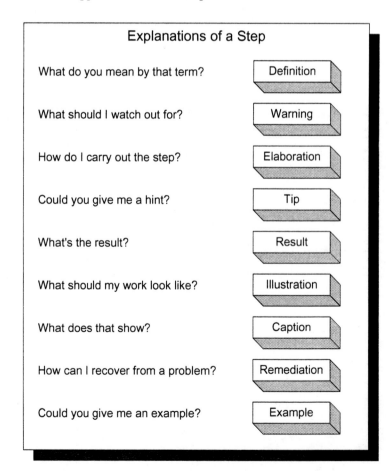

Explanations of a Step

What do you mean by that term?	Definition
What should I watch out for?	Warning
How do I carry out the step?	Elaboration
Could you give me a hint?	Tip
What's the result?	Result
What should my work look like?	Illustration
What does that show?	Caption
How can I recover from a problem?	Remediation
Could you give me an example?	Example

Carving explanations up into separate paragraphs, each addressing a specific type of question, makes the explanations into distinct elements, so you and your users can reuse, include, or exclude them on the fly. Planning several distinct explanation types speeds up writing, too, because you are not trying to weave several different kinds of information together into a compelling paragraph. You are just sorting facts into bins—and in the process, your prose gets simpler, more purposeful, and, because you are just answering one question per paragraph, it seems abrupt.

Yes, some of these paragraphs end up being one sentence. If that answers the question, hey, that's all you need.

Question: "What's that?"
Answer: Reference

Sometimes, people just wonder what an icon, tool, feature, or field is for. If you are thorough, you'll give functional definitions of every part of your site's interface, from the shopping cart to the department buttons. This kind of reference material should be short enough to appear in a rollover, tiny pop-up, or label on the pages. Repeat the info within the Help system, if you offer one, because some people don't realize they can hover to get more information, or click the magic *i* in a circle to get information. And some don't even notice a label.

Focus your description on the purpose of the interface element. "Puts today's date in the form" gets the point across better than a simple noun, "Date."

Your first level of organization will be the parts list, the process flow, or the vocabulary of the programming language. Then each of those gizmos gets a full interrogation—the complete set of questions you've developed, each leading to a particular reference element. For instance, for a command reference, you might answer the following questions with individual elements:

- What's the purpose of the command? **Functional definition**
- What's the syntax? **Syntax diagram**
- What do those parameters do? **Parameters**
- Can you give me an example of the way I would use this? **Example**

- What do I have to do before using this command?
 Prerequisites
- What actually goes on when I issue this command?
 Processing
- What do these messages mean, during the operation?
 Messages
- What results can I expect? **Results**
- What should I watch out for? **Warnings**
- Is there another way to get the same effect? **Shortcuts**
- Is there some more information about this command?
 See Also

Command Description

Question	Component
What's the purpose of the command?	Definition
What's the syntax?	Syntax
What do those parameters do?	Parameters
Can you give me an example?	Example
What's do I have to do first?	Prerequisites
What actually goes on when I issue this command?	Processing
What do these messages mean?	Messages
What results can I expect?	Results
Is there anything I should watch out for?	Warnings
Is there another way to do this?	Shortcuts
Is there more info about this?	See Also

Creating a standard model of reference speeds up your writing because the architecture simplifies your research (you know what to look for), organizes the writing (you know where each fact goes), and reduces the size of each paragraph (once you answer an element's question, you stop).

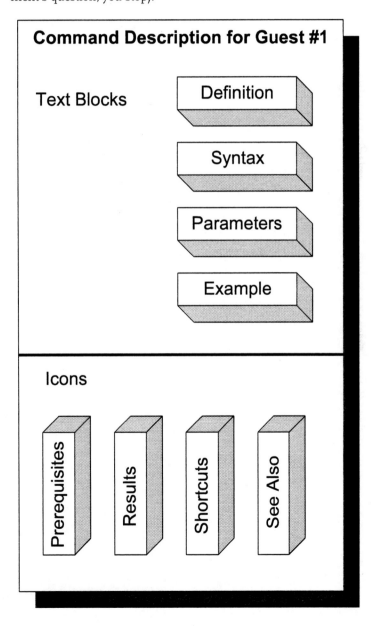

You can also offer guests the opportunity to pick and choose which elements they want displayed in their own personal reference pages. For instance, one guest might choose to have only four text blocks displayed at first—the Definition, Syntax, Parameters, and Example—making icons out of Prerequisites, Results, Shortcuts, and See Also, so that kind of information would be available in pop-up windows, but only when requested. This guest chooses to hide all other elements. A second guest might want even less information displayed initially, choosing instead to have more icons. By chunking your reference material in discreet objects, you make that kind of personalization possible.

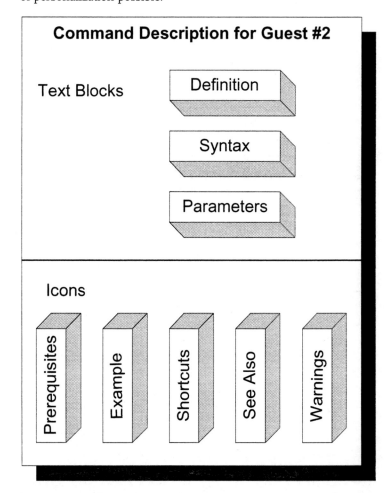

Question: "What's the big idea?"
Answer: Concept

Concept chunks explain an idea, a process, or a relationship. Often, you want to be able to send people to these "About" sections from several different procedures for background information. The problem is that you may be developing the concept from a few notes from an engineer, several drafts of purple prose from marketing, and one oracular statement from the boss.

Sort your information into a structure by answering your user's questions with elements like this:

- Can you summarize this idea for me? **Overview**
- What does that mean? **Understanding X**
- How do I apply this idea? **Using X**
- Where can I find out more? **Resources**

Overview: Start with the familiar and proceed to the new, so people can build their own model, attaching the new ideas to ones that already exist in their head. They understand more that way and remember it longer. Stress the goal—the reason why this concept is important to motivate people to read more. Without that rationale, why should they bother? You're arousing their self-interest by describing a common need, a widespread problem, or a startling opportunity.

Understanding: Put your main point first, because this section

acts like a miniature essay, beginning with the gist of the idea itself, the kernel, and then moving onto the details.

Figure out consciously how you are going to organize those details. The biggest problem with most concept sections is disorganization. Sometimes, writers start off suggesting that the section will follow one order, such as a quick march through history, then veer off into a completely different structure, such as goals followed by methods of achieving them. The structure should echo ordinary patterns of thought:

- Most important to least important. Excellent for impatient readers.
- Familiar to unfamiliar. Best if you are modifying an existing idea, product, or process.
- Most common to least common. Appealing because it postpones the esoterica.
- Chronological order. Very easy to understand, particularly if you are describing a series of actions.
- Problem and solution. Dovetails well with marketing claims.

Whatever structure you decide on, advertise it up front and follow it methodically. In a way, the opening sentences promise the reader that you are going to organize the material in a certain way. Do what you promise, and drop in adverbs and adjectives throughout the text signaling that you are continuing to follow that path. For instance:

The most important...almost as critical...somewhat less significant...a trivial observation.

Ordinarily....often...commonly...not so often...rarely.

Huge...moderate in size...even smaller...tiny.

In this way, you help people anticipate what is to come, and, as they read, integrate new ideas with existing ones, expanding their model of the information in a way that guarantees they will understand, and remember it well.

Using: Explain how the idea actually works in practice. You've led people through its purpose and explained the key aspects of the idea. Now describe how it applies, moving forward chronologically

through a series of decisions. (You're not writing a step-by-step procedure here. You're narrating a process, so you are at a much higher level than individual procedures. If you've written relevant procedures, provide them in links for the person who wants to know exactly how to do one of these chores).

Resources: Conceptual overviews demand intense concentration, and in this situation you can distract people by throwing in a lot of unimportant references.

Postpone any references to white papers, specs, templates, benchmarks, books, backup sites, or standards until the end. By removing these citation links from the rest of the text, you make it easier to read, and you allow a guest to choose to have the resources included or excluded during customization.

Question: "What does this term mean?" Answer: Definition

The simplest definition—a sentence or a phrase—can be offered when someone hovers over the term. You display rollover text just above the term or pop up a little window with your tight definition.

But these brief definitions, being generic, cannot reflect the particular context, so guests often want more information, and many rollovers lack any way for users to click for more info. Even the definitions in pop-up windows (where such links would be possible) seem a bit austere, lacking detail and links to further resources.

To address this problem, some Web sites make key terms into links taking you to a whole page with an extensive description of the term, so that guests can get a fully rounded picture of the topic without going anywhere else. The downside is that guests have to leave the page they were on, in order to understand. The plus is that the target page, offering so much information, may be all the person needs.

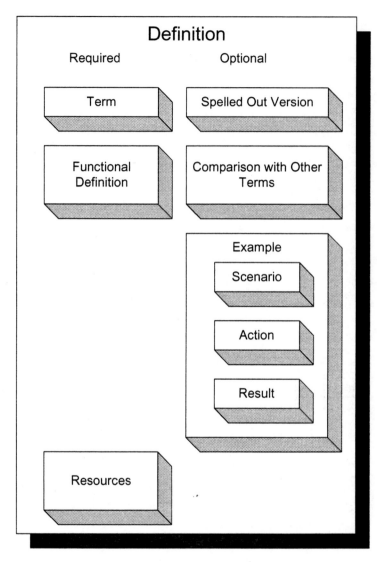

This more generous description starts off like a standard glossary chunk with the term itself, and—if it is an acronym or abbreviation—the spelled-out version. But then the description may include several different definitions explaining what the tool, department, option, or gizmo actually does in different contexts. The key here is functionality: what actions proceed from this thingamajig? Or, more pointedly, what good is it to me?

If the term is often confused with similar or related terms,

devote a section to sorting out those distinctions. How is *Clear* different from *Delete, Kill, Expunge,* and *Erase?*

For each definition, consider including an example. To succeed, an example must set the stage, indicating what the main character wanted to do, describe the action taken, and then report on the results. In this way, your guests can decide whether their goals are similar to those of the heroine before they risk taking the action; and they can consider your description of results to confirm that this is the way they want to go.

Finally, link to resources, giving the full title, and, if relevant, description, date, and status. Your definition chunk should be acting as a pointer to a lot of content, so write these annotated links to let your guests know what they can expect to find out in the ether, before they make a false click.

See: Abella and Clements (2001), Boggan, Farkas, and Welinske (1996), Duffy, Palmer and Mehlenbacher(1992), Hackos and Stevens (1996), Honebein (1997), Horton (1990), Nielsen (1999f), Price and Korman (1993), Price (1997, 2000), Welinske (2001), Wexler (1998).

Case Study: Help at eBay

Learn How to Bid New to eBay? | **Learn How to Bid** | Learn How to Sell | Why eBay is Safe

If you need help finding stuff to bid on, visit New to eBay? Once you find an item you're interested in, take these easy steps:

(1) First, you'll need to register as an eBay member if you haven't done so already. It's free and only takes a couple of minutes.

(2) Carefully look over what you're bidding on. In this example, the item costs $20.00.

The huge auction site eBay grabs newcomers with a big, blue oval superimposed on an orange search bar, right underneath the main menu (Browse, Sell, Services, Search, Help, and Community). "Welcome new users!" Inside the oval is a button urging you to register, plus four more ovals, asking:

- New to eBay?
- How do I bid?
- How do I sell?
- Why eBay is safe.

Clearly, the help team realized they need to catch newbies, and show them how to search, browse, buy, and sell—while reassuring them that they're safe. Each of these pages shows screenshots (what a breakthrough!), with arrows swooping into the key locations, and text on the right giving instructions. At the bottom of each of these beginner pages, they invite people to go to eBay

Education, Help Basics, a Guided Tour of Registration, or a Letter from the Founder. Then, best of all, the Help team includes a riff that they put at the bottom of every Help page: "Still have a question? Search for help on"—and we see another search box with the button Find Help. This convention is great; the team never makes me scroll back up to the top to locate a search box. I also get the feeling that they understand I may not have gotten exactly what I was after, that I may still be looking, despite all their efforts, and their little offer to do another search warms my heart.

The tone of the introduction to each procedure is casual but quick.

> If you need help finding stuff to bid on, visit <u>New to eBay</u>? Once you find an item you're interested in, take these easy steps:

The writers have used a link to take care of the prerequisite (you have to have found a product before you make a bid), inserted the minimal marketing pitch, and casually passed over the self-contradiction involved in offering multiple levels of help on an activity that is, they claim, easy. So we see a lightweight introduction, branching to several other sources of help.

Even the conceptual stuff explaining security is broken up into short chunks, each with a few sentences explaining the idea ("Instantly check the 'reputation' or business practices of anyone at eBay."), and a link letting you learn more or take action.

When I click Help Basics, I go to a page of help on help, showing me 13 different ways to get information—six branches of Help (basics, buyer guide, seller guide, my info, billing, rules and safety), plus online courses through eBay Education, discussions in the Community Help forum, appraisals of an item, advice about improving my listings, a glossary of terms, and top questions (half a dozen answers in each of six categories such as Bidding and Selling). Wow! You can see that the Help team believes in offering a ton of information (we once started printing out every Help page on eBay, but we stopped after 700 single-space pages). Plus, they give you several different paths to the same information, so you could start out in New to eBay, Help Basics, Buyer Guide, or deep

within one of those (for instance, on the Tips for Buyers page) and still end up at the same information about placing a proxy bid. Then, just to be Weblike, the Help team writes up the same subject two or three different ways.

Making sense of the architecture here is a metaphysical challenge. But few users need to work out the structure of these overlapping Help resources (only the staff needs to grok it). What works, in a very hypertexty way, is the sheer abundance of information. If you can't find what you want over here, you'll probably bump into it over there.

Almost every Help page has a Search field at the top, inviting you to explore titles and descriptions if you want, or even run a smart search. (No thanks, I'd prefer a stupid search.) At the bottom of Help pages, usually, there's another search field, with a Find Help button.

Ironically, the top Search only looks at the auctions, while the bottom one, only looks at help pages—a distinction that may not be obvious, despite the difference in button names. Still, once you realize which search form to use, the mechanism delivers a rich set of relevant links to other help pages.

Best of all, when I go to a page that came up in a Help Search, the site recognizes that's why I came to the page, and, at the bottom, asks whether the page really answered my question.

eBay values your feedback. Does this search result answer your question?

Click Yes or No.

This kind of feedback form convinces me that the team is really trying to find out whether their search mechanism works for users, and even though I am only one of three million users, I get to vote. Great idea.

Privacy Policy

As soon as your site asks my name, I get suspicious. Then if you ask for my address, phone number, credit card number, bank names, account numbers, health history, or current job info, I worry about what you are going to do with that information, and I am likely to nudge legislators around the world to order you to protect my privacy.

If your site mines raw transaction data to identify me, to come up with new offers, to sell my name to eager merchandisers, or to run a more sinister scam, you are going to have to explain how you "share" that information within your own family of companies and outside, or else you will be hearing from the lawyers.

How can you avoid lawsuits and reassure your guests?

The makers of our Constitution undertook to secure conditions favorable to the pursuit of happiness. ... They conferred, as against the Government, the right to be let alone—the most comprehensive of rights and the right most valued by civilized men. To protect that right, every unjustifiable intrusion by the Government upon the privacy of the individual, whatever the means employed, must be deemed a violation of the Fourth Amendment.

—Louis Brandeis, dissenting,
Olmstead v. U.S.

Go ahead, reassure me

Two thirds of Internet users are willing to accept a guarantee that you won't abuse their privacy. "We guarantee that we will not violate your privacy." Just the statement is enough—very few of these folks actually read privacy policies.

Of course, about a quarter of the Web population feel extremely nervous about the way their personal information might be used, and these folks are not likely to be placated with a simple statement.

For the rest of the Web world, though, assertions are often good enough. Put a link to your privacy policy on every page, and make a big deal out of going to your secure server when a customer makes that leap, and, whenever you ask someone to fill in a form, put your guarantee right up there.

Does this strategy make you feel a little anxious as a writer? You might want to make sure that your company really will protect the consumer's privacy before you scribble the announcement. An interesting way to probe your organization's honesty would be to volunteer to write an in-depth explanation of their privacy policy.

Your boss's reaction will tell you more than the policy does.

Reward me for exposing myself

If your firm really needs my personal information, give me a reason to take the risk—and the time. Almost two thirds of the folks out on the Internet have parted with their e-mail address and "real" name in order to get access to a site's content, special e-mail newsletters, affinity points on purchases (such as frequent flyer miles), or a chance to enter a sweepstakes. If you offer the opportunity to personalize the site, most say they will give you their real name for that convenience.

People swap info for benefits. So write up the benefits on the page on which you are asking folks to respond to a question, complete a form, or opt into an e-mail.

Let me out

Give me access to my personal profile or account, and let me delete myself. If you give people the opportunity to edit their information, oddly, they provide even more. Almost no one destroys his or her data.

So as soon as you display the personal information, write labels indicating how they can edit it and resubmit.

Since one of the biggest invasions of privacy is spam, make sure that you allow people to opt into your e-mail newsletter twice (once by clicking the checkbox and Submit button, again by responding to the e-mail notification that they can subscribe if they reply). **Double opt in** makes it more likely that people know what they are doing when they volunteer for the e-mail. But let them unsubscribe, and write clear directions for that in every issue. You really don't want to end up testifying in front of some group like the U.S. Federal Trade Commission on something they call UCE—"unsolicited commercial e-mail."

All we ask is to be let alone.
—Jefferson Davis, Inaugural, 1861

Write a privacy policy that people can understand

Unfortunately, most privacy policies are written by lawyers, with headlines inserted by marketing veeps. The tone is schizophrenic. The big type says, "We would never tell," and the fine print inserts

exceptions, excuses, and bland generalities that leave anyone wondering, "Are they sincere?"

Avoid the "We-we's." *We* do this, *we* do that, but what about the user? "We use advanced technology and well-defined employee practices to help ensure that customer data is processed promptly, accurately and completely," says American Express. Thank goodness. American Express feels much better now, but I don't. Those employee practices, in particular, give me an eerie feeling that something isn't being told; for instance, why aren't those practices actually spelled out here, if they are so well defined, and what difference do they actually make to me?

Stop boasting. Politically, you may have a hard time getting rid of bogus phrases like:

- "Our policy is simple."
- "The security of your personal information is of the utmost importance to us."
- "We are in the forefront of the critical issue of privacy."

But make the effort. A ten-page legal document is not simple. Making money is probably more important than privacy. So don't make bogus claims, or you vitiate the whole purpose of the policy, which is to build trust.

Don't pontificate. Guests don't think of you as a philosophy professor, so edit the heck out of the boss's reflections on subjects like "consistent service quality." In fact, try not to sound like the boss. The managerial perspective seems alien to most customers, even when couched in "you" phrases. Take this sentence describing one of the "key values" of Bank One's privacy policy:

> Information must be shared to fulfill your requests, deliver products and services, administer and update accounts, reduce fraud and other risks, and to comply with laws and regulations.

True, but here we are looking at things with the eyes of an Information Technology Officer, or CIO, not a consumer.

Also, watch out for grandiose phrases reflecting defensiveness (why we are forced to collect information about you), self-pity

The free state offers what a police state denies—the privacy of the home, the dignity and peace of mind of the individual. That precious right to be let alone is violated once the police enter our conversation.

—William O. Douglas, Address, American Law Institute

(the darn law makes us tell you these things), or just managerial duplicity (we reserve the right to sell your information anytime we feel like it, but we can't admit that). Lying, of course, is the biggest stylistic problem in privacy policies, and one reason so many people distrust these otherwise bland and boring documents. As a mere writer you can only do so much to force your organization to be honest with consumers. But give it a shot. And if you get a lot of jive talk back, maybe you should pull out your resume for a little update.

Lead up to the jargon, or ax it. Too often the authors of privacy policies assume that the readers know acronyms like SSL, understand the subtle differences between internal and external sharing and selling, and enjoy hearing about encryption standards. Using industry or in-house jargon without explanation simply makes readers suspect that you are trying to pull the wool over their eyes. Sure, you may have to talk about your security precautions, but walk people through these safeguards in plain English before you mention IP addresses. Remember, a lot of people still think cookies are a great snack.

Phrase the policy as a FAQ. People are used to this organization on the Web, and it breaks the information up into digestible chunks, in the give and take of a virtual conversation. Answer questions like these:

- Why do you want to know my name and e-mail address?
- Why do you want to know my credit card number and street address?
- What other information do you track about me?
- Do you collect information from children?
- How do you verify parental consent for information about their children?
- How do you make sure nobody steals my credit card information?
- How do you use this information?
- Do you share my information with other parts of your company?
- Do you share my information with other companies?
- Do you sell my information to anyone?
- What do you do if one of your employees violates my privacy?

- Can I see and change the information you have about me, personally? Can I review information you have about my child?
- How can I start or stop receiving e-mail from you?
- How do you protect the privacy of my e-mails to your customer support team?
- Where can I learn more about my right to privacy?
- Who can I talk to if I have a question about my privacy?

If you can answer most of these questions in a paragraph or two of plain English, you will surprise and please most consumers, even if your legal team has a fit. If you must defend yourself against your own firm's lawyers, do some user testing to show what people understand, and what they don't, in their prose and yours. Then make the case that the document claims to be addressed to the general public, not just lawyers, and so the norms, conventions, and standards of ordinary people are what the text must be judged by—not the stricter, but slippery language that is legally correct.

Explain security before and during the transaction

Don't just dash off a little paean to security in your general FAQ. Explain what makes your server secure, and why that matters to me, as a consumer—before I have to enter my credit card number, and inside any forms I have to fill out to complete the buy.

Point out how your consumers can tell if they are really on a secure server (the change in the URL, the icons that show up on the status bar). In other words, tell people what you take for granted, as obvious, about security. Say more than you think is really needed, and folks will be grateful.

Not too techie, please. Take a shot at explaining encryption, and the Secure Sockets Layer, if you dare. But concentrate on the benefits to the consumer. Most online transactions are safer than a trip to the local dry cleaner (where they keep a paper copy of your information), and a lot safer than e-mail. But trying to explain this fact can be a challenge, particularly when you are really just writing a label on a form.

Sure, you can link to a fuller explanation in the FAQ or Privacy Policy, but make a solid effort to capture the gist of those ideas at the moment of action, so most people don't have to leave the page to learn what is going on.

See: Agre and Rotenberg (1997), American Civil Liberties Union (2000), American Express (2001), Bank One (2001), Davies (2001), Federal Trade Commission (1999), Gilbert (2001), Givens (2000), MasterCard (2001), Porter (1987), Price and Price (1999), Rotenberg (2000), Visa (2001).

Case Study: Privacy Policy at VeriSign

HOME | PRODUCTS | CONSULTING | TRAINING | SUPPORT | CORPORATE

Home > Truste

VeriSign, Inc.'s Privacy Statement
Version 2.2 - September 12, 2000

VeriSign is committed to providing you with excellent service for all of our products. Because we respect your right to privacy, we have developed this Privacy Statement to inform you about our privacy practices for the entire VeriSign site (which covers verisign.com and signio.com).

VeriSign, a company that issues and manages certificates of authenticity for software, Web sites, and even individual documents, is in the business of trust, so they have developed an elaborate privacy statement, following the guidelines of another organization, Truste Privacy Program, which places its seal on sites that agree to follow its rules (and pay a licensing fee). So the VeriSign privacy policy sounds a lot like the policies on other TRUSTe-endorsed sites, but the VeriSign lawyers have added their own special edits. Printed out, the statement takes up eight pages, with seven major headings, and 13 subheads—and 37 very long paragraphs in between.

The team of lawyers start out with an impassioned appeal:

> Because we respect your right to privacy, we have developed this Privacy Statement to inform you about our privacy practices for the entire VeriSign site (which covers verisign.com and signio.com).

The parenthetical comment adds a lawyerly touch. This page exists on the VeriSign site, and its URL begins www.verisign.com. I have never heard of this other site devoted to signio.com. The editorial insertion (in the interests of complete accuracy and legal precision) dilutes the force of the original sentence.

And that's the way a lot of the text goes. Earnest beginnings trail off into legal or technical jargon. Repetitions, acronyms, passive verbs, and weasel words make the prose seem to frown like a judge:

> With respect to VeriSign's Public Certification Services, the VeriSign Certification Practice Statement ("CPS") presents the practices that VeriSign and our affiliates, subscribers, customers, and relying parties follow in issuing, managing, and using certificates and in maintaining a certificate-based public key infrastructure and related trust services. The CPS is intended to legally bind and to provide notice to all parties that create and use certificates within the context of VeriSign's Public Certification Services.

Surely, this kind of talk is aimed at lawyers, not consumers. And, sure enough, in another tangled paragraph, the writers admit that this privacy statement only covers "non-Public Certification Services" for "our site visitors and subscribers." Of course, ordinary visitors like us have no idea what the difference might be. We saw their certification on a public site, so is that covered by this other document, the famous CPS? Who knows? The lawyers forgot to tell us outsiders. But we can tell they have definitely covered their ass.

Getting past the lyric outbursts ("Privacy is of great concern to most users of the Internet and is a critical part of an enjoyable and satisfactory user experience,") and wading through the legalisms, we do discover a few phrases that sound like one person talking to another, albeit a little coldly:

> "...we do not collect personal information from you unless you provide it to us."

"We use links throughout our site to provide you with the opportunity to contact us via e-mail to ask questions, request information and materials, or provide comments and suggestions."

"When you visit our site, our computers may automatically collect statistics on your visit."

The tendency to cover the waterfront (like telling us all the reasons we might ask them to e-mail us) stems from the merging of the legal and the technical mind—both of which hate half thoughts, incomplete statements, and partial truths. So this document is thorough enough to intimidate anyone who might just wonder whether VeriSign was passing along personal information to its licensees. (The answer is yes, but the third parties must sign a confidentiality agreement.) The sentences go long, the lines extend far across the page, and the paragraphs extend to a dozen or more lines. The phrases that answer key questions lie deep within those nests, almost inaccessible to the average reader.

Fortunately, the statement includes the street address, if you care to use snail mail. Ironically, the only e-mail address I could find is for customer support for people who have already purchased something called a Digital ID. The rest of us will just have to put our questions on paper, rummage up a stamp and envelope, put the address on there, and carry our little letter out to the mailbox. Hey, we should hear back within a month or two.

The company seems reliable, even valuable, but the privacy statement is written by and for lawyers and engineers, not the "visitors and subscribers" they claim to be committed to. I get the feeling this statement will work well in court. And, if the aim is to baffle ordinary consumers, keeping the real practices a commercial secret, the statement succeeds. It keeps the policy private.

E-mail Responses to Customers

E-mail lets you answer a lot more questions than you could handle on the phone or by regular mail. You have a few moments to think, and you can write a reasonably personal response without having to dial, wait, go through an extension, interrupt the consumer at work, exchange pleasantries about the weather, and listen to a long historical narrative leading slowly up to the problem itself. So invite e-mail questions from your guests.

Provide detailed contacts with names and pictures, not faceless forms

Invite people to call, e-mail, or write you a letter. Putting up real names and pictures with e-mail addresses, snail mail addresses, and (most daring of all) phone numbers will make people feel as if they actually have a chance of reaching a human being, not some robotic autoresponder.

Plus, if your organization can stand it, you can carve up responsibility for answering customer e-mails, and suggest that if the question deals with printers, this person is the one to write to, but if people are having a problem with a scanner, they should try this other person. You can filter a lot of questions right on the Web site, rather than depending on expensive software to analyze incoming traffic. If you don't dare admit who you are on the site, then spend the money to route the e-mail to the right respondent, within seconds, so e-mails don't end up in the hands of idiots or people who could care less about the issue.

Set up guidelines for responses

Set up an auto-responder to reply within a minute, saying, "Thanks for your message. I'll get back to you within 24 hours." People suspect their e-mail will go wrong. So getting an immediate response is reassuring, even if the text is boilerplate. (Of course, you ought to put your full name, address, and phone in there, too, as evidence of your good faith).

Write as though Mom were reading.
—Nancy Flynn,
The ePolicy Handbook

Then beat their expectations by responding within 6 hours. Don't let a day go by without a response.

You must set some kind of deadline for replies. The sign of a mature site is absolute determination to reply within a few hours. Beginning sites often neglect this little touch, making thousands of customers mad enough to vow never to return.

Set some limits on what respondents can say, too. You can't preannounce products or services, promise repairs that may not materialize, swear that if the reader just follows your advice everything will work like a well-oiled machine.

Develop a styleguide just for e-mail. Define the exact capitalization, spelling, punctuation of product names, departments, technical terms, so you are consistent within your message, and if anyone else writes to the same customer, the text looks as if it comes from the same company. You'll probably want to ban e-mail abbreviations like BTW ("by the way"), and THX ("Thanks") because some people imagine those are airports, or car models.

Make the subject line mean something

You don't want the customer deleting your message, thinking it is just another pitch for working at home, winning a sweepstake, losing weight, spying on people, or getting a diploma without taking a course. Use at least one word from the customer's description of the problem.

The subject line is your friend.
—Jim Sterne,
Customer Service on the Internet

What's the point? You have a purpose: articulate that in your subject line.

If the customer wrote a particular subject line, repeat it. Don't go generic.

Start off recognizing what they said

Your consumer is still a bit suspicious. To capture attention right away, begin your message by writing a sentence that includes the language the customer used. Don't just quote them—that's too mechanical. Think about what they said and apologize for the difficulty, taking care to show you have actually listened to their representation of the problem.

If the customers have sent nasty, snotty, vicious, or stupid mes-

sages, make the effort to put yourself in their position. Try to understand how your site could have provoked such a reaction. Of course, some folks are just jerks, and no amount of empathy will make you respect them. And if you have some smart-aleck comment, tell your neighbor, but resist typing it into your response. Snappy put-downs have a way of turning an irritated customer into a militant adversary.

Deliberately express sympathy and interest

Your job's to help, not poke a customer with a stick. So, within the constraints of diplomacy and your job, dare to say that you are sorry, that you are concerned, that you care.

Even if you are talking about a technical subject, indulge in a little enthusiasm if you can manage it, but don't just throw in a few exclamation points. Real interest shows in nouns and verbs—not smarmy adjectives, and oily adverbs. And never, never go ALL CAPS. That's shouting in your reader's ear. Alas, most businesses discourage the use of emoticons, that wonderful iconic language indicating the tone of voice. ☺

Encourage your feminine side

Gender differences show up in conversations via e-mail, according to some recent research. If the subject is technical, the tradition is male.

> Men come online to give information or give an answer, and in essence, stop the conversation. (David Silver, Resource Center for Cyber Culture Studies)

> Men tend to make strong assertions. (Susan Herring, Indiana University at Bloomington, Information Sciences and Linguistics)

Male-pattern e-mail seems to be abrupt, informational, and aggressive. Men tend to start or contribute eagerly to flame wars, but otherwise aim to limit the amount of interaction.

Useful, practical, to the point—that's the masculine style. But

Women tend to use the electronic medium as an extension of the way they talk—lavishly and intimately, to connect with people and build rapport.

—Joyce Cohen,
He-Mails, She-Mails,
New York *Times*

it's a bit off-putting in an e-mail to a puzzled, upset, angry, or anxious consumer.

The feminine approach to e-mail is to soften most assertions, raise questions, make offers, give suggestions, and throw in a lot of polite comments, to support the other person. In all these ways, women encourage others to engage, according to professors Herring and Silver.

For guys, this style can mean slowing down, indulging in a little thought about the other person, making an effort to be agreeable, and weakening any assertions about what the customer may have done or thought.

Of course, you're writing in public, to someone you don't know. You can be polite without being fake, and you can keep your language gender neutral by talking about "you" not "he" or "she."

Drop in boilerplate answers to common questions

You don't have time to answer the same question a hundred different ways. Settle on a pretty good response, and drop that into the e-mail after you have made a personal connection and expressed your feelings. The boilerplate version should be a very simple, very plain analysis of the problem, with clear steps to remedy it.

Just make sure your boilerplate doesn't give you away. If the standard chunk sounds completely unlike your opening, or refers to an illustration "above," your cover will be blown. Best bet—reread the material in context and make a few edits, to keep the tone and content relevant.

Expression is the act of the whole man, that our speech may be vascular. The intellect is powerless to express thought without the aid of the heart and liver and of every member.

—**Henry Thoreau**, *Journal*

Add a signature block

Let them get hold of you. Put as much of an address as you can stand. Put a favorite quote, if your firm allows it.

Sign your name. What a simple way to personalize a message!

Iron out the wrinkles

Run the spell checker and grammar checker, will you? Don't assume that because so many e-mails look like the senders typed them with their toes, you can get away with typos, left-out words, repeated words, messed-up punctuation.

Open up the page, too. Break up the text into a lot of short paragraphs, put extra white space around headings, and use asterisks for bullets (the dingbats, circles, and squares may not survive e-mail hell). Set your e-mail program to break lines after 65 characters, so, with luck, the reader can see your whole text without having to scroll horizontally, or choose Word Wrap, just to figure out what you are saying.

You don't want irritating little wrinkles to distract the reader from your message, so turn on the iron and apply the steam.

Don't send attachments

You don't know what software the recipient has, so you have no guarantee that the document will appear as you formatted it; in fact, it may just show up as boxes and hexadecimal numbers. Plus, if you have any virus, you can spread it fast with the attachments—not a confidence builder. Some organizations refuse attachments for this reason.

Better to copy and paste. Put the relevant parts of the document into your message.

Many of the problems, and most of the lawsuits, that result from employee use of computers in the workplace revolve around electronic mail.

—Michael R. Overly, *e-Policy*

See: Cohen (2001), Flynn (2001), Hartman and Nantz (1996), Herring (1996), Korenman (1999), Overly (1999), Silver (1997, 2000), Sterne (1996).

Case Study: E-mail Responses from Amazon.com

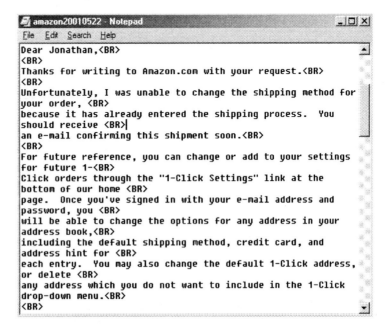

```
amazon20010522 - Notepad                              _ |□| x|
File  Edit  Search  Help
Dear Jonathan,<BR>
<BR>
Thanks for writing to Amazon.com with your request.<BR>
<BR>
Unfortunately, I was unable to change the shipping method for
your order, <BR>
because it has already entered the shipping process.  You
should receive <BR>
an e-mail confirming this shipment soon.<BR>
<BR>
For future reference, you can change or add to your settings
for future 1-<BR>
Click orders through the "1-Click Settings" link at the
bottom of our home <BR>
page.  Once you've signed in with your e-mail address and
password, you <BR>
will be able to change the options for any address in your
address book,<BR>
including the default shipping method, credit card, and
address hint for <BR>
each entry.  You may also change the default 1-Click address,
or delete <BR>
any address which you do not want to include in the 1-Click
drop-down menu.<BR>
<BR>
```

So I was shopping for a book, and I chose the famous patented 1-Click® order, and then I realized I would need the book faster than usual, so I went to My Account and changed the shipping options. Or so I thought. Turns out—I figured out after an hour of fiddling—once you start a 1-Click® order, you cannot change the settings for that order. Any changes only apply to the next order. What I now realize I should have done is cancel that order and start over. But I was too stupid to do that. (Not that the labels warned me that changing my shipping options didn't really change my shipping options right away).

When I got the confirming e-mail for my order, I discovered that I was going to be getting the order at the usual pace (three to five business days, which turns out to be fairly cheap). I immediately e-mailed them—long before the warehouse got around to packing

up the order. I asked them to change the shipping option for that order, and I told them my sad story.

I got an answer back right away. The speed was great. But the customer support person had just copied and pasted the instructions for changing my shipping options in my account. I knew how to do that. I had already said I had done that. It just didn't work—or at least, it didn't work right away, the way I thought it would.

So I wrote back, with a longer version of my tale, apologizing for not having explained my situation very clearly, and begging, yes, begging them to speed up the order.

I got back a very friendly refusal. Gosh, this writer really cared. She wanted me to know she was upset that she just couldn't help, because the order was underway, and, well, there was nothing she could do. She signed her real name, and invited me to write her if there was anything else she could help me with.

I replied. Within a few hours, I got a note thanking me for writing, and apologizing for the difficulty.

> I've passed your message along to the appropriate people in our company—I know they will want to hear about your experience. We truly value customer feedback such as yours, as it helps us continue to improve the service we provide.

Well, having seen how well Amazon.com adapts itself to customer demands, morphing this way and that, I can believe that "the appropriate people" do actually listen, despite the slightly smarmy tone.

Then the writer issued another apology:

> I am really truly sorry that we were not able to fulfill your expectations for this level of service. I hope that you will honor us with another opportunity to prove the quality of our service to you in the future.

Well, OK. I am mollified. I like all those apologies, and I like the fact that the writer is not just stonewalling, or acting like I am an idiot. At least the writer makes an effort to pretend to care. I particularly like the "really truly" part.

But then the writer copied and pasted instructions on adding items, changing quantities, and canceling a 1-Click® order—none of which I had asked about. I wonder why. Perhaps the writer just wanted to be helpful, and thought these boilerplate paragraphs were the closest to my situation. Perhaps the writer didn't read my e-mail very carefully. I was left with mixed feelings—pleased at the speed and volume of response, vertutzt that the responses never addressed the problem I had raised.

Turns out the package arrived within three days, which was fine. I couldn't have read the book when I originally planned to. The crisis turned out to be nothing special, so my anger faded, and I have no reason to nurse a grudge. In fact, what stays with me was the "really truly" emotion that the three different writers put into their e-mails. I had made contact, even though at an odd angle. That's what sticks with me: despite the weird balkiness of one part of their software, I feel an even deeper connection with the folks at Amazon.

POST |

Express your own idea on:
HotText@yahoogroups.com

Subscribe:
HotText-subscribe@yahoogroups.com

Unsubscribe:
HotText-unsubscribe@yahoogroups.com

Visit:
http://www.WebWritingThatWorks.com

My Idea:

Post to HotText@yahoogroups.com

chapter 13

Persuading Niche Markets Individuals, and the Press

Web Marketing Copy

Sure, your boss says your marketing is centered on the customer. The CEO claims dramatically, in slide show after slide show, to live or die by the customer.

But no organization is really centered around the consumer. Customer-centricity is a myth. Your organization may act as a kind of matchmaker between the needs of customers and the products and services that might address those needs, drawing together customers, in-house departments, suppliers, and partners. But the organization itself plays the central role.

> It matches its own resources and those of its suppliers and partners to the preferences and priorities of its customers. Smart companies consider not only what the customer needs, but also what they can profitably deliver. If you want enduring and profitable growth in this era, you must manage customer, supplier and partner relationships in parallel. (Knowledge Capital Group, *Customer Relationship Management)*

With that awareness of your role as spokesperson for your Internet-enabled company, with its train of suppliers and partners, and its conflicting internal groups, you have to tap dance even more adroitly when you write marketing copy on the Web than copywriters used to when they put the same kind of pitch on paper.

And customers online are often focused on a particular task, decision, or problem they want resolved. If they encounter burbling prose online, they get much more impatient than they used to when your firm sent them glossy brochures.

So, despite being urged to include several different marketing slogans in the same piece, your language must sound more Spartan, practical, and useful than ever.

And you must also demonstrate to the consumers that your product is relevant. "Relevance" is a praise word, earned through a lot of encounters with the people you are trying to reach. So...

- **Listen to real consumers**. Study the tapes of focus groups; go out to trade shows and talk with them; devour the e-mails sent into customer service; sit in on customer service phone calls. Sop up their attitudes, concerns, and expressions.
- **Write about your consumers first**. Only mention your product after you have shown you understand their situation with its many challenges. Put the customer at the center of your story and bring the product in by the back door.
- **Look for what moves people**, what lies at the emotional heart of the issue, and infuse your opening with those feelings.
- **Cut the marketing babble**. People hate this stuff online. They hate it more online than they did when they came across it on paper. People consider obvious B.S. "not relevant."

But when you are writing for the Web, your prose gets another round of reviews because you have to pull together conflicting marketing messages, pleasing various in-house constituencies, and you also have to fit into the corporate site, which has its own styleguide, demanding an end to fluff. On the Web copywriting is even more collaborative and iterative than it was when people drafted text for the back of the box, or the take-one data sheets.

As a Web marketing writer, you are in the middle of a whirling gossip mill, taking part in a lot of intense conversations, rarely able to go off in a corner and craft a coherent message. Your prose risks being pulled apart, or, worse, stuffed with snippets from everyone else's messages. How do you stay sane in a crazed Net whirl?

Straight talk

On the Web, marketing doesn't sound quite as sentimental as it does on paper. The twin curses of marketing—hype and fluff—don't work very well on the Web. But straightforward information sells. How ironic—the truth shall make your sales!

And they all gave essentially the same reason: "We have no money in the budget for web content." In most cases the hidden subtext included: "Plus, the higher ups only want our website to say one thing—buy our shit."
—Eric Norlin, on why some clients were canceling plans for creating content, in *The Titanic Deck Chair Rearrangement Corporation Newsletter*

The Internet is most useful for communicating with people who are already interested in learning more about a product.

—Saul Hansell, "Marketers find new avenues on the Internet,"
New York *Times*

A lot of sites where you would expect hype and fluff actually take a very straightforward, information-focused approach to content. (Amy Gahran, quoted in *Little Grasshopper Meets Content Guru* 2001)

The Web consumer has seen that some companies expose all their data on the Web and they expect you will let them see full information about your products, your finances, and your history. They expect neutral advice, not self-serving or snide appeals.

Earnest, honest—can this be marketing?

Having been burned before, consumers fear that any prose you post on your site will be corporate speech, some kind of committee report that hides more than it reveals. In this sense, any prose that sounds like an "official" presentation is suspect.

And interacting with a personal agent, natural language search engine, or diagnostic wizard often seems mechanical because the responses don't adapt to your questions the way a human would in conversation. You can sense that you are dealing with a computer.

Surprise the humans by being one yourself. One day marketing writer Nick Usborne was getting help at iQVC, using their live chat service, and after he'd gotten his question answered, the person signed off saying "Thank you for using iQVC and have a wonderful day." Usborne immediately suspected boilerplate message, and challenged the chat person, who replied, "I'm a real person. Honest." What a great line, thought Usborne. He admits that it's hard to write customer support as if you were a real person, but he suggests giving it a try.

To prove you are human, risk a little stream of consciousness. Ramble. Get confused. Straighten yourself out. Insist on your point, to clean up any confusion.

In other words, don't be too polished. Sure, in official presentations, you'll have to use complete sentences, and you'll probably want to look pretty well organized. But even there you can choose to reveal your own personality.

Avoid using regulation-issue phrasing. Make the headline, opening, and quotes new each time. (Some standard chunks are OK,

such as the corporate history and the contact info).

Admit a few problems. (Does the VP of Marketing really think customers were too stupid to wonder about these issues?)

You don't have to break down and cry, or blurt out the latest gossip about the slowdown in production, or the decline in sales. You just have to find a tone that meets your customer's reasonable expectations and makes a promise that your fellow employees can get behind.

Ask yourself how honest you can make your persona—that invented character who appears to be speaking through you—and how sincerely you can articulate the relationship between you, your company, and the consumer. Despite the pressure, and the tradition of marketing, you can speak for your company in a direct, reassuring, but no-shit tone. Take the Web as an excuse for developing your own voice.

Go gonzo

Television made it possible for there to be 40 different brands of dishwashing liquid. The Internet lets a car maker print fewer brochures.

—Myer Berlow, President of Interactive Marketing, America Online

If you can't put your heart into your text as you write, the words may march along quite nicely, filling up the screen, looking as if they are hard at work, but turning inwardly feeble, bland, lacking in oomph. Hell, you've always known that. But the Web demands more energy, more personal investment, than paper ever did, because the screen's chilliness must be melted, and because the real spirit of the Web is direct conversation with other people—one-to-one. The closer you get to your idiosyncratic self, the more the other person can hear you coming through. Ironically, the best spokesperson on the Web is a unique human being, not a professional corporate clone.

> In marketing, just as in government, professionalism tends to hew unimaginatively to its own timid orthodoxy. It does not provide leadership, enthusiasm, or the kind of impassioned personal engagement that has come to be called gonzo. (Christopher Locke, *Gonzo Marketing: Winning Through Worst Practices*)

When you face brand new micromarkets springing up every

month, you can't start out with demographic data, professional predictions, and careful plans. You just wade in. You have to speak up on newsgroups, discussion groups, e-mail lists, weblogs—the fractured media of the Web—not just your own Web page. But even on your Web site, you are addressing niche audiences (or should be), and you personally may be attuned to one group more than you are to another—make that group your personal target, and leave the other groups to the rest of your team. Grow yourself into being part of those people, and they will no longer look like a market segment; they will be a community you participate in.

But this approach to marketing—more personal, more conversational—demands that you take a less buttoned-down tone on your site. Can you stand it?

Mission 'shmission, who's got the ax?

Most mission statements sound like a committee hoping to inspire deadhead employees while conning the customers. Unfortunately, you usually can't edit these stupid documents because they represent a carefully worked-out consensus (and that's part of why they bore the hell out of most readers).

But you can make the page with the mission statement a little livelier by adding links to pages that prove your organization really practices what it preaches—if it does. For instance, if you have testimonials, case studies, or success stories, create some menus around the key values, with links pointing to this kind of evidence.

Fight to demote the mission statement to a subordinate position somewhere within the About Us section. Scream and yell to keep the mission statement off the home page, where it can put visitors to sleep before they get to the third sentence. Putting all this corporate prose on the first page ignores the fact that the home page is a field of action, a set of menus, a place where people make choices, more like an airport than a billboard. Best move—kill the sucker off.

Product information

Provide more, not less. On the Web, crabbed little one-paragraph descriptions look like dried-up dog poop. You have a lot of

information about the product or service, so give it up. If you are customizing around tasks or market niches, then create a different product page for each group. Within that page, organize around the major questions that those people ask:

- What does it look like? **Product shot**
- What exactly does this thing do? **Overview**
- What good is it to me? **Benefits**
- How do you manage to do that for me? **Features** (subcomponent of benefits, not a lead-in, or peer)
- Can you show me how that works? **Animation, tutorial**
- What are some typical results? **Output** or **results**
- Can you give me technical information? **Data sheet**
- What do other people say about this? **Reviews, testimonials, success stories, case studies**
- How does this product stand out from the crowd? **Competitive analysis**
- What's this product category do, anyway? **White papers**

You can see that multiple product pages link deep into the same backup material. But customizing the product page means that the guest sees that additional material in the right frame of mind.

Overview: Here's where you write the haiku. You're saying why your product, service, or idea is valuable—to this particular niche audience. The biggest curse of paper marketing is the drive to appeal to all comers at once. To simplify your work, make sure you customize the marketing pitches, so you can concentrate on one particular group. That makes your job easier—one key value per niche.

Product shot: Big enough to see the buttons, small enough to download fast. The best e-commerce catalogs use an array of thumbnail shots as the menu—the product names are just tiny little captions, available if someone really wants to read, but not necessary. Reverse the text bias of the Web and make your images hot. (Of course, for accessibility, provide alternate text behind the scenes, so blind people can navigate to your full descriptions).

Benefits (with features): Use gritty prose for these. Sand out the bumpy little cheating adjectives. Pry loose the adverbs that exaggerate, like "immediately," and "automatically." Sure, for most

Copywriting on the Web is like writing song lyrics. ... Too many words, the wrong words, or even words with too many syllables— and you lose your audience. Switching Web sites is as easy as switching radio stations.

—Kathy Henning,
Writing well online:
Talent isn't enough

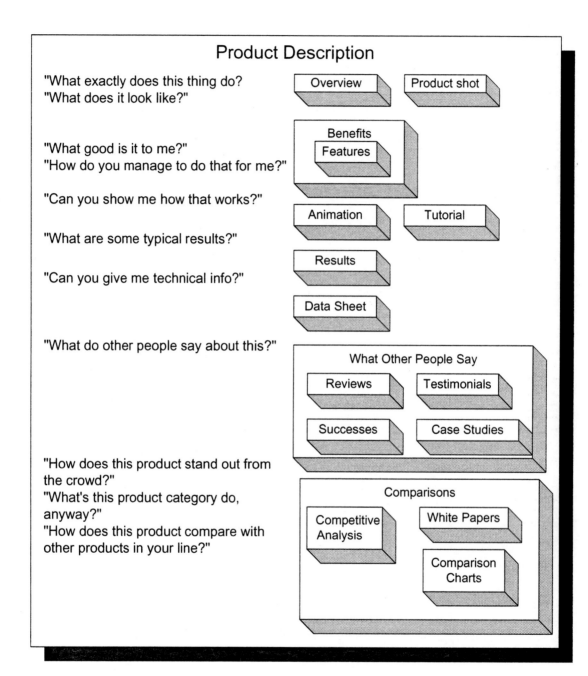

Product Description

"What exactly does this thing do?
"What does it look like?"

Overview Product shot

"What good is it to me?"
"How do you manage to do that for me?"

Benefits
Features

"Can you show me how that works?"

Animation Tutorial

"What are some typical results?"

Results

"Can you give me technical info?"

Data Sheet

"What do other people say about this?"

What Other People Say

Reviews Testimonials

Successes Case Studies

"How does this product stand out from the crowd?"
"What's this product category do, anyway?"
"How does this product compare with other products in your line?"

Comparisons

Competitive Analysis White Papers

Comparison Charts

niches, the benefits are primary, the features secondary (more like proof you can really bring the benefit), but for engineers you may want to organize this differently—with features trailing brief benefit statements. Either way, watch out for enthusiastic cover-ups—you know, the kind that come down from on high, where the VP of Marketing has agreed to cover up some defect or slide past a missing feature that most of the consumers want. The biggest lies involve glossing over problems, not mentioning difficulties, and pretending something really works the way people hope. Omission is a sin, here. Battle to get permission to admit you don't handle something, rather than adroitly leaving it out and letting the customers discover it later, ha ha, after they have made the purchase. Compare:

Lets you save your pictures in popular Web formats.

Lets you save your pictures in Web formats gif and jpg (but not png).

The first sounds more reassuring. The second sounds more honest. Which one will work best on the Web? Ironically, on the Web, the second one will sell better, because you are proving you are trustworthy.

Animation or tutorial: Sure, these are amusing, but they take a lot of time to download, and they break unexpectedly and disappoint. Give these low priority. If you decide to do the storyboards, walk through the action frames over and over, beating on them, to make sure you are really moving forward one meaningful step at a time. Often, writing an animated demo or a tutorial involves slapping your head and saying, "Oh my gosh, but before that, I have to put this in." Like a teacher, you'll find you keep having to go back and back and back, to insert material you took for granted or forgot to mention, but need to cover first, in order to get to the juicy parts. (If you have no background in training, teaching, or instructional design, get someone who does to check your material several times). Then test the heck out of your prototypes, even if you have to use paper mockups. The more you test, the smoother the

sequences will roll. In our experience, some very simple beginner tutorials have worked well as presales demos, even though we hadn't originally planned them that way. One odd recommendation from testing these "educational" demos—keep the progress extremely simple. You know the material inside out, but the guests don't, and out of impatience you may be tempted to rush through explanations, skip key moments, and roll the video at a furious pace. Don't. Let people take their own time with these things, and they will advance much more slowly than you would. You'll cringe as you watch them through the one-way mirror, but often, they come away beaming, because they grokked the whole concept. If you feel the pace is embarrassingly slow, you are probably moving at the right rhythm for your audience, because the material is much less familiar to them, and they need time to absorb it.

Results: Give me the payoff. What's the return on investment—a dramatic improvement in reading scores, successful launch rate, or whatever? Make an effort to pull these numbers, tables, and charts out of product managers, who guard them nervously. Customers long for any proof that your product works.

Data sheet: OK, these are all the facts and figures that the geeks and engineers want. Let them come here right away.

Organize these around major features, rather than benefit clusters, because this list reflects the structure of the product, as seen by insiders, professionals, and experienced users. Keep the prose tight, more like a database report than running text.

What other people say: Assume that nobody trusts you, and you have to bring in piles of evidence. Links to reviews posted on other sites give you independent support. Success stories and the more sober case studies are a little more suspect because you write them—narratives in the heroic mode, where a team faces a big problem, and, thanks to your product or service, triumphs. The more quotes and faces you use the better, because you want a rich air of verisimilitude. Even better—the e-mail address or phone number of the project lead, who offers to talk to future customers. You may never be able to get a partner to do this, but if one agrees, your story seems more trustworthy, even if no one actually makes the call. Testimonials—short quotes, like blurbs on a movie ad—help a little, but because they are taken out of context, they cannot do more than

The best brands are built at the intersection of what the consumer wants and what the brand offers. How you find that meeting point is research.

**—Amy Palmer,
Senior Planner, Leo Burnett**

suggest a groundswell of enthusiasm for your offerings.

Comparisons: If you have a lot of products, campaign to get the site to offer side-by-side comparisons, so a potential customer can see which features each has, at what price, gauging priorities, working out a compromise, and settling on the perfect product. Going back and forth from one page to another makes this kind of comparison difficult. Printing out each page and laying the sheets out on a desk is also frustrating. You've got a site, so make it do something useful. You may have to reassure product managers that these comparisons do not damage anyone's product because the customer is trying to work out a balance between cost, features, and glamour, and that thought process is personal, and requires a lot of back-and-forth comparisons. By making thought convenient, you take a big step toward a sale—any sale. So comparison tables benefit the firm as a whole, and, really, bring several products to notice at the same time.

Competitive analysis: This is best kept to yourself because attacking the competition always leads to counterattacks, and then you both look bad. But if you're in a tough competitive battle, and you really feel you have to ding your direct competitors, write carefully. You don't want to give the customer reason to think you are being petty, so focus only on important differentiators. You don't want to sound like a whiner, kvetcher, or gossip, so present a table, or a chart, showing the comparison of features—these look more scientific, methodical, and neutral than a few paragraphs that say the same thing. But include pop-ups or rollovers to explain what those features do—many of your consumers have no idea, and consider the terms just so much jargon. If possible, illustrate each row with a picture of the option, feature, or process, to give people a clue.

White papers: These offer a better way to position your firm vis à vis the competition. You state a broad problem, outlining in a way that you know will favor your particular solution, then walk through the components of a best practice, and lo and behold, at the end, your product emerges as the winner. The big-think tone gives an air of impartiality to these papers, particularly if you pay a consulting firm or an academic to sign one. But they are also useful; they give people an insider's view of the problems in the field, and a reasoned argument for your place in that world.

Why are markets always defined in terms of sellers and products? Why can't they be defined in terms of customers and activities?

—**Mohan Sawhney and
Dave Parikh,
*New Economy Boundaries:
Use 'Em or Lose 'Em***

Architectural note: organize around activities first

Web consumers resent traditional marketing with its attitude that customers are prey, to be shot at with a rifle or a shotgun, products are bait, sales are some kind of switcheroo, and relationships are a macho matter of conquering or taking possession of a consumer, measured in eyeballs, transactions, and clicks. The new consumers want to see evidence that you are aware of their situation, their goals, and their process of decision. Toward that end, marketing has to stop interrupting and grabbing people who might possibly be a customer for a product, and, instead, start helping the guests make their own informed decisions about which product would be best for them, if any.

> To discover points of leverage, firms need to think of their customers in terms of their activities and workflow. This is a customer-centric view of markets. It involves finding products for customers. (Mohan Sawhney, *Contextual Marketing and the Rise of Consumer Metamediaries*)

Find out what activities people want to perform at your site or at a portal like the ones Sawhney calls "metamediaries" because they act as super intermediaries between you and potential consumers. An individual consumer's activities involve particular tasks such as getting house prices for a particular neighborhood, and these low-level tasks can be grouped within several higher-level tasks, such as finding a new home, buying or renting a home, or moving into a home. These tasks, and the overall activity, are what matter most to the guest. For instance, on a site run by a food manufacturer, people get more involved in information about cooking than about recipes, and care more about using the recipes than learning about the products within them. You need to promote information (neutral, helpful, informative material) that aids in the activities, while demoting information about your products to a support role.

Oddly, this kind of information lives, traditionally, in technical

writing, training, and customer support groups, but not marketing. Go get it, recruit those folks to write more, and reorganize your site to encourage activity.

Sure, you still need to write product descriptions and let people zip right to one if they want; but you will delight people more if you help them do what they want, making the purchase simply a step on the path to the final transaction, which is the way the consumer likes to think about it.

Eventually, through personalization and real-time tracking, you will present promotional offers at the moment the customer seems to be making a decision, rather than broadcasting them over every page or slinging them at everyone who comes to the site that day. At that instant, your offer becomes relevant and even welcome.

But until you get to that point, you need to shape the great bulk of the architecture of your site around consumer goals, tasks, and activities—not products.

See: Hansell (2001), Henning (2000a, 2000b, 2001a), Knowledge Capital Group (2001), Locke (2001), Price and Price (1999), Sawhney (2001), Sawhney and Parikh (2000), Sawhney and Zabin (2001), Usborne (2001a, 2001b, 2001c).

Case Study: Web Marketing Copy at mySimon

MySimon.com pitches itself as a tool for finding the best products at the best prices throughout the Web. Simon himself overlooks every page in many different poses, acting as the site's persona (an obviously virtual face, grinning with irrepressible good cheer). Simon is assisted by human editors, who pick out products to recommend, articles from *Consumer Reports*, decision guides (interactive wizards that lead you through the process of deciding which options you really want, ending in a list of products that fit those criteria). The marketing folks at mySimon.com have to walk a tightrope stretched between tooting their own service and rooting for the products they recommend. In between lies an enthusiastic neutrality.

One strategy the marketing folks use is restraint—they keep the adjectives and adverbs to a minimum, picking the one or two with the biggest impact.

Need help deciding which to buy? Get highly personalized and completely unbiased product recommendations with our decision guide!

The excitement contained within that exclamation point spills over into the "highly" and "completely," the adverbs modifying the two key benefits—personalization and objectivity.

The tone throughout is similar to that—sober, hinting of a conversation, but "written" in the sense that most of the text would not work if read aloud. When the writers pitch a new product category, they often start with the rhetorical question routine, but instead of segueing into a folksy chat, they take a condensed, detail-packed approach, suggesting that they have done a lot of work behind the scenes, and that they are bringing you the results in as tight a paragraph as they can make.

Extreme/Multisport Men's Watches

Planning to climb the High Sierra or check out a coral reef? Luckily, for any hard-core athlete, this season's sport watches boast an impressive array of exercise-friendly functionality: timing laps, monitoring heart rate and even checking the height or direction of the ride can be done while breaking a sweat.

Nice touches:
- Defining the audience—The writers make clear who these products are aimed at, narrowing the focus, but intensifying their grab.
- Hinting at the now—It's this season, not last season.
- Subtle spin—These watches don't just have features. They boast of features. The set of functions is not just an array, it's an impressive array.
- Cliché reversal—Usually, marketing folks talk of doing something "without breaking a sweat." But here, the whole point is to consult your watch while exercising. The switcheroo draws a little attention to the writers' own good taste, as if they were saying, "We don't indulge in clichés."

The lame conclusion suggests a less inspiring aspect of the marketing style—an over-eager English major at work. When we read that the watches boast a lot of functionality, and see a colon, followed by a list, we tend to think of all the items in that list as examples of the functionality. But no! The writer adds a verb phrase ("can be done"), turning all of these items into subjects, requiring a little mental flip-flop. Perhaps the writer felt anxious that the list of items might look like an incomplete sentence. But the grammatical whiplash makes the finale painful.

The humor's a little strained, too. In writing about tricycles, for instance, the writer says that one recommended product is tough enough to "endure the inevitable backyard demolition derby." OK, so it's a joke. The site gets points for trying humor. But the tone is arch, almost professorial, hey, even a little condescending.

Mostly, though, the writers succeed at compressing a lot of features and benefits into a small space. Product descriptions fit into two or three lines. For instance, here's a dog dish:

> Lightweight bowl med.
> Plastic dish. Outside diameter 7 inches by 3 inches deep.
> Color may vary.

MySimon and his buddies work hard to summarize a lot of information briefly, while pushing their own service and their recommended products, without seeming too pushy. The marketing copy here seems adroit, light, even, do we dare say it—fun?

News Releases

Public relations is no longer just about "ink."

—**Don Middleberg,**
Winning PR in the Wired World

The emerging Web has changed public relations by giving the audience greater control over what writers must produce, and when. Reporters still act as the advance scouts for other audiences, but they are followed (within a day or so) by chattering discussion groups, viral sneezers (they cough, and hundreds of people are infected with the idea), and customers e-mailing each other. And, increasingly, reporters say they get story ideas from Internet rumors, which they seek to confirm by using your Web site. As a PR person in this environment, you're driven to respond to breaking news on a cycle of hours, not days or weeks, as in the past. You can't waste time going through levels of approval and news-release boards; you have to get out there now. You keep discovering new audiences, new forums, new ways to combine print, radio, TV, and Internet campaigns, so you can no longer develop steady routines, specializations, and focus. You don't have time for in-depth research because you have to work with quick snapshots, adapting your strategy on the run. Your advance planning extends a few months, not years.

Internet news releases go out as e-mail, not paper sheets, and they must be written for the screen. Tons of public relations copywriters ignore this fact, preferring to follow the traditions established by—in fact, demanded by—editors, reporters, and production managers at old-line newspapers, industry journals, consumer magazines, radio stations, talk shows, and TV shows. The basic structure of the genre is OK, but the prose needs tweaking for the Web.

Your audience is still the press, but now that they do research on the Web, get releases by e-mail, and (often) post online, reporters are even more impatient, rude, self-pitying, quick to doubt, and careless than they used to be in the days of paper. Unlike marketing folks, who address real customers, you're trying to reach those customers indirectly, through someone else's writing—whether

that person is writing in a traditional media outlet or its site, for a pure webzine, or for a discussion group—and you are using e-mail to get through to most of these writers. That means you have to adapt your prose for electronic delivery to other writers, including some folks who would hate to be thought of as your peers.

You're repping the rep, electronically. To start, visit discussion lists, industry guru sites, and media outlets to find out what your organization's reputation really is. Monitor the fads, trends, and controversies inside your industry because this buzz gets reflected pretty quickly in the stories for the general public. Figure out where your organization shows up on the Net radar, understand your weak points, and calculate your boasting score, so you can spin your "news" into a favorable review, a little applause, a solid plug in a competitive overview. Where marketing tries to build a story that will attract customers, you have to adapt that story for an audience that is better informed than most customers, a lot more cynical, and, unless you sell only to early adopters, much more obsessed with what's hot, new, and different. Customers generally care about what works well, what saves them some time, what costs less, and what adds to an existing setup. But reporters want stories—service pieces, tales of heroism and innovation, attacks on established ideas (and products), and gossip. The best way to get your releases read is to create them so they can be easily cannibalized.

Remember—even though you must get along with all the people who might have a stake in the wording of your press release, you should fight to get them to recognize that the release will be rejected by reporters if it ends up being inflated with blather, jammed with jargon, or pointlessly complicated. Your job is to fight off the stakeholders, to get your pony through to the people who will write the actual stories—you know, those sponges who hang out in the press room eating all of your carrot sticks and bagels, gossiping with each other, and, ungrateful wretches, forgetting to mention your new product in their survey of the trade show. (As members of this crew, we have to admit that we are all a tough lot to pitch).

To make your case, explain that you're assembling the components of the press release to answer the journalists' questions, more or less in order.

The first rule is, simply, move fast.
—**Don Middleberg,**
Winning PR in the Wired World

- "What's new here?" **Headline**
- "When did this happen?" **Date issued and official release date**
- "Who's this from?" **Company name**
- "OK, what's the gist of the story?" **Opening paragraph**
- "What are the details?" **Follow-up paragraphs**
- "Have you got a quote for me?" **Quotes**
- "What's the background of the company?" **About section**
- "How can I reach you?" **PR contact info**, executive contact info, hot link to the PR section of the site

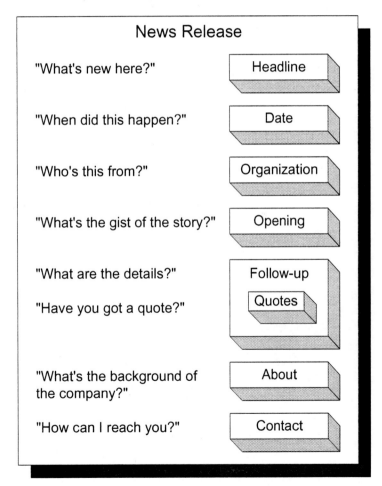

For agencies, the ultimate client is the journalist. If an agency loses its credibility with a journalist— it's over.

—Don Middleberg,
Winning PR in the Wired World

Material that doesn't answer a reporter's question doesn't belong in that particular section (and may not belong anywhere in the release). You have to defend your reporters against consensus releases, which cram everyone's favorite phrases into one or two ungainly sentences that no one, except the original committee, can understand. Take notes, listen thoughtfully, but go your own way. Even though you may be called a company spokesperson, you have to write on behalf of and as an advocate for readers who write.

Get over the notion that reporters depend on you for information and ideas. Sure, some do. In fact, some drudges just edit press releases all day long. But most reporters come up with 80% of their ideas on their own (or through chats with industry insiders, editors, other writers, and cab drivers). Once they have a story idea, though, journalists do count on your serving up the latest info from your company in a form they can reuse. (How come your latest press release isn't up on the site? Why is the last "news" item on the site three months old? Isn't anything happening?) That's why you need to build a helpful set of Press pages on your site, to support the e-mailed release.

But first you have to get a reporter's attention. You have to get past the Delete button in the e-mail application.

Put the gist of the story into the subject line and headline

That's all you've got, at first. If your subject line doesn't work, a reporter never sees the rest of the e-mailed release.

The headline must do its job, announcing the kernel of the story. The headline is usually the subject line, so it has to work twice as hard to capture a reporter's attention within 60 characters or less (the e-mail software may not display more than the first part of the subject line).

Don't put clichéd marketing claims into the headline. Reporters at major sites use filters to delete messages that come in with subject lines that include words such as "best," "first," "leading edge," "customer-centric," "mission-critical," and "solutions." As one *Wall Street Journal Interactive* editor told the Gable Group, "No thanks, I'm done covering solutions.... Please don't write to me about solutions anymore...They've become a problem."

Some companies put out one or more news releases a week, whether they have real news or not. ... They do it to populate the databases of the world, so their names show up when financial analysts go searching.

—Gable Group,
Stories Not Getting Through?

Instead, ask yourself, what makes your announcement news? What good is it for the end audience, that is, the people who read what the reporter writes? Why will they care? Generally, the more concretely you can describe the benefits for these folks, the more likely a reporter is to read on instead of clicking the Delete button.

Think marketing for a moment. What is your product differentiator, here? What is your unique selling proposition for this story? The headline is your pitch.

But the writing challenge is to describe the benefits without using in-house or industry shorthand. One way to get the headline is to ask yourself, what is the most important fact you would like to get a reporter to pick up and pass along?

Opening

Despite all the pleas from product managers, vice presidents, and other helpful editors of your prose, your opening must sound like a news lead, not a puff. If you smell any mission-statement crap, remove that with a stick. And excise branding terms such as:

- *A world-class technology vendor...*
- *The industry leader in...*
- *The world's only...*
- *Leveraging its expertise in...*
- *Enabling and empowering customers...*
- *Providing end-to-end solutions...*
- *Seamlessly integrating...*

In a survey of electronic news releases pouring through PR Newswire and Business Wire during one week, the Gable Group found a new "solution" every eight minutes, and more than half the companies claiming they were the "leading providers" without any supporting evidence. Blanking out the names in releases from 11 companies (of whom 9 claimed to be the "market leader"), the group asked a client to identify which company was which. He spotted only one out of eleven, overlooking the release from his own company. That's generic writing, all right. Ten of those copywriters had adopted the same clichés, and pretended to work for the same imaginary superpower, forgetting to be themselves.

Go through your first paragraph crossing out any phrases that you would be embarrassed to explain, much less prove, if a reporter were to challenge you. Immediately, your release will stand out from most of the others.

Start editing when you realize you've been handed half a dozen nouns strung together as a single giantism, like "Next-generation online comparison shopping technology integration services." Who can tell where the other hyphens ought to go? Who, but the president of the firm, can untangle that kind of noun train before it collides with the brain? Blowing up this kind of phrase often requires several sentences. Write them. Even though the Internet demands brevity, these noun strings are so compressed that an outsider cannot interpret them without reading the full release, plus touring the site.

Journalists don't have time to wade through deep, complex navigation trees or sift factual wheat from marketing chaff.
—**Kara Coyne and Jakob Nielsen, Nielsen Norman Group,** *Designing Websites to Maximize Press Relations*

Follow-up and quotes

Give some evidence for your claims. Reporters question your headline and opening, and whatever summary statements you make there, you should follow up with some facts, figures, quotes, or anecdotes to show why you make the claim.

Write in short paragraphs. Too often copywriters reared on paper cram about five ideas into every thick paragraph, making it tough to disassemble on-screen. On-screen, a succession of short paragraphs organizes the information so it is easier to absorb.

You can write a lot if you just break it up into separate chunks, each addressing a different potential question, such as:

- How much does it cost?
- What features distinguish this product from the competition?
- Have you won any praise for this?
- What limits, constraints, restrictions apply?

In advertising, long copy sells better than short, and on the Internet, a two-page press release often works better than an e-mail that runs two paragraphs and out. The reason is that if any reporters care, they must ransack your release for material that applies to their audiences, and the longer release gives them more items they can grab.

The about section

Include the one-paragraph description of the company so that reporters can lift whole sentences. Include the answers to common questions, such as:

- How big is the company in sales, number of employees, number of offices, number of products?
- What are its major products, services, lines, and brands?
- What were its latest financial numbers, and what is the trend?
- How does the company position itself?
- Who's the boss?

This paragraph is boilerplate. You should craft it so it can be placed at the end of every release. Because you are now using the Internet, and writers want to grab whole sentences electronically, leave out phrases they would not normally use, such as the effusions about the brand, the jargon juggernaut, and the mission malarkey. If a reporter could not use the phrase without getting caught plagiarizing your release, omit the phrase. Remember—you want your key facts lifted, and to get that to happen, you must throw a few pet phrases overboard.

Contact info

If a reporter is interested, you must be available, right away. The Internet speed has intensified deadline pressure, so reporters often have less than an hour before they must post. Let them call you or e-mail you. Include a backup person for those times when you leave the office or go to lunch.

Include the full corporate address, and, if you are sending HTML e-mail, make the Web site address hot (offering a complete path to the release on the site, if you have managed to get it posted before you e-mailed it out). To write an online story, the reporter must be able to provide links to the main site (or the release itself), and many editors insist that reporters insert lines like, "based in Albuquerque, New Mexico," to give readers a little orientation.

Journalists are not gullible, and they do not take a company's own word as truth.

—**Kara Coyne and Jakob Nielsen,**
Designing Websites to
Maximize Press Relations

Set up a Web press center that gives reporters what they want

When we think a release will fit into a story we are working on, we go to the company's Web site to find out more. To make sure your press releases fall on fertile ground, build a full online press center. Unfortunately, many organizations are stingy about providing the materials a reporter might need. If we can't find what we need on your site, we figure you probably won't return our phone calls or e-mails quickly, and we move to a competitor's site. If that site gives us the additional info we need to flesh out the story, they get the mention, and you don't.

When the Nielsen Norman Group assigned 20 journalists a hypothetical story, and asked them to look for the information they would need on 10 major Web sites, the press corps failed to locate basic facts in more than a third of the sites, and reacted to those uninformative Media pages like this:

The function of the press is very high. It is almost holy. It ought to serve as a forum for the people, through which the people may know freely what is going on. To misstate or suppress the news is a breach of trust.

—Louis Brandeis,
in *Collier's Weekly*

"I would be reluctant to go back to the site. If I had a choice to write about something else, then I would write about something else."

"Better not to write it than to get it wrong. I might avoid the subject altogether."

"Makes me think someone is being evasive, or that they are incompetent." (Reporters, studied by Norman Nielsen Group 2001)

The press or media section of your site ought to answer these questions:

- How can I reach a human being who will talk on the record? **Contact info**
- What's the history, and focus of the company? **Company history**
- What happened when you did x, y, or z? **Archived press releases**
- Who's in charge? **Biographies**

- What's your position on x, y, or z?
Position statements, white papers
- What have other people said about you?
External resources

Contact info—At the very least, make it easy for reporters to get the e-mail address and phone number of each PR contact. When a reporter is covering a breaking story, the canned info on the site is not enough. To get your views, give the reporter a way to call you, page you, fax you, e-mail you, every which way.

> It's amazing why companies keep information such as addresses and phone numbers a secret. Unless you're located in Area 51, you ought to make this information very easy to access. (Ed Pyle, Executive Producer, KNX, quoted in Solomon, *What Does the Media Think of Your Site?*)

Put your own e-mail address with your full (human) name, not just a generic corporate.communications@bigcompany.com. The generic names make reporters think, "No one will get back to me on time. My e-mail will be lost or ignored."

Company facts—Explain the main twists and turns in the history of the company. If a lot of reporters ask about some episode in the past, include that. Drag out all the skeletons and force management to explain them; then post your story on the Web, as a precaution against surprise attacks and reporters who stumble on the tale late on Saturday night when you forget to check your messages. Don't make them read through the whole history wondering about that episode, only to find you have stonewalled. If you force them to call to get a quote, well, they may not bother to mention you at all.

Archived press releases—These are gold for reporters. Include the headings in the menu, not just dates. Who knows when that big event actually took place?

Biographies of major executives, with pictures—Do the one paragraph summary, followed by as much interesting personal detail as you can worm out of these folks. Go back through their other jobs. Try to show how their life makes sense. Include

downloadable pictures—those often make a mention more likely, because the editors want illustrations. (How about two shots—a formal suit and an informal, at-play shot? But from an editor's point of view, the less formal shot is what she pays a professional to go out and capture on a site visit, for a lead story. If you can provide that right away, your people will get coverage.)

Annual report, and an archive of quarterly financial reports— Reporters need this information to flesh out their analysis, even though their analysis is rarely as detailed as a Wall Street analyst. You may just want to link from the press section over to the area for stockholders or analysts. But make the information very easy to spot. Writers generally hate numbers, but they become very suspicious when a company hides the profit-and-loss statement.

Position statements and white papers—Reporters want to know how your organization positions itself. How do you see yourself stacking up against the competition? Where do you fit in your industry? What exactly do you do for your customers and what do they say about it? Position statements give your standard pitch on breaking news for the reporter who gets to your site after hours. White papers detail lengthy arguments for your approach—including lots of statistics, specs, tables, and big-think posturing—give a reporter a few paragraphs of smart prose. Excellent extra: an explicit offer to put reporters directly in touch with real customers (very tempting, when a reporter needs to get some support for your claims).

External resources—Journalists tend to view news releases as your side of the story. So, to get an outside opinion, they want to read what reviewers, analysts, and even customers have said.

Give the full name of the article, and link to the article on its original site, going directly to that article, not the top of the site. Going outside your own site increases the credibility of the link; you have clearly not tampered with the article if it appears on the other company's site.

There are two forces that can carry light to all corners of the globe— the sun in the heavens, and the Associated Press down here.

—Mark Twain

Articles from independent newspapers and magazines are often considered to be much more credible than the company's own press releases.

—Kara Coyne and Jakob Nielsen,
Designing Websites to Maximize
Press Relations

See: Gable Group (2001), Middleberg (2001), Nielsen Norman Group (2001), Solomon (2001).

Case Study:
News Center and Releases at Reflect.com

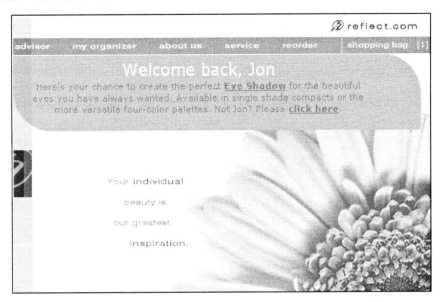

Here is a company that makes customized cosmetics by interviewing customers on its Web site, using their answers to build up personal recipes, and then manufacturing one-of-a-kind products. Funded by the giant Procter and Gamble, and backed by the collective knowledge of P&G scientists, the site runs artificial intelligence code to match customer choices with ingredients and packaging, so consumers participate in building their own moisturizers, fragrances, and other cosmetics. The company has pioneered using the Web to personalize the actual design and manufacture of individual products. Because so many of these ideas are unfamiliar to reporters and editors, explaining how the company works, and boasting about its progress has been a challenge for the PR team.

Edelman Public Relations has cranked out one or two Reflect.com releases a month, touting news such as second-round

financing, partnerships, new products, shifts in advertising, changes in operations, and milestones. ("Reflect.com reaches over one million customizations.") These releases generally give journalists what they need, while struggling to make the key marketing points. You can hear the heavy breathing in a lead like this:

> Reflect.com, the first interactive, truly customized beauty service created solely for the Internet, announced today...

Imagine the committee meeting that led up to that lead, with half a dozen folks brainstorming.

"Hey, we are the first! We are numero uno."

"First what?"

"Uh, first to customize... ."

"But other sites let you customize their content."

"But that's not real customization. We really do customization."

"Yeah, we customize products, right?"

"Interaction is the key. We interact with the customers on the site, and that's how they get to build their own products."

"So you could say that what we offer is a service then?"

"Yes, and don't forget that we only work on the Web. We don't have any retail outlets. You know, we're a pure play."

Then I imagine the boss saying, "OK, just wrap all that up into one sentence, and we're ready to go."

The final consensus solution, used for at least six months:

> Reflect.com, the first interactive beauty care service empowering women to reflect their authentic beauty by creating customized products, announced today...

So the marketing team got their way with the lead. But the PR folks crammed the releases with the kind of details that reporters really need:

Exact numbers. For instance, we learn that the IT department expanded from 5 to 25 people.

Clean headings. Most are sculpted to go right into a trade journal or business page without heavy editing. "Reflect.com

and Proflowers.com Extend Partnership to Give Women a Gift of Flowers."

Expansive subheads. The team lets itself go in the subhead, telling the whole story in a few lines for the inattentive reporter. The subheads include the key ingredients of the story, plus a nice helping of marketing marmalade. For instance, "Partnership Enables Reflect.com to Continue Delighting Women by Giving Them a Free Floral Gift after Their First Purchase." Sure, "free floral gift" is a bit much, giving away the flowers twice, and implying that they are actually part of a floral arrangement. But the qualifier is helpful. You have to buy something to get this gift, and the PR folks get that detail into the subhead, too.

The nitty-gritty details. We find that the "floral shipment" includes two Dendrobium orchid stems, "greenery" to "accent" the orchids, a gift card, care instructions, a protective tube, foil wrap, cotton, water tubes, and elastic ribbons. Plus, we get the reason why—"to ensure freshness while making a truly memorable impression on the recipient." Most writers will edit out the rationale, but, in an effort to sound as if they actually did some legwork, many reporters will include a few of the details in their stories.

Quotes from named people. Sure, some of these quotes come with the obligatory expressions of satisfaction ("'We are very pleased with Reflect.com's momentum over the past year,' said Tim Haley, a founding partner of Redpoint Ventures and member of Reflect.com's board of directors.") But some actually let us overhear the insiders talking. ("The repurchase rate also increases dramatically among these women.") With two or three quotes per release, the PR team makes the reporter's job easy. No need to make a phone call, if the deadline is tight. Just edit what you're given.

Plenty of About. The boilerplate sums up the company's position and background in a paragraph that mixes the clichés of the Web ("harnesses the power of the Internet") with awkward but convincing phrases ("products that don't exist until a woman helps create them"). Result—this material is easy to edit if reporters need another paragraph on a job where they are paid by the word.

Contact info. OK, but strange. You have to go through the PR team. No one from the company is listed. Just the Web site.

When you go to the site, you find the press releases listed on a menu next to a colorful photo. The full text is there, but nothing more.

The site provides only minimal information—a street address, and a general phone number, without the name and extension of anyone in particular at the company. The implication is if you want an interview, you will go through the PR agency. (By the way, "We've worked through the PR team, and found them very cooperative, setting up interviews, and responding to queries promptly, so this route is not a dead end").

On the other hand, the management bios are helpful, and give an eager reporter a person to target for an interview. The site offers pictures of the key managers, reasonable backgrounders, and quotes—enough to put together a story without having to call anyone, and a reasonable starting point for a real interview. In a section aimed at customers, the site also lists favorable articles in print media, with links to the original pieces, so reporters can (how do we put this?) crib from their peers.

So, despite encouraging women to answer dozens of questions in an effort to find their "authentic beauty" the site guards its own privacy carefully. As a reporter, you can break through to a real person (we have) but despite the emphasis on personalization, the site does not encourage direct personal contact with the managers. Hey, they have some real work to do.

POST |

Express your own idea on:

HotText@yahoogroups.com

Subscribe:

HotText-subscribe@yahoogroups.com

Unsubscribe:

HotText-unsubscribe@yahoogroups.com

Visit:

http://www.WebWritingThatWorks.com

My Idea:

Post to HotText@yahoogroups.com

chapter 14 |

Making News That Fits

News Articles

Web users are willing to pay for news that gives them a financial edge. Investors, brokers, analysts, and managers ante up almost $60 a year to peek behind the public front pages of the *Wall Street Journal Interactive*, to get relevant, current info in short takes on the site, and by e-mail newsletter. By delivering exactly the kind of news these people want, written specifically for that audience, and published fast enough so the users can get a jump on the market or competitors, the site pulls in real revenue (not just kudos), supplementing the ton of cash earned from the paper editions. The site defines a successful Web news site—a lot of stories, most of them current, and all on target. In the paper world, reporters worship inside dope, multiple sources, accuracy, depth, reliability, and reputation—plus delivering on deadline and ahead of the competition. But Web news writers must worship volume, speed, and focus—and those goals affect the way you write news articles, no matter what site you are working for.

> Successful online pubs are sites of very targeted information that post a lot of info very regularly to drive the traffic to the site. (Randy Scasny, *Website Flow*)

You're a filter

It's not your father's newsroom.
—Steve Outing, article title,
Editor and Publisher

As a reporter, you have to sift through a dozen press releases, hundreds of e-mails, several e-mail newsletters every hour, and tour your beat—the sites you think may have some interesting tidbits—just to pick out the subjects that will interest your niche audiences. Just by picking the topics, you are performing a service.

> No matter how low the journalist remains on the public's Trust Meter, at best he or she provides a valuable filter service. (Ken Layne, After the fall: Late notes from the online journalism conference).

You filter the news by the way you write about those topics showing what you think is important, and not, through your headline and lead. But best of all, your voice filters the news. Your attitude, your stance toward the event, gives the user a handle on the news, a way to take hold of it, adopting your perspective for a moment in order to understand how the event grows out of similar ones in the past, how it differs from that chain of history, and how it impacts you.

The old objective stance—which was always something of a fake—lacked personality, so articles written from that point of view (pretending not to have a point of view) did not tell as much as an op-ed piece, where the bias and feistiness of the individual writer told us more about what the real story might be, even when we disagreed. On the Web, the best news articles are opinion pieces, so that people can get the gist of the stories quickly.

So develop your own persona. Express a few pet peeves. Indulge your hobbyhorses. You'll make a more dramatic impression, and therefore do a better job of reporting.

Why should I bother reading your piece?

Guests skim your headline, glance at the lead phrase or sentence, and, if you are lucky, skim the first paragraph or two. After that, most leave. If you want to make sure that some folks actually read your piece, make those opening hooks sharp.

> You can't afford to bury the lead online because if you do, few readers will get to it. When writing online, it's essential to tell the reader quickly what the story is about and why they should keep reading—or else they won't. (Jonathan Dube, Writing news online)

Online news articles are "get-to-the-point news." Yes, back when we worked on the student paper, we all learned about this curious architectural phenomenon, the inverted pyramid, with all the answers to key questions frontloaded. But answering all those w-questions weighs down the lead. Postpone the date, location, and even the participants, if they are not central to the story. You can get to them in the second graf. So on the Web the pyramid is right

After watching the ebbs and flows of the traffic on my web site as well as our whole news channel, I really believe that Web reading is immediate, current, of-the-moment reading.
—**Randy Scasny,** *Website Flow*

side up, with just the point showing, at the top.

Because the headline and lead must condense the story for people who are just passing through, while teasing others into reading more, you are working like a poet here, condensing and yet suggesting. Let your persona help, so your text expresses your mood, your reaction, and your take on the story.

Tip: If you're like us, you don't know what you think until you write the rest of the story. So do the beginning last, when you have figured out your position, digested the facts, and come to a real conclusion.

Use loaded terms to get hits

If your job depends on traffic, your article has to show up when someone does a search for the topic you've just covered. Think through the terms people would enter if they wanted to find your piece. Make a list of half a dozen, consciously, and toy with them as you make up your headline and lead.

Simply rewriting your headline to include more keywords can multiply your hits by ten. But don't let the search terms take over. Your job is to integrate them into your point, rather than letting them smother it.

How much can you leave out?

If you want people to keep coming back, write your piece with an eye on repeat visitors—the ones who actually read your stories yesterday and the day before. Assume that your guests know about the election, and just want to hear about the latest scandal with the Bernalillo County ballot boxes. You don't need to provide the full story in lumbering background—filling phrases that tell the out-of-it reader what is going on. You can skip a lot of that catch-you-up talk, just by creating a sidebar with links to those old stories.

Leaving stuff out speeds up the article, and suggests that you and your guest are in the middle of some ongoing conversation, and you are just picking up the next thread, assuming a lot of history. You're emphasizing the now, inviting newcomers to get on the train, and showing that you respect the folks who have already been along for the ride.

Explain whatever relates to the current news later in the piece.

Online journalism has not led to any dramatic increase in the quality of reporting.

—John Markoff,
Farewell to the Web

Print readers have less vested in any given story, because they haven't done anything proactive to get the article.

—Jonathan Dube,
Writing news online

You need to serve those few brave souls who have ventured below the fold, to read the rest of your piece.

The story can be quite long if you break it up into meaningful pieces. (Avoid chopping a coherent piece into a series of small pages, just to present short pieces). Short takes run 250 words; full-length articles hover between 500 and 750 words; and thumb-suckers go to 3,000 or 5,000 words, carved into half a dozen mini-articles, so people can just jump to one or another, and not have to plow through the whole piece, like a *New York Times* Sunday Magazine article with jumps through the real estate ads.

Quotes and lifts

People like to talk, and they like to read anything in quotation marks. The more your story suggests a back-and-forth conversation, the better. So polish up those quotation marks.

But be careful about wholesale lifting from other people's work. The Web makes theft so easy, you may overlook the way borrowing an idea shades into picking up a phrase here and there. Particularly if you indulge in rewriting press releases, you may get in bad habits. Obviously, PR people love it if you take their whole release and issue it under your name. But other reporters may not feel as grateful when you grab their work, even if you give them a mention.

We've been struck at how often reporters interview us about something like online shopping, grab good ideas, and fail to attribute any of them to us, even though our words show up in the piece. Hmmm. Practice a little generosity and credit your sources as you go. Of course, doing so makes you look less like an authority, something that traditional journalists see as a perk of the job. But on the Web, namedropping, thanks, and quotes show you are immersed in a wide-ranging conversation. Instead of losing respect, you gain credibility.

For any person you quote, give readers a clue as to possible bias. Mention that the figures for teenage drinking come from a beer company. Hint at the person's objectivity, too, pointing out, for instance, that the quotes about economics come from a professor of medieval art who leads a faculty union.

No story should come from a single source. You only have so

much time, but you have enough time to cross check your story with five or six folks who are independent, some of whom may yield intriguing quotes. These interviews give depth to your piece, because you begin to see the nuances of the situation, the various sides of the discussion, and, gradually, you form your own opinion.

Thorough research builds up your own understanding, so when you do write the piece, you can write simply. The old rule applies: If you know what you are talking about, you can explain anything to anyone in a responsible way. But if you are just faking it, your prose will sound like plastic wrap, and your readers will soon say, "Yea, sure!"

Partnering with the devil

For traditional journalists, advertising reps always had to be kept at arm's length. But on the Web, your front page is crammed with commerce, and your site is partnering with companies whose products you may have to describe. You may find yourself in an ethically gray area. Press tours, press packages, press gifts—the temptations have always been there, but in the past, reporters acted as if they were incorruptible, while demanding more free passes, sample goodies, and outright giveaways. The Web institutionalizes an ambiguity that has always been around. How objective are you? How much do financial relationships influence your opinion? On many Web sites, your job is to bring in traffic, while not offending the many announced and undisclosed partners, their marketing organizations, their PR teams, and their cranky CEOs. Advertisers are pressing you to create sponsored content that will fold into the site alongside your regular articles. If you find yourself becoming upbeat about every story, pause a moment to see if you have inadvertently moved into marketing.

The people running most content sites do not come from a journalism background, and see nothing wrong with a little slant here, a plug there, and a discrete omission of embarrassing facts. But you have to argue that honesty actually builds trust, and traffic.

Define the way content is presented before marketing defines it for you.
—**Richard Gingras,**
Five hot tips for successful online journalists (or how to deal with the 26-year-old Harvard M. B. A. who'd rather you didn't exist)

Include images, sounds, and video

These myriad content offerings can so easily be linked together (review the book, buy the book) that each component of content begs for its own labeling and sourcing.

—Richard Gingras,
Five hot tips for successful online
journalists (or how to deal
with the 26-year-old Harvard
M. B. A. who'd rather you didn't exist)

For the moment, text still rules the news. You have to grab a bright, revealing photo to put up by your lead, but eye-tracking research shows people still read the headline and first sentence, and the caption if there is one, before bothering with the image.

Part of your job, though, is to snap, beg, borrow, and "re-purpose" images without outright stealing. The responsibility for art has shifted onto your shoulders.

On some sites, you have to collect audio bites, and in a few locations, video, too.

Your text still acts as the glue holding all these chunks together. Your text sits at the starting point, suggesting people click and view. If the text doesn't make the story compelling, folks have no reason to waste their time waiting for a video download or replacing the song that's playing on their computer with your audio.

But you have to write the story to advertise the picture (mentioning something you see there, to encourage people to check it out), the sound (mentioning the tone, the context, the message, to give people a reason to play the audio), and the video (mentioning the scene, and point, to justify a long and potentially unsuccessful download).

Imagine a world with no newspapers.
—Mark Potts,
Musing on the future of journalism

Art, sound, and video are not illustrations or add-ons. They are part of the whole story. Write about them with respect, and even though your main loyalty may be to text, learn how to edit these other media, so you don't frustrate your editor, and users.

Links are part of the story

Be selective about the off-site links you throw into the sidebar. Make sure that if I follow your link I will learn something you didn't mention. Links are not footnotes, proving you have done your homework. Links add value to the story, but only if the target sites actually expand on themes you have introduced.

> Many sites have a paranoid fear that if they include links
> to other sites, readers will surf away and never return.
> Not true! People prefer to go to sites that do a good job of
> compiling click-worthy links—witness Yahoo!'s success.
> (Jonathan Dube, Writing news online)

You don't legally have to get an OK from another site to link to a particular page, but you'll get grateful thanks if you do. Avoid any framing that implies the other site's content is really your own.

Of course, all your stories on the site are relevant (we hope!). Identify your own back issues as your own, though, in the link list, so users can distinguish your stories from the background info.

If you hate letting people out the door, you may decide to put all the links at the end of the story. That way, someone would come to the links with the full context. Of course, postponing the outbound links just frustrates most Web users. They expect those links to appear next to the first few paragraphs as a kind of submenu, allowing them to skip your piece and go to something they are really interested in. Forcing people to wait for links is like making students sit through a whole lecture just to find out what questions will be on the exam—a bit inhuman.

Bring together a whole set of stories

If you have done a series of stories on the same subject, or if several writers have triangulated on the same subject, create a page that integrates all those and shows people why they should read each one. You have an enormous advantage over print newspapers because your archive is all online, and you can turn out a special edition, just by posting an aggregating page. APBNews.com did a wonderful job pulling together police reports, articles, maps, audio, and video to tell the tale of nine unsolved murders in the Great Basin desert. You could play detective, using their questions and examining the evidence.

If you're covering a high-profile trial, like the Microsoft anti-trust case or the case of the cops who killed an unarmed immigrant, you have a chance to post the court filings, daily observations, and backgrounders, so that a visitor can get as much information as might go into a non-fiction book.

Even though each story will probably have to be short, you can offer so many stories that you saturate the subject. You begin to be the place to go to get the latest.

Multiple links—multiple sources—are desirable.

—Roland de Wolk,
Introduction to Online Journalism

See: Dube (2001), Gingras (2001), Layne (2001), Nielsen (1998b, 1998c, 1999e, 2000b), Scasny (2001).

Case Study: News Articles at Wired News

Wired.com offers Wired News arranged in five categories—business, culture, politics, technology, and top stories. Appealing to a niche audience (sophisticated high-tech folks who live and work electronically), the writers identify trends, tease out the implications of events their readers might otherwise dismiss, and spot new gizmos. By bringing these ahead-of-the-wave topics to our notice, these very cool journalists give many of us a reason to visit the site on our daily cruise through the Web.

Having such a specific audience to write for, Wired News journalists can build their leads around the readers' biases and opinions. For instance, reporting that the National Book Foundation would now consider e-books for the National Book Award, M. J. Rose writes:

But there's a catch.

Publishers submitting e-books must send a hard copy of the work—printed and bound on letter-size paper.

She knows that we'll be outraged. Her two-paragraph lead sets its hook. We want to know more about these Neanderthals over at the National Book Foundation. We want to know how they can justify such a stupid demand. And we hope to hear someone else attacking them for being hypocrites or old fogeys.

Sure enough, she gets great quotes on both sides of the debate. And, like most Wired News reporters, she doesn't bother explaining what this audience already knows—what e-books are, for instance. She assumes we know, and then she lets us find out more through her examples. After mentioning one successful e-book, she cries out:

> How much of the hyperlinked <u>story</u> would keep its integrity if printed out?

Embedding a link within her rhetorical question makes her point. On the paper page, that link is dead. On the screen, you can click it to find out more about Caitlin Fisher's e-book, *These Waves of Girls* (which recently won the Electronic Literature Organization's fiction award).

Unlike writers at traditional media, most of whom have to express their opinions obliquely through slant, some of these Wired News writers create little personal essays—more like *The Atlantic* and *Harper's* than Associated Press. For instance, Reena Jana argues that artists creating their own software are turning code into a form of conceptual art. But her pace is Web-fast. Here's her lead:

> Sometimes a commercial software program like Flash or Photoshop doesn't offer artists all of the creative tools they need.
>
> So some, like the duo of Jennifer and Kevin McCoy, write their own programs—and along the way arguably turn the tedious task of writing code into an art form.

The site emphasizes two-to-four paragraph openings, giving the text a wider layout, then throwing in a See Also with links to related articles before letting you read on. Result: those openings have to live on their own, as a miniature story, while drawing you in enough to jump to the See Also and go on.

For instance, here's the whole opening for Steve Kettmann's article, "1,001 Arabian Nights of Sex."

> ABU DHABI, United Arab Emirates—It's all about sex.
>
> That, at least, was the surprise conclusion that came bursting out of a panel discussion Monday on what people in the Arab world are looking for when they go to the Internet. In other words, they are like Web surfers everywhere else in the world.

Joke! And then the See Also breaks in, like a commercial after the teaser at the start of a TV show. The rest of the story offers a duel of quotes, pro and con, on the idea that even Saudi surfers like sex on the Web.

Every story on Wired News uses short paragraphs, often with alternating quotes, which make the text seem like a conversation; most include some (but not many) links. But almost none have subheads. So you can't easily skip through these articles. The assumption seems to be that you like to read. Perhaps a lot of visitors scan the opening and print.

E-mail Newsletters

When your e-mail newsletter appears in inboxes, it brings your ideas to subscribers who might not have thought about returning to your Web site. These electronic newsletters remind people that you exist, that you take a certain position on an issue that matters to them, and that you want to reach out to them in a virtual conversation. Writing and publishing a newsletter by yourself or with a small group gives you a platform from which to rant, beg, whine, cajole—and entertain. Creating a newsletter for an organization deepens your relationship with the customer, re-enforcing the brand and increasing the likelihood of repeat business. In most cases, e-newsletters drum up new business for the publisher (whether that means selling products, signing up consulting clients, or getting new speaking gigs), while helping to retain old customers and deepening influence in an industry or market.

But most e-mail newsletters are junk. The publishers make mistakes like these:

- Filling the pages with ads—excluding most other content.
- Pretending to provide objective information while actually just promoting their own products, events, and services.
- Reducing the content to a list of phrases and links—giving you too little information to tell whether or not the links are worth pursuing.
- Repurposing press releases that the subscribers already see in the trade journals, or copying someone else's marketing pitch without modifying it, or offering a comment.
- Playing safe, saying nothing controversial, and making no personal statement.
- Letting bad grammar and typos litter the page.
- Refusing to let you unsubscribe.

Most of these problems stem from misunderstanding what subscribers want. Subscribers want to feel as if they are participating

"Buy our shit" does not qualify as having something to say.
—**Eric Norlin,** *The Titanic Deck Chair Rearrangement Corporation Newsletter*

in a conversation with you. First, that means the conversation must be voluntary. If you just trap people in your mailing list, you are like a bore cornering them at a party. They will squirm, delete, and do anything to get away.

Then, once you've made it clear that the conversation is voluntary, you have to make the exchange worth their time. Because even if you send your newsletter for free, they are paying you with the currency of their attention. And they want more than ideas and links—they want an experience.

Let subscribers choose you

Spam is not news. Don't let management convince you that sending an unsolicited pitch via e-mail is somehow news. It's annoying, counterproductive, and maybe even illegal.

Get permission, or get your teeth kicked in. If you send out any kind of e-mail without getting people's OK, they will react badly. Some will curse you, others will refuse to come to your site ever again, and a few will launch counter-sites, to serve as forums for everyone who hates you. Plus, if you offend knowledgeable geeks or lawyers, they will track down all your service providers and nag them to block you from sending any more e-mail.

Get permission twice. Don't trick people with a little box on your registration form that says, in effect, "If you don't look here and deselect this little checkmark, uh, we will bombard you with mail advertising our products and services, OK?"

These inconspicuous lines do allow someone to opt out, but only if they notice the line, and if they understand the weasel-worded message.

Best to make the user actively check the box, asking for these e-mail notices, newsletters, or sales alerts. Interestingly, at the moment people are registering or purchasing, they have great hopes, and, contrary to the vows they may have made in the past, many people eagerly sign up.

If you are pitching an e-mail newsletter, put a link to an overview and sample, so the nervous or uneasy folks can see exactly what they will be getting. On the overview page, answer key questions:

The Internet community has reached a stage at which an accusation of spamming is almost the same as a conviction for spamming in many people's minds. Many administrators will block your newsletter at the first bleatings of an upset recipient.
—Peter Kent,
Poor Richard's Web Site News

- How often does this newsletter come?
- Who writes this stuff?
- Will there be ads, too?
- What do you do with my e-mail address?
- How can I subscribe? (Another chance to opt in).
- How can I unsubscribe?

To the folks who opt in, send a confirming e-mail and require that they respond, to really get signed up. That process, known as double opt-in, makes people more aware of what they are doing. Also, the confirmation shows you are on the ball, responsive, and quick. You have begun a conversation, through the odd mechanism of e-mail.

From then on, in every e-mail, tell them that they subscribed, and let them unsubscribe easily. Remember—even if I subscribed long ago, my life has changed, and I may want to get off your mailing list. If you don't make that easy, I begin to resent you, and, at the very least, every time I see e-mail from you, I will click Delete.

Let me unsubscribe simply by sending a blank message to a particular e-mail address, which you include in every e-mail you send. In addition, in every e-mail, put the address of the Web page that describes the newsletter and explains how to unsubscribe.

Ideas + Links = Experience

How can your newsletter make the subscriber's life more fun, more efficient, and more profitable? In what way do you intend to change the subscriber's day?

Focus on the moment the person gets your newsletter and skims through it. What experience are you promising?

In order to be invited into the end user's mailbox (and to get the user to read the message), you have to offer something unique and of value.

—John Funk, "The importance of the end-user experience," in Poor Richard's E-mail Publishing

Don't fool yourself with thoughts of the long-term benefits. Most people want to see something concrete, usable, or amusing in each issue, to justify opening the next one. Sure, you may not be able to hit the target every time, but if you do fairly often provide an idea they can take away, a link to an intriguing site, a tip they can act on, or a story they laugh out loud about...well, they may not unsubscribe just yet.

Clearly, you need to know your audience very well, to anticipate what will work this magic for them. The narrower your niche, the

more you can predict what topics will click, but the fewer topic areas you can cover.

Also, many newsletter editors find that a lot of short issues work better than several long ones. People tend to skip through the long ones and miss a lot of good information. To keep an issue short, offload some info into links or into the next issue. A few screens worth would be ideal, but if you really have thicker content, go two to five printed pages, and out.

So now you have to consider frequency. Subscribers want quick access to perishable information (late-breaking news, stock tips, rumors about industry shakeups), so you have to plan to send those messages pretty often. But less critical information, such as reviews of books, promotions for your latest upgrade, success stories from your customers...well, no one wants to hear that kind of stuff every day. If you can, let people choose to get the daily or weekly edition for content that brings fresh news and information, and offer content that smacks of marketing every other week, or monthly.

> Your publishing schedule should reflect the availability/creation of new and different content that is of value and desired by the end user. (John Funk, The importance of the end-user experience)

Visionaries only

Don't even start a newsletter if you have a vague idea to do something "just like so and so," or "because we probably ought to have some kind of a newsletter." That way you will quickly drift into a mechanical, crank-'em-out routine. Pointless: you don't get many subscribers, but you do add another uninspiring item to your weekly To Do list. Save the world, and yourself, from another dud e-mail.

To launch a newsletter, you must envision how you can make a difference for a particular group of people. Your mission must grow out of whatever you have already been doing, while presenting you with a challenge you haven't faced before, a dream you've had, a crusade you can get caught up in. Lame-ass reasons include getting your name out there, telling folks about your latest sales items, or announcing promotions. If you find you're a little fuzzy

on the purpose of your newsletter, but think you have the seed of an idea, then think about your audience and what kind of content they could use, what they would laugh at, or what they would grab and forward to a friend.

We're not talking about your voice here, but your vision. What can you imagine happening as a result of your newsletter, for one person at a time? The more you let your imagination furnish that picture with detail, the more ideas you get for a position, a slogan, a brand and, flowing from that, articles long and short.

I'd encourage any sort of style that evokes any emotions in readers.
—Chris Pirillo,
Poor Richard's E-Mail Publishing

Self-promotion is a perfectly acceptable reason for doing a newsletter. But the newsletter won't succeed if you don't have an idea of the way your content could make an impact on individual subscribers' lives.

Write up a blurb for your newsletter, to set direction for yourself. This is a cheap version of a mission statement, but it helps you figure out why someone might subscribe and what you have to offer.

Your own voice, please

Once you have a vision and a blurb, you should have a sense of the tone to take. Help people feel like they know you personally. Admit quirks, obsessions, and passions. If you're excited, show it.

Develop your role like an actor, feeling your way into certain speeches, bringing in sense memories, grounding yourself in your through-line—the goal you are pursuing, act-to-act. To sound like yourself takes many rewrites. Like an actor, enrich your part by stretching for new intensity, different takes on your central position, twists and turns. Open yourself up to random inspiration because the spirit can take you way beyond your original concept.

You can tell your persona is working when you get a lot of enthusiastic responses, complex arguments about what you said, suggestions for other avenues to follow, or tips on relevant sites. You are letting the spirit flow through you and getting it back a hundredfold.

Make your newsletter *from someone*. Give it a consistent unifying voice that people can connect with every time they read it. (Geoffrey Kleinman, In the trenches with *The Kleinman Report*)

When we talk about developing your persona, we know it sounds as if we are recommending you fake the personal. That won't work. Really, we are talking about exploring your own reactions, going beyond the identity you built up on your resume, discovering new aspects of your self, becoming more articulate. You might as well put your heart into this effort because if you choose to write an e-mail newsletter, you are committing yourself to a lot of writing, and honesty can help you turn out clean prose quickly.

Uniqueness counts, especially online.
—Chris Pirillo,
Poor Richard's E-Mail Publishing

Their voices, too

People love to be recognized, mentioned, and praised in your newsletter. If someone sends you a tip, follow up on it and thank them publicly by a personal e-mail. In this way, you build up a team of contributors and a community.

Getting feedback indicates they trust you. Reciprocate. Eric Norlin starts his newsletter from the Titanic Deck Chair Rearrangement Corporation, "Valued Co-conspirators!" That's the tone.

Focus on only a few offers

If you're going to market something in your newsletter, keep the focus on one offer, or one or two, not half a dozen. You'll sell better, and you won't make your newsletter look like a tissue of pitches.

Ads and promos are OK, too, as long as your layout separates them. Generally, even in HTML newsletters, the text ads get better click-through rates than the graphic ads. We don't know why, but perhaps it's that people just naturally steer clear of those obvious ad blocks, and get caught in the text trap.

I think that campaigning will increasingly be through e-mail, not through Web sites.
—Dick Morris, Vote.com

People understand that you need sponsors to pay the costs of your e-mail service, and they don't seem to object to occasional plugs. But make sure the advertisers are responsible companies because you are saying, "Give these folks a try." If the advertiser turns out to be a bum, you've broken your faith with your

subscribers—and that trust is worth a lot more than the dollars you earn for the ad.

If you're going to ramble on about your offer, give each benefit its own paragraph. Chunk your pitch so people can skip and skim. They're more likely to dip into a bunch of short paragraphs than one long block.

If your newsletter ends up being mostly marketing, people may develop a habit of deleting dozens of issues, then read one, almost by accident—and you could get a sale then. The payoff, financially, is uncertain. But the newsletter keeps going out to all those people who opted in, making your presence known and tempting them to double-click. Not a very inspiring prospect, but as in so many aspects of PR and marketing, persistence does get results.

To get heard above the din, you should offer some useful information before and after the marketing riffs. Perhaps you can give the gist of an inside report you've just published, available from a special page on your Web site. In this way, you benefit people without a sale and predispose them to rely on you. If they trust your content, eventually they will trust your argument that they ought to buy x, y, or z from you, or from a partner.

Make Web pages support the newsletter

What if someone accidentally deletes an issue? What if a new subscriber finds out about that special issue you did last December? How can wanderers on the Web find out about your newsletter?

Web pages devoted to your newsletter support it, and give you a venue for archives, supplementary rants, downloads, images, and whatnot. In this way, you can keep plugging your site throughout your newsletter ("For more, see...."), treating the site as a resource.

Respond

The bigger and better your list, the more e-mail you get. You get ideas, reactions, good feedback, and complaints—you'll learn from your subscribers, if you provoke them to write.

To keep up your end of the conversation, though, you must reply personally. Take it from the folks who run newsletters with several hundred thousand subscribers—you get deluged with

"What, if anything, keeps you up at night worrying?"
"What keeps me up at night is doing my own e-mail."
—**Gordon Moore, co-founder of Intel, interviewed by Matt Richtel, New York *Times***

e-mail when you say something outrageous, when you goof, and, sometimes, when you have no idea why. But you have to reply or hire someone who can imitate your voice, to say something to each correspondent.

For each person, the newsletter is just you, personally, talking to him or her individually. One subscriber has no idea how many other e-mails you are getting. Each correspondent just wants to know what you think about his or her comment, within a few hours.

What a chore. But, in a way, you promised to respond, when you offered subscriptions. You extended your hand, and now they are shaking it.

Luckily, these e-mails often fall into several categories, and after you have answered a few dozen, you can start copying and pasting the main response, after saying something in the first line indicating that you really have read their e-mail. Now you're talking!

See: Allen, Kania, and Yaeckel (2001), Funk (1999), Kent (1999), Kent and Calishain (2001), Kleinman (1999), Manjoo (2001), Norlin and Locke (2001), Ohi (2001), Pirillo (1999), Rose and Adair-Hoy (2001), Sammons (1999).

Case Study: E-mail Newsletter from the Titanic Deck Chair Rearrangement Corporation

Welcome to the
Titanic Deck Chair Rearrangement Corporation
(NASDAQ:TDCRC)

Subscribe to our FREE email newsletter below
(Damn you, sign up!).

submit

Read the TDCRC archives.
We Fear Nothing.

If the ship is going down, play a little music and rearrange the deck chairs. That's what Eric Norlin and Christopher Locke have done with their e-mail newsletter, launched from www.tdcrc.com. Having started a similar irregular rant from Personalization.com, the pair left when that ship got sold, and set up a Web site that imitates IBM, with its sliced logo and corporate layout; then undermines the whole effect by saying, "Damn you, sign up!"

You know how some computers address you as "Valued Sony Customer" until you change the default? Well this newsletter addresses you as "Valued Co-Conspirators."

Then we hear how Eric's work is not going well, Chris has been busy with his book on gonzo marketing, and clients are finking out on jobs, because the bosses only want sales copy, not content.

You get to see a little of what's going on in their lives, like a screen cam showing them at their desks. You hear them razz each other and answer questions from their subscribers.

They can write tight when they need to make a point. And they can rant like a Mark Twain on deadline:

> Not 48 hours ago, I told Locke I had made a resolution
> not to send to this list until I got my head straight.
> Yea, I've been a bit off lately—stressed, if you will.
> So—in grand, overblown, Wild West American fash-
> ion—I hiked up my pants, grabbed my bootstraps,
> and mounted my horse (no, not like that). I was riding
> deep into the desert of my soul.

Fortunately, his sense of humor has not died. He comes back to life to announce the Apocalypse. But first, he reminisces about his father, a dedicated Microsoft devotee. Eric was raised on Microsoft.

> In short, I'm not one of the Grateful Dead, Apple-
> rules, Open Source, Hackers-not-Crackers adherents.

When he gets to the point, he cusses, he kicks, and he stomps. Some of his maxims:

- Personalization means nothing without being personal. Period. That's it. Really—it isn't much more complicated than that.
- Personalization technologies are pointless without honesty.
- Never even consider crossing the "privacy line."

What's invigorating about these rants is that they defy conventional corporate thinking, arguing that the Web's true nature is personal—a way to connect with other people, one by one, rather than a new mass medium. The Web is not the next TV, thank God. And both Eric and Chris have a bad attitude. Eric says,

> Become an artist, not a salesperson. Start a tangled
> conversation—and make fun of the new boss. Better
> yet, writhe onstage in a wedding dress cooing about
> your virginity.

Impractical, imprudent, immodest—yes, they'd probably agree that their newsletter is all of that. But we find that even on days when we are deleting one e-mail after another as fast as we can go, we stop and read this newsletter for a bracing dose of personal outrage.

Weblogs

*Express yourself to the world,
whenever the feeling strikes you.*
—**Slogan for Weblogs.com**

Putting up a Weblog lets you comment every day on a subject you care intensely about—a hobby, an idea, or, most likely, yourself. You have to care intensely, though, to undertake the work, which involves regularly recording your experiences, your visits to other sites, and your take on the news, and then posting those on your blog.

The most self-involved blogs track the owner's dreams, complaints, shopping lists, sexual experiences (or, more often, lack thereof), and paranoid fantasies. But many sites undertake public crusades, arguing for a political, social, or ethical point of view, interpreting each day's events through that lens. And when a blogger reaches out to a niche audience such as an academic discipline, an occupation, or a political group, the site acts as a forum, bringing together links, comments, and outrage, while the owner stirs the pot and adds the secret sauce.

Blogs are a form of personal journalism. They get around the gatekeepers at the big newspapers, magazines, TV and radio stations, and humongous portals. In the old days, we had to rely on producers, editors, and even writers to put together a summary of the day's news, because there was only so much time and paper, and these physical constraints meant the media could only give us filtered news. Of course, the media folks loved filtering the news, and still do. But now blogs let anyone be a publisher, and the gates are opening.

> A new style of journalism, based on a "raw feed" directly from the source, is emerging. (Paul Andrews, "Who are your gatekeepers?" in *Hypodermia*)

Running a blog is like having your own TV show, where you sit at the anchor desk and call in one feed after another. Instead of just mouthing off to your friends or submitting articles to an editor for

changes and possibly rejection, you post what you think. And if other folks who think along the same lines happen to put up their own blogs, and you link to theirs, and they link to yours, you begin to build a community. But even if you are just solo, you may draw people who are looking for material that has not been sanitized, generalized, and neutralized by the gatekeepers.

Record whatever whenever

Instant communication power by letting you post your thoughts to the Web whenever the urge strikes.
—Slogan for Blogger.com

Tracking a mix of random thoughts, pointers to Web pages you've discovered, and rants on the spur of the moment, Web logs are an Internet form that makes a daily journal seem tame. The key is to add enough perspective so the reader hears your voice, but not so much that you turn the text into a full article. Blogs are more casual, informal, and tentative.

> Sometimes I'm working on a column about a particular topic. I may say so here, telling readers what I believe at the moment and why—and then invite you to comment. (Dan Gillmor, The whys and hows of Weblogs)

A weblog is kind of a continual tour, with a human guide you get to know.
—Weblogs.com,
What are Weblogs?

They invite comments from visitors. And often those comments get commented on and reinserted into the blog.

The conversation becomes visible. And that very record of the interaction drives the virtual exchange and encourages it to grow. As other bloggers point to your site, traffic and your e-mail increase.

But because the blog is embedded in the Web, real-time, you will feel compelled to update often. Some bloggers post comments every few hours, others every few days. (The more often you post, the more often people come by).

Payoff: You get to see your stuff up immediately—compared to the days it might take an average site to post your piece, or the months you might wait for a paper magazine to appear. Instantaneity makes the process addictive.

Even when you're writing for a weekly magazine, it seems like it takes forever to see your work in print. With a Weblog, you hit the send key and it's out there. It's the perfect disposable journalism for our age. (Deborah Branscum, quoted in J. D. Lasica, Blogging as a form of journalism)

Growing like a weed

Structure? Sometimes. Often, the new thoughts just get wedged in at the top, shoving everything else down, so a visitor can scroll down for a reverse-chronology tour of the blogger's changing thoughts. In this sense, the organization of the blog, as a whole, just evolves organically. There's a theme, usually, but not much architecture.

Many writers who are used to working in structured environments (technical writing, journalism, instructional design) relish the freedom to go their own way, without having to follow someone else's guidelines, cautions, or dictates. You don't have to work within some schema, document type definition, or template. You can just ramble along.

Linklist or junkpile

Some blogs are just linklists that keep on growing. But what really makes a list into a blog is the commentary. You don't have to say much. But say something. If you were moved enough to capture the link, say why. A sentence will do. In fact, one-sentence comments work best.

But who can resist adding an after-thought, and then taking that back and reconsidering. In this way, the links take on more mystery, tempting the reader to go find out what provoked all this cogitation.

But you aren't forced to offer balancing pro and con quotes from so-called experts, so you look balanced and objective. You can quote any damn fool you want, and you don't have to give equal time. Of course, to blog successfully, you must start out opinionated. Pigheaded is good.

Resist the pressure to take back a crazy statement. Don't veer to the middle of the road. The blog is designed to let you make mistakes, try out concepts, and sound off, without having to pretty up your ideas.

But a funny thing happened on the way to the Web's irrelevance: the blogging phenomenon, a grass-roots movement that may show the seeds for new forms of journalism, public discourse, interactivity and online community.

—J.D. Lasica,
Blogging as a form of journalism

Blogs tend to be impressionistic, telegraphic, raw, honest, individualistic, highly opinionated and passionate, often striking an emotional chord.

—J. D. Lasica,
Weblogs: A new source of news

The links can take people to solid, reliable sites, and crazy, embarrassingly messed-up sites. You don't have a corporate patron looking over your shoulder and tut-tutting a link because the target site, interesting as it is, violates some taboo. In fact, the earliest blogs rose to the surface because the owners found so many odd-ball sites that their lists became a goofy portrait of the Web. So if you find a page interesting, post a notice. (Determined bloggers report visiting 150-200 sites a day, scanning for news).

Making sense

After a while, dedicated bloggers begin to see that they are follow-ing a consistent path through the Web, and their postings track their own intellectual (well, maybe) development. You begin to act as a guide to the field, like the folks at About (formerly Mining Co), who collect the best links in their field, give you a little con-text, and then send you off.

Your focus, like your personality, filters the news, gives it your own slant, and makes weird sense after a while. Part of the process is unraveling the kinks in your own mind.

Counter the conglomerates

Blogs let individual voices get heard. They seem credible in a cul-ture dominated by mergers of big print, big music, big radio, big TV, and big portals, where self-serving mutual publicity makes ordi-nary people feel like they are being run over by a steamroller.

The cost of entry is your time, because you can use free online tools to publish your blogs. If you are already obsessed with a sub-ject and cruise the Net incessantly looking for ideas in that area, the Weblog is just a notepad for your explorations, and you won't begrudge the time involved, particularly if you get feedback. So you are not burdened by the financial burdens that worry the CFOs of corporations. And, ironically, if your ideas get picked up, responded to, linked to, and amplified by a community, you become an author-ity to be quoted by the mainstream media.

Get validation from incoming links

You become an authority just because other people link to your blog. But the point is not the audience size, but the depth and extent of the conversation.

> I don't want an audience. I feel I'm writing stuff that's part of a conversation. Conversations don't have audiences (Doc Searls, quoted in J.D. Lasica, Weblogs: A new source of news)

Searls suggests that as you persist, you develop niche expertise, and the network of related blogs becomes a sort of reputation engine.

See: Andrews (2001), Branscum (2001), Gillmor (2001), Lasica (2001a, 2001b)

Case Study: Weblog by Dave Winer

UserLand

DaveNet

Part of the DaveNet website, syndicated on **Scripting News.** ›

News
2001
2000
1999
1998
1997
1996
1995
1994
Who Reads
DaveNet?

Back from Europe

Thu, May 31, 2001; by Dave Winer.

A warmup piece ↵

It's a little over two days since I got back from a week in Europe. As always it shifts my perspective. I need a quick piece to hit the reset button. There's much new work to do in XML, networking, writing and programming tools, but first I have a queue of little stories from Europe that I'll probably pick up on in future pieces.

DaveNet is an occasional Weblog from Dave Winer, who long ago created a fantastic outlining program called More, and more recently set up UserLand, a company offering developers an environment for creating Web sites (including Weblogs). He's a major mover among programmers because he's got wide-angle vision, but also because he likes chatting, e-mailing, speaking at conferences, and weblogging. He gets his ideas out there, and some of these ideas matter to anyone who writes for the Web.

Idea #1: The Web is a writing environment. "Writers flow their ideas and opinion to people who only know the writer by name, not by brand." He argues that the Web is a conversation, and that

fact works against the conglomerates taking over the whole Web with their megalomaniac branding. But he argues that writing for an employer necessarily compromises your integrity because you may have to over-simplify, tell only part of the truth, or outright lie. If so, he urges you to write directly on the Web, to see what difference you can make.

Idea #2: The Web gives you the power to publish as an individual. You don't have to kowtow to a boss, accept editorial changes, or compromise in order to get published. You just publish directly on the Web, as an individual. That's the spirit of the Weblog, and Dave's postings are inspirational.

Idea #3: It's a challenging time for professional writers. How come? Because amateurs, posting on discussion boards, communicating with their peers by e-mail, and publishing their own opinions on Weblogs, are able to offer their personal account of events, their individual reaction to news breaking across the Web, without being constricted by corporate policy, whether explicit or just implied. Amateurs may have more integrity than the pros. As a litmus test, he challenges professional journalists to try writing one story that could undermine their own livelihood. "I also have an interest in the pros adopting the techniques of the amateurs, doing less shaping, coloring, and casting of news, and more straight delivery." He's not opposed to professionalism, but he thinks there should be a little more mutual respect, and maybe even a recognition that "LittleCo's can do things that the Big Ones can't."

Dave asks tough questions of himself, and us. For instance, he asks himself whether he has integrity, when he writes his column:

> I try to disclose my interests, and maybe I don't succeed in doing that, or perhaps a new reader comes along and doesn't understand that I'm often writing about software I create. I try to not push my software too much through DaveNet. On the other hand Scripting News is an hour-to-hour log of my work. Inevitably it does push what I do because that's what it's about. But I don't tell all there. So perhaps that's an integrity problem.

That kind of self-reflection is what makes his Weblog fascinating. You feel as if you are listening in on his internal debate—not watching a polished slide show. Oddly, that humility combined with his natural aggressiveness makes Dave a leader. His Weblog defines the stubborn, almost truculent stance of a lot of bloggers, and he speaks for most of them when he says:

> There is a big difference between what I do and what the BigPubs do. I'm an amateur. I make software. I write because I love to write, and because I want to make sure that my side gets out without interference.

POST |

My Idea:

Post to HotText@yahoogroups.com

Express your own idea on:
HotText@yahoogroups.com

Subscribe:
HotText-subscribe@yahoogroups.com

Unsubscribe:
HotText-unsubscribe@yahoogroups.com

Visit:
http://www.WebWritingThatWorks.com

chapter 15 |

Entertaining People Who Like to Read

Webzine Articles

A good Webzine article deliberately provokes questions and discussion, raises the reader's temperature, connects to sites around the world, and ends in an exclamation point because a webzine is different from a paper magazine. Compared to paper magazines:

- Webzines act **faster**. Users expect comment on current events within 12-24 hours. Editors respond by return e-mail. Readers post questions and discussion points within minutes of publication.
- The **lag time** between delivery of a piece and publication is a lot **less**, averaging about a week or two, compared with two to six months.
- Every chunk is **shorter**: paragraphs, sentences, headings.
- The **pieces are shorter**, overall: 250 words is a respectable length for an article, 500-750 words are stretching it, and 1,000 words or more will only fly if broken up into shorter sections. Very few articles run the length of a *Harper's* piece—2,500 to 3,000 words.
- Instead of sidebars, you have **links** to related resources.
- As the writer, you are now responsible for creating or finding **audio clips** to supplement the piece. (Sometimes you also have to locate video.)
- As the writer, you are responsible for finding, capturing, and editing **art**.
- You must develop even more of a **personal voice** than you might use on paper.
- You are paid to **provoke discussion**. Your article is a cue to readers to send in their thoughts, which are what they really like reading. You launch a conversation, rather than capping it.
- And yes, you have to do **a little HTML**. But most sites provide templates you have to follow, so you rarely have to write any complex code.

But compared with many other sites on the Web, Webzines are for people who really like to read. People often stick around a Webzine for 20 minutes, half an hour. The articles are thicker, dense with in-your-face style, aggressively "written." And for people who want entertainment, mixed with a little learning, a few stunning facts, occasional arousal, and raw passion, Webzines act as a forum for launching into the fray, a focal point for catching up and plugging in—the Web way.

Webzines often violate reasonable rules

No matter what the Webzine, there are probably going to be a bunch of stories that are straight factual narratives like those in a conventional paper newspaper or magazine. These stories follow usability experts' guidelines for informative sites; they are fast, neutral, simply put.

But if you choose to write for one of the more controversial sections of a Webzine, follow these guidelines:

- Get intensely personal.
- Reveal intimate details.
- Write emotionally.
- Play subtly with language: indulge in metaphor, puns, irony, and double entendre.
- Admit your ignorance at times.
- Be conversational.
- Rant, occasionally.
- Provoke a lot of discussion, on purpose.

In the next few sections, we'll explain why, and how.

Get intense, expressing yourself

The best newspaper journalists are those who assemble the facts and write the story so it just seems to flow, while they keep themselves out of the story, distancing themselves by taking on the persona of "the reporter." This faux-objective approach works fine in newspapers, but is death on a Webzine. Some of the best writing in Webzines steams with emotion and attitude. Why? To get the readers' attention.

Let's face it. Reading a lot of text on the Web can be a drag.

Writing, when properly managed (as you may be sure I think mine is) is but a different name for conversation.

—Laurence Sterne,
Tristram Shandy

So you have to engage the reader. The more outrageous, the better. Being out there works on the Web. Not surprisingly, the sites with the strongest voice tend to have loyal readers.

Reveal your anger, lust, envy, greed, gluttony, jealousy, and zits

Emotions sell. Don't think so? Why do you like that particular beer ad? What worked, in the ads for those politicians who won big? Why is it that you find the commercial for that big electronics store so offensive, but drive by the store nonetheless? All these spots stirred something emotional within a lot of people.

When writing for a site, take a look at its audience. What rattles their chains? What pisses them off? What makes them smile, laugh or roll their eyes?

Figure this out, and you'll have them eating out of your hand. Of course, you have to dig deep and find these emotions within yourself first so you don't sound condescending.

Provoke argument and discussion

Ever notice how many sites have talk-back or reader comment sections after an article? People like to put in their two cents and then see their prose up in lights. These same readers will come back the next day to see what *other* readers had to say about *their* comments, and so on. The best way to augment this kind of discussion is to say something controversial. We're not saying that you should write mean or nasty rants. But instead of playing it safe, get off the fence and say exactly what you feel. Hold nothing back... like you're writing in your journal. Be honest and go for it. You'll probably provoke some interesting (and wild) discussion, which is a very good thing.

Organize strenuously and intellectually with subheads

Web readers have gotten to the point where they start out looking for the meat of the story, article, newsletter or product description. Now, just like when ordering a steak, one customer might think "rare" is the way to go, while another might prefer well-done; the

I write in order to attain that feeling of tension relieved and function achieved which a cow enjoys on giving milk.

—H. L. Mencken

I write when I'm inspired, and I see to it that I'm inspired at nine o'clock every morning.

—Peter de Vries

"meat" of your content will be different for each reader. Being Web readers, though, they'll want their orders quick. That's where a little thought about organization and subheads comes in.

Let's say you're writing a monthly column for a philanthropic organization. Find four pearls of information that you want to polish and display. Organize by date, importance, or flash and dash. Give each point a paragraph, or in the Web lingo, a chunk. Then give each chunk a subhead. Someone reading the column may not be interested in points two and three, but want to read more on one and four. They can skip whatever seems irrelevant to them.

Depending upon how the Web site is designed, these subheads may also appear on the left margin, making it even easier for a reader to skip right to the meat. So, make the headings descriptive, not cute. Short but informative.

Provide links that add to the story

Because you can so easily link to another story, going right to the source, the Web has (except in academic circles) done away with the dreaded footnotes. You know those little numbers that refer to some article or book that you have to leave room for at the end of each page? Now instead of burdening your reader with the task of looking up the other document, you can simply link to the article. Quoting statistics from a recent survey? Just give your reader the results and link to the survey for more in-depth figures. Referring to a historical speech? Link to the text and just report the gist of it.

Using links in your story is another good way to keep it short and readable.

We do our best to respond to all inquiries, but be aware that we are sometimes inundated. If you have not heard back from us after three weeks, please assume that we will not be able to use your idea or submission.

—Salon.com

Fit within the word count, or die

One of the biggest problems we had when we were Web feature editors was that many writers were unable to turn in a piece at or near the assigned word count. We wish we had a dime for every time we heard, "Oh, I just couldn't do it in 500 words. You edit it the way you want to." Well, thanks, but no thanks.

If you are coming from print journalism, it will take you some time to craft a 500-word piece from research that cries out for 3,000 words. But that's the task. Web editors don't have a lot of time to drastically cut your articles. And, besides *you're* the one who did the research, so you are in a better position to know what's vital to the piece and what isn't. When you just can't seem to come in at the word count, use these helpers:

- Bullets (use one or two words, instead of one or two sentences)
- Captions (use art, photos or screenshots to convey a chunk of information)
- Links (refer to a survey, study, speech, rather than rambling through a long description)
- Subheads (they can serve as information, a question, or statement)

Slate's audience is educated, affluent, and influential. 61 percent of Slate readers have a college degree or higher. 69 percent of the audience is between the ages of 25-54. The mean income is $90,108 and the median income is $73,728.

—Slate.com

Follow the template, so the editor doesn't have to clean up after you

Unlike print, content for each Web site has to fit into a predefined template, often with tight limits on length and constraints about structure. There is absolutely no way to change this template because each "page" has to work well with the other "pages." In other words, when the site was designed, each page is basically the same as the other, so you can link from page to page and to the information listed in the margins. Everything you see on the Web page has to go into a template that was created by the design or editorial team.

Some editors will give you the template and ask that you put your content into it. Here's where a basic knowledge of HTML comes in handy because if you have a grounding in the tags, you can make sense out of the template (most of it, not all of it, probably). For example, <p> means the start of a paragraph, and </p> means the end. Forget those little marks, or neglect to put your text within those marks correctly, and you'll get running text that looks awful. Another common tag is <h2> meaning the start of a subhead, and </h2> the end of a subhead. You can see why this is important. (For more information on HTML, go to HTMLGoodies

at http://www.htmlgoodies.com.)

Some Web editors will ask that you not use HTML and not use their template because they find it easier to edit your work without your attempts at tagging or fiddling with the preset form. That's the kind of editors we were (and our writers loved it). But as more and more writers are becoming savvy about HTML, we think the tide will be going towards using templates, particularly ones with tags indicating what each chunk of content means, using the eXtensible Markup Language (XML). If you are given a template, stick to it religiously. Even if you think you know better (and you might), resist the temptation because you will just make more work for the editor who has to undo all your "improvements." Stick to the template and gain the gratitude of your editor.

While we still very much believe that content on the web can support itself, Automatic Media is not able to succor us until we see that day. As of today, we are in suspended animation, cooled to a temperature at which our metabolic rate is near zero.

— Stefanie Syman and Steven Johnson, *Feed Magazine*

Pitching a Webzine

Studying a Webzine

Study a Webzine as a virtual organization, to see how you might fit in. Read several entire issues and explore the discussion threads for several hours.

Figure out who the audience is, as you would in a regular magazine. Find out how the Webzine was invented, to understand its slant:

- Heavily funded by people who want to be a portal, such as America Online, Microsoft Network.
- From scratch, by writers, as with *Salon*.
- To exploit a niche on the Web, as with *Womens Wire*.
- To give the paper magazine a presence on the Web, as with the *Atlantic* (whose electronic version is called *Transatlantic*), *Family Fun*, or *Playboy*.
- To get rid of paper altogether, as with *Omni*, *Progressive Architecture*, *Millennium Science Fiction*.
- As part of a magazine conglomerate's site, such as those from Hearst or Condé Nast.
- As content to give extra value to an online store, like KBKids.com
- As a public service or vanity operation that doesn't pay a dime, run and written by hobbyists, public-spirited people, or folks with too much time on their hands

Analyze the topics the Webzine usually covers.

- Which ones are already written by the staff? (No hope there, until you are hired fulltime.)
- Which ones seem to be written by invited guests, VIPs, and celebs? (Forget these topics, unless you are already a star.)
- Which ones seem to be contributed by non-staffers? (These are often short news items, reviews, service articles.)

- Of those, which topics come close to topics you would like to write about?
- Therefore, what topics could you provide, that come close to the ones the webzine already covers, but offer something new—a new slant, a new perspective, or a new angle?

Get right into some of the discussion. (This is the fastest way to get noticed by the editors).

Analyze the Webzine's tone and style. Ask yourself questions like:

- How personal and intimate is this?
- How elaborate is the verbal artifice required?
- How loud do I have to get?
- How much concrete detail do they like?
- How long do they make sentences and paragraphs?

How to write a query to the editor in an e-mail message

Sound like the zine right away. The first sentence of your e-mail proposal should sound as if it were lifted from one of their articles. In fact, the first few paragraphs of your query should demonstrate that you can handle their style.

Cover your idea in the first paragraph, give details in the next one or two paragraphs, and end with a paragraph saying why you are the person to do the story.

- Include a title, early.
- Within that first paragraph, name the word count you have in mind.
- Give details. The numbers, statistics, or quotes that an editor can drop casually at lunch, to good effect.
- Why you? You know the subject, and you have already been published here and there. (Online, we hope). Stress that you meet deadlines.
- Identify your topic in a way that makes it clear how it is different from anything they have already covered.
- Mention the department you think this story would fit in.

Idea: Mention an earlier article you like, and show how your piece goes beyond it, goes into more depth, and gives a new topic in that line.

A query is a job of writing

Writing good Web queries (essentially asking "Would you be interested in this idea?") is just as important as writing the article itself. Study the site for style and make sure that your idea doesn't rehash a recent article. Most Web editors prefer e-mail queries. However, sending in a proposal by e-mail can be tricky. Follow these guidelines to minimize any problems:

- If you want your query to be read, write it in the body of the e-mail because editors are suspicious of opening up attachments from unknown sources. When we were Web editors, we NEVER opened up such a query.
- Check the site to see if there are submission requirements. Some editors may want you to send in your query in HTML formal; others prefer plain text.
- Don't send in full, unsolicited manuscripts. The editor is busy and doesn't have time to read these. A short query is much better. (It also shows that you are a professional.)
- Include all of your contact information in your e-mail. Use a signature line with some of your best credits (and links).

Style

It always amazed us how many professional writers proposed long, long articles to us that would have been perfect for, say, *Child* magazine, but almost useless for BrainPlay.com or KBKids.com. Each medium has its own rules. The Web is extremely visually oriented. With the exception of some academics, very few people want to read long, rambling articles on the Web. They can pick up *The New Yorker* for that.

Style counts even more on the Web. Paragraphs should be around three sentences. The text should be broken up into chunks or sections with a subhead. Bullets can do wonders for presenting a lot of information in a small amount of space.

When querying an editor, you should use Web style to show you "get" the Web.

> *By the way, after six years of publishing, if there is anyone out there who can give us some suggestions on how we can make some money out of this magazine—please let us know.*
>
> **—The Virtual Gardener,**
> **gardenmag.com**

Length

All editors are extremely busy. Make your query no longer than three paragraphs—plus a paragraph about yourself at the end. (This tactic also shows how you can take a lot of information and distill it—a skill the editor is looking for.) To save space, use links whenever possible.

What about clips?

Samples of your work—clips—are your calling cards. In your query, you *tell* the editor how good you are by including a brief bio and the names of a few places you've been published in. Clips *show* how good you are. We never used new writers without seeing some of their previous work. But how do you send clips when you are e-mailing a query?

If you've been writing online, all you need to do is place links to some of your work in the query. If you're proud of some of your magazine writing, ask the editor for his or her fax number and fax the clips.

What to discuss with an editor who wants your story

Here are some reasonable issues to discuss:

- What software and hardware does the editor use? (You will present material in that format.)
- What HTML template does the editor use, and how can you download it?
- What format do they want art, audio, and video in?
- When rights will revert to you, if ever? (Most want electronic rights forever, but some will cave in and allow you to reuse the material on paper later, as long as the reprint is not in a competitor's site).

Case Study: Webzine Articles at *Slate*

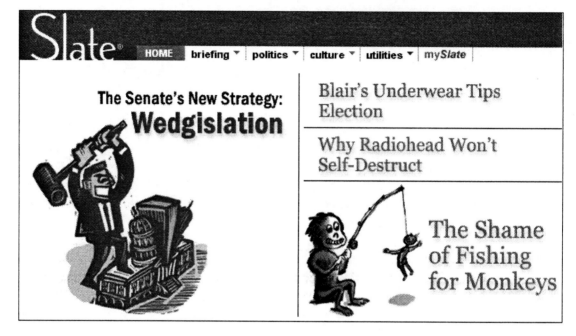

Slate is a culture of a thousand conversations. Its writers work hard to provoke chatter, recording highlights from reader postings, inviting new comments, making their own catty comments about what other magazines, newspapers, and weblogs are saying. If Slate were a party, it would be one of those New York or Washington scenes that are dominated by a klatch of extremely verbal, intensely argumentative, surprisingly amusing folks who just love to talk.

The watchwords of this community are:

- **Be complete.** The Slate team loves to summarize a wide range of sources, rounding up political gossip, giving a snippy digest of the headlines in the major national papers, mounting a gallery of current editorial cartoons.

- **Reverse the spin.** Writers must work hard to step back from the conventional interpretation in politics ("Why Tony Blair's underpants spell success"), TV, music, even business ("Why Jack Welch's reputation is overblown"). When dealing with an issue the whole country is obsessing about, writers must give it a surprising new twist, reframing the story. New writers seem to get their break telling stories about stuff the rest of the team has never heard of, such as fishing for monkeys, the topic of a recent story that turned out to be, mostly, fiction.

- **Take nonsense seriously.** *Slate* writers discuss silly or outrageous subjects within standard newspaper departments such as shopping advice ("Which mints work best on nasty breath?"), Dear Abby ("What if I meet Mrs. Right after I've married Mr. Perfect?"), and Mr. Science ("What's consumption and why did it kill Nicole Kidman?"). The tone is usually very serious, sympathetic, even intense—so you learn a little, get a glimpse of another world—and laugh.

- **Go long.** Lead articles run five to seven pages, single-spaced, without a single subhead—just text, text, text. But people read these carefully, and reply using the discussion boards by clicking Enter the Fray. *Slate* has some of the stickiest pages on the Web.

- **Provoke the fray.** The point is to challenge readers, tease them, drive them to write in. Then other readers write to them, and others reply to those, and soon the site is bustling with people checking to see how other people responded to their own posting, and picking up a new angle on old debates.

These articles are very "written." They take the essay form seriously, articulating an interesting idea early, often by coining a new term such as *Wedgislation*, proposed by William Saletan:

Neither party expects—or even intends to try—to earn enough bipartisan support to pass most of its agenda. Instead, hearings, bills, schedules, amendments, and votes will be orchestrated to create wedge issues for the next election. This isn't legislating. It's wedgislating.

Writers like Saletan tick off the evidence for their idea in clear, clever prose that draws attention to itself as language, while nudging the point forward past all quoted objections, reducing opponents to puffballs. These writers sound like lawyers—and some are. Because the evidence and argument grow unwieldy, the writers have to draw tight conclusions, so the art of the epigram lives on. Saletan, for instance, releases these zingers:

- "Politicians love the power that comes with majority status, but they hate the responsibility."
- "The pattern in these issues is their pure symbolism."
- "In theory, elections were a means to legislation; in practice, legislation was just another means to election."

La Rochefoucauld, the French master of maxims, would get a kick out of *Slate's* writers, who turn an antithesis into a riposte, and state a position with a pun.

But there's something sensuous in all this word play—a love of the physical effect of language, a joy in the twist and turn of thought and taste and touch, as the sentences unroll. Listen to Anne Hollander talking about a Versace design:

> The most perfect garment is a sleeveless black dress of tough synthetic net, ornamented with inspired beading and delicate black leather appliqués that rise from the hem in black flames (maybe seaweed) around the thighs and pelvis and descend from the neckline in uneven black clusters of grapes (maybe clouds) over the breasts and shoulders.

That kind of prose, so unlike everything that usability engineers recommend for serious information sites, proves that text still has the power to pull our attention through the loop-the-loops of

We provide information and a service on the Web that is not found in the print world. In a way, it's marketing 101. New products succeed when they fit an unmet need.

**—Steve Waldman,
Editor-in-Chief, Belief.net**

vicarious experience, even on the Web. The subject matter doesn't matter, finally. What we follow are the bright eyes, the moving lips, the subtly changing tone of voice, the heart of the conversation. Text can do that.

POST |

Express your own idea on:

HotText@yahoogroups.com

My Idea:

Post to HotText@yahoogroups.com

Subscribe:

HotText-subscribe@yahoogroups.com

Unsubscribe:

HotText-unsubscribe@yahoogroups.com

Visit:

http://www.WebWritingThatWorks.com

chapter 16 |

Getting a Job

Web Resume **422**

E-mail Resume **440**

Web Resume

We don't consider manual work as a curse, or a bitter necessity, not even as a means of making a living. We consider it as a high human function, as a basis of human life, the most dignified thing in the life of the human being, and which ought to be free, creative. Men ought to be proud of it.

—David Ben Gurion,
Statement, Anglo-American
Commission of Inquiry

Getting a job has never been easy. Apprenticing yourself to a master craftsman, becoming an indentured servant to earn passage to America, knocking on the door of a sweatshop, elbowing your way into a work gang for the railroad, working on the family farm—the old ways of getting a job involved personal contact, directly meeting with the employer, and reaching an understanding together, however brutal the conditions. But now employers can't rely on neighborhood gossip to announce their openings because potential employees—like you—live all over the globe.

The Internet has transformed the job search into a heavily electronic effort, quadrupling the amount of work you have to do, but speeding up the process, and automating it in ways your parents could never have imagined. Eventually, you get to meet face-to-face with an employer, but in today's high-tech marketplace, the interview is the final stage, not the starting point.

You still need a resume, the summary of qualifications that first emerged as a genre when big business began to hire millions of white-collar workers based on their training, background, and knowledge. Eventually, every applicant for any job needed a resume, however brief, to beat out the competition. And, to help high school grads get their first jobs, guidance counselors began coaching students on "the right way" to write a resume. Now there are folks who make their living writing other people's resumes. Heck, we've edited more than a thousand resumes—for free—and we can tell you, there is no perfect way to write a resume. Ignore the self-righteous claims that "This is the only way to do it." No, there may be a slightly different approach that's right for you, when you apply for a particular job, at a particular stage in your career.

No model is universal. Even the advice we're about to give you should be tempered with your own common sense, your awareness of your own limitations, your need to cover over

embarrassing patches in your work history, and your pursuit of your own dreams. You should adapt your master resume each time you apply for a new job, so it seems as if you are the perfect candidate. (Crafting a resume is a writing job—even if you feel it verges on fiction). No more photocopying a single paper resume and mailing the copies out to a hundred employers. For every job you apply for, you should edit your resume so it stresses the job title that company uses, the skills asked for in the ad, and the tone of voice you sense will work for that employer. New opening? New resume. Hey, that's what word processing is for.

A resume answers the questions of the person who screens resumes

When you're working on developing a master resume—the one from which you will spin off all future variations and formats—you will often encounter doubts about whether to mention a particular skill, success, job, or school. One way to resolve your own uncertainty is to think about what the employer wants to know. Consider the resume to be your response to a bunch of questions that the boss typically has in mind when looking over your resume. Your main effort must be to answer those questions, and formatting—often the aspect stressed by resume counselors—is only a way of articulating your answers and getting them read. So fonts, layout, and the overall look of a resume are not as important as the degree to which you respond to the unstated, but intensely felt questions coming from the employer. To answer those, you are going to need to come up with a lot of factual information—and a little marketing spin.

Typical questions:
- Who are you? What's your name and address, e-mail, URL?
- Can you work at the level we are looking for?
- What exactly can you do for us?
- Have you already done something like that?
- Who trusted you enough to hire you to do that?
- Did they keep you on the job beyond the honeymoon?
- What exactly were you responsible for, on those jobs?
- What tasks have those organizations entrusted to you?

- Can I trust you?
- Do you generally back up your claims with specifics (numbers, dates, proper names)?
- What is the arc of your career so far?
- Where did you start? (High school, college, military).
- Are there any worrying gaps, twists, or turns in your history?
- Is the resume itself organized and written so that I can find out what I want, without much difficulty?
- How do I get hold of you to bring you in for an interview?

Adapt your style to speed up access to answers

As you write the master resume, imagine you are the boss—suspicious, dubious, or paranoid—reading the text. Here are some ways to write your resume so you allay those fears and show that you are a "can-do" person, full of energy, and eager to get to work.

- Begin items with verbs in the past tense ("Created budget"), not adjectives following forms of the verb *to be* ("Was responsible for budget"). Verbs give your claims activity and energy.
- Use nouns that correspond to the terms the company includes in the job listing (such as tools, document types, skills). The software reviewing your resume looks for these keywords, and if it finds a lot of the keywords it is looking for, raises your priority, so you have a better chance of getting noticed by the humans.
- Include dollars and cents, numbers, dates, names, titles, and anything that can be checked to confirm your claims. Many of these details cannot be checked, but they look as if they could be. Including these details—particularly the ones involving numbers—will give your text a gritty feel, as if it must be true. (How true it is, of course, depends on your own conscience).
- Be specific, but not long-winded. No more than two lines of text for any particular item. No long paragraphs. They baffle the human readers.
- Open the page up with white space and bulleted lists.

Computers don't much care about the white space, but people do. If you make it easy to skim through the resume, they can get the gist of it faster, and they feel more confident in your ability to communicate.

- Write simply. Edit out extra clauses, redundant phrases, unnecessary words—without sacrificing key details.
- Organize the components of the resume to answer the key questions, following well-worn conventions (so the reader knows where to look for what).

Prepare four versions

If you want to write or edit content on the Web, you're going to need to make a master copy of your resume and then spin that off into several different formats.

All work, even cotton-spinning, is noble; work is alone noble.

—Thomas Carlyle,
Past and Present

If you're applying to a company that lives or dies by the Internet—including almost any Fortune 1000 firm—you can be sure that they will want to receive resumes embedded within an e-mail message, using software to sift through the text looking for keywords describing the job, ranking you in competition with other candidates, and automatically putting your information into a database. Or, using a job board or its own Web site, the company will invite you to enter your text directly into the database, one field at a time, essentially carving up your resume into their bits and pieces. (We call this version of your resume the all-text, or **ASCII version**).

If the company accepts scannable paper resumes, someone lays each page onto the scanner bed and runs the Optical Character Recognition software, sucking up your text (more or less accurately) and feeding it into the same human resource software, to rank you and drop you into a database. (We call this version of your resume the **scannable paper version**).

If your resume can't be read quickly and accurately by the Optical Character Recognition software during scanning, or if the software reading your e-mail resume has trouble figuring out what you are talking about, then you don't get the job.

If you are aiming for a job having anything to do with the Web, you will also create a personal **Web resume** (without any pictures of your pets).

And finally, if you get invited for an interview, or you meet a VIP at a conference, you need a **fancy paper version** of your resume—that's the old-fashioned kind.

So, all told, you will need four versions of your resume. The last, and least important, is the fancy paper version, but you may want to use that as your master copy. It's the least valuable because machines have trouble reading unusual fonts, lines, and other neat graphic effects you might choose to use in a resume that is now relegated to the interview, or other moments when you can personally hand someone a piece of paper. (Or when someone has specifically asked for your resume, and you know that only humans will be reading it).

Devolving from your formal version, you create a Web version by splitting it up into individual pages and formatting it for easy browsing.

Finally, you make a drab, all-text version that can be included within e-mail messages, carved up and dropped into job board databases, and printed out to be easily read by a machine. (Even though humans would think the unformatted look a bit plain, OCR software gobbles it up).

Here's the sequence most people follow creating these different editions of the same resume:

1. Master copy. This is the fancy paper version, to show how well you can format, when given the chance, for hand delivery or mail follow-up (not for scanning, not to be sent as an attachment).
2. Web version to prove you can put up a site, and to offer samples of your work, testimonials, and links to your online work.
3. Ascii (plaintext) for e-mailing or posting on databases.
4. Scannable paper version to fax or mail for scanning into the corporate database.

Make the master copy

Given the number of spin-offs, you need a master copy of your resume for each type of job you are applying for (one master for writing jobs, say, another for graphic jobs, and so on, through your

whole range of careers). The master resume acts as a repository for all your successes, all the details of your past jobs, so that you can pick the right ingredients to spin off into a resume for a particular employer. When you realize you forgot to mention an award or a promotion, you add that to the master resume. Often, the master resume is longer and more complete than the resume you will end up creating for a job. The idea is that you need a lot of ammunition, and the master resume is where you store that, carefully.

The master resume can be organized in several different ways. If you have worked for a long time in exactly the kind of job you will be applying for, a traditional chronological resume, organized job by job back into the mists of time, will work OK for you. But if you are looking for your first job, changing careers, or re-entering the work force after raising a family, that chronological resume makes you look bad—suggesting you have not held enough jobs, or you have had jobs with the wrong job titles, or worse, you have had long periods with no paying job. In these circumstances, a chronological resume can make you look inexperienced, irrelevant, or lazy.

To emphasize your skills, and de-emphasize previous job titles, chronology, and age, we like the functional structure, which brings your skills to the top, and leaves work history for a little lower down. The idea is to communicate to the employer that you know what skills are needed on the job, and you have those skills— before admitting that, well, you have never actually held a job that has the same title, or maybe, but only once, and not for very long, or... well, you know how that goes.

If you already have a gigantic master resume, great. If not, here are some tips on building up each section, if you decide it's relevant to the job you are applying for, and shows off your own experience well.

Identification Area—Put your name right up there at the top, big and bold. But—sad to say—more important than your actual name is your contact info. Let people know how to reach you, if they want to interview you or hire you today. You'd be amazed at how many people forget to put their phone number on the resume. If you are writing or editing on the Web, of course you have to highlight your e-mail address and the address of your resume Web site.

Blessed is he who has found his work; let him ask no other blessedness. He has a work, a life-purpose; he has found it and will follow it.

—Thomas Carlyle,
Past and Present

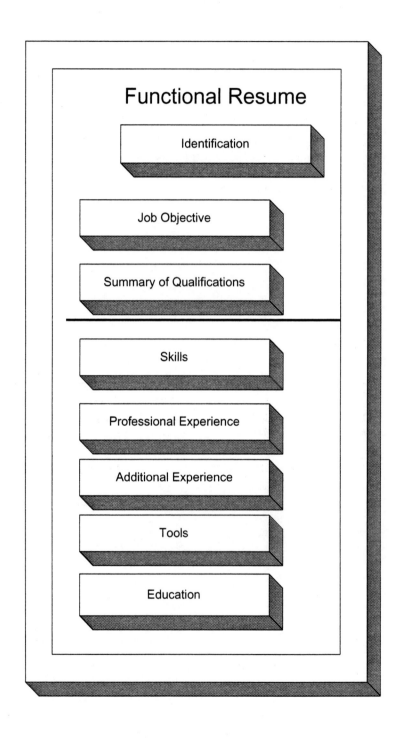

Functional Resume

Identification

Job Objective

Summary of Qualifications

Skills

Professional Experience

Additional Experience

Tools

Education

When more and more people are thrown out of work, unemployment results.

—**Calvin Coolidge**

Job Objective—Yes, you need one because the software reviewing your e-mailed resume needs to know what job to file you under, and the humans who have to sort your paper resume into tubs in Human Resources need to know which folder to drop your papers into, and the person who has to scan your resume needs to know which job category to list you under. If you don't mention a job objective, none of these folks know where to put you, and you end up in the circular file, or the pile of resumes to be looked at "sometime, when we have time." Logically, the job you want is the job the company is offering, so put in whatever title the company uses for the job. That has always been your career objective, right?

Just the job title, please. No malarkey about looking for a challenging position in the food services field. Yes, if geographic location is critical, say so at the end of the job objective: "Marketing copywriter at Peninsula organization." If you absolutely will not go into the office, admit that here: "Job objective: Freelance Web journalist."

Summary of Qualifications—Not necessary, but often urged on you by earnest counselors in job programs, to help you overcome a diffuse or irrelevant job history—what was once known as "a checkered career." These blocks help you state your case when you fear that the rest of your resume won't make clear what your strengths are. We think you can skip this section, but if you feel nervous, then put in three to five bulleted items, or a very short paragraph, singing your own praises—while using keywords from the ad.

Skills—The guts of your resume, the skill blocks, ought to appear early enough so an employer catches sight of them right away (another reason to leave out the summary of qualifications). These items are built around the skills you think are necessary on the job you are applying for. Identify three to five skills (no more), such as Writing, Editing, Managing, Production, Customer Service, or Marketing. Put the most relevant skill first. Then, under each skill, describe three to five successes—achievements that demonstrate you really have that skill. Each success should start with a bullet in the master version (asterisks or plus signs in the e-mail and scannable versions, to avoid confusing the soft-

ware). Then put a verb in the present or past tense ("Wrote," "Edited"). And follow with details, stressing keywords from the ad (the terms the software is looking for), then inserting data such as numbers of people affected, amount of money involved, page count, software used, titles of content, and target audiences—the specifics that create a rich picture of your work, in the mind of the employer. By the way, money really matters. Stretch to include some hint of the company's investment in the site, the revenues (if any) relevant to your work, the savings brought about by your innovations. Particularly in the United States, you are considered a better candidate if you have been hanging around with a lot of money. Overcome your natural modesty about mentioning money, and guess—if you don't have exact figures, an approximation helps the employer get a sense of the scale of your work and its relative importance.

A man has a right to work only if he can get a job, and he has also a right not to work.

—Clarence Darrow,
The Railroad Trainman

Professional Experience—Here's where you put in the chronological history of your jobs going back five or ten years—not forever. You have to include these because if you just mention skills, suspicious employers think you have something to hide.

- Dates. Each job has its own block of text, with a start date and end date, so the software knows it is a job. Start with the latest job and work backward (reverse chronological).
- Job you did. Use a lowercase noun for the name of the job you did, rather than a verb. (In this way, you may avoid the actual job title, if it is embarrassing). If you are proud of all the job titles, go ahead and use them. But be consistent. If you fudge one, fudge all.
- Company name and location (city, phone number). If you worked at a company that changed its name, make sure you mention that, so an employer sees that job as one job, not two or three.
- Responsibilities. Briefly, because all the best achievements already appear above, under skills.

Additional Experience—Optional section. If you have had big gaps in your job history, create a cover story here ("Consulted with Indian ashram," "Freelance travel writer in Brazil," or "Dry cleaning specialist in state facility" to explain that year of meditation, the

year off, or your brief period in the state pen). If you have had some totally irrelevant jobs, put those here. By separating them out, you show that you understand they are less relevant, but you are a thorough person, and want to provide this extra information. You might, for instance, include volunteer jobs on which you learned important skills, mention the job of mothering, or excuse a long slow spell as consulting. The format is the same as for professional experience.

Tools—Important if the job involves high-tech toys. Also, this section responds to the employer's questions about whether you can get to work immediately without extra training. Do you know the same software we use here? Ads often make it sound as if you must know all kinds of tools, but in reality, if an employer sees you can do the job and learn the tools quickly, you may get the nod. Don't overclaim, here. If you know a tool well, include it; if the ad says another tool is required, and you have a little experience with it, put that in. But don't claim tools you have never heard of. If you have a lot of tools, carve the list up into groups such as:

- Software: (include product names, not general categories, such as "word-processing programs.")
- Operating Systems
- Programming Environments
- Hardware

Education—Often the most ticklish section to write. If you have just graduated, or are about to graduate, Education may have to move up ahead of Professional Experience, because you have so little of that, and you will need to go into some real detail about the actual courses you have taken (not just their names) so the employer has an idea what you might know. If you went to a college for a while, then dropped out, just say, "Attended." If you graduated years ago, the Education block dwindles to a line or two.

For college or university education include:

- Date of graduation. Include the date unless you have a very strong reason not to. (HR departments do toss resumes if they suspect you are covering something up, like failure to graduate at all, by omitting dates). (On the other hand, if you have been out of school for more than

Every man has the inalienable right to work.

—Eugene Debs

10 years, the education section is going to be unimportant, and may not require any dates).

- School and location.
- Major, particularly if the ad requests a specific major and yours matches it.
- Awards and scholarships (more if you only recently graduated, fewer or none if college was more than ten years ago).
- Courses. Include a list of courses if you have just graduated in the last few years, or if your coursework was in a field that is relevant to the business. Rewrite course titles as subjects studied, to reflect actual content, so the reader can tell what went on. If these courses are critical to your job search, mention three to five topics covered in them, in parentheses.

You do not have to include your grade-point average unless it is fantastic. If you do choose to include some mention of your grades, you can say your overall average or your average in your major. If your grades were below 3.0 or B, then discretely omit them. (Only include grades if they give you bragging rights).

If you started a program, but did not finish, but you still want to get some credit for it, summarize what you did accomplish. "Colorado University, Boulder, CO, Doctoral study in English Literature (All but dissertation). June 2000. Completed 42 of 48 credits."

Add any training programs after regular education. Include workshop or program names (rewriting if necessary so that the titles will make sense to the employer), along with a list of three to five of the topics covered, to get across what you learned. If you got a certificate, say so.

Professional Affiliations—Optional. If relevant, membership in an industry organization may boost your credibility. Drop these mentions in after education.

FAQ about the master resume

Why do hiring managers throw away a resume?

"It does not respond to my needs, requirements, or makes it hard for me to find out whether the candidate can do the job."

Solution: Include keywords, successes that mirror the requirements. Squeeze in plenty of specifics, to clarify real achievements

Solution: Move the relevant skills to the top.

Solution: Use lists and white space to enable skimming.

"Makes me suspect that the person is lying."

Solution: Include facts and figures that give a full picture of each success, job, educational experience—if relevant to the job you are applying for.

Solution: Avoid including dates for one job, but omitting them for another. Be consistent in areas that HR folks consider critical: job titles, company names, and dates.

"Includes too much irrelevant stuff I have to wade through."

Solution: Revise the resume for each job, to demote or ax skills that are not really relevant to the job you are applying for.

Solution: Drop any info about hobbies and personal interests.

"Looks dense, thick, hard-to-read right off."

Solution: Use more white space. On paper, use bulleted lists and hierarchy of tabbed indents.

"Does not seem to know our organization."

Solution: Use the terms, ideas, and approaches you gather from their job description.

"Weak language from someone applying for a writing job. Typos and misspellings. All-purpose platitudes, particularly at the start. Seeking a challenging position in a high-tech firm..." (No focus on the needs of this particular employer; lame writing). Also, too many items starting with an adjective: 'Responsible for... .' Too much reliance on adverbs to inflate the achievement: "Distributed spectacularly successful brochure..."

Solution: Energetic writing with lots of nouns and verbs, facts, figures, and specifics.

I never did anything worth doing by accident; nor did any of my inventions come by accident; they came by work.

—Thomas Alva Edison

"The applicant was applying for a different job or had no particular job objective. Cover letter focuses on the applicant's needs, wishes, and dreams."

Solution: Focus on what you can do for the employer.

Man has indeed as much right to work as he has to live, to be free, to own property.

—William O. Douglas, Dissent,
Barsky v. Regents

What about a job I was fired from within a few months?

Generally, omit it from the resume. If it is your best experience, then you should explain why you left so fast in your cover letter. If you leave it out, assume that the HR folks will uncover the unsightly gap and ask you what you did during that time. 'Fess up. There is no shame in saying that the job just wasn't a good fit. (You have a grace period of 2-6 months in which leaving is not considered a disgrace).

How should I handle the request for salary history?

The easiest way is to put the last salary you earned after each job you mention. Of course, if you earned more than the employer is willing to pay, these figures may disqualify you; and if you earned a lot less, you lose some negotiating muscle for a better salary. Also, salaries from jobs more than ten years ago will seem diminutive compared to current salaries, due to inflation. (Consider including salaries for the last five years).

If the company asks for a salary history, but does not require it, and you see some real disadvantages, leave it out, but be prepared to be rejected for that reason alone, or interrogated at length if you are asked for an interview.

In general, do not include salaries in your resume.

Should I include really trivial experiences or skills?

No. Don't make your resume seem like a puff.

What if I lack a college degree?

- If you have no education beyond high school, omit the education section, and be prepared to answer questions about college in your interview. If you have some college, just put "Attended..." with the dates. If this was long ago, just be ready to explain why you left school before the degree. If recent, explain it in your cover letter.

- If you have a lot of experience in the industry you are applying for, the degree may be a non-issue—unless the company specifies a college degree as a requirement for the job. (Many do). If you have the interest and stamina, take night courses and complete your degree.

Should I include personal interests and hobbies?

No. If these after-hours activities relate to the job, put them into the description of your skills. If not, skip them. They don't help, and may get you in trouble, particularly during an interview if you claim more knowledge than you have. If you pretend you do gardening as a hobby, you are sure to be interviewed by someone who used to run a gardening supply house. David Jensen, who helps research scientists find work, argues that 7 of 10 hiring managers dislike personal info, where the other 3 love it.

How can I handle the fact that I am twice the age of the employer (or so)?

- Emphasize what you can do. Show you know what this company really needs. Include phrases that address the unstated suspicion that you are inflexible ("Led change management seminars..."), low-tech (use the company's own buzzwords), unable to get along with others (emphasize words like *team*, *participated*, *cooperated*), low energy (show real enthusiasm, and demonstrate work done recently).
- Emphasize work done in the last ten years. If your writing skills go back before then, mention them in the skill section and in the employment history. But avoid giving much detail about jobs you held more than 15 years ago in the work or employment history section. Act as if you have moved beyond all that.
- Also, look for companies whose customers are your age or older, so that you can empathize with your audiences. And target companies that receive money from the state or federal government: they have to prove they are not discriminating because of age in hiring.

What are the most common lies on resumes, and how easy are they to catch?

- Wrong job title (easy to catch)
- Exaggerated statement of responsibilities on a job (harder to catch)
- Wrong dates to cover unemployment or exaggerate length of time on the job (the bigger the fib, the easier to catch)
- Made-up degrees (easy to catch)
- Exaggerated claim of participation in a project (time-consuming to check)

Develop a list of potential references

Line up references ahead of time—half a dozen would be great. Don't put these on the resume. In fact, don't even say "References available upon request." Of course they are! Otherwise, you won't get the job. Just get the references ready for the moment a company shows some interest.

- Make sure you have up-to-date information such as name, phone, fax, e-mail, and snail mail addresses.
- Find at least one person who can talk knowledgeably about the skills relevant to the jobs you want.
- Consider former colleagues, subordinates, suppliers, clients, and people you have assisted over the years.
- Recognize that each previous employer will be checked, whether you list a contact as a reference or not. The employment verification may lead to a discussion of your qualifications.
- Talk to each potential reference, explain you are looking for work, ask for ideas, and ask permission to use them as a reference. If yes, remind them of what you did for them, what your job title was, and what years you worked there. (Even enthusiastic references forget).
- Worried about what a former boss might say? Hire a company to ask for your references, and tell you what was said, and how the response sounded. A team at www.myreferences.com will check your references for a hundred bucks, asking about performance, skills, judg-

ment, integrity, productivity, technical savvy, employment dates, job title and description, and reason for departure. (They say that half the references they check range from lukewarm to downright negative. Also, some employers hand out misinformation about dates, job titles, and so on, which a potential employer might take as proof that you are lying).

Money makes a man laugh.
—**John Selden,** *Table Talk*

- Whenever the target company asks for references, call all of them, telling them to expect a call and briefing them on the key points to make to the employer. (These differ from job to job).
- If someone offers to give you a letter of recommendation, accept and ask if you can post that on your resume Web site, as a testimonial.
- Thank them after they have been interviewed by the employer. Hey, these little interviews take anywhere from 15 minutes to an hour, so your references are investing in your future.

Turn the master resume into a Web resume

Moving the content from your master resume onto Web pages lets you demonstrate your Web skills. At a minimum, you must show you can create a reasonably useful menu system, an easy way to move forward and back through the pages, and, underneath, a sensible architecture. If you can also add some other bells, whistles, and sirens to show off particular skills, by all means do so. Here, though, we will talk about the basics.

Format simply.

- Use standard fonts (such as Arial and Times New Roman). Do not require fonts that may not appear on the employer's machine, because your pages may end up displayed in a substitute font you hate, making you look silly.
- Keep your HTML clean. Don't just pour a Word file into Front Page because Microsoft sends so much junk along. Remember: If the job involves the Web, the employer is going to View Source.

We may see the small value God has for riches by the people he gives them to.

—Alexander Pope,
Thoughts on Various Subjects

- Make the layout simple. Each page should include the main menu, top and bottom, plus the content of that part of your resume, and not much else.
- Include a button to a page that has an entire resume ready to print or save. (This print version is another HTML page, laid out so it will print well). The idea is to offer a way for someone to get the whole resume in printed form without having to go to a bunch of pages, print each one, and staple them all together.

Create a straightforward architecture. Create a main menu pointing to individual pages that contain the major sections of your resume, such as Skills, Professional Experience, and Education. Add pages that show off your sample work (or provide a linklist to online examples).

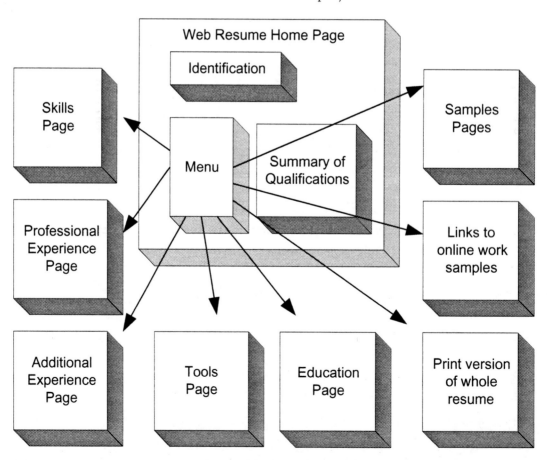

Publish your Web resume

If you already have a professional site, and want to add the resume pages there, go ahead. Otherwise, create a new site just for your Web resume. Do not, repeat NOT, attach your resume to your family site, even if your dog and cat pictures look cute.

- It is OK to use a personal site on America Online, or at a similar place, like Microsoft Network. You do not need your own domain name.
- If you don't have a site, go to a portal that offers a free page.
- Post samples as an online portfolio and provide links to current Web pages you have done.

Link back

- Include links to your resume site on all other versions of your resume.
- Put your URL in your e-mail signature.
- Participate in newsgroups that the employer might frequent and use your e-mail signature with the URL.

See: Bolles (1999), Dikel (2001), Dixon (2000a, 2000b), Kennedy (1995), Parker (2001), Smith (2000a, 2000b), Troutman (2001).

E-mail Resume

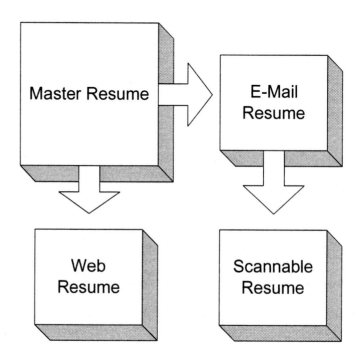

To respond to ads, you need a version of your resume that you can insert into an e-mail message without creating a mess of strange characters and ugly line breaks. Often these messages are read by software that must deduce what each line means and put its text into the right field in the corporate database. Essentially, this is a text-only version of your resume. Hence, it can also be used when you need to copy and paste your resume, in chunks, into the fields of an online database at the employer's site or a job board.

To make this version of your resume, you take your master resume, save it as a text file to strip out all the formatting, and then build it back up out of raw text, using only the formatting options available to the crudest e-mail program.

Use job boards with restraint

If you are looking for a first job or an entry-level position, you probably won't face the problem of contract companies grabbing your resume without your permission and running it around to see if they can get a fee when you get the job, or just pretending you work for them. But if you have a fair amount of experience, watch out.

These unscrupulous firms may submit your resume to your own company, or a partner, which could get you fired. Some recruiters post bogus job listings to collect resumes, and then shop those around to other recruiters.

When your knowledge is in demand, or your skills are hot, avoid general postings, to keep your inbox free of junk, and respond only to actual listings if the description names the employer. Also, make sure that the job board will notify you of each request for your resume, allowing you to deny the resume to certain firms. And only use job boards that let you block your current employer from reading your resume.

Don't send your resume as an attachment

Many employers resist reading attachments because:

- Company policy prevents attachments from coming through, or orders people not to open them because of the very real threat of viruses.
- Even if someone downloads the attachment, it may end up in some strange location on the server, and the person may never find it again.
- Perhaps the employer does not have a word processing program that can read your resume.
- Perhaps the employer does not have the same fonts you do.

Also, think of time-and-motion studies. The employer has to choose to download, specify a place to save the file, wait while the file is downloaded, leave the e-mail program, double-click the file, and if the file comes from an alien system, identify an application that might just read the file, wait for the application to open, wait for the document to open, discover that the document is a bunch of rectangles with hexadecimal numbers, close the document, close

There is nothing so habit-forming as money.

—Don Marquis

the application, find another application that will read the file, open the application, open the file, print the file. If you expect anyone to do all this for a stranger, you are dreaming.

Format for the machine

Here's some formatting advice for resumes a computer will read (that is, included within e-mails to the employer, in fields in an online database, or in a paper resume that will be scanned).

- Use single spacing within paragraphs.
- Only put dates with descriptions of individual jobs and education.
- Ramble, if you must. You can go to three or four pages if you have a lot of relevant experience because the computer can handle the length.
- Include the key terms from the ad, several times if possible.
- Write in your word processor, save as ASCII, which is also known as Text Only, or MsDOS Text, and spits out a file in Windows with a .txt suffix.
- If your word processor will limit lines to 65 characters, do so. (Setting margins does not force lines to wrap in the text-only version. Pressing Shift-Enter, which generates a line break in a word processor, is just interpreted as a return character in ASCII).
- Do *not* use bullets. Use asterisks instead. Your tabs will probably survive.
- Use extra returns to separate sections.
- If you want to emphasize the name of a section, go ahead and use ALL CAPS even though they are ugly as hell. (Better to use upper and lower case, and make the heading stand out on its own by putting a return ahead of it and after it.)

Start the e-mail with the job reference number in the subject line and in the contents.

Write out the full text of most jargon and then use the abbreviation or acronym as well. (Remember: you are writing for a computer, not a human).

Here are the steps to starting an e-mail resume:

The shortest and best way to make your fortune is to let people see that it is in their interests to promote yours.

—La Bruyère, *Characters*

1. Write your master resume in your word processor, so you can write it easily with as much formatting as you like, reorganizing and rewriting until it is perfect.
2. Spell check the document, print it out and proofread it. Ask someone else to proof it, too.
3. Save as text only (raw text, or ASCII text), with the suffix ".txt" at the end, on a PC.

Then, reopen the file in a text editor such as Notepad, Wordpad, or Simple Text to edit the raw text. (You can't trust your word processor to leave the text unformatted, even when you open the file as a Text Only file.)

1. Make each line break after 65 characters. Yes, you have to count a line to figure out where this will be, if your software doesn't allow you to set line lengths by characters.
2. Put each phone number on its own line.
3. Instead of bullets, use asterisks (*) or plus signs (+) at the beginning of lines.
4. Instead of horizontal lines, use a series of dashes to separate sections, if you want. But insert a carriage return before and after the line, so the scanner does not confuse the dashes with text.
5. Do not use boxes, columns, vertical lines, or graphics.
6. Instead of bold text for headings, put the text on its own line starting and ending with four or five asterisks.
7. If your editor allows tabbing, make sure that all items at the same level have the same number of tabs, so they line up correctly for any stray human that happens to look at this. If tabbing does not work, use one, two, or three hyphens or space characters to indicate the indents.
8. Print it out and proof it.
9. E-mail yourself a copy and make sure that the process has not changed your line breaks or arrangement.
10. Compare your resume with those of your competitors in the job market, any time you can.

Get ready to go public

If you do not want total strangers getting your phone number, get a voice mail account. (You must have a phone number.) If you use your home number, consider the feature that lets you call back using the caller ID because many recruiters' voices are distorted, since they are on cell phones or speaker phones.

If you don't want to give out your street address, get a post office box for the length of your job search.

Before you post your resume, find out

- Who will be allowed to read it?
- Will you be notified if your resume is requested or forwarded to an employer?
- Can your current boss discover that you are looking for work? (Or can you block certain companies or people from discovering your resume?)
- Are updates free? (They should be).
- Will the old resume be deleted after a reasonable amount of time, such as 3-6 months, so you do not have an antique version representing you next year?

Post with restraint

Leafleting makes you look desperate. Hit two or three major job databases and some targeted databases (in the industry); then wait. The more places you post, the more likely you are to get spammed with get-rich-quick schemes, multi-level marketing scams, and ads for porn.

No response in a month? Remove the resume from that site and move on.

If recruiters find you by themselves, they persuade themselves that you fit the job; if you send your resume to them, they may nitpick. Higher-level jobs are often handled by headhunters and recruiters without ever posting an ad because the ad might upset someone inside the company.

Reuse the text resume as a scannable paper resume

Once you've made an e-mail version of your resume, you can use that as the basis for a scannable paper version. This goes to employers who ask for a resume to scan, which includes most Fortune 1000 companies when they advertise in the newspapers. If you are going for a Web job, send your e-mail resume, rather than sending in a paper version for scanning, if you can. You'll end up with fewer errors in their database. But if you must put something on paper for a company that will be scanning it, follow this advice. Note that you still want a formal resume for your interview, but because of its very formatting, it may not scan well. These tips help you make a version just for the scanner.

- Use plain white 8.5"x 11" paper. Colored backgrounds and specks on the sheet may confuse the Optical Character Recognition (OCR) software. Other sizes will get crunched in the scanner.
- If faxing it, use the highest resolution your fax machine offers.
- Do not staple.
- Avoid shading, patterns, lines, and boxes, for the same reason.
- Make the text 12-14 points, even if that extends your resume to three or four pages.
- Use the most common fonts you can find, such as the sans-serif fonts Arial or Helvetica, not narrow.
- Use asterisks or solid bullets.
- Do not use italic, bold, or underlining.
- Do not use ampersands, parentheses, brackets, percent signs, or math symbols.
- If you must use slashes, put a space before and after each, so the OCR does not mistake the slash as part of one of the surrounding characters.
- Left justify.
- Do not use multiple columns.
- Do not include a picture.
- Put your name at the top of every page.

- Give each phone number its own line.
- Print at 600 dpi or better.
- Use white paper.
- Do not photocopy: Rewrite and print anew.
- Do not staple or bold.

Suggestion: If you fax this version, follow up by mailing this version (or the really fancy paper-only version) to the employer, because the faxing process may have made some words a bit fuzzy, and therefore hard for the computer to read.

See: Bolles (1999), Dikel (2001), Dixon (2000a, 2000b), Kennedy (1995), Parker (2001), Smith (2000a, 2000b), Troutman (2001).

POST |

Express your own idea on:
HotText@yahoogroups.com

```
My Idea:

Post to HotText@yahoogroups.com
```

Subscribe:
HotText-subscribe@yahoogroups.com

Unsubscribe:
HotText-unsubscribe@yahoogroups.com

Visit:
http://www.WebWritingThatWorks.com

part 4

Become a Pro

chapter 17

So You Wannabe a Web Writer or Editor

Where Web Writers and Editors Come From

Who knows? We fell into this line of work. For several years, we had written a 3,000-word "At Home" section for *FamilyPC* magazine. Budget cutbacks, fired editors, and a new owner brought our work there to an end. Looking for another gig, we decided to check out the Web. We sold some articles to a new site, named Thunderbeam (because no one else had chosen that as a domain name, the boss told us). A few months later, the editor quit, and we were hired as her replacement for the grand sum of $700 a month. OK, the work was easy (a few articles, a little editing). We learned how to code a little HTML, how to use Photoshop, and how to cut. We went from writing 3,000-word articles to compressing a lot into 500 words. We discovered bullets, chunks, and links. The site morphed into new designs, new names, and new identities several times, and eventually became KBkids.com. In a few years, just by doing it, we became Web writing and editing experts. We left the site, took on Web clients, wrote a book about online shopping and another about digital imaging, and started appearing on TV, radio, and online chats as Web mavens. Sound like something you'd like to do?

Good writing is not data.
—**Constance Hale, *Wired Style***

The pay

The pay range for Web writing or editing is as wide as the United States itself. The physical location of the job matters: Silicon Valley still pays the most, with the Boston and New York areas coming in second. And pay depends on skills. You may be able to be a content editor for a site if you have a BA, the "strong attention to detail" that most sites ask for, and a rudimentary knowledge of HTML. That combination of skills will get you about $35,000 a year. On the other hand, at another site, a content editor may show up knowing DreamWeaver, Java, Excel, and XML with at least five years experience in the field. If you have qualifications like that,

Writing's not terrible, it's wonderful. I keep my own hours, do what I please. When I want to travel, I can. But mainly I'm doing what I most wanted to do all my life.
—**Raymond Carver**

you can expect to find a job in the $65,000 to $100,000 range, depending on the location and size of the company.

Content providers, aka "writers," get a little less. If you are looking for your first job out of school, you can expect to make about $25,000. As your experience and knowledge grows, you can make up to $75,000 for a top-notch company. You'll get even more if you are a subject matter expert (called an SME). For example, if you were once a nurse, a medical site would be thrilled to get you and pay you extra because you have both kinds of expertise—medicine and writing.

FAQ on life as a professional Web writer

Q: I'd like to write for the Web, but all of my writing experience is for print publications. How should I approach the Web sites for work?

A: The good news is that many magazines and newspapers now operate their own Web sites, and many of these sites use original content, as well as reprinting articles from their print publication. If you've worked with such a publication or one like it, start there.

Q: Do I need to put up my own Web site if I want to write for the Web?

A: No, but it helps if you have a lot of online clips. This way instead of typing in long, laborious URLs in your query, you can just point the editor to your Web page where you'll have links to your online clips.

Q: Do I need to know HTML or XML to write for the Web?

A: No, but a basic understanding helps. It's easier to edit text that isn't littered with HTML codes, so most editors prefer raw text that has no formatting, no tags, no nothing—so it's easy to fold into a template or sprinkle with tags. Some editors like plain vanilla Word files with an absolute minimum of formatting. Many writers avoid tagging altogether. But if you find you like experimenting with tags for format (HTML) and content (XML), you'll have plenty of opportunities to play with these, on your own site, at startups, and in teams building new templates.

We must acknowledge that the reader is doing something quite difficult for him, and the reason you don't change point of view too often is so he won't get lost, and the reason you paragraph often is so that his eyes won't get tired, so you get him without him knowing it by making his job easy for him.

—**Kurt Vonnegut, quoted by John Irving, Review of** *Hocus Pocus,* **Los Angeles** *Times Book Review*

Q. How do I go about getting work at business Web sites?

A. Online job boards have a lot of jobs for Web writers, even during the downturn in the economy. When looking for work, it pays to do a number of things. First, make sure that you have a great resume. Send it out to any place that you'd like to work. (You should also check their company Web site, to see if they list a job board.) Second, network. Let everyone know that you're looking for work. Third, call up a professional recruiter or headhunter. Here are some particularly good job boards for writers:

- Dice.com
- HotJobs.com
- MediaBistro.com
- Monster.com
- Techies.com

FAQ on life as a professional Web editor

Q: Do you need to know HTML to be a Web Editor?

A: It depends. Most sites will create a template for their content. As the editor, your job is to see that the content is correctly poured into the template. You can't manage this feat without a basic understanding of HTML. Also, there are some crucial HTML codes that aren't in the template, and no matter how strong the schema is, some articles just need a little special fillip, and for that, you need to get out the HTML reference and experiment a bit. As in any job, the more you know, the more you'll receive. Ditto for XML.

Q: How easy is it to go from Web writing to editing?

A: We've always believed that the best editors were good writers first. But ask yourself how much you depend on an editor to make your words count. One of the most important tasks for any Web editor is to take a lot of information and make it short but readable. If you like to send in lots of info expecting the editor to cut it down, the editorial life isn't for you. However, if you find that your pieces usually get published pretty much the way you wrote them, then give an editing career some thought.

To write simply is as difficult as to be good.

—W. Somerset Maugham

Q: What tools do I need?

A: You have to enjoy the Web—not just tolerate it. Of course you should have the fastest modem you can afford, the latest Internet browser (possibly two or three), and a current e-mail program. Plus:

- You must use Word, the common application of shops, well enough to follow a template, apply styles, copy and paste, make your text look dramatic, or reduce it to unvarnished, unformatted stream of characters in the American Standard Code for Information Interchange (ASCII), or one of its descendants.
- You probably should know how to create a simple Web page. If you're a potential geek, you can write this in a text editor; if you are a lazy consumer like us, you'll want a graphic user interface, like that of Front Page or DreamWeaver.
- You need to be able to use your browser to steal pictures off someone else's Web site (well, you're Press, after all, and you're doing a story about them), use simple bitmap or screen-capture programs to grab images of other sites (screenshots) and edit them (cropping, trimming the edges, resizing, brightening, changing the contrast).
- To keep track of your hours, articles, authors, editorial schedule, and budget, you should get familiar with a spreadsheet like Excel, or a database program (we enjoy FileMaker Pro).

Q: What personal traits make for the best editors?

A: First, you must be organized, self-directed, and flexible. If you don't have these qualities, then sell cars. It also helps greatly to be ethical and persistent. You'll be dealing with a lot of artistic people (Web designers, writers, artists) and a lot of business people (venture capitalists, advertisers, your boss), so you'll probably need a sense of humor, and a little humility.

The harder the writer works, the easier for the reader.

—Donald Norman,
Turn Signals are the Facial Expressions of Automobiles

Web Editing—The Basics

Edit visually

You're vying for each guest's attention. A snappy headline may get it. A blinking picture may grab it. But then what? Web readers want to see what the article or site is about in a snap. If they can't figure it out right away, they'll go elsewhere. So, grab them with an attention-getting title, tightly, and then, to hold them, design sparkling subheads.

Good test: Imagine there's no text at all—only subheads. What would you say? How would you list them? Make them the story. (It might be the only thing a reader skims.)

Got some text to go with those subheads? Great. Sprinkle a little text in. (And be sure you don't get sucked into the Web trap of using jargon or techno-babble just because you're on the Web.)

Got a paragraph with more than three sentences? Seriously consider using bullets. Readers like short, insightful, information-packed stories. The shorter, the better.

Want to reference something on the Web? Paraphrase it in one sentence and then provide a link to it. No need for readers to have to slog through the findings if they're not interested.

Make the text consistent

One reason that general-purpose Web sites have had problems making money is that they are very broad. The sites that are doing well have branded themselves into the reader's mind by taking a consistent tone throughout their site, in their e-mail, and in their advertising. Readers appreciate this. They know what to expect. Readers get angry when you change a site that they've become accustomed to. Don't think so? Why did everyone hate the final episode of *Seinfeld*? Didn't Jerry, George, Elaine, and Kramer always get away with everything? Didn't you love to see them accomplish that? In the last episode that all changed. They were

After you've written a letter, memo, or report, the tweaking can be endless. Should it be single-spaced or double-spaced? Bold-face or italic for emphasis? Shadow style section headings?

—L. R. Shannon, New York *Times*, May 11, 1993

sent to jail for their past and present "sins." The last episode would have been better if their lawyer had gotten them out on some totally insane technicality after they were sent to jail.

Think globally, act locally

What's the right usage? That's a big debate among Web editors. The Web has ushered in so many new words that we see widely different spelling, capitalization, and even grammar choices on different sites or on different pages within the same site. There are two basic schools of thought about usage: One is to use the AP (Associated Press) Style Guide, which tends to opt for the English Major version of words (*e-mail, Web site, on-line*) and a lot of optional punctuation like commas and hyphens. The other is to use the "common" or "down" style—the way you see these words most often on the Web (email, website, online.) This approach also tends to eliminate all but the most critical commas, decrying colons, and wiping out semicolons. Our feeling is that this "down-style" will eventually win the field.

As an editor, a big part of your job is to decide which style to use and stick to it. When you have time (OK, so stop laughing), you should write up a styleguide for your site and give it out to all of the writers and copy editors, if you have them. It will eventually make your job a lot easier. (Check out the Web Editor's Toolkit at http://www.sciencesitescom.com/webresources.html, compiled by Merry Bruns, Content Strategist, Editor and Trainer of ScienceSites Communications. Bruns gives Web writing and editing workshops, and has done a terrific job assembling a list of resources for the Web editor.)

And make sure that you edit each text a few times. You'd be surprised how many inconsistencies, typos, and grammatical mistakes you miss on the first pass. (You might also want to proofread the text in different browsers, such as Internet Explorer and Netscape. Even look at AOL if a lot of your readers come from there, too.)

And even though this is the Web, print out your final version to make one last editing pass. It's easier to catch little mistakes on paper than on-screen.

There's always a further embellishment. It looks like a last embellishment and then it turns out not to be—yet once more, and yet once more. One is always saying farewell to it, it is always saying farewell to itself, and then it perpetuates itself.

—Harold Bloom,
***Paris Review* Interview**

Take this test to see if you're up for the challenge

Think you're ready for Web editing? Follow these steps for a crash course:

1. Pick up a copy of *The Smithsonian, The Nation, Vanity Fair, National Geographic,* or any other magazine that has long, leisurely stories.

2. Pick any article that you like and reduce it to half of its original word length.

3. Cut the article in half again, making 4 sections. Write headings for each section.

4. Make each section no more than two paragraphs long. (Hint: use bullets).

5. Give the finished product to a friend to see if the article makes any sense.

Sound silly? Then Web editing is not in your future. As an editor, more often than not, you'll be expected to take vast amounts of information and cut to the core, finding the nugget for your readers.

Take a look at these paragraphs and see what happens when we edit them for the Web.

Mesa Communications released the results of a year-long study today. According to John McCurran, Chief Strategist for Mesa, more people than ever are using the Web, and even though there have been a lot of dot-com layoffs in recently months, consumer spending at online stores is at an all-time high with an expected $10 billion being spent on consumer goods in the first quarter of the year alone. These figures are good news for online stores looking for more venture capital money.

Women still have a small lead among purchasers at online stores (52%). The majority of women who purchase on the Web are in the 25–40 age range. Books still continue to sell well, according to McCurran, but apparel sites are on the rise, especially those with either a physical or catalog presence.

Mesa Communications found that customer service and personalization were big reasons for the upsurge in apparel sites. Ease of returns is also a factor. "E-Commerce is here to stay," said McCurran.

OK. Now you want to summarize these findings for your site or for a newsletter.

Mesa Communications released the <u>results</u> of its year-long study of e-commerce today. They say e-commerce is healthier than ever with consumers expected to spend $10 billion online this quarter.

Other highlights:
- 52% of all purchases are made by women.
- 25–40-year-olds are the women mostly likely to buy on the Web.
- Sales of apparel are catching up to sales of books.
- Consumers opt for stores with good customer service and personalization.

A rose by any other name...

We use the term *Web editor*. But, as with so many things on the Web, you'll see the same job described in many ways. So be careful when looking for a job. Don't discount a good possibility because of the job title. When the Web started, we just borrowed job titles from the magazine and newspaper worlds. Then, as the Web evolved to include audio and video, we started taking job titles from the movies and TV. Finally, the Web said, "Hey, we want our own job titles," so we got a whole new set of terms. Here are some titles that you should check out on the job boards to see if the job really is Web editing or not:
- Content developer
- Content strategist
- Executive producer
- Information manager
- Managing editor
- Producer
- Project manager

Even when I think I've made all the changes I want, the mere mechanical business of touching the keys sharpens my thoughts, and I find myself revising while doing the finished thing. In a way the machine acts as a stimulus; it's a cooperative thing.

—Henry Miller,
***Paris Review* interview**

457

The Debate: Freelance Gigs vs a Staff Job

We once edited a site that put up three to four articles a week, dealt with dozens of freelance writers, answered queries, wrote a monthly column for the site, managed a budget, and participated in all sorts of marketing, advertising and design meetings—all from the comfort of our home, 500 miles away from the head office. (And this was before we could get ISDN and DSL lines!) Yes, freelancing can be done (after all, this is the Internet), but staff jobs predominate, and there are pluses and minus to both situations.

For instance, if you discover that the staff job of your dreams is located 1,000 miles away, wait before you sign up for the all-expense-paid move. There are a lot of financial considerations to think about, especially what kind of salary you'll need in a new town. For example, you can live well on $50,000 a year in Albuquerque, New Mexico. But in Silicon Valley, you won't be able to qualify for a garage mortgage on that. So how do you know? One way is by going to a HomeStore (http://www.homestore.com) and clicking Moving. Fill in the information for the Salary Calculator to compare the cost of living in hundreds of communities in the U.S. For staff jobs, the biggest plus and minus is the site—you have to be there. Here are some other advantages and disadvantages to each way of earning a living.

> *I revise a great deal. I know when something is right because bells begin ringing and lights flash.*
>
> —E. B. White,
> **Paris Review** Interview

The pluses of working on staff

- You get benefits such as health, dental, and life insurance.
- You may get Workman's Compensation benefits.
- You can count on a paycheck during sick days and vacations.
- You can enjoy the camaraderie with your fellow workers.
- You probably get a pretty good computer and quick modem.
- Someone else has to repair your network.
- You have plenty of time to schmooze—the challenge is finding time to do any writing.

- If you get laid off, you get some kind of compensation package.
- Important! You get the office gossip over the cubicle wall, so you know before lunch about the new site redesign, and don't waste any more time on the old one.
- The company has a clear picture of you, your work, and your value. The boss knows you are not lying in a hammock all day.
- The job title gives you something good for your resume.
- You get free cake when it's a co-worker's birthday.

The minuses of working on staff

- You have to work long hours, often without overtime or comp time.
- You squeeze into a small cubicle, far from the sunlight in a maze.
- You share the printer with the rest of the staff.
- You discover your lunch has been stolen out of the fridge.
- You can't hold long, loud, private phone conversations.
- You have to be careful about sending e-mail messages. Your surfing gets monitored, perhaps.
- Too many meetings.
- Everyone has an opinion about your new article.
- The coffee is lousy, unless you work near a Starbucks.
- You have to spend more money on clothes and childcare.
- You have little time and less freedom to moonlight for other sites.

The pluses of being a freelancer

- You can work all day in your slippers.
- You can take as much time off as you want, as long as you get the job done.
- You can have bad hair days and no one knows.
- You get all comments filtered through a single contact person, so you don't have to beat heads together, to get agreement. You just get told what direction to run in.
- You can write for many places at once, so you don't get bored or cramped by continual politicking.

I cut adjectives, adverbs, and every word which is there just to make an effect. Every sentence which is there just for the sentence. You know, you have a beautiful sentence—cut it.

—**Georges Simenon,**
***Paris Review* interview**

- You can take a walk anytime to relieve sore-butt syndrome.
- No one is looking over your shoulder to see what you're looking at on the Web.
- You don't have to freak out when one of your kids is sick.
- You can order whatever darn office supplies you like.
- You never have to leave your dog home alone.

The minuses of being a freelancer

- No paid sick leave or vacation time.
- No paid benefits, such as health, dental, or life insurance.
- No company-paid pension.
- No options.
- Drastic ups and downs in your cash flow.
- You have to pay for office equipment yourself (even though this equipment is tax deductible).
- You don't have any serious water-cooler discussions.
- You miss out on fast-breaking technical information, and more important, you don't keep up on the gossip at the office.
- It's harder to network with other professionals because you only meet them online or by phone.

When we tested our first invention, a computerized reference manual that was obviously marvelous, we found that students did better with the original paper book.

—Thomas Landauer,
The Trouble with Computers

Freelance Markets for Web Writers and Editors

Sure, some thoughts and ideas are complex, but the real test of the power of the idea—and of the thinker—is the ability to translate it into terms that the rest of us can understand.

—Donald Norman,
Turn Signals are the Facial Expressions of Automobiles

Here are some markets for freelance Web writers and editors. They pay.

We're tired of publishers who tell us that if we contribute articles for free we will have a wonderful chance to express ourselves, get great exposure, and bring traffic to our own site. We'd rather get a direct transfer to our bank account. When Sam Goldwyn was wooing Bernard Shaw for the rights to make a play into a movie, Goldwyn kept talking about art. Shaw said, "The difference between us is that you are interested in art, and I am interested in money."

E-mail newsletters

People like having information delivered straight to their inbox. E-mail newsletters save impatient folks a lot of time they would otherwise spend clicking around and up and down. Most e-mail newsletters are very narrowly defined; they are tailored for a specific audience. You might find ones relaying the latest Hollywood gossip, little-known history facts, breakthroughs in medicine, or whazzup with the wrestling crowd.

An editor should tell the author his writing is better than it is. Not a lot better, a little better.

—T. S. Eliot,
***Paris Review* interview**

The writing style for these online newsletter is brief and breezy. People are looking for fascinating content fast. And what better way to remind customers or readers about your site than to send them periodic newsletters about your service? If you think your writing talents might go in this direction, take a look at Shagmail.com (http://www.shagmail.com), a site that offers subscriptions to over 70 different e-mail newsletters.

E-mail newsletters are being used by corporations, e-commerce sites, writers, Webzines, and Internet radio stations—you name it. This growing field will only get bigger. If you can do this kind of writing well, you'll be able to line up a lot of business for yourself. And the pay ain't bad either. You can expect to be paid anywhere from $40 to $100 per hour. Visit:

- CyberTip4theDay (http://www.cybertip4theday.com)—Sends out a daily free newsletter with a tip in the category or categories that you choose.
- Switchboard.com (http://www.switchboard.com)—Offers maps, yellow-and-white page directories to portals, and they also send out e-mail newsletters for business owners.
- Writing for Dollars (http://www.awoc.com)—This newsletter is great for freelancers in two ways: You can submit articles for their free weekly newsletter, and you keep up on sites looking for freelancer writers.

General news sites

The news sites have taken huge hits. Some have folded, while others have announced huge layoffs. The bad news for freelancers, (now, anyhow) is that the news sites are reusing more and more content from their paper publications, from partners, or from syndicators. For example, MSNBC used to be freelancer friendly, paying about $1 per word. Now, they get most of their content from staffers and from *Newsweek*. If you find a news site looking for freelancers, expect an average of 50 cents per word. Sites to explore:

- ABCNews (http://www.abcnews.com)—Looking for all sorts of stories. Go to their site and check out the various departments.
- CNN (http:www.cnn.com)—General news for CNN or financial pieces for CNNfn (http://www.cnnfn.com).
- Correspondence.com(http://www.corresponden.com)—If you have a nose for news, but want to stay a freelancer, try this place (see Syndication section), which uses freelancers to cover breaking stories from around the world.
- New York *Times* on the Web (http://www.nytimes.com)—By the time this book reaches you, this site may be by subscription only (a la the *Wall Street Journal's* interactive WSJ.com), but so far it's free. Technology articles are a good way to break in.
- *USA Today* (http://usatoday.com)—Takes a few articles a month. Favors the high profile, late-breaking news story.
- *Wired News* (http://www.wirednews.com)—Emphasis is on Net culture, technology, business, and politics.

No passion in the world is equal to the passion to alter someone else's draft.

—H. G. Wells

Another way to report the news is to write news-type articles for various sites. You usually have to be an expert in a particular field or write like one.

- *Editor & Publisher Interactive* (http://www.mediainfo.com)—Looking for newsy articles about the online and newspaper industry.
- Plansponsor.com (http://www.plansponsor.com)—This is the Web site for the magazine *Plan Sponsor*. The audience is managers of pension funds. The site is looking for writers who can submit 500-word newsy articles for their readership.

Trade sites

These are sites that cater to professionals in a certain field. They are looking for information to make them richer, save them time, and get a leg up on their competition, learning about new technologies or advancements in their respective fields. You have to know something about the profession, but you can pick up a lot if you are a quick study. Generally, your expertise will determine the amount of $$$ you get for a story. The circulation figures for the publication (the eyeball count, combined with any subscription numbers) also affect the pay. Expect anywhere from 25 cents to $2 per word.

- PubTown (http://www.pubtown.com)—New portal for magazine professionals who want to find out about the latest trends (has a job line, too).
- FashionWindows (http://www.fashionwindows.com)—If you have ideas how to turn a department store window into a thing of beauty, then this is the site for your talents. Stories with photos a big plus.
- Industry Click (http://www.industryclick.com)—For executives in the online and paper catalog biz.
- Quill (http://www.thequill.com)—How-to articles for the beginning writer.
- Web Monkey (http://www.webmonkey.com)—Looking for hi-tech articles for Web builders and developers. Knowledge of Java a big plus.

- Wine Spectator (http://www.winespectator.com)—This site isn't just for people who are in the trade. Wine lovers are encouraged to read the colorful articles and wine reviews.
- Writer Online (http://www.novalearn.com)—Ezine and resource center for writers. Writers' guidelines can be found at http://www.novalearn.com/wol

Popular health and science

Information about health, especially alternative therapies, is mushrooming on the Web. A few years ago, medical sites were paying big bucks for contributions. Unfortunately, their business models weren't the best and many folded. The ones remaining are still looking for solid reporting and good writing, but they prefer writers who have some expertise in the subject. The pay is all over the place. If you are a health professional, expect to be paid more, sometimes up to $2 per word.

- FitnessLink (http://www.fitnesslink.com)—Looking for anything on diet, exercise, or fitness for men and women.
- HealthyFamilyMagazine.com(http://www.healthy-magazine.com)—This is a good place to try if you are new to this niche. The pub is new and isn't paying much (they paid with comp copies of the paper mag for the first issue), so your competition won't be very stiff.
- KidsHealth (http://www.kidshealth.org)—Oft quoted site for articles and information about healthy living for young kids and teens.
- Self (http://www.self.com)—Online arm of *Self Magazine*.

Marketing communication and public relations

Most businesses are discovering that they need a Web site to stay competitive, even if they don't sell anything on the Web. In most cases, these Web sites serve as marketing tools, a way to get the word out on their company or product to the public at large. Often, the content for these sites is written by PR firms that the businesses hire. Unfortunately, a traditional PR agent isn't necessarily very good at hyping her client on the Web. More and more these firms are looking for writers to help fill this gap. Look at the online job

boards under Public Relations or just under Writer. These jobs can be done in-house or out. If you are bidding on a job, you should know that the average pay is about $75 per hour.

- MKTX (http://www.mktx.com)—The merging of high-tech with public relations. Most of their articles are hidden in the client-only section, so click on the Principals link to get more info.
- Promo (http://www.promo.com)—Looking for how-to articles, trends, profiles, and anything having to do with promotion.

Travel

An editor will usually edit one kind of material at a time, beginning with the text.
—Chicago Manual of Style

Travel sites have been quite successful on the Web. In general, the sites are not looking for destination pieces, but articles with a narrower slant, such as how to work out when traveling, where you can save money on an expense account, or what to do with the kids when your flight is delayed. Sometimes, you can find a travel section within a larger site. You should also check for sites focused on big cities, such as New York, Seattle, Los Angeles, even Nashville because these sites often publish touristy-type articles. These usually pay pretty well.

- CitySearch (http://www.citysearch.com)—This is the general site that will lead you to close to 50 specific city guides. Know a city well? Then query the individual city's site with your idea.
- Discovery Channel (http://www.discovery.com)—Prefers travel articles that complement their TV shows. So turn on that TV!
- Maiden Voyages (http://www.maidenvoyages.com)—Articles for female travelers.
- NationalGeographic.com (http://www.nationalgeographic.com)—You know the name, but did you know that you have a better chance here if you can supply photos, video or art?
- Travel by Road (http://www.travelbyroad.net)—Articles and tips for happy campers in the Southwest and Mexico.

- Trip.com (http://www.trip.com)—Looking for articles for the business traveler.

Subscription sites

While general content sites such as *Slate* and *Salon* have had trouble finding a money-making business plan, sites focused on specific content have been booming, making lots of money in subscription fees. What makes these sites so popular is that they offer lots of small tidbits of top-notch content for a narrowly defined audience. For example, diet sites are cashing in on the $40 billion that is spent each year on weight reduction products and methods in the U.S. But they're not the only ones that offer specific information that people are willing to pay for.

- Ancestry.com (http://www.ancentry.com)—The third largest subscription site on the Web. They charge their 200,000 members $59 a year for information and genealogy resources.
- Asimba.com (http://www.asimba.com)—The prices vary, but members get to consult with personal coaches and trainers online, as well as pore through the information on nutrition, training gear, and more.
- eDiets (http://www.ediets.com)—Starting at $10 a month, this site offers 35 boards with over 250,000 postings, all about losing weight.
- SellYourBrainFood.com (http://www.sellyourbrainfood.com)—Gives information to authors and publicists about promoting books online. It has a subscription base of 1,200 paying $19.94 a month.
- WeightWatchers.com (http://www.weightwatchers.com)—Recipes rule on this interactive section of the popular magazine.

E-commerce sites

This is the area hurt most by the dot-com bust of the new millennium. Many e-commerce sites offered their customers lots of articles hoping that readers would turn into customers. In the lingo of the time, content was supposed to make the sites "sticky."

Editing is a craft. Practicing a craft means recognizing and transcending its constraints.

—**Judith Tarutz**, *Technical Editing*

Unfortunately, many of these companies went bust.

However, original content is not dead on the e-commerce sites. Reviews are the mainstay of many e-commerce sites. An average review of a book, video game, toy, or CD goes for $50. These are the types of reviews some e-commerce sites are looking for.

- Amazon.com (http://www.amazon.com)—Book reviews (no, duh).
- CDNow (http://www.cdnow.com)—Music albums.
- Family Wonder (http://www.familywonder.com)— Family-oriented videos, CDs, video games, TV shows, toys, and books.
- KBkids.com (http://www.kbkids.com)—Kid's software reviews.

Syndication

There's a good news/bad news scenario about syndicating, or reprinting, your work on the Web. First, you have to maintain the rights to your material. Second, you have to find a place that will syndicate your articles. Details like these are still getting worked out on the Web, and you'll probably never make loads of money this way, but you might be able to make a few extra bucks. Why is the pay so low? Well, these companies are still trying to figure out a good business model. The popular syndicate, Themestream, folded this year. Some writers self-syndicate their work. How do they do it? They compile a list of Web editors and e-mail a list of articles available. You'll make more money this way because you won't have to split the fee, but you'll also spend more time doing it. However, the outlook is not all dim in the syndication world. With the recent downturn in the economy, newsrooms, newspapers, magazines, and Web outlets are letting staff writers go and are looking for cheaper content alternatives. Buying content from syndicates will be one way to go. Watch for this trend to continue.

Here are some online syndication places:

- @Large Features Syndicates (http://www.atlargefeatures.com)—This might be a good place to try because it is new. They syndicate your work to newspapers, and you retain all rights to your material, plus

The editor doesn't count spelling errors and judge the writer accordingly; the editor is a reader, user advocate, and writing consultant.

—**Judith Tarutz,** *Technical Editing*

you get 75% (not the usual 50%) of all revenue generated from your work.

- Correspondent.com (http://www.correspondent.com)—Not a syndicate in the traditional sense of reusing previously printed material. Here you sign up as one of their journalists and then file original news articles that are sent out along their wire to hundreds of newspapers and Web outlets across the country. (Correspondent.com is based in the U.K.) The more your article is picked up, the more money you make.
- Featurewell.com (http://www.featurewell.com)—Still a good place for freelancers to syndicate their work. Featurewell likes longer articles and buys a lot from print. They sell primarily to Web sites and magazines. Authors receive 60% of the sale.
- Indipen.com (http://www.indipen.com)—You set the price of your article and Indipen then syndicates it worldwide. They take a 15% cut of any sale.
- ISyndicate (http://www.isyndicate.com)—A big wheeler-dealer in the field, they aggregate (pull together) tons of content (from the likes of you) and distribute it to major corporations; they also make money setting up little syndication services inside a corporate Intranet.
- iTravelSyndicate (http://www.itravelsyndicate)—They send an e-mail out to travel professionals listing the articles available (which usually go for $100-$200). Freelancers set the price and iTravel keeps 40% commission.
- Jasmine's Web (http://brandijasmine.com/web/writers/iwrite.html)—Good place for freelancers who self-syndicate their columns. There's no fee to be listed, but the site's owner asks for a donation via PayPal, if you sell your work. Nice concept. Plus Brandi speaks up for freelancers.
- MediaBullet (http://www.mediabullet.com)—Freelancers set the fee and MediaBullet retains a 10% fee. Sells mostly to newspapers. Is also looking for packages that contain video, photos or graphics.

- ScreamingMedia (http://www.screamingmedia.com)—This was one of the first Web syndicates and now is one of the slickest. Unfortunately, they rarely buy from freelancers, preferring to buy from outfits offering lots of content.
- SecondRights.com (http://www.secondrights.com)—Looking to buy second-rights for technology and computer-related articles for resale to newspapers, magazines, and Web sites. Writers set the fee and negotiate directly with the editor. SecondRights takes a 10% finder's fee for each article sold.
- YourNews (http://www.yournews.com)—This is another syndicate that mostly buys from large print (*Business 2.0*) and Web (C|Net) content providers. About the only thing they are looking for now from freelancers are news packages that contain audio and video.

Zines

Webzines, more commonly known as zines, haven't grown up yet. Oh, the zines themselves have evolved into first-rate publications, but they are struggling to find ways to earn a steady stream of revenue. Unfortunately, some good zines have gone belly up, and others have had to reduce the money paid to freelancers. Some of the zines doing the best are those that have well-defined, niche audiences.

- eGrad (http://www.egrad.com)—Firsthand advice articles for the new college grad on subjects ranging from paying back loans to negotiating a better salary for that first job.
- GenerationJ (http://www.generationj.com)—Mostly funny, very hip zine for Jewish GenX'ers
- Salon (http://www.salon.com)—Looking for big stories...the unique and different. Salon makes money by syndicating its content worldwide, so an international slant to a story is always welcome.
- Slate (http://www.slate.com)—Microsoft's zine is hard to break into, but is the best paying of the lot.

Most editors do not spend their days sequestered in dark, quiet rooms, making cryptic scrawls on manuscripts.

—Judith Tarutz, *Technical Editing*

Some authors need to be discouraged from distracting the reader and interrupting the subject matter by frequent remarks on the structure of their work.

—*Chicago Manual of Style*

- SonicNet (http://www.sonicnet.com)—Zine from MTV focusing on anything having to do with music or the music biz.
- Windowbox.com (http://www.windowbox.com)—Especially looking for articles about city and container gardening.

Other sources for work

- Content Exchange Classifieds (http://www.content-exchange.com/cx/app/classifieds—Leads to freelance and staff online writing and editing jobs.
- MarketsforWriters.com (http://marketsforwriters.com)—Web site from Anthony and Paul Tedesco, authors of *Online Markets for Writers*. Buy the book, and then sign up at the site for frequent updates to their markets section.
- MediaBistro.com (http://www.mediabistro.com)—Use the search to filter out the staff and print jobs. Good place to keep abreast of the comings and goings of editors and publishers.
- Newsjobs.net (http://www.newsjobs.net)—Jobs for online and print journalism, plus links to other job resources.
- Writersmarkets.com (http://writersmarkets.com)—You'll get articles, as well as a list of markets all tailored to free-lancers. They also accept short articles.

POST |

My Idea:

Post to HotText@yahoogroups.com

Express your own idea on:

HotText@yahoogroups.com

Subscribe:

HotText-subscribe@yahoogroups.com

Unsubscribe:

HotText-unsubscribe@yahoogroups.com

Visit:

http://www.WebWritingThatWorks.com

part 5 |

Backup

chapter 18 |

Writerly Sites

To get the latest advice, news, and gossip, go online. These sites will keep you up-to-date on trends in online writing. Some will also answer questions and entertain your own rants, as you talk to other writers or folks who care about the impact of Web text.

Blogdex

http://blogdex.media.mit.edu/
Crawls all over the Web looking for links to blogs and reports back the results of this democratic survey.

Blue Ear

http://www.blueear.com
A collaborative enterprise sharing good writing and lively discussions, guided by Ethan Casey, an editor who is tuned into the excitement and anxiety of writing for the Web.

ClickZ

http://www.clickz.com/design/write_onl/index.php
Nick Usborne's column on marketing writing is a weekly must-visit. Browse the rest of the site for practical advice on marcomm.

Cluetrain Manifesto

http://www.cluetrain.com/
Get a clue, by browsing this manifesto against conventional marketing. Written by Christopher Locke, Rick Levine, Doc Searles, and David Weinberger, this is the classic revolutionary call to arms in favor of conversation and writing that is "natural, open, honest, direct, funny and often shocking."

Content Exchange

http://www.content-exchange.com/cx/index.cfm
The tiptop of sites devoted to the process of creating online content, with discussions, newsletters, advice, news, jobs, and classifieds. Home of the stars: Amy Gahran and Steve Outing, and a cast of (literally) thousands.

Contententious

http://www.contentious.com
A great ezine aimed at anyone who is creating content for online media, meaning, mostly, the Web, from Amy Gahran. News, tips, insider insights.

Cyberjournalist.net

http://www.cyberjournalist.net
Jonathan Dube's helpful site for anyone who writes on the Web, but especially journalists. Tips, headlines, links to job sites.

Eastgate Systems

http://www.eastgate.com/HypertextNow/
Thoughtful essays on the literary approach to links, in fiction, poetry, nonfiction—serious hypertext.

Eaton Web

http://portal.eatonweb.com
Checks out thousands of blogs and lists favorites under a few dozen categories.

Edit-Work.com

http://www.edit-work.com/
For advice about editing and writing on the Web and a discussion list for Web editors.

e-Media Tidbits

http://www.poynter.org/tidbits/index.htm
Started by Steve Outing, the interactive media columnist for *Editor & Publisher Online*, and hosted by the Poynter Organization, this Weblog offers short takes on the business of online media.

E-Writers.net

http://e-writers.net/tips.html
Christine Reed responds to e-mails from writers, posts advice, book reviews, and links for online writers.

E-Zine Tips

http://ezine-tips.com/
Advice on content, format, list management,

Good Documents

http://www.gooddocuments.com
Dan Bricklin, veteran of the software wars, gives practical advice on business writing on the Web.

Inscriptions

http://www.inscriptionsmagazine.com
Jade Walker sends out this sympatico e-zine for writers once a week, and the site archives back issues. Focus is on professional writing, not just online writing.

Insert Text Here

http://www.inserttexthere.com/
Online writing jobs and media news, reflecting the personal take of Michelle Nicolosi.

Internet Content Net

http://www.internetcontent.net/
Home of e-Media Tidbits, the collective Weblog headed by Steve Outing, and an archive of content (rather than new material) because the site ran out of money in the dot-com crash.

Internet Marketing Center

http://www.marketingtips.com/tipsltr.html
For marcomm tips and a heavy dose of self-promotion.

Jargon Free Web

http://www.jargonfreeweb.com/newstory.html
Join the crusade to stamp out jargon in press releases on the Web.

Jim Romenesko's Media News

http://www.poynter.org/medianews/index.cfm
Gossip, breaking news, and a great take on journalism on paper, on the air, and on the Web. You may want to make this a regular visit.

Marketing Profs

http://www.marketingprofs.com/index.asp
Great info on marketing, most of which applies to online copywriting. From professors and professionals.

Marketing Sherpa

http://www.marketingsherpa.com/index.cfm
Advice and news on marketing writing and the content business.

Markets for Writers

http://www.marketsforwriters.com
Anthony Tedesco and his little brother Paul put together this wonderful, up-to-date listing of places you can sell your Web writing, taking off from their book, *Online Markets for Writers: How to Make Money by Selling Your Writing on the Internet.*

Media Bistro

http://www.mediabistro.com
Founded seven years ago by freelance journalist Laurel Touby, for writers, editors, copywriters, producers, designers of new media, this site offers links to current articles, job listings, lively discussions, nitty gritty details of insurance, contracts, freelancing.

Media Channel

http://www.mediachannel.org
To follow trends in all the media, but particularly the Web, look at this nonprofit's action toolkits, special reports, forums, and job lists.

Media Map

http://www.mediamap.com
Research, news, and jobs for online and print journalists, and PR folks.

National Writers Union

http://www.nwu.org/
A fighter for freelancers, the union offers sample contracts, legal defense, and a place to gossip. (Not just Web writers, here). Worth visiting, for their defense of freelancers against corporations grabbing all rights from writers.

New Media Studies

http://newmediastudies.com/
A fascinating, if artsy, take on all forms of communication over the Internet. Lots of theory and examples of hip design.

Nielsen Norman Group

http://www.nngroup.com
For the latest usability research, some of which relates directly to text.

NUA

http://www.nua.ie/surveys
Want a stat right away? NUA collects summaries of all Internet surveys, and gives you links to the original research. Plus, Gerry McGovern and his staff comment on online writing. Check their count of Internet users: How Many Online?

Online Journalism Review

http://ojr.usc.edu/index.cfm
For news from around the world on many kinds of online writing, from the USC Annenberg School for Communication. Plus a jobs board and a list of resources for online reporters. Good stuff.

Online News Association

http://www.journalists.org
A focal point for online journalists, with its own conference and occasional research.

Online Writing List

http://www.content-exchange.com/cx/html/owl.htm
Sign up for this discussion, with daily digests. Follow trends, learn inside dope, and, maybe, answer some questions from other Web writers.

Pew Internet
and American Life

http://www.pewinternet.org/
Lots of great info on your visitors.

Poynter

http://www.poynter.org/research/nm.htm
Resources for online journalists, with news items and fascinating articles by real writers—and researchers.

Publish

http://www.publish.com/
The online site for the paper magazine offers insider articles about content, e-marketing, usability, standards, and operations.

Rank Write Roundtable

http://www.rankwrite.com
Heather Lloyd-Martin and Jill Whalen answer questions from folks who want to write their way to search heaven.

Science Sites

http://www.sciencesitescom.com
Merry Bruns' site, with lots of resources such as the Web Editor's Toolkit, and tips on how to find a job writing or editing online.

Studio B

http://www.studiob.com/ab/lists.asp
David Rogelberg's site has a great e-mail newsletter for professional writers, particularly those concentrating on high tech subjects.

Sun Oasis

http://www.sunoasis.com/newmanna.html
David Eide's resources for online writers, with interviews, articles, tips, and links to job sites, plus a zine with his own poems, and other folks' stories.

Target Marketing

http://www.targeting.com/index.html
Jim Sterne's corporate site offers articles and research reports on what works and what doesn't, in online marketing.

The Page of Only Weblogs

http://www.jjg.net/portal/tpoowl.html
Lists faves, topical obsessions, journalistic blogs, and only blogs.

The Titanic Desk Chair
Rearrangement Corporation

http://www.tdcrc.com
Fun rants on personalization and gonzo marketing from Eric Norlin and Christopher Locke in their newsletter, plus rants and chapters of their work.

University of
California Graduate School
of Journalism

http://www.journalism.berkeley.edu/jobs/othersit.html#NewMedia
Writing-related job banks on the Internet, with a focus on reporting jobs. Most jobs are in traditional TV, radio, and newspapers; but some are online.

Uncle Netword

http://www.uncle-netword.com
A site devoted to web text, not design, infrastructure, or whatnot. Styleguide, tips, and articles.

Useit.com

http://www.useit.com/papers/webwriting/
Jakob Nielsen's research on writing for the Web. After you read these articles, browse the rest of the site, for valuable insights into the way people think and act when using the Web.

User Interface Engineering

http://world.std.com/~uieweb/
Jared Spool's group comes up with startling conclusions in its research; you may dispute their statistical validity, but you can't deny their ideas are controversial.

Web Editors List

http://www.topica.com/lists/webeditors
To discuss Web editing with other editors.

Weblogs.com

http://www.weblogs.com
From Userland, this site lists new and updated sites by the hour.

WinWriters

http://www.winwriters.com
A site devoted to online help within software and on the Web. Great resources. Run by an actual writer, Joe Welinske, the site acts as ground zero for conferences, workshops, and advice about customer assistance.

chapter 19

If You Like to Read

Aaron, J. 2000. *Little Brown Essential Handbook for Writers, Third Edition*. New York: Addison-Wesley Educational.

Abeleto.com. 1999. How to write usefully for the Web. http://www.abeleto.com/resources/tutorials/webwriting.html

Abella, V. J., and C. L. Clements. 2001. Helping a crowd: User breadth and depth in online help. (Speech). *STC 48th Annual Conference*, Chicago, IL.

Agre, P. E., and M. Rotenberg (eds). 1997. *Technology and Privacy: The New Landscape*. Cambridge, MA: MIT.

Albrecht, J. and E. O'Brien. 1993. Updating a mental model: Maintaining both local and global coherence. *Journal of Experimental Psychology: Learning, Memory, and Cognition* 19. 1061-1070.

Alexander, C. 1977. *A Pattern Language: Towns/Buildings/Construction*. New York: Oxford.

Allen, C., D. Kania, and B. Yaeckel. 2001. *One-to-One Web Marketing, Second Edition: Build a Relationship Marketing Strategy One Customer at a Time*. New York: Wiley.

Alred, G. J., W. E. Oliu, and C. T. Brusaw. 1992. *The Professional Writer*. New York: St Martin's Press.

America Online. 2001.Webmaster Info. http://webmaster.info.aol.com/webstyle

American Civil Liberties Union (ACLU). 2000. Do You Know Where Your Data Is? http://www.aclu.org/action/privcard.html

American Express Company. 1998. *Customer Privacy Principles*. http://home3.americanexpress.com/corp/consumerinfo/principles.asp

American National Standards Institute. 1988. *Electronic Manuscript Preparation and Markup: American National Standard*. New Brunswick, New Jersey: Transaction.

Ameritech. 1998. *Web Page User Interface and Design Guidelines*. http://www.ameritech.com/news/testown/library/standard/web_guidelines

Ames, A. 2000. *Architecture and Design of Online Information for Information-Rich User Interfaces and User Assistance*. San Jose, CA: University of California Santa Cruz. http://www.verbal-imagery.com/architecture.htm

Andrews, P. 2001. Who are your gatekeepers? *Paul Andrews' Hypodermia*. http://www.paulandrews.com/stories/storyReader$122

Apple Computer. 1987. *Human Interface Guidelines: The Apple Desktop Interface*. Reading, MA: Addison-Wesley.

— 1999. Apple Web Design Guide. http://www.apple.com/

Arthur, L. 2000. Design. http://glassdog.com/design-o-rama/design/index.html

Asher, S. R. 1980. Topic interest and children's reading comprehension. *Theoretical Issues in Reading Comprehension*, R. J. Spiro, B. C. Bruce, and W. F. Brewer, eds. Hillsdale, New Jersey: Lawrence Erlbaum. 525-534.

Austin, J. H. 1999. *Zen and the Brain: Toward an Understanding of Meditation and Consciousness*. Cambridge, MA: MIT.

Ausubel, D. D. 1968. *Educational Psychology: A Cognitive View*. New York, New York: Holt, Rinehart, and Winston.

— 1978. In defense of advance organizers: A reply to the critics. *Review of Educational Research*, 48, 2. 251-257.

Bailey, R. W. 1983. *Human Performance Engineering: A Guide for System Designers*. Englewood Cliffs, New Jersey: Prentice Hall.

Baker, J. D., and I. Goldstein. 1966. Batch vs Sequential displays: Effects on human problem solving. *Human Factors, 8.* 225-235.

Bakhtin, M. M. 1986. *Speech Genres and Other Essays*. Trans. V. McGee, edited by M. Holquist and C. Emerson. Austin, TX: University of Texas Press.

Baldwin, R.S., Z. Peleg-Bruckner, and A. McClintock. 1985. Effects of topic interest and prior knowledge on reading comprehension. *Reading Research Quarterly* 220, Number 4. 497-504.

Balestri, D. P. 1988. Softcopy and hard: Word processing and writing process. *Academic Computing.* 14-17, 41-45.

Bank One. 2001. *Privacy Policy*. http://www.bankone.com

Barber, M. 2000. *The Longman Guide to Columbia Online Style*. New York: Addison Wesley Longman.

Barstow, T. R., and J. T. Jaynes. 1986. Integrating online documentation into the technical publishing process. *IEEE Transactions on Professional Communication*, PC-29, 4. 37-41.

Baudrillard, J. 1983. *Simulations*. (Trans. P. Foss, P. Patton, and P. Beitchman). New York: Semiotext(e).

Bazerman, C. 1994. *Constructing Experience*. Carbondale, IL: Southern Illinois University Press.

Beaugrande, R. de, and W. Dressler. 1981. *Introduction to Text Linguistics*. New York: Longman.

Belew, R. K. 2000. *Finding out About: A Cognitive Perspective on Search Engine Technology and the WWW*. Cambridge, UK: Cambridge University Press.

Benedikt, M. (ed.). 1991. *Cyberspace: The First Steps*. Cambridge, MA: MIT.

Berners-Lee, T. 1992-1998. *Style Guide for Online Hypertext*. http://www.w3.org/Provider/Style/All.html

Bernhardt, S. A. 1986. Seeing the text. *College Composition and Communication*, 37, 66-78.

Bernhardt, S.A., P. Edwards, and P. Wojahn. 1989. Teaching college composition with computers: A program evaluation. *Written Communication*, 6, 108-133.

Beyer, H., and Holtzblatt, K. 1997. *Contextual Design: Defining Customer-Centered Systems*. San Francisco, CA: Morgan Kaufmann.

Bieber, M., F. Vitali, H. Ashman, V. Balasubramian, and H. Oinas-Kukkonen. 1997. Fourth generation hypermedia: Some missing links for the World Wide Web. *International Journal of Human-Computer Studies* 47, Number 1. 31-66. http://ijhcs.open.ac.uk/bieber/bieber.html

Black, R., and S. Elder. 1997. *Web Sites That Work*. San Jose, CA: Adobe.

Boggan, S., D. Farkas, and J. Welinske. 1996. *Developing Online Help for Windows 95*. Boston, MA: Thomson Computer Press.

Bolles, R.. 1999. *Job Hunters Bible*. http://www.jobhuntersbible.com

Bolter, J. D. 1991. *Writing Space: The Computer, Hypertext, and the History of Writing*. Hillsdale, NJ: Erlbaum.

Boomer, H.R. 1975. Relative comprehensibility of pictorial information and printed words in proceduralized instructions. *Human Factors.* 17, 3. 266-267.

Borenstein, N. S. 1985. Help texts vs Help mechanisms: A new mandate for documentation writers. In *Proceedings of SIGDOC '85*. New York: Association for Computing Machinery. 8-10.

Borges, J. A., I. Morales, and N. J. Rodriguez. 1998. Page design guidelines developed through usability testing. In *Human Factors and Web Development*, ed. C. Forsythe, E. Grose, and J. Ratner. Mahwah, New Jersey: Lawrence Erlbaum. 137-152

Bork, A. 1983. A preliminary taxonomy of ways of displaying text on screens. *Information Design Journal*, 3, 3. 206-214.

Bradley, N. 2000. *The XSL Companion*. Harlow, England: Pearson/Addison-Wesley.

Branscum, D. March 5, 2001. Who's blogging now? *Newsweek*. http://stacks.msnbc.com/news/535681.asp

Bransford, J. D., and M. K. Johnson. 1972. Contextual prerequisites for understanding: Some investigations of comprehension and recall. *Journal of Verbal Learning and Verbal Behavior* 11. 717-726.

Bricklin, D. 1996-1998. *Good Documents*. http://ww.gooddocuments.com

Broadbent, D. E. 1957. Immediate memory and simultaneous stimuli. *Quarterly Journal of Experimental Psychology*, 8, 145-152.

— 1978. Language and ergonomics. *IEEE Transactions on Professional Communication*. PC-21: 34-37.

Brown, G.V. 2000. *Intelliforum: Intro to the Action Point Theory*. http://www.intelliforum.com/theory/actionintro.htm

Bruffee, K. A. 1986. Social construction, language, and the authority of knowledge: A bibliographical essay. *College English* 48: 773-790.

Brusaw, C. T., G. J. Alred, and W. E. Oliu. 1997. *Handbook of Technical Writing*, Fifth Edition. New York: St. Martin's Press.

Burgess, J. H. 1984. *Human Factors in Form Design*. Chicago: Nelson-Hall.

Burke, K. 1969. *A Rhetoric of Motives*. Berkeley, CA: University of California Press.

Bush, D. W., and C. P. Campbell. 1995. *How to Edit Technical Documents*. Phoenix, AZ: Oryx.

Bushell, C.B. 1995. *Design Requirements for Hypermedia*. Master's Thesis. University of Illinois at Urbana-Champaign.

Card, S., T. P. Moran, and A. Newell. 1983. *The Psychology of Human-Computer Interaction*. Hillsdale, NJ: Erlbaum.

Carroll, J. M. 1984. Minimalist training. *Datamation*, 30, 18. 125-136.

Celsi, R., and J. Olson. 1989. The role of involvement in attention and comprehension processes. *Journal of Consumer Research* 15, Number 2. 210-224.

Charney, D. 1994. The effect of hypertext on processes of reading and writing. In C. L. Selfe and S. Hilligoss (eds.) *Literacy and Computers: The Complications of Teaching and Learning with Technology*, pp. 195-219. New York: Modern Language Association.

Chase, W.G., and H.H. Clark, 1972. Mental operations in the comparison of sentences and pictures. In L. Gregg (ed.) *Cognition in Learning and Memory*. New York: Wiley.

Cheskin Research and Studio Archetype/Sapient. 1999. *eCommerce Trust Study*. http://www.cheskin.com/think/studies/ecomtrust.html

Clark, G. 1990. *Dialogue, Dialectic, and Conversation: A Social Perspective on the Function of Writing*. Carbondale, IL: Southern Illinois UP.

Clark, H. H., and E. V. Clark. 1968. Semantic distinctions and memory for complex sentences. *Quarterly Journal of Experimental Psychology*, 20. 129-138.

Clark, H. H., and S. E. Haviland. 1977. Comprehension and the given-new contract. In *Discourse Production and Comprehension*, R. O. Freedle, ed. Norwood, New Jersey: Ablex. 1-40.

Clark, H.H., and W. G. Chase. 1982. On the process of comparing sentences against pictures. *Cognitive Psychology*, 3. 472-517.

Clark, R. P. 2000. How to write a good story in 800 words or less. http://poynter.org/centerpiece/LDL-frameset.htm

Coad, P., and E. Yourdon. 1991. *Object-Oriented Design*. Englewood Cliffs, New Jersey: Prentice Hall.

Cohen, J. May 17, 2001. He-Mails, She-Mails: Where sender meets gender. New York *Times*.

Conklin, J. 1987a. Hypertext: An introduction and survey. *IEEE Computer*, 20: 9. 17-41.

— 1987b. STP-356-86, Rev. 2, A Survey of Hypertext. Microelectronics and Computer Technology Corporation.

Conner, M. 2001. Attention links. http://www.learnativity.com/attention.html

Coombs, J. H., A. H. Renear, and S. J. DeRose. 1987. Markup systems and the future of scholarly text processing. *Communications of the ACM*, 30, 933-47. Reprinted in G. P. Landow and P. Delany (eds.) 1993 *The Digital Word, Text-based Computing in the Humanities* (85-118). Cambridge, MA: MIT.

Cooper, Alan. 1995. *About Face: The Essentials of User Interface Design*. Indianapolis, IN: IDG.

— 1999. *The Inmates are Running the Asylum: Why High-Tech Products Drive Us Crazy and How to Restore the Sanity*. Indianapolis, IN: Sams.

Costanzo, W. 1994. Reading, writing, and thinking in an age of electronic literacy. In C. L. Selfe and S. Hilligoss (eds.) *Literacy and Computers: The Complications of Teaching and Learning with Technology*, pp. 195-219. New York: Modern Language Association.

Coyne, K. P., and J. Nielsen. 2001. *Designing Web Sites to Maximize Press Relations: Guidelines from Usability Studies with Journalists*. http://www.nngroup.com/reports/pr/

Creaghead, N. A., and K. G. Donnelly. 1982. Comprehension of superordinate and subordinate information by good and poor readers. *Language, Speech, and Hearing Services in the Schools* 13. 177-186.

Cuff, R. N. 1980. On casual users. *International Journal of Man-Machine Studies*. 12, 2. 163-187.

Dack.com. 2001. Best Practices for Designing Shopping Cart and Checkout Interfaces. http://www.dack.com/web/shopping_cart_Print.html

Daiute, C. 1985. *Writing and Computers*. Reading, MA: Addison-Wesley.

Dalgleish, T. 1995. Performance on the emotional Stroop task in groups of anxious, expert, and control subjects: A comparison of computer and card presentation formats. *Cognition and Emotion*, 9, 341-362.

Davenport, T. H., and J. C. Beck. 2001. *The Attention Economy: Understanding the New Currency of Business*. Cambridge, MA: Harvard Business School Press.

Davies, S. 2001. Time for a byte of privacy, please. Privacy International. http://www.oneworld.org/index_oc/issue697/davies.html

de Wolk, R. 2001. *Introduction to Online Journalism: Publishing News and Information.* Needham Heights, MA: Allyn and Bacon.

Dee-Lucas, D. 1995. Study strategies for instructional hypertext: Effects of text segmentation and task opportunity. In *ED-MEDIA 95 World Conference on Educational Multimedia and Hypermedia Proceedings.* Charlottesville, VA: Association for Advancement of Computer Education. 175-186.

Dee-Lucas, D., and J. Larkin. 1990. Organization and comprehensibility in scientific proofs, or 'consider a particle p...' *Journal of Educational Psychology* 82, Number 4. 701-714.

Deese, J., and R. A. Kaufman. 1957. Serial effects in recall of unorganized and sequentially organized verbal material. *Journal of Experimental Psychology* 54. 180-187.

DeRuiter, C, and J. F. Brosschot. 1994. The emotional Stroop interference effect in anxiety: Attentional bias or cognitive avoidance. *Behavioral Research and Therapy*, 32. 315-319.

Dewer, R. E. 1976. The slash obscures the symbol on prohibitive traffic signs. *Human Factors*, 18, 3. 253-258.

Dikel, M. 2001. *The Riley Guide.* http://www.dbm.com/jobguide. Also, www.rileyguide.com

Dillon, A. 1994. *Designing Usable Electronic Text: Ergonomic Aspects of Human Information Usage.* London, UK: Taylor & Francis.

Dixon, P. 2000a. *Job Searching Online for Dummies.* Foster City, CA: Hungry Minds.

— 2000b. *The Dixon Report.* http://www.pamdixon.com

Dodd, J. S., and American Chemical Society. 1997. *The ACS Style Guide: A Manual for Authors and Editors, Second Edition.* New York: Oxford University Press.

Doherty, M. 2001. @TITLE THIS_CHAPTER AS... [WAS: ON THE WEB, NOBODY KNOWS YOU'RE AN EDITOR] in J. F. Barber and D. Grigar (eds.) *New Worlds, New Words: Exploring Pathways for Writing about and in Electronic Environments.* Cresskill, NJ: Hampton Press.

Dragga, S., and G. Gong. 1989. *Editing: The Design of Rhetoric.* Amityville, New York: Baywood.

Dube, J. 2001. Writing news online: A dozen tips. *CyberJournalist.net.* http://www.cyberjournalist.net/tips.html

Duffy, T. M., J. E. Palmer, and B. Mehlenbacher. 1992. *Online Help Design and Evaluation.* Norwood, NJ: Ablex.

Dumas, J. S., and J. C. Redish. 1993. *A Practical Guide to Usability Testing.* Greenwich, CT: Ablex.

Dumas, J. 1988. *Designing User Interfaces for Software.* Englewood Cliffs, New Jersey: Prentice Hall.

El-Shinnawy, M. 1998. Interface: Susan T. Kinney and Richard T. Watson on 'The effect of medium and task on dyadic communication.' *IEEE Transactions on Professional Communication*, Vol. 41, 2, June. 140-142.

Engelbart, D. C., and W. K. English. 1968. A research center for augmenting human intellect. In I. Greif (ed.), *Computer-Supported Cooperative Work: A Book of Readings* (81-105). San Mateo, CA: Morgan Kaufmann.

Esperet, E. 1996. Notes on hypertext, cognition, and language. *In Hypertext and Cognition*, J. F. Rouet, J. J. Levonen, A. Dillon, and R. J. Spiro, eds. Mahwah, New Jersey: Lawrence Erlbaum, 149-155.

Farkas, D. K., and J. B. Farkas. 2000. Guidelines for designing Web navigation. *Technical Communication*, Volume 47, Number 3. 341-358

Federal Trade Commission, U.S. 1999. *How to Comply With The Children's Online Privacy Protection Rule.* http://www.ftc.gov/bcp/conline/pubs/buspubs/coppa.htm

Fish, S. 1980. *Is There a Text in This Class? The Authority of Interpretive Communities.* Cambridge, MA: Harvard.

Flower, L., J. R. Hayes, and H. Swarts. 1983. Revising functional documents: The scenario principle. In *New Essays in Technical and Scientific Communication: Research, Theory, Practice*, P. V. Anderson, R. J. Brockmann, and C. R. Miller, eds. Farmingdale, New York: Baywood. 41-58.

Flynn, N. 2001. *The ePolicy Handbook.* New York: American Management Association.

Forsythe, C., E. Grose, and J. Ratner (eds.). 1998. *Human Factors and Web Development.* Mahwah, New Jersey: Lawrence Erlbaum.

Fortune, R. 1989. Visual and verbal thinking: Drawing and word processing software in writing instruction. In G. E. Hawisher and C. L. Selfe (eds.), *Critical Perspectives on Computers and Composition Instruction* (145-161). New York: Teachers College Press.

Foucault, M. 1972. *The Archaeology of Knowledge and the Discourse on Language.* Trans. A. M. S. Smith. New York: Pantheon-Random.

Fowler, H. R., J. E. Aaron, and K. Limburg. 1992. *The Little Brown Handbook.* New York: HarperCollins.

Fowler, S. L, and V. R. Stanwick. 1995. *The GUI Style Guide.* Boston: AP Professional.

Frase, L. T. 1969. Paragraph organization of written materials: The influence of conceptual clustering upon the level and organization of recall. *Journal of Educational Psychology* 60, Number 5, Part 1. 394-401.

Freebody, P., and R. C. Anderson. 1986. Serial position and rated importance in the recall of text. *Discourse Processes* 9, Number 1. 310-36.

Freed, R. C., and G. J. Broadhead. 1987. Discourse communities, sacred texts, and institutional norms. *College Composition and Communication* 38, 154-165.

Frisse, M. 1988a. From text to hypertext. *Byte* (October). 247-253.

— 1988b. Searching for information in a hypertext medical handbook. *Communications of the ACM*, 31, 7. 880-886.

Funk, J. 1999. The importance of the end-user experience. In Pirillo, C., *Poor Richard's E-mail Publishing: Creating Newsletters, Bulletins, Discussion Groups, and Other Powerful Communication Tools.* Lakewood, CO: Top Floor Publishing.

Furnas, G. W. 1997. Effective view navigation. *Proceedings of CHI 97 Human Factors in Computing Systems.* Atlanta, GA: ACM Press, 367-374.

Gable Group. 2001. Stories not getting through? You could be trapped in a media bozo/jargon filter. http://www.jargonfreeweb.com/newstory.html

Gagne, R., and Briggs, L. 1979. *Principles of Instructional Design.* New York: Holt, Rinehart, and Winston.

Gahran, A. 2001. Little grasshopper meets content guru, interview by Susan Solomon. http://www.clickz.com/article/cz.3683.html

Galitz, W. O. 1985. *Handbook of Screen Format Design*. Wellesley, MA: QED Information Sciences.

Gamma, E., R. Helm, R. Johnson, J. Vlissides. 1995. *Design Patterns: Elements of Reusable Object-Oriented Software*. Reading, MA: Addison-Wesley.

Gaylin, K. 1986. How are windows used? Some notes on creating an empirically based windowing benchmark test. In *CHI '86 Proceedings*. New York: Association for Computing Machinery. 96-100.

Gee, N. R., D.L. Nelson, and D. Krawczyk. 1999. Is the concreteness effect a result of underlying network interconnectivity? *Journal of Memory and Language*, Number 40. 479-497.

Gilbert, J. 2001. Privacy? Who needs privacy? *Business 2.0*, January 23. 42.

Gillmor, D. The whys and hows of Weblogs. *eJournal: Dan Gillmor's News and Views*. http://web.siliconvalley.com/content/sv/2001/02/20/opinion/dgillmor/weblog/ GillmorWeblogExplainer.htm

Gingras, R. 2001. Five hot tips for successful online journalists (or how to deal with the 26-year-old Harvard M. B. A. who'd rather you didn't exist). In de Wolk, R., *Introduction to Online Journalism: Publishing news and information*. Needham Heights, MA: Allyn and Bacon.

Givens, B. 2000. Privacy expectations in a high tech world. San Diego, CA: Privacy Rights Clearinghouse. http://www.privacyrights.org/ar/expect.htm

Glass, R. L. 1989. Software maintenance documentation. *SIGDOC 89 Conference Proceedings*. New York: ACM.

Goldberg, A., and K. S. Rubin. 1995. *Succeeding with Objects: Decision Frameworks for Project Management*. Reading, MA: Addison-Wesley.

Goldfarb, C. 1990. *The SGML Handbook*. Alexandria, VA: Graphic Communication Association, or New York: Oxford.

Goldfarb, C. F., and P. Prescod. 2000. *The XML Handbook*. Upper Saddle River, NJ: Prentice-Hall.

Goldhaber, M. H. 1992. The attention society. *Release 1.0*, No. 3, March 26. New York, Edventure Holdings. 1-20.

— 1996. Principles of the new economy. http://www.well.com/user/mgoldh/principles.html

— 1997a. The attention economy and the net. *First Monday*. http://www.firstmonday.dk/issues/issue2_4/goldhaber/ Or http://www.well.com/iser/mgoldh/AtECandNet.html

— December 5, 1997b. Attention shoppers. *Wired*. http://www.wired.com/wired/5.12/es_attention_pr.html

— 1998. Art and the Attention Economy. *Telepolis*. http://www.heise.de/tp/english/inhalt/kolu/2241/1.html

Golledge, R. G. 1999a. Human wayfinding and cognitive maps. In Golledge, R. G. (ed.), *Wayfinding Behavior: Cognitive Mapping and Other Spatial Processes*. Baltimore, MD: Johns Hopkins University Press.

— (ed.). 1999b. *Wayfinding Behavior: Cognitive Mapping and Other Spatial Processes*. Baltimore, MD: Johns Hopkins University Press.

Gould, E. W., M. Gurevich, and P. D. Pagerey. 1998.Conducting surveys over the World Wide Web. *STC 45th Annual Conference 1998 Proceedings*. Arlington, VA: Society for Technical Communication. 294-297.

Green, M. 1991. Visual search, visual streams, and visual architectures. *Perception and Psychophysics*, 50, 388-403.

Gregory, R. L. 1980. *Eye and Brain: The Psychology of Seeing*. New York: Oxford.

— 1987. *The Oxford Companion to the Mind*. New York: Oxford.

Gutzman, A. D. 2001. *The e-Commerce Arsenal*. New York: American Management Association.

Haas, C. 1989a. Does the medium make a difference? A study of composing with pen and paper and with a computer. *Human-Computer Interaction*, 4. 149-169.

— 1989b. How the writing medium shapes the writing process: Effects of word processing on planning. *Research in the Teaching of English*, 23, 181-207.

— 1996. *Writing Technology: Studies on the Materiality of Literacy*. Mahwah, NJ: Erlbaum.

Haas, C., and J. R. Hayes. 1986. *Pen and Paper vs the Machine: Writers Composing in Hard Copy and Computer Conditions*. CDC Technical Report 16. Pittsburgh, PAA: Communication Design Center, Carnegie Mellon University.

Hackos, J. T. Finding out what users need and giving it to them: A case study at Federal Express. *Technical Communication*, 42 (2) 322-327.

Hackos, J. T., and J. C. Redish. 1998. *User and Task Analysis for Interface Design*. New York: Wiley.

Hackos, J. T., and D. M. Stevens. 1996. *Standards for Online Communication*. New York: Wiley.

Hagen, P. with H. Manning and R. Souza. July 1999. *Smart Personalization*. Cambridge, MA: Forrester Research.

— 2001. *Demand Chain Redefines Personalization and CRM*. Cambridge, MA: Forrester Research.

Hansell, S. March 26, 2001. Marketers find new avenues on the Internet. New York *Times*.

Harnack, A., and E. Kleppinger. 1997. *Online!* New York: St. Martin's Press.

Hartley, J., and M. Trueman. 1983. The effects of heading syntax on recall, search, and retrieval. *British Journal of Educational Psychology* 53. 205-214.

Hartman, D. B., and K. S. Nantz. 1996. *The 3 Rs of E-Mail: Risks, Rights, and Responsibilities*. Menlo Park, CA: Crisp Publications.

Hasslein, V. 1986. Marketing survey on user requests for online documentation. In *Proceedings of 33rd International Technical Communication Conference*. Washington, DC: Society for Technical Communication. 434-438.

Hawisher, G. E. 1987. Research update: Writing and word processing. *Computers and Composition*, 5. 7-23.

— 1991. Connecting the visual and the verbal. In W. Wrensch (ed.), *Lessons for the Computer Age* (129-132). Urbana, IL: NCTE.

Heckel, P. 1984. *The Elements of Friendly Software Design*. New York: Warner.

Heim, M. 1987. *Electric Language: A Philosophical Study of Word Processing*. New Haven, CT: Yale.

Henning, K. 2000a. Writing well online: Talent isn't enough. http://www.clickz.com/article/cz.2948.html

— 2000b. The seven qualities of highly successful Web writing. http://www.clickz.com/cgi-bin/gt/article.html?article-2997

— 2001a. Clarity by design. http://www.clickz.com/article/cz.3131.html

— 2001b. Fruit flies like a banana: Writing unambiguously. http://www.clickz.com/article/cz.3234.html

— 2001c. Writing for readers who scan. http://www.clickz.com/article/cz.3326.html

— 2001d. Online, consistency is crucial. http://www.clickz.com/article/cz.3413.html

— 2001e. Writing consistently across media: Ten proofreading tips. http://www.clickz.com/article/cz.3494.html

— 2001f. Wireless: Good news for writers who write tight. http://www.clickz.com/article/cz.3598.html

Herring, S. 1996. Posting in a different voice: Gender and Ethics in CMC. In *Philosophical Perspectives on Computer-Mediated Communication*, edited by C. Ess, 115-146. Albany, NY: State University of New York Press.

Herriot, P. 1970. *An Introduction to the Psychology of Language.* London: Methuen.

Herwijnen, E. 1990. *Practical SGML.* Dordrecht/Boston: Kluwer.

Hix, D., and H. R. Hartson. 1993. *Developing User Interfaces: Ensuring Usability through Product and Process.* New York: Wiley.

Hoffman, M. 1996. *Enabling Extremely Rapid Navigation in Your Web or Document.* http://www.pdrinterleaf.com/infoaxcs.htm

Holcomb, P.J., J. Kounios, J. E. Anderson, and W.C. West. 1999. Dual-coding , context-availability, and concreteness effects in sentence comprehension: An electrophysiological investigation. *Learning, Memory, and Cognition* 25, Number 3. 721-742.

Honebein, P. 1997. *Strategies for Effective Customer Education.* Chicago, IL: American Marketing Association.

Horton, W. K., L. Taylor, A. Ignacio, N. Hoft. 1996. *The Web Page Design Cookbook.* New York: Wiley.

Horton, W. K. 1990. *Designing and Writing Online Documentation: Help Files to Hypertext.* New York: Wiley.

Hudson, P.T., and M. W. Bergman. 1985. Lexical knowledge and word recognition: Word length and word frequency in naming and decision tasks. *Journal of Memory and Language,* Volume 24, Number 1. 46-58.

Hunter, D., and C. Cagle, D. Gibbons, N. Ozu, J. Pinnock, and P. Spencer. 2000. *Beginning XML.* Birmingham, UK: Wrox.

IBM Ease of Use (Dong, J., Kieke, E., Martin, S., Tilson, R.). 1997-1999. *Web Design Guidelines.* http://www-3.ibm.com/ibm/easy/eou_ext.nsf/Publish/572PrintView

Isakson, C.S., and J. H. Spyridakis. 1999. The influence of semantics and syntax on what readers remember. *Technical Communication* 46, Number 3. 366-381.

Jacobson, I., M. Ericsson, A. Jacobson. 1994. *The Object Advantage: Business Process Re-engineering with Object Technology.* Reading, MA: Addison-Wesley.

James, W. 1890/1950. *The Principles of Psychology,* Vol. 1. New York: Dover.

— 1925. *The Varieties of Religious Experience.* New York: Longmans, Green.

Johnson, N., and S. Philips. 2001. *Legal Research Exercises Following the Bluebook,* 7th Edition. Eagan, MN: West Wadsworth.

Johnson, S. 1997. *Interface Culture: How New Technology Transforms the Way We Create and Communicate.* New York: HarperCollins.

Johnson-Eilola, J. 1994. Reading and writing in hypertext: Vertigo and euphoria. In C. L. Selfe and S. Hilligoss (eds.) *Literacy and Computers: The Complications of Teaching and Learning with Technology,* pp. 195-219. New York: Modern Language Association.

Jonassen, D. H., W. H. Hannum, and M. Tessmer. 1989. *Handbook of Task Analysis Procedures.* New York: Praeger.

Joyce, M. 1988. Siren shapes: Exploratory and constructive hypertexts. *Academic Computing,* November. 10-15.

— 1995. *Of Two Minds: Hypertext, Pedagogy, and Poetics.* Ann Arbor: University of Michigan Press.

Just, M. A., and P. A. Carpenter. 1976. The relation between comprehending and remembering some complex sentences. *Memory and Cognition* 4, no 3: 318-322

— 1980. A theory of reading: From eye fixation to comprehension. *Psychological Review* 84, Number 4. 329-354.

Kaiser, Jean. 2000. Web Design. About. http://webdesign.about.com/compute/webdesign/library/howto/htwrite.htm

Kaplan, N., and S. Moulthrop. 1990. Computers and controversy: Other ways of seeing. *Computers and Composition,* 7. 89-102.

— 1993. Seeing through the interface: Computers and the future of composition. In G. P. Landow and P. Delany (eds.), *The Digital Word: Text-based Computing in the Humanities* (253-270). Cambridge, MA: MIT Press.

Kay, M. 2000. *XSLT Programmer's Reference.* Birmingham,UK: Wrox.

Keeker, K. 1997. Improving Web site usability and appeal. http://www.microsoft.com/workshop/management/planning/improvingsiteusa.asp#TOP2

Keep, C. J. 1999. The disturbing liveliness of machines. In M.L. Ryan (ed.), *Cyberspace Textuality: Computer Technology and Literary Theory.* Bloomington, IN: Indiana University Press. 164-181.

Kellogg, R. T. 1994. *The Psychology of Writing.* New York: Oxford.

Kennedy, J. L. 1995. *Electronic Job Search Revolution.* New York: Wiley.

Kent, P. 1999. Poor Richard's Web site news. In Pirillo, C., *Poor Richard's E-mail Publishing: Creating Newsletters, Bulletins, Discussion Groups, and Other Powerful Communication Tools.* Lakewood, CO: Top Floor Publishing.

Kent, P., and T. Calishain. 2001. *Poor Richard's Internet Marketing and Promotions: How to Promote Yourself, Your Business, Your Ideas Online,* Second Edition. Lakewood, CO: Top Floor Publishing.

Khoshafian, S., and R. Abnous. 1995. *Object Orientation.* New York: Wiley.

Kieras, D. 1978. Good and bad structure in simple paragraphs: Effects on apparent theme, reading time and recall. *Journal of Verbal Learning and Verbal Behavior* 17. 13-28.

Kieras, J. L. 1980. Initial mention as a signal to thematic content in technical passages. *Memory and Cognition*, 8, 4. 345-353.

Kilian, C. 1999. *Writing for the Web*. North Vancouver, BC: Self-Counsel Press.

— January 2, 2001. Good Web Writing: Small Latin and Less Geek. *Content Exchange*. http://www.content-exchange.com/ex/html/newsletter/2-16/ck2-16.htm.

Kintsch, W. 1993. Text comprehension, memory, and learning. *American Psychologist* 49, Number 4. 294-303.

— 1992. A cognitive architecture for comprehension. In *The Study of Cognition: Conceptual and Methodological Issues*. H. L. Pick, P. van den Broek, and D. C. Knill, eds. Washington, DC: American Psychological Association. 143-164.

Kintsch, W. A., and T. A. van Dijk. 1978. Toward a model of text comprehension and production. *Psychological Review* 85. 363-394.

Kirsner, S. 1997. Community: Can corporate players be convincing—or successful—in the communitarian role? *CIO Magazine*, December 1. http://www.cio.com/archive/webusiness/120197_main.html

Kleinman, G. 1999. In the trenches with *The Kleinman Report*. In Pirillo, C., *Poor Richard's E-mail Publishing: Creating Newsletters, Bulletins, Discussion Groups, and Other Powerful Communication Tools*. Lakewood, CO: Top Floor Publishing.

Knowledge Capital Group. March 26, 2001. *Customer-Relationship Management*. White paper. New York *Times*.

Kollock, P., and M. Smith. 1994. Managing the virtual commons: Cooperation and conflict in computer communities. http://www.sscnet.ucla edu/soc/csoc/vcommons.htm

Korenman, J. 1999. E-mail Forums and Women's Studies: The Example of WMST-L. In Hawthorne, S., and R. Klein, eds., *CyberFeminism: Connectivity, Critique and Creativity*, Australia: Spinifex Press, 80-97.

Krug, S. 2000. *Don't Make Me Think*. Indianapolis, IN: Que. http://www.circle.com/krugbook/

Landow, G. P. 1992. *Hypertext: The Convergence of Contemporary Critical Theory and Technology*. Baltimore, MD: Johns Hopkins.

Landow, G. P. and Delany, P. (eds). 1993. *The Digital Word: Text-based Computing in the Humanities*. Cambridge, MA: MIT Press.

Lanham, R. 1993. *The Electronic Word: Democracy, Technology, and the Arts*. Chicago: University of Chicago Press.

— 1994. The economics of attention. *Proceedings of 124th Annual Meeting Association of Research Librarians*, Austin, Texas. http://sunsite.Berkeley.edu/ARL/Proceedings/124/ps2econ.html

Larkin, W., and D. Burns. 1977. Sentence comprehension and memory for embedded structure. *Memory and Cognition* 5, Number 1. 17-22.

Larson, K., and M. Czerwinski. 1998. Web page design: Implications of memory, structure, and scent for information retrieval. Microsoft Research. http://www.research.Microsoft.com/users/marycz/chi981.htm

Lasica, J. D. 2001a. Weblogs: A new source of news. *USC Annenberg Online Journalism Review*. http://ojr.usc.edu/content

— 2001b. Blogging as a form of journalism. *USC Annenberg Online Journalism Review*. http://ojr.usc.edu/content

Lawless, K. A., and J. M. Kulikowich. 1996. Understanding hypertext navigation through cluster analysis. *Journal of Educational Computing Research* 14, Number 4. 385-399.

Layne, K. 2001. After the fall: Late notes from the online journalism conference. *USC Annenberg Online Journalism Review*. http://ojr.usc.edu

Lee, G. 1993. *Object-Oriented GUI Application Development*. Englewood Cliffs, New Jersey: Prentice Hall.

Levine, R. 1997. *Sun Guide to Web Style*. http://www.sun.com/styleguide

Levine, R., C. Locke, D. Searles, D. Weinberger. 1999. *The Cluetrain Manifesto*. http://www.cluetrain.com

Lie, H. W., and B. Bos. 1999. *Cascading Style Sheets: Designing for the Web*. Harlow, England: Pearson/Addison-Wesley.

Lloyd-Martin, H., and J. Whalen. 2001. *Rank Write Roundtable*. RankWrite@RankWrite.com. Or http://www.rankwrite.com.

Locke, C. 2001. *Gonzo Marketing: Winning through Worst Practices*. Reading, MA: Perseus.

Lohse, G. L, and P. Spiller. 1998. Quantifying the effect of user interface design features on cyberstore traffic and sales. *CHI '98 Conference Proceedings* (Los Angeles, CA). Los Alamitos, CA: ACM Press.

Lorch, R., and E. Lorch. 1985. Topic structure representation and text recall. *Journal of Educational Psychology* 77, Number 2. 137-148.

— 1995. Effects of organizational signals on text-processing strategies. *Journal of Educational Psychology* 87, Number 4. 537-544.

Lovelace, E.A., and S. D. Southall. 1983. Memory for words in prose and their locations on the page. *Memory and Cognition* 11(5). 429-434.

Lynch, K. 1960. *The Image of the City*. Cambridge, MA: MIT Press.

Lynch, P., and S. Horton. 1999. *Yale C/AIM Web Style Guide*. http://info.med.yale.edu/caim/manual/

Lynch, P. 2000. *Visual logic*. http://patricklynch.net/viz/viz021500.html

MacEachren, A. M. 1992. Application of environmental learning theory to spatial knowledge acquisition from maps. *Annals of the Association of American Geographers*, 82 (2), 245-274.

— 1995. *How Maps Work: Representation, Visualization, and Design*. New York: Guilford.

MacKinnon, R. 1992. *Searching for the Leviathan in the Usenet*. Masters Thesis, San Jose State University. gopher://gopher.eff.org:70/00/Publications/CuD/Papers/leviathan

Mahler, W. J. 1987. Interactive touch screen design. In *Proceedings of the 34th International Technical Communication Conference*. Washington, DC: Society for Technical Communication. VC 72-77.

Mandel, T. 1994. *The GUI-OOUI War, Windows vs OS/2, The Designer's Guide to Human-Computer Interfaces*. New York: Van Nostrand Reinhold.

— 1997. *The Elements of User Interface Design*. New York: Wiley.

Mandler, J. M. 1984. *Stories, Scripts, and Scenes: Aspects of Schema Theory*. Hillsdale, NJ: Erlbaum.

Manjoo, F. 2001. Spam spam spam spam spam. *Wired News.* http://www.wired.com/news/ebiz/0,1272,44095,00.html?tw=wn20010525.

MarketingSherpa.com. 2001. *ContentBiz* (newsletter). ContentBiz@lists.marketingsherpa.com.

Markoff, J. 2001. Farewell to the Web. In de Wolk, R., *Introduction to Online Journalism: Publishing News and Information.* Needham Heights, MA: Allyn and Bacon.

Marschark , M., and A. Paivio. 1977. Integrative processing of concrete and abstract sentences. *Journal of Verbal Learning and Verbal Behavior* 16, 217-231.

Martin, H. C. **1957.** *The Logic and Rhetoric of Exposition.* New York: Rinehart.

Martin, J., and J. Odell. 1992. *Object-Oriented Analysis and Design.* Englewood Cliffs, New Jersey: Prentice Hall.

MasterCard. 2001. MasterCard's commitment to your privacy. http://www.mastercard.com/about/privacy/

Mayer, R. 1992. *Thinking, Problem Solving, Cognition.* New York: Freeman.

Mayer, R. E., J. L. Dyck, and L.K. Cook. 1984. Techniques that help readers build mental models from scientific text: Definitions, pretraining, and signaling. *Journal of Educational Psychology* 76. 1089-1105.

McGovern, G. 2001. Boring is beautiful. Newthinking-list@lists.nua.ie.

McGrath, S. 1998. *XML by Example: Building E-Commerce Applications.* Upper Saddle River, NJ: Prentice-Hall.

McKoon, G. 1977. Organization and information in text memory. *Journal of Verbal Learning and Verbal Behavior* 16. 246-260.

McLuhan, M. 1962. *The Gutenberg Galaxy.* Toronto: University of Toronto.

— 1964a. *Understanding Media: The Extensions of Man.* New York: Signet. Reprinted 1996. Cambridge, MA: MIT.

— 1964b. Introduction to reprint of H. Innis, *The Bias of Communication.* Toronto: University of Toronto.

Megginson, D. 1998. *Structuring XML Documents.* Upper Saddle River, NJ: Prentice-Hall.

Mena, J. March 8, 2001. Beyond the shopping cart: A case study of using offline data to your best online customers. *Intelligent Enterprise.* 35-40.

Meyer, B. J. F. 1984. Text dimensions and cognitive processing. In *Learning and Comprehension of Text,* H. Mandl, N. L. Stein, and T. Trabasso (eds.) Hillsdale, New Jersey: Lawrence Erlbaum. 3-51.

Meyrowitz, N., and A. van Dam. 1982. Interactive editing systems: Parts I and II. *ACM Computing Survey,* 14, 321-415.

Microsoft Developers Network Online Web Workshop. 2000. Improving Web site usability and appeal. http://msdn.Microsoft.com/workshop/management/planning/ improvingsiteusa.asp

Middleberg, D. 2001. *Winning PR in the Wired World: Powerful Communications Strategies for the Noisy Digital Space.* New York: McGraw-Hill.

Miller, G. A. 1956. The magical number seven, plus or minus two: some limits on our capacity for processing information. *The Psychological Review,* 63. 81-97.

— 1962. Some psychological studies of grammar. *American Psychologist,* 17, 11. 748-762.

Minasi, M. 1994. *Secrets of Effective GUI Design.* Alameda, CA: Sybex.

Morkes, J. and J. Nielsen. 1998. Applying writing guidelines to Web pages. http://www.useit.com/papers/webwriting/rewriting.html

Mortensen, D. 1997. *Miscommunication.* Thousand Oaks, CA: Sage.

Munger, D., D. Anderson, B. Benjamin, C. Busiel, and B. Paredes-Holt. 2000. *Researching Online, Third Edition.* New York: Longman.

Musciano, C. and B. Kennedy. 1997. *HTML: The Definitive Guide.* Sebastopol, CA: O'Reilly.

NCSA Technology Research Group (Berk, R. and A. Kanfer). 1996. Review of Web style guides. http://www.ncsa.uiuc.edu//edu/trg/styleguide/

Nelson, T. H. 1967. Getting it out of our system. In G. Schechter (ed.). *Information Retrieval: A Critical Review* (191-210). Washington, DC: Thompson.

Nielsen Norman Group. 2001. Designing Websites to maximize press relations: Guidelines from usability studies with journalists. http://www.nngroup.com/reports/pr/summary.html

Nielsen, J., and J. Morkes. 1997. Concise, SCANNABLE, and Objective: How to Write for the Web. http://www.useit.com/alertbox/9710a.html and http://www.useit.com/papers/webwriting/writing.html

Nielsen, J. 1995. Features missing in current Web browsers. Alertbox, July. http://www.useit.com

— 1996. Top Ten Mistakes in Web Design. Alertbox, May. http://www.useit.com/alertbox/9605.html

— 1997a. Be succinct! (Writing for the Web). Alertbox. March 15, 1997. http://www.useit.com.

— 1997b. How users read on the Web. October. http://www.useit.com

— 1997c. The fallacy of atypical Web examples. Alertbox, June 1. http://www.useit.com

— 1997d. The tyranny of the page. Alertbox, November 1. http://www.useit.com

— 1998a. Using link titles to help users predict where they are going. Alertbox, January 11. http://www.useit.com

— 1998b. Microcontent: How to write headlines, page titles, and subject lines. Alertbox, September 6. http://www.useit.com/alertbox/980906.html

— (with Schemenaur and Fox). 1998c. Writing for the Web. Sun Microsystems. http://www.sun.com/980713/webwriting/

— 1999a. Trust or bust: Communicating trustworthiness in Web design. Alertbox, March 7. http://www.useit.com/alertbox/990307.html

— 1999b. The top ten new mistakes of Web design. Alertbox, May 30. http://www.useit.com/alertbox/990530.html

— 1999c. Content integration. Alertbox, June 27. http://www.useit.com/alertbox/990627.html

— 1999d. Ten good deeds in Web design. Alertbox, October 3. http://www.useit.com/alertbox/991003.html

— 1999e. Prioritize: Good content bubbles to the top. Alertbox, October 17. http://www.useit.com/alertbox/991017.html

— 1999f. *Designing Web Usability.* Indianapolis, IN: New Riders.

— 2000a. Is navigation useful? Alertbox, January 9. http://www.useit.com/alertbox/20000109.html

— 2000b. Eyetracking study of Web readers. Alertbox, May 14. http://www.useit.com/alertbox/20000514.html

— 2000c. Customers as designers. Alertbox, June 11. http://www.useit.com/alertbox/20000611.html

Norlin, E. February 21, 2001. *Personalization Newsletter*, Vol 3, No. 4. personalization@personalization.com

Norlin, E., and C. Locke. 2001. *The Titanic Deck Chair Rearrangement Corporation* (newsletter). tdcrc@topica.com

Norman, D. A. 1980. Cognitive engineering and education. In *Problem Solving and Education: Issues in Teaching and Research.* New York: Wiley.

Norman, K. 1991. *The Psychology of Menu Selection.* Norwood, New Jersey: Ablex.

O'Malley, C. E. 1986. Helping users help themselves. In *User-Centered System Design.* Hillsdale, New Jersey: Lawrence Erlbaum Associates. 377-398.

Object Management Group. (A. Hutt, ed.) 1994. *Object Analysis and Design: Description of Methods.* New York: Wiley.

Ohi, D. R. 2001. Secrets of creating and maintaining a successful e-zine. In Rose, M. J., and A. Adair-Hoy, *How to Publish and Promote Online.* New York: St Martin's Press.

Ohnemus, K. R. 1997. Web style guides: Who, what, where. *15th Annual International Conference on Computer Documentation Conference Proceedings, SIGDOC 97, Crossroads in Communication,* October 19-22, 1997. New York: ACM. 189-198.

Olson, M. 1965. *The Logic of Collective Action: Public Goods and the Theory of Groups.* Cambridge, MA: Harvard.

Omanson, R. C., J. A. Cline, C. E. Kilpatrick, and M. C. Dunkerton. 1998. Dimensions affecting Web site identity. *Proceedings of the Human Factors and Ergonomics Society,* 42nd annual meeting. 429-433.

Ong, W., S. J. 1975. The writer's audience is always a fiction. *PMLA* 90, 9-21.

— 1982. *Orality and Literacy: The Technologizing of the Word.* London: Methuen.

Ostrom, E. 1990. *Governing the Commons: The Evolution of Institutions for Collective Action.* New York: Cambridge.

Otte, F. H. 1982. Consistent user interface. *In Human Factors and Interactive Computer Systems.* Norwood, New Jersey: Ablex. 261-275.

Outing, S. 2000. It's not your father's newsroom. *Editor and Publisher.* http://www.editorandpublisher.com

Overby, B. A. 1997. Order and chaos: A sociological profile of TECHWR-L. *15th Annual International Conference on Computer Documentation Conference Proceedings, SIGDOC 97, Crossroads in Communication,* October 19-22, 1997. New York: ACM. 199-206..

Overly, M. R. 1999. *e-Policy: How to Develop Computer, E-Mail, and Internet Guidelines to Protect Your Company and its Assets.* New York: American Management Association.

Palmer, S., and Rock, I. 1994. Rethinking perceptual organization—the role of uniform connectedness. *Psychonomic Bulletin and Review,* 1, 29-55.

Park, D. 1986. Analyzing audiences. *College Composition and Communication* 37, 478-488.

Parker, Y. 2001. *Damn Good Resumes.* Berkeley, CA: Ten Speed. http://www.damngood.com.

Pashler, H. 1998. *The Psychology of Attention.* Cambridge, MA: MIT.

Peppers, D., and M. Rogers. 1993. *The One-to-One Future: Building Relationships One Customer at a Time.* New York: Doubleday.

— 1997. *Enterprise One to One: Tools for Competing in the Interactive Age.* New York: Doubleday.

Phelps, L. W. 1990. Audience and authorship: The disappearing boundary. In Kirsch, G., and D. H. Roen, eds., *A Sense of Audience in Written Communication.* Newbury Park, CA: Sage, 153-174.

Pirillo, C. 1999. *Poor Richard's E-mail Publishing: Creating Newsletters, Bulletins, Discussion Groups, and Other Powerful Communication Tools.* Lakewood, CO: Top Floor Publishing.

Porter, J. E. 1987. Truth in technical advertising: A case study. *IEEE Transactions on Professional Communication* 30, 182-189.

Porter, J. E. 1992. *Audience and Rhetoric: An Archaeological Composition of the Discourse Community.* Englewood Cliffs, NJ: Prentice Hall.

Potts, M. 2001. Musing on the future of journalism. In de Wolk, R., *Introduction to Online Journalism: Publishing news and information.* Needham Heights, MA: Allyn and Bacon.

Price, J., and H. Korman. 1993. *How to Communicate Technical Information.* San Francisco, CA: Addison Wesley Benjamin Cummings.

Price, J. 1982. *Thirty Days to More Powerful Writing.* NY: Fawcett.

— 1985. *Put That in Writing.* NY: Viking.

— 1988. Creating a style for online help. In E. Barrett (ed.), *Text, ConText, and HyperText: Writing with and for the Computer.* Cambridge, MA: MIT Press. 330-341.

— 1997. Introduction. Special Issue of *IEEE Transactions on Professional Communication: Structuring Complex Information for Electronic Publication.* June.

— 1998. So you want to freelance as a Webzine writer? *45th Annual Conference 1998 Proceedings.* Arlington, VA: STC. 174.

— 1999. *Outlining Goes Electronic: A Study of the Impact of Media on our Understanding of the Role of Outlining in Virtual and Collaborative Conversations.* ATTW Series, Ablex.

— 2000. eCommerce Customer Assistance. *8th Annual WinWriters Online Help Conference, Proceedings.* San Diego, CA: WinWriters.

— 2001. Introduction. *Special Issue on Modeling Information in Electronic Space. Technical Communication.* Volume 48, Number 1. 19-21.

Price, L., & J. Price. 1997. Web writing. *Writer's Digest,* October. 44-47.

— 1999. *The Best of Online Shopping.* New York. Ballantine.

Quirk, R., et al. 1972. *A Grammar of Contemporary English*. London: Longman.

Rajani, R., and D. Rosenberg. 1999. Usable? ... Or not? ... Factors affecting the usability of Web sites. *CMC Magazine*. http://www.December.com/cmc/mag/1999/jan/rakros.html

Rand, P. 1993. *Design Form and Chaos*. New Haven, CT: Yale University Press.

Raskin, J. 2000. *The Humane Interface: New Directions for Designing Interactive Systems*. Boston: Addison Wesley.

Rayner, K., M. Carlson, and L. Frazier. 1983. The interaction of syntax and semantics during sentence processing: Eye movements in the analysis of semantically biased sentences. *Journal of Verbal Learning and Verbal Behavior* 22. 358-374.

— 1993. Understanding readers. In C.M. Barnum and S. Carliner (eds.), *Techniques for Technical Communicators*. New York: Macmillan. 14-41.

Rehling, L. 1997. Breaking the rules for Web sites. *1997 IEEE International Professional Communication Conference, IPCC 97 Proceedings, October 22-25, 1997*. Piscataway, New Jersey: IEEE. 101-107.

Reigeluth, C.M. (ed.). 1983. *Instructional Design Theories and Models: An Overview of Their Current Status*. Hillsdale, New Jersey: Erlbaum.

Reigeluth, C. M., M. D. Merrill, and B.C. Wilson. 1980. The elaboration theory of instruction: A model for sequencing and synthesizing instruction. *Instructional Science*, 9. 195-219.

Reigeluth, C. M. and Stein, F. S. 1983. The elaboration theory of instruction. In C.M. Reigeluth (ed.), *Instructional Design Theories and Models*. Hillsdale, New Jersey: Erlbaum.

Relles, N. 1981. A user interface for online assistance. In *Proceedings of 5th International Conference on Software Engineering*. New York: Institute for Electrical and Electronics Engineers. 400-408.

Rhodes, J. S. January 11, 1999. The hidden truth about Web content. http://www.webword.com/moving/hiddentruth.html

Robinson, E. R. N. and F. G. Knirk. 1984. Interfacing learning strategies and instructional strategies in computer training programs. In *Human Factors Review*. Santa Monica: The Human Factors Society. 209-238.

Rodgers, P.C., Jr. 1965. Alexander Bain and the rise of the organic paragraph. *Quarterly Journal of Speech*, 51. 399-408.

— 1966. A discourse-centered rhetoric of the paragraph. *College Composition and Communication*, 17. 2-11.

Roemer, J. M., and A. Champanis. 1982. Learning performance and attitudes as a function of the reading grade level of a computer-presented tutorial. In *Proceedings of Human Factors in Computer Systems Conference*. Gaithersburg, MD: Institute for Computer Sciences and Technology, National Bureau of Standards. 239-244.

Rose, M. J., and A. Adair-Hoy. 2001. *How to Publish and Promote Online*. New York: St Martin's Press.

Rosenfeld, L. July 9, 1999. Cuisinarts, E-Commerce, and... controlled vocabularies. *WebReview*. http://webreview.com/1999/07_09/strategists/07_09_99_3.shtml

Rosenfeld, L., and P. Morville. 1998. *Information Architecture for the World Wide Web*. Sebastopol, CA: O'Reilly.

Rotenberg, M. (ed.). 2000. *The Privacy Law Sourcebook: United States Law, International Law, and Recent Developments*. Washington, DC: Electronic Privacy Information Center.

Rothkopf, E.Z. 1971. Incidental memory for location of information in text. *Journal of Verbal Learning and Verbal Behavior* 10. 608-613.

Rowland, C. May 26, 2000. Users matter: Meeting site visitor needs. *Web Review*. http://webreview.com/2000/05_26/strategists/05_26_00_1.shtml

Rubin, J. 1994. *Handbook of Usability Testing: How to Plan, Design, and Conduct Effective Tests*. New York: Wiley.

Rumbaugh, J., M. Blaha, W. Premerlani, F. Eddy, W. Lorensen. 1991. *Object-Oriented Modeling and Design*. Englewood Cliffs, New Jersey: Prentice Hall.

Sammons, M. 1999. *The Internet Writer's Handbook*. Boston: Allyn and Bacon.

Sawhney, M. 2001.Contextual marketing and the rise of consumer metamediaries. Presentation at MSN Strategic Account Summit, Redmond, WA. http://www.mohansawhney.com

Sawhney, M., and D. Parikh. 2000. Net economy boundaries: Use 'em or lose 'em. [Draft]. http://www.mohansawhney.com.

Sawhney, M., and J. Zabin. 2001. *The Seven Steps to Nirvana*. New York: McGraw-Hill.

Scasny, R. 2001. *Website Flow*. Personal communication.

Schriver, K. A. 1997. *Dynamics of Document Design*. New York: Wiley.

Seybold, P. B., with R. T. Marshak and J. M. Lewis. 2001. *The Customer Revolution: How to Thrive When Customers are in Control*. New York: Random House.

Seybold, P. B., with R. T. Marshak. 1998. *Customers.com: How to Create a Profitable Business Strategy for the Internet and Beyond*. New York: Random House.

Shearer, N.A. 1972. Alexander Bain and the Genesis of Paragraph Theory. *Quarterly Journal of Speech*, 58, pp. 408-417.

Shirk, H. N. 1988. Technical writers as computer scientists: The challenges of online documentation. In *Text, ConText, and HyperText: Writing with and for the Computer*. Cambridge, MA: MIT Press. 311-327.

Shneiderman, B., and G. Kearsley. 1989. *Hypertext Hands-On!* Reading, MA: Addison-Wesley.

Shneiderman, B. 1982. System message design: Guidelines and experimental results. In *Directions in Human/Computer Interaction*. Norwood, New Jersey: Ablex. 55-78.

— 1989. Reflections on authoring, editing, and managing hypertext. In E. Barrett (ed.), *The Society of Text: Hypertext, Hypermedia, and the Social Construction of Information*. Cambridge, MA: MIT Press.

— 1992. *Designing the User Interface: Strategies for Effective Human-Computer Interaction*. 2nd Edition. Reading, MA: Addison-Wesley.

— 1998. *Designing the User Interface: Strategies for Effective Human-Computer Interaction*. 3rd Edition. Reading, MA: Addison-Wesley.

Siegel, D. 1996. *Creating Killer Web Sites.* Indianapolis, IN: Hayden.

Silver, D. 1997. Introducing cyberculture. http://www.otal.umd.edu/~rccs/

— 2000. Looking backwards, looking forward: Cyberculture studies 1990-2000. In Gauntlett, D., ed., *Web.Studies: Rewiring Media Studies for the Digital Age,* New York: Oxford University Press. 19-30.

Silvia, S. 1998. Art/Technology. Interview with Amy Gahran. http://arttech.about.com/hobbies/arttech/library/weekly/aa101598.htm

Simpson, H. 1985. *Design of User-Friendly Programs for Small Computers.* New York: McGraw-Hill.

Slatin, J. 1988a. Hypertext and the teaching of writing. In *Text, ConText, and HyperText: Writing with and for the Computer.* Cambridge, MA: MIT Press. 111-129.

— 1988b. Toward a rhetoric for hypertext. *In Hypermedia '88.* Houston, TX: University of Houston-Clear Lake and NASA/Johnson Space Center. 135-139.

Smith, R. 2000a. *Electronic Resumes and Online Networking.* Career Press.

Smith, R. 2000b. *eResumes and Resources.* http://www.eresumes.com

Solomon, S. March 20, 2001. What does the media think of your site? http://www.clickz.com/article/cz.3604.html

Spool, J., with T. Scanlon, W. Schroeder, C. Snyder, and T. De Angelo. 1997. *Web Site Usability: A Designer's Guide.* North Andover, MA: User Interface Engineering.

Spyridakis, J. H. 2000. Guidelines for authoring comprehensible Web pages and evaluating their success. *Technical Communication,* Volume 47, Number 3. 359-382.

Sterne, J. 1996. *Customer Service on the Internet: Building Relationships, Increasing Loyalty, and Staying Competitive.* New York: Wiley.

— 2001a. Making metrics count. *Business 2.0.* June. 72

— 2001b. Measuring up. http://www.targeting.com/measuring-up.html

Stevens, K. 1980. Toward an interactive-compensatory model of individual differences in the development of reading fluency. *Reading Research Quarterly* 16, Number 1. 32-71.

Suh, S., and T. Trabasso. 1993. Inferences during reading: Converging evidence from discourse analysis, talk-aloud protocols, and recognition priming. *Journal of Memory and Language,* 32. 279-301.

Sullivan, Terry. 1996-1998. All things Web. http://www.pantos.org/atw

Sun Microsystems (Nielsen, Schemenaur, Fox). 1994-2000. Writing for the Web. http://www.sun.com/980713/webwriting/

Tarutz, J. 1992. *Technical Editing: The Practical Guide for Editors and Writers.* Reading, MA: Addison-Wesley.

Taylor, D. 1992. *Object-Oriented Information Systems: Planning and Implementation.* New York: Wiley.

Tedesco A., and P. Tedesco. 2000. *Online Markets for Writers: How to Make Money by Selling Your Writing on the Internet.* New York: Holt.

Thinus-Blanc, C. and F. Gaunet. 1999. Spatial processing in animals and humans: The organizing function of representations for information gathering. In Golledge, R. G. (ed.), *Wayfinding Behavior: Cognitive Mapping and Other Spatial Processes.* Baltimore, MD: Johns Hopkins University Press.

Thorngate, W.. 1988. On paying attention. In Baker, W., L. Mos, H. VanRappard, and H. Stam (eds.), *Recent Trends in Theoretical Psychology.* New York: Springer-Verlag. 247-264.

— 1990. The economy of attention and the development of psychology. *Canadian Psychology/Psychologie Canadienne.* Volume 31. 262-271.

Titchener, E. B. 1908. *Lectures on the Elementary Psychology of Feeling and Attention.* New York: Macmillan.

Tognazzini, B. 1992. *Tog on Interface.* Reading, MA: Addison-Wesley.

Trabasso, T., and P. van den Broek. 1985. Causal thinking and the representation of narrative events. *Journal of Memory and Language* 24. 612-630.

Travis, B., and D. Waldt. 1995. *The SGML Implementation Guide: A Blueprint for SGML Migration.* Berlin: Springer.

Treisman, A. 1982. Perceptual grouping and attention in visual search for features and for objects. *Journal of Experimental Psychology: Human Perception and Performance,* 8. 194-214.

Troutman, K. K. 2001. *The Resume Place.* http://www.resume-place.com

Tufte, E. R. 1983. *The Visual Display of Quantitative Information.* Cheshire, CT: Graphics Press.

Tulving, E., and F. I. M. Craik (eds.). 2000. *The Oxford Handbook of Memory.* New York: Oxford University Press.

Tuman, M. C. 1992. *Word Perfect: Literacy in the Computer Age.* Pittsburgh: University of Pittsburgh.

Turner, R., T. Douglass, A. Turner. 1996. *Readme 1st: SGML for Writers and Editors.* Upper Saddle River, New Jersey: Prentice-Hall.

Uncle Netword. 1999a. Creating user-centered copy. http://www.uncle-netword.com/articles/writeweb4.html

— 1999b. Information architecture. http://www.uncle-netword.com/articles/writeweb3.html

— 1999c. Web style guide. http://www.uncle-networkd.com/webstyle/index.html

University of Chicago Press Editorial Staff. *A Manual of Style, 14th Edition.* Chicago, IL: The University of Chicago Press.

— *The Chicago Manual of Style* FAQ (and not so FAQ). http://www.press.uchicago.edu/Misc/Chicago/cmosfaq.html

Usborne, N. 2001a. The importance of being earnest. http://clickz.com/print.jsp?article=3156

— 2001b. Can a company speak with a sincere voice? http://clickz.com/print.jsp?article=3444

— 2001c. Who says long copy doesn't work online? http://clickz.com/print.jsp?article=3525

Utting, K., and N. Yankelovich. 1989. Context and orientation in hypermedia networks. *ACM Transactions on Information Systems,* 7:1. 58-84.

van Dijk, T., and W. Kintsch. 1983. *Strategies of Discourse Comprehension.* New York: Academic Press.

Veen, J. 1994-2000. Hot Design Tips. http://hotwired.lycos.com/webmonkey/98/34/index1a_page6.html?tw=design

— 2001. Interview. http://www.webreference.com/interviews/veen/

Visa. 2001. *Privacy Matters.* http://www.visa.com/ut/faq/privacy.html

Voss, J. F., R. H. Fincher-Kiefer, T. R. Greene, and T. A. Post. 1986. Individual differences in performance: The contrastive approach to knowledge. In Sternberg, R. J., (ed.), *Advances in the Psychology of Human Intelligence*, Hillsdale, New Jersey: Lawrence Erlbaum, 297-345.

W3C. 1999. *Web Content Accessibility Guidelines 1.0.* http://www.w3.org/TR/1999/WAI-WEBCONTENT-19990505/

Waern, Y. 1989. *Cognitive Aspects of Computer-Supported Tasks.* New York: Wiley.

Waite, R. 1982. Making information easy to use: A summary of research. In *Proceedings of International Technical Communication Conference.* Washington, DC: Society for Technical Communication. E 120-123.

Walker, J. H. 1987a. Document examiner: Delivery interface for hypertext documents. In *Hypertext '87 Papers.* Chapel Hill, NC: University of North Carolina. 307-323.

— 1987b. Issues and strategies for online documentation. *IEEE Transactions on Professional Communication*, PC-30, 4. 235-248.

Walker, J., and J. Ruszkiewicz. 2000. *Writing@online.edu.* New York: Addison-Wesley Educational.

Walker, J. R., and T. Taylor. 1998. *The Columbia Guide to Online Style.* New York: Columbia University Press.

Wasson, P. C., and P.N. Johnson-Laird. 1972. *Psychology of Reasoning: Structure and Content.* Cambridge, MA: Harvard.

Weber, R. J. 2000. *The Created Self.* New York: Norton.

Weblogs.com. 2001. What are Weblogs? http://www.weblogs.com/about

Webster, B. 1995. *Pitfalls of Object-Oriented Development.* New York: MIS Press, Holt.

Weiss, E. 1991. *How to Write Usable User Documentation.* Phoenix, AZ: Oryx.

Weiss, M. J. 2001. Online America. *American Demographics.* March 2001. http://www.americandemographics.com

Welinske, J. 2001. *WinWriters.* http://www.winwriters.com

Wexler, S. 1998. *Official Microsoft HTML Help Authoring Kit.* Redmond, WA: Microsoft Press.

Whitaker, L. A. 1998. Human navigation. In Forsythe, C., E. Grose, and J. Ratner (eds.), *Human Factors and Web Development*, Mahwah, New Jersey: Lawrence Erlbaum, 63-71.

Whitaker, L. A., and S. Stacey. 1981. Response times to left and right directional signals. *Human Factors*, 223.4. 447-452.

White, C. March 8, 2001. Custom Fit: Personalization can greatly improve productivity and usability while providing key marketing advantages. *Intelligent Enterprise*, 26-31.

Wickens, C.D. 1984. *Engineering Psychology and Human Performance.* Columbus, OH: Merrill.

Williams, J.M. 1990. *Style: Toward Clarity and Grace.* Chicago: University of Chicago Press.

— *Style: Ten Lessons in Clarity and Grace, Fourth Edition.* New York: Harper Collins.

Williams, T.R. 1994. Schema theory. In Sides, C.H. (ed.), *Technical Communications Frontiers: Essays in Theory*, St. Paul, MN: Association of Teachers of Technical Writing, 81-102.

— 2000. Guidelines for Designing and Evaluating the Display of Information on the Web. *Technical Communication*, Volume 47, Number 3. 383-396.

Winsberg, F. Y. 1987. Online documentation: Tutorials that are easy to take. In *Proceedings of 34th International Technical Communication Conference.* Washington, DC: Society for Technical Communication. ATA 101-104.

Wood, L. E. 1996. The ethnographic interview in user-centered work/task analysis. In Wixon, D. and J. Ramey (eds.), *Field Methods Casebook for Software Design*, New York: Wiley, 35-56.

Wurman, R. S. 1996. *Information Architects.* NY & Zurich: Graphis.

Young, M. J. 2000. *Step-by-Step XML.* Redmond, WA: Microsoft.

Young, R.L., A.L. Becher, K.L. Pike. 1970. *Rhetoric: Discovery and Change.* New York: Harcourt Brace.

Yourdon, E. 1994. *Object-Oriented Systems Design: An Integrated Approach.* Englewood Cliffs, New Jersey: Prentice Hall.

Zemke, R., and T. Connellan. 2001. *e-Service: 24 Ways to Keep Your Customers when the Competition is Just a Click Away.* New York: American Management Association.

Zimmerman, D., M. Muraski, E. Estes, and B. Hallmark. A formative evaluation method for designing WWW sites. *1997 IEEE International Professional Communication Conference, IPCC 97 Proceedings, October 22-25, 1997.* Piscataway, New Jersey: IEEE. 223-230.

Zipf, G.K. 1949. *Human Behavior and the Principle of Least Effort.* Reading, MA: Addison-Wesley.

Index

Publishing
the Voices
that Matter

OUR BOOKS

OUR AUTHORS

SUPPORT

| web development | graphics & design | server technology | certification |

NEWS/EVENTS

PRESS ROOM

EDUCATORS

ABOUT US

CONTACT US

WRITE/REVIEW

You already know that New Riders brings you the Voices that Matter.

But what does that mean? It means that New Riders brings you the

Voices that challenge your assumptions, take your talents to the next

level, or simply help you better understand the complex technical world

we're all navigating.

Visit **www.newriders.com** to find:

- ▶ Never before published chapters
- ▶ Sample chapters and excerpts
- ▶ Author bios
- ▶ Contests
- ▶ Up-to-date industry event information
- ▶ Book reviews
- ▶ Special offers
- ▶ Info on how to join our User Group program
- ▶ Inspirational galleries where you can submit your own masterpieces
- ▶ Ways to have your Voice heard

New Riders

WWW.NEWRIDERS.COM

HOW TO CONTACT US

VISIT OUR WEB SITE

WWW.NEWRIDERS.COM

On our web site, you'll find information about our other books, authors, tables of contents, and book errata. You will also find information about book registration and how to purchase our books, both domestically and internationally.

EMAIL US

Contact us at: **nrfeedback@newriders.com**

- If you have comments or questions about this book
- To report errors that you have found in this book
- If you have a book proposal to submit or are interested in writing for New Riders
- If you are an expert in a computer topic or technology and are interested in being a technical editor who reviews manuscripts for technical accuracy

Contact us at: **nreducation@newriders.com**

- If you are an instructor from an educational institution who wants to preview New Riders books for classroom use. Email should include your name, title, school, department, address, phone number, office days/hours, text in use, and enrollment, along with your request for desk/examination copies and/or additional information.

Contact us at: **nrmedia@newriders.com**

- If you are a member of the media who is interested in reviewing copies of New Riders books. Send your name, mailing address, and email address, along with the name of the publication or Web site you work for.

BULK PURCHASES/CORPORATE SALES

If you are interested in buying 10 or more copies of a title or want to set up an account for your company to purchase directly from the publisher at a substantial discount, contact us at 800-382-3419 or email your contact information to corpsales@pearsontechgroup.com. A sales representative will contact you with more information.

WRITE TO US

New Riders Publishing
1249 Eighth Street
Berkeley, California 94710

CALL US

Toll-free (800) 571-5840
If outside U.S. (317) 581-3500
Ask for New Riders

VOICES THAT MATTER

New Riders

WWW.NEWRIDERS.COM